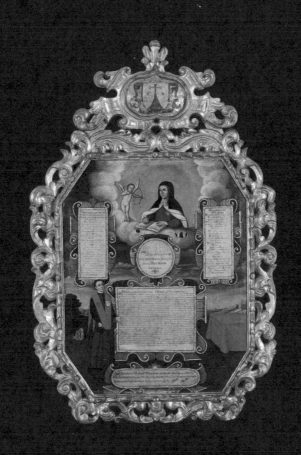

Retratos

2,000 Years of Latin American Portraits

Retratos

2,000 Years of Latin American Portraits

ELIZABETH P. BENSON

FATIMA BERCHT

MIGUEL A. BRETOS

CAROLYN KINDER CARR

CHRISTOPHER B. DONNAN

MARÍA CONCEPCIÓN GARCÍA SÁIZ

RENATO GONZÁLEZ MELLO

KIRSTEN HAMMER

LUIS-MARTÍN LOZANO

MARION OETTINGER JR.

LUIS PÉREZ-ORAMAS

TEODORO VIDAL

San Antonio Museum of Art

National Portrait Gallery, Smithsonian Institution

El Museo del Barrio

Yale University Press

New Haven and London

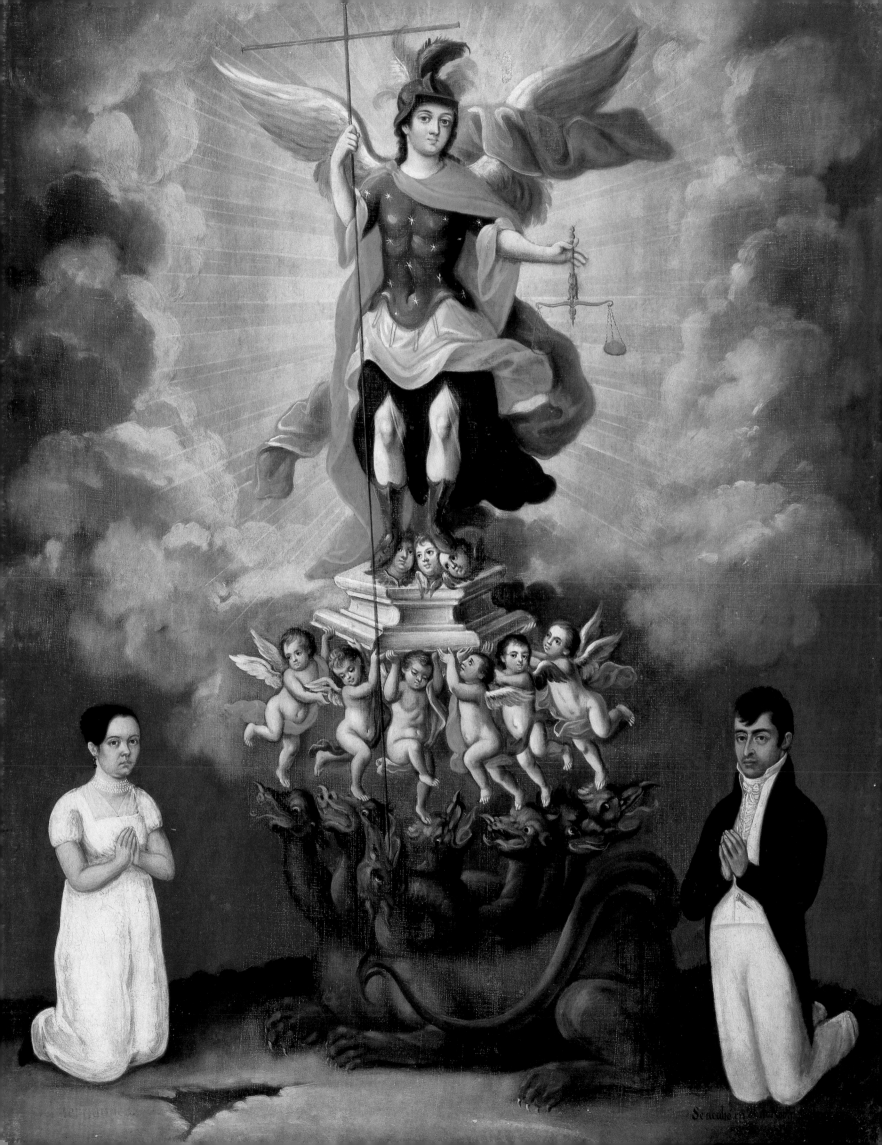

Exhibition Itinerary

El Museo del Barrio, New York
December 3, 2004–March 20, 2005

San Diego Museum of Art, California
April 16–July 12, 2005

Bass Museum of Art, Miami Beach, Florida
July 23–October 2, 2005

National Portrait Gallery at the S. Dillon Ripley Center,
Smithsonian Institution, Washington, D.C.
October 21, 2005–January 8, 2006

San Antonio Museum of Art, Texas
February 4–April 30, 2006

This project and all related programs and publications
are made possible by Ford Motor Company Fund.

This project has received support from the
Latino Initiatives Pool, administered by
the Smithsonian Center for Latino Initiatives.

Library of Congress Cataloging-in-Publication Data
 Retratos : 2,000 years of Latin American portraits /
 Elizabeth P. Benson ... [et al.].
 p. cm.
 Issued in connection with an exhibition held Dec. 3,
 2004–Mar. 20, 2005, El Museo del Barrio, New York,
 and at four other museums at later dates.
 Includes bibliographical references and index.
 ISBN 0-300-10627-0 (hardcover : alk. paper) —
 ISBN 1-883502-12-8 (softcover : alk. paper)
 1. Portraits—Latin America. 2. Portrait painting,
 Latin American. 3. Portrait painting, Mexican.
 I. Benson, Elizabeth P. II. Museo del Barrio.
 III. San Antonio Museum of Art.
 N7595.5.R48 2004
 704.9'42'098—dc22 2004015988

Published by Yale University Press in association with
San Antonio Museum of Art; National Portrait Gallery,
Smithsonian Institution; and El Museo del Barrio

Edited by Dru Dowdy, National Portrait Gallery
Proofread by Sharon Rose Vonasch
Indexed by Sherry Smith
Designed by Jeff Wincapaw
 with assistance by Zach Hooker
Typeset by Jennifer Sugden
Color separations by iocolor, Seattle
Produced by Marquand Books, Inc., Seattle
 www.marquand.com
Printed and bound by C&C Offset Printing Co., Ltd.,
China

DETAILS:

Front cover: Diego Rivera, *Elisa Saldívar de Gutiérrez Roldán,* 1946 (pl. 99); back cover and page 149: José Gil de Castro, *José Raymundo Juan Nepomuceno de Figueroa y Araoz,* 1816 (pl. 43); page 3: Unidentified artist, *The Hernándezes Honoring Their Devotion to the Archangel Saint Michael,* 1818 (pl. 40); page 5: Frida Kahlo, *Self-Portrait with Thorn Necklace and Hummingbird,* 1940 (pl. 95); page 21: Andrés de Islas, *Ana María de la Campa y Cos y Ceballos,* 1776 (pl. 15); page 28: Unidentified artist, *Genealogy and Ancestry of Don Ramón Neira Nuñez and Barbosa,* eighteenth century (pl. 20); page 31: Andrés Sánchez Galque, *The Mulattoes of Esmeraldas,* 1599 (pl. 9); page 44: Unidentified artist, *Male Effigy Vessel,* A.D. 100–600 (pl. 5); page 47: Unidentified artist, *Seated Dignitary with Cape and Headdress,* A.D. 600–900 (pl. 8); page 57: Unidentified artist, *Stirrup Spout Portrait Vessel,* A.D. 100–600 (pl. 6); page 72: Leandro Joaquim, *Dom Luíz de Vasconcellos e Sousa,* 1780 (pl. 23); page 75: Joseph Mariano Lara, *Matheo Vicente de Musitu y Zalvide y su Esposa Doña María Gertrudis de Salazar,* c. 1791 (pl. 30); page 87: Unidentified artist, *Crowned Nun,* late eighteenth century (pl. 34); page 103: José Campeche y Jordán, *An Ensign in a Regiment of the Permanent Infantry of Puerto Rico,* c. 1789 (pl. 28); page 146: Unidentified artist, *A Gentleman of the Canals Family Wearing Spectacles,* 1840–55 (pl. 64); page 206: Abraham Ángel, *The Family,* 1924 (pl. 89); page 209: Lasar Segall, *Self-Portrait III,* 1927 (pl. 90); page 219: Diego Rivera, *The Painter Zinoviev,* 1913 (pl. 85); page 250: Salomón Huerta, *Untitled Figure,* 2000 (pl. 114); page 253: Iñigo Manglano-Ovalle, *Carter, Anna, and Darryl* (from *The Garden of Delights*), 1998 (pl. 113)

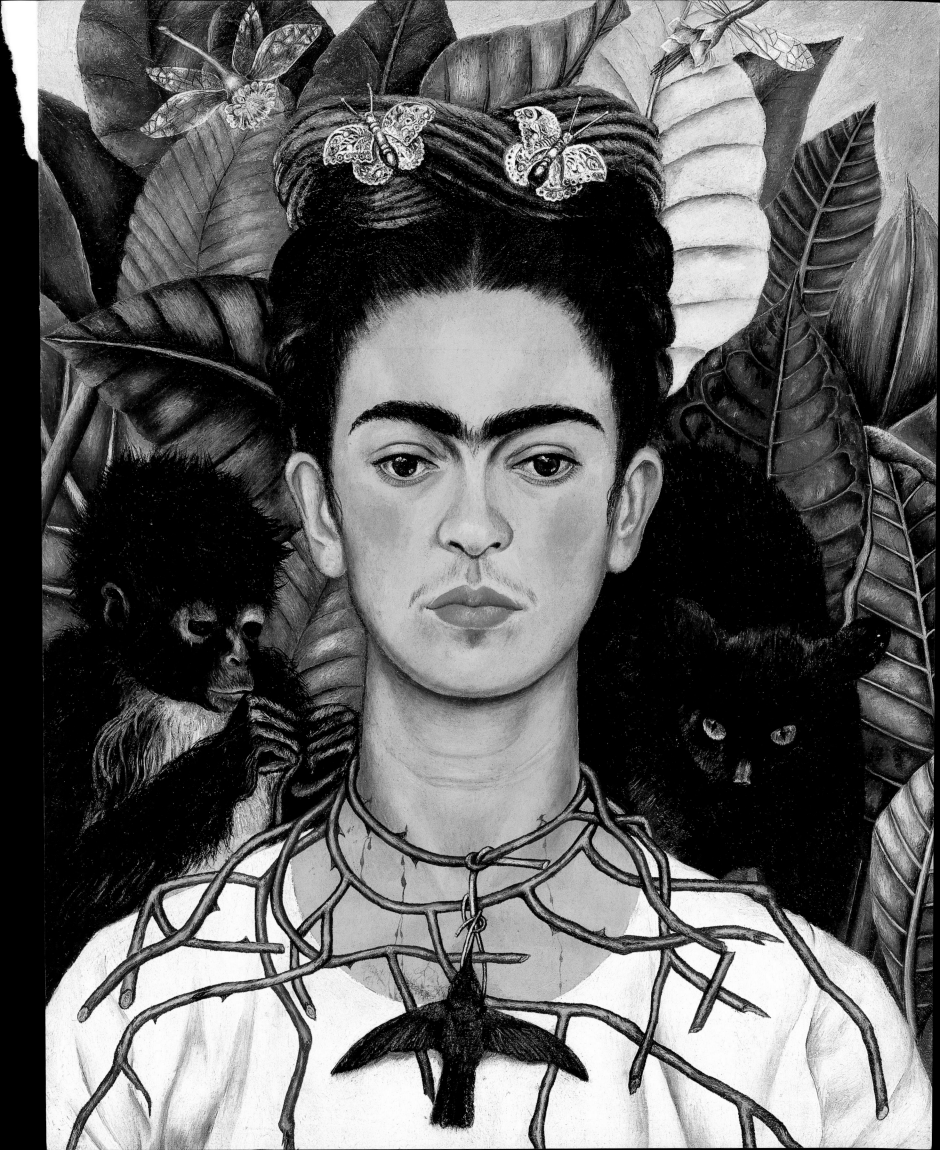

CONTENTS

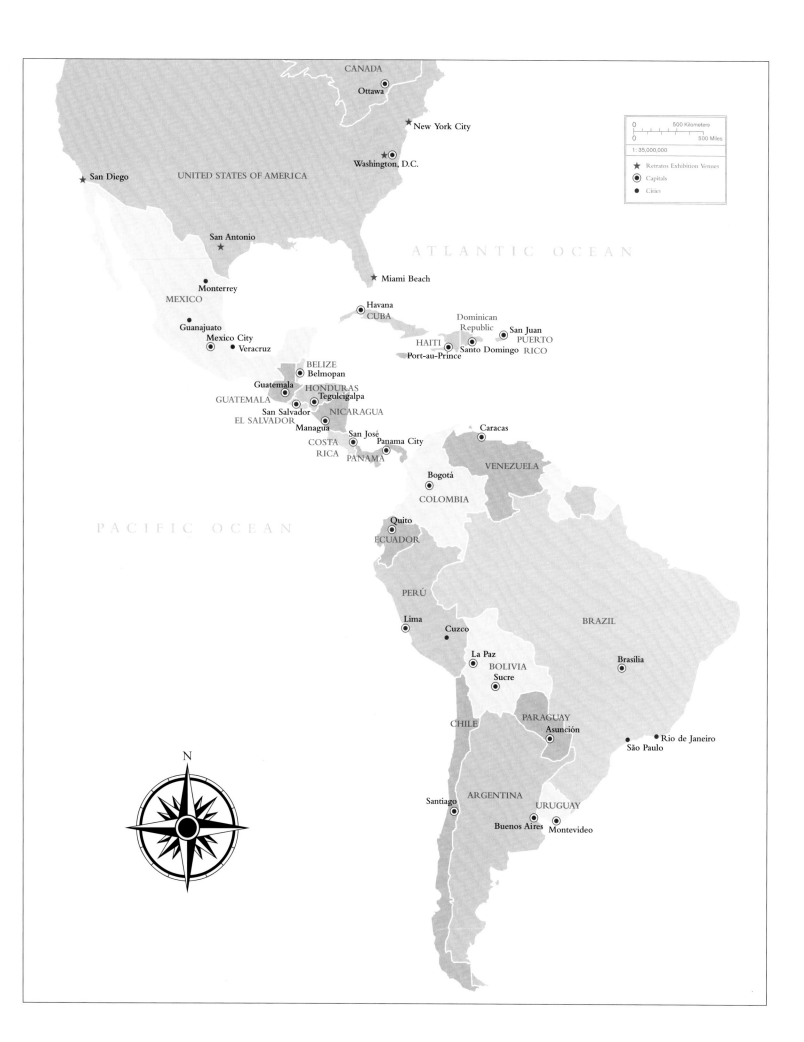

CANADA

Ottawa

★ New York City

★ Washington, D.C.

UNITED STATES OF AMERICA

★ San Diego

ATLANTIC OCEAN

San Antonio
★

★ Miami Beach

Monterrey

MEXICO

Havana
CUBA

Dominican
Republic

San Juan
PUERTO
RICO

Guanajuato

Mexico City
Veracruz

HAITI

Santo Domingo

Port-au-Prince

BELIZE
Belmopan

Guatemala

HONDURAS
Tegulcigalpa

GUATEMALA

San Salvador

NICARAGUA

EL SALVADOR

Managua

Caracas

San José
Panama City

COSTA
RICA

PANAMA

VENEZUELA

Bogotá

COLOMBIA

PACIFIC OCEAN

Quito

ECUADOR

PERÚ

BRAZIL

Lima

Cuzco

La Paz
BOLIVIA
Sucre

Brasilia

PARAGUAY

CHILE

Asunción

Rio de Janeiro
São Paulo

N

ARGENTINA

URUGUAY

Santiago

Buenos Aires
Montevideo

500 Kilometers
0
0
500 Miles
1 : 35,000,000

★ Retratos Exhibition Venues
◉ Capitals
• Cities

8

Retratos: 2,000 Years of Latin American Portraits proves that good things are born from the union of diverse strengths. This major project brings together the work of many of Latin America's most accomplished artists, showcasing the similarities and differences among the rich cultures of Mexico, Central and South America, the Caribbean, and the United States. At Ford Motor Company, we are proud to support a project that honors the heritage and achievements of the Hispanic community and fosters cross-cultural exchange.

This project has flourished because it was led by people and institutions that are exceptional in different ways. The team—Marion Oettinger, senior curator and curator of Latin American art at the San Antonio Museum of Art; Fatima Bercht, chief curator at El Museo del Barrio; Carolyn Kinder Carr, deputy director and chief curator at the Smithsonian Institution's National Portrait Gallery; and Miguel Bretos, a historian with expertise in Latin America and senior scholar with the National Portrait Gallery—scoured much of the Western Hemisphere for exhibition material. We brought our resources to the table, brainstormed with the team, and together found that these different connections, creative ideas, and scholarly insights were our greatest strength.

The team has succeeded beyond all expectations, and we are thrilled to be a part of it. At Ford, we know that art is a powerful tool for education. We are certain that *Retratos* will be a very meaningful experience for the thousands of people engaged by the exhibition, community outreach programs, educational materials, website, and this important publication.

William Clay Ford Jr.
Chairman and Chief Executive Officer
Ford Motor Company

ACKNOWLEDGMENTS

Retratos: 2,000 Years of Latin American Portraits has enlisted the efforts of numerous people throughout Latin America, the United States, and Spain. The broad and unusually complex nature of this project, as well as the need to work with art from more than a dozen countries and more than seventy different lenders, required the generous assistance of scores of art historians, anthropologists, collectors, registrars, government and embassy officials, designers, educators, publishers, translators, photographers, friends, and colleagues. Without their help, neither this exciting exhibition nor the catalogue that chronicles it would have happened.

We are particularly pleased that the Ford Motor Company Fund has supported this exhibition and book. The Fund has been a most generous patron. Ford's sponsorship celebrates the arts and culture of Latin America in honor of our own vibrant Latino population. Sandy Ulsh, president of the Ford Motor Company Fund, leads this effort, and we are enormously grateful for her unwavering support. Rocky Egusquiza, also of the Fund, provided valuable assistance and leadership in the area of community outreach programming.

Fred Schroeder of Resnicow/Schroeder Associates has been constant in his support and a key liaison between the organizers and Ford. Kim Gilbert and Sophie Henderson, also of Resnicow/Schroeder Associates, were essential. Kim—a fluent Spanish speaker—saw that deadlines were met, while Sophie coordinated public relations and marketing. Gloria Rodriguez, president of MAPA Communications and also a member of the Ford team, astutely aided us in establishing partnerships with community-based organizations.

At the Smithsonian Institution, the Latino Initiatives Fund enabled the team to conduct essential research and to bring together the directors, educators, and curators from each venue to plan innovative outreach programs. It also contributed to the success of the installation of *Retratos* in Washington, D.C.

Retratos has been co-organized by the San Antonio Museum of Art, the National Portrait Gallery, Smithsonian Institution, and El Museo del Barrio. Many people within those organizations made this project succeed.

At SAMA, registrar Rachel Mauldin and her two capable associates, Karen Zelanka Baker and Heather Snow, managed insurance and shipping, loan contracts, and venue agreements during the first phase of the project. They are also responsible for traveling the exhibition within the United States. Rosario Laird, special assistant to the project, skillfully dealt with lenders and, just as important, was a convincing advocate. Nancy Fullerton, assistant curator of the Department of Latin American Art at SAMA, assumed responsibility for the department during research trips and helped manage the project's complex budget. Heather Eichling organized files and data on each lender and work of art. Marita Adair did an excellent job of securing photographs and permissions for figure illustrations for the catalogue. Polly Vidaurri, Joanie Barr, and Mary Villarreal made sure the bills were paid

on time. SAMA's Exhibitions Department designed and built the wonderful display cases, platforms, and graphic panels for the traveling exhibition. Rose Demir, curator of education, and her capable staff played a key role in producing SAMA's educational programs and the printed materials that traveled with the exhibition. Emily Jones was valuable as a coordinator of graphic works.

During the second phase of the project, El Museo del Barrio assumed the responsibility of securing final loan agreements. María Paula Armelin and Margarita Aguílar shouldered most of these burdens.

At the National Portrait Gallery, exhibitions and loans coordinator Claire Kelly worked with SAMA's Rachel Mauldin to clarify contractual language guiding each of the organizing institutions, while Eileen Kim assisted with the myriad logistical and editorial tasks. Carol Wyrick, NPG's head of education, planned educational materials for the national tour. She also organized a symposium so that venue educators could plan education strategies for the project.

Encouragement, optimism, and faith are as important as technical support. Ed Marquand of Marquand Books in Seattle provided all in abundance, as did Patricia Fidler of Yale University Press, the co-publisher of the catalogue. Project coordinator John Trombold and designer Jeff Wincapaw, also of Marquand Books, contributed to the organization and look of the book. Mervyn Samuel did an excellent job of translating most of the Spanish articles into English. Dru Dowdy, head of publications at the National Portrait Gallery, edited the catalogue expertly and worked long and hard to make sure that it was of the highest quality. The large number of authors and extensive illustrations made this a complex task.

We are indebted to lenders, museum professionals, and embassy officials throughout Latin America who gave freely of their time and energy. We give special thanks to three people, also mentioned elsewhere, for serving as our representatives and for introducing us to many people who helped make this project happen. They are Bertha Cea Echenique, cultural assistant to the United States embassy in Mexico, Natalia Majluf Brahim, principal curator of the Museo de Arte de Lima, and Ximena Carcelén, an art historian in Ecuador.

In Argentina, we thank Isabel Anchorena de Tassara and Laura Buccellato, Museo de Arte Moderno; Américo Castilla, Office of National Patrimony; Jorge Luis Cometti, Museo Isaac Fernández Blanco; Eduardo Constantini Jr. and Victoria Noorthoorn, Museo de Arte Latinoamericano de Buenos Aires; Juan José Cresto, Museo Histórico Nacional; and Jorge Glusberg, formerly of the Museo Nacional de Bellas Artes.

In Brazil: Vera de Alencar and Elizabeth Carbone Baez, Museus Castro Maya; Marcelo Araujo, Pinacoteca do Estado de São Paulo; Vera Lucía Bottrel Tostes, Vera Lima, and José Bittencourt, Museu Histórico Nacional; Maria Regina do Nascimento Brito and Dorto Carrero, Museu de Arte Moderna; Denise Grinspun, Museu Lasar Segall; Marta Fadel Lobão, Coleção Fadel; Maurício Vicente Ferreira Júnior, Museu Imperial; Raquel Glezer, Museu Paulista; István Jancsó, Institute of Brazilean Studies at the University of São Paulo; and Paulo Herkenhoff, Cícero D'Almeida, and Heloísa Aleixo Lustosa, Museu Nacional de Belas Artes.

In Chile: José Palumbo Ossa and Jorge Carroza Solar, Galería Jorge Carroza e Hijos, Ltda.; Germán Domínguez Gajardo, Museo del Carmen de Maipú; Milan Ivelic Kusanovic and Ana María Steadling, Museo Nacional de Bellas Artes; Rosa Puga Domínguez, Museo Colonial de San Francisco; and Bárbara de Vos Eyzaguirre and Juan Manuel Martínez, Museo Histórico Nacional.

In Colombia: Beatriz González, Cristina Lleras, and Elvira Cuervo de Jaramillo, Museo Nacional de Colombia; Fabio Franco Rodríguez and Darío Jaramillo Agudelo, Banco de

la República; María Constanza Toquica Clavijo, Museo de Arte Colonial; Jorge Orlando Melo, Luis-Angel Arango Library, Bogota; and Gloria Zea, Museo de Arte Moderno.

In Ecuador: Reverend Mother Inés María Arias, Convento de la Concepción; Ximena Carcelén; Janeth Cornejo, Universidad Central de Ecuador; Juan Carlos Fernández-Catalán, Museo Nacional de Arte Colonial; Pablo Guayasamín, Fundación Guayasamín; and Raúl Pérez Torres and Carlos Yánez, Casa de la Cultura Ecuatoriana.

In Mexico: José Enrique Ortiz Lanz, Elvira Báez, and Erica Gómez, Instituto Nacional de Antropología e Historia, INAH; Walter Boesterly Urrutia, Centro Nacional de Conservación y Registro del Patrimonio Mueble, INBA; Gabriela Eugenia López and Elisa Nava, Coordinación Nacional de Artes Plásticas, INBA; María Teresa Márquez Diez-Canedo, Jaime Noalart, Alberto Fierro, Carlos Enriquez Verdura, Susana Oubiña Fernández, and Carmen Bancalari, Consejo Nacional para la Cultura y las Artes, CONACULTA; Luis Enriquez Chávez, Miguel Angel Nevárez, and José Luis Pérez Arredondo, Banco de México; Armando and Esperanza Ayala; José Ortiz Izquierdo and Refugio Cárdenas, Patrimonio Artístico Banamex; Carlota Creel and Eduardo Bezauri; Viviana Corcuera; Angeles Espinosa Yglesias; José Castelló and Oriana Tickel de Castelló; the late Fernando Gutiérrez Saldivar and Guillermo Gutiérrez Saldivar, Colección Pascual Gutiérrez Roldán; Daniel Liebsohn, Galería Daniel Liebsohn; José Mayora Souza; Nahum Zenil, Mariana Pérez Amor, Patricia Torres, and Alexandra Iturbe, Galería de Arte Mexicano; Armando Colina, Galería Arvil; Luis-Martín Lozano, Laura González Matute, Judith Gómez del Campo, and Martha Alfaro, Museo de Arte Moderno; Alfredo Hernández Murillo, Museo Nacional de las Intervenciones; Héctor Rivero Borrel and Julieta Giménez-Cacho, Museo Franz Mayer; Roxana Velásquez Martínez del Campo, Graciela de la Torre, Julia Molinar, Claudia Barrón, and Karina Gómez, Museo Nacional de Arte, MUNAL; Luciano Cedillo Alvarez, Noemí Cortés Mondragón, and Nina Serratos Zavala, Museo Nacional de Historia; Rodrigo Rivero-Lake, Rodrigo Rivero-Lake Antigüedades; Soumaya Slim de Romero and Mónica López Velarde Estrada, Museo Soumaya; Miguel Angel E. Fernández and Miguel Angel Riva Palacio, Museo Nacional del Virreinato; Agustín Cristobal, Anticuario; Martha Cecilia Gutiérrez Schroeder, Fernando Santibañez Flores, Manuel Tron, and Carlos Phillips Olmedo, Museo Dolores Olmedo Patiño; and Michel Zabe, all in Mexico City; Héctor Alvarez Santiago, Museo de la Alhóndiga de Granaditas in Guanajuato; Fernanda Matos Moctezuma, Claudia Reyes Toledo, and Adrián Charloy, Instituto Cultural Cabañas in Guadalajara; Martelba Gómez and Frida Itzel Mateos González, Museo Regional de Guadalajara; Carlos Navarro Velasco, Guillermo Urrea, Javier Tostado Pérez, and Fernando Vásquez Ibarra in Guadalajara; Márgara Garza Sada de Fernández and Guillermo Sepúlveda, Galería Arte Actual, and Gina Ulloa, El Museo de Vidrio in Monterrey; Rosa Estela Reyes, Museo Regional de Querétaro; and Victor Arredondo Alvarez and Miguel Angel Ehrenzbaig, Universidad Veracruzana in Jalapa.

In Paraguay: Nicolás Darío Latourrette Bo.

In Peru: Manuel Castañeta Carillo de Albornoz; Cecilia Bákula Budge, Museo del Banco Central de Reserva de Perú; Agusto del Valle Carenas, Museo de Arte de la Universidad de San Marcos; Enrique González Carré, Museo Nacional de Antropología e Historia de Perú; Pedro Gjurinovic, Museo Pedro de Osma; José Ignacio Lambarri-Orihuela; Jaime and Vivian Liébana; Natalia Majluf Brahim, Museo de Arte de Lima; Francisco Stastny; and Luis Eduardo Wuffarden.

In Puerto Rico: Eduardo Morales Coll and Evelyn Morales, Ateneo Puertorriqueño; Maud Duquella, Galería Botello; Agustín Arteaga, Gladys Betancourt, Zorali de Feria, and Hiromi Shiba-Lecompte, Museo de Arte de Ponce; Mr. and Mrs. David Morrow; Carmen Ruiz de Fishler and Soralí de Feria, Museo de Arte de Puerto Rico; and Teodoro Vidal.

In Spain: Paz Cabello, Ana Castaño, and María Concepción García Sáiz, Museo de América; and Miguel Angel Zugaza Miranda and María Muruzábal, Museo Nacional del Prado.

In Uruguay: Angel Kalenberg, Museo Nacional de Artes Visuales.

In Venezuela: Francisco d'Antonio and Leonor Solar, Galería de Arte Nacional; and Rafael Romero, Fundación Cisneros.

Many important loans came from museums in the United States, and we are grateful not only to many key people within those generous institutions, but also to those who helped us secure loans: Debra Armstrong-Morgan and Thomas Staley, Harry Ransom Humanities Research Center of the University of Texas at Austin; Elizabeth Broun and Michael Blakeslee, Smithsonian American Art Museum; Ana María López and Susan Aberbach, Susan Aberbach Fine Art; Ron and Stephanie Burkard; Fernanda Benett, Nassau County Museum of Art; Michael Brothers, Cuban Foundation Collection, Daytona Museum of Arts and Sciences; Josie Brown, Max Protetch Gallery; María Magdalena Campos-Pons; Ignacio Durán and Santiago Ordóñez, Mexican Cultural Institute; Henry B. González Jr.; J. Leon Helguera, Vanderbilt University; Maria Angela Leal, Oliveira Lima Library, Catholic University of America; Philip Linhares and Bill McMorris, Oakland Museum of California; Shane McClellan; José Neistein, Brazilian-American Cultural Institute; Nancy Rosoff and Dottie Canady, Brooklyn Museum of Art; Richard Townsend and Barbara Thompson, Art Institute of Chicago; Lisbeth and August Uribe; and Miriam Ramos de Ward.

We would also like to thank cultural officers working in U.S. embassies throughout Latin America for their help and guidance during our field research. They include Thomas Haran in Buenos Aires; David Bustamante in Santiago; Collette Christian in Quito; Marjorie Coffin, Bertha Cea Echenique, and Martha Chávez-Camacho in Mexico City; Angela Emerson and María Elena Saucedo in Guadalajara; Lynn Roche and Vanessa Wagner de Reyna in Lima; and Janet Pina in Rio de Janeiro.

Finally, we want to thank the ambassadors, cultural attachés, and other members of the diplomatic community in Washington, D.C., from the countries lending materials to the exhibition. Their advice and assistance was of great help to us. They include Ambassador Eduardo Pablo Amadeo of Argentina; former Ambassador Rubens Barbosa and Antonio Luz of Brazil; Verónica López of the Embassy of Chile; Ambassador Luis Alberto Moreno of Colombia; Jorge Saade-Scaff of the Embassy of Ecuador; Oscar Centurion of the Embassy of Paraguay; Eloy Alfaro of the Embassy of Peru; Ambassador Javier Rupérez of Spain; Ambassador Hugo Fernández Faingold of Uruguay; and Carolina Márquez de Massinaí of the Embassy of Venezuela.

Marion Oettinger Jr.
Senior Curator and Curator of Latin American Art
San Antonio Museum of Art, Texas

Fatima Bercht
Chief Curator
El Museo del Barrio, New York City

Miguel A. Bretos
Senior Scholar
National Portrait Gallery, Smithsonian Institution, Washington, D.C.

Carolyn Kinder Carr
Deputy Director and Chief Curator
National Portrait Gallery, Smithsonian Institution, Washington, D.C.

LENDERS TO
THE EXHIBITION

Susan Aberbach, New York, United States
Amando Ayala Anguiano, Mexico
The Art Institute of Chicago, Illinois, United States
Ateneo Puertorriqueño, San Juan, Puerto Rico
Banco de la República, Bogota, Colombia
Banco Nacional de México, Mexico, D.F.
Nicolás Darío Latourrette Bo, Paraguay
Brooklyn Museum of Art, New York, United States
Ron and Stephanie Burkard, Oklahoma, United States
Casa de la Cultura Ecuatoriana, Quito, Ecuador
Colección Cisneros, Venezuela
Mr. and Mrs. Lindsay A. Duff, Texas, United States
Hecilda and Sérgio Fadel, Brazil
Margara Garza Sada, Mexico
Gutiérrez-Bermúdez Collection, Santurce, Puerto Rico
Fundación Guayasamín, Quito, Ecuador
Harry Ransom Humanities Research Center, The University of Texas at Austin,
 United States
Instituto Cultural Cabañas, Guadalajara, Mexico
Colección Lambarri-Orihuela, Peru
Lehigh University Art Galleries Museum Operation, Bethlehem, Pennsylvania
Daniel Liebsohn, Mexico
Iñigo Manglano-Ovalle, courtesy of the Max Protetch Gallery, New York City,
 United States
María Teresa and Shane McClellan, Texas, United States
Monasterio de la Concepción, Quito, Ecuador
Mr. and Mrs. David Morrow, Puerto Rico
Oscar Muñoz, Colombia
Museo de América, Madrid, Spain
Museo de Arte Colonial, Bogota, Colombia
Museo de Arte de Lima, Peru
Museo de Arte de Ponce, Puerto Rico, The Luis A. Ferré Foundation, Inc.
Museo de Arte de Puerto Rico, San Juan
Museo de Arte Hispanoamericano Isaac Fernández Blanco, Buenos Aires, Argentina
Museo de Arte Moderno, CONACULTA-INBA, Mexico, D.F.
Museo de Arte de la Universidad Nacional Mayor de San Marcos, Lima, Peru
Museo Franz Mayer, Mexico, D.F.
Museo Histórico Nacional, Buenos Aires, Argentina
Museo Histórico Nacional, Santiago, Chile

Museo Nacional de Arqueología, Antropología e Historia del Perú, Instituto Nacional de Cultura, Lima

Museo Nacional de Arte, CONACULTA-INBA, Mexico, D.F.

Museo Nacional de Bellas Artes, Buenos Aires, Argentina

Museo Nacional de Bellas Artes, Santiago, Chile

Museo Nacional de Colombia, Bogota

Museo Nacional de Historia, CONACULTA-INAH, Mexico, D.F.

Museo Nacional del Prado, Madrid, Spain

Museo Nacional del Virreinato, CONACULTA-INAH, Tepozotlán, Mexico

Museo Regional de Guadalajara, CONACULTA-INAH, Mexico

Museo Regional de Guanajuato: Alhóndiga de Granaditas, CONACULTA-INAH-INBA, Mexico

Museo Regional de Querétaro, CONACULTA-INAH, Mexico

Museo Soumaya, Mexico, D.F.

Museu de Arte Brasileira, FAAP, São Paulo

Museu de Arte Moderna do Rio de Janeiro, Brazil

Museu Histórico Nacional/IPHAN, Rio de Janeiro, Brazil

Museu Lasar Segall/IPHAN/MinC, São Paulo, Brazil

Museu Nacional de Belas Artes/IPHAN/MinC, Rio de Janeiro, Brazil

Museu Paulista da Universidade de São Paulo, Brazil

Museum of Arts and Sciences, Inc., The Cuban Foundation, Daytona Beach, Florida, United States

Museum of Contemporary Art San Diego, California, United States

Nassau County Museum of Art Permanent Collection, Roslyn Harbor, New York, United States

The Oakland Museum of California, United States

Roberto Palumbo Ossa, courtesy of Galería Jorge Carroza, Santiago, Chile

Private collection, courtesy of Galería Arvil, Mexico, D.F.

Private collection, courtesy of Galería de Arte Mexicano, Mexico, D.F.

Private collection (C.N.), Guadalajara, Mexico

Private collection, Mexico, D.F.

Private collection, San Antonio, Texas, United States

Rodrigo Rivero-Lake, Antigüedades, Mexico, D.F.

Pascual Gutiérrez Roldán, Mexico

The San Antonio Museum of Art, Texas, United States

Smithsonian American Art Museum, Washington, D.C., United States

José Mayora Souza, courtesy of Museo Nacional de Arte, Mexico, D.F.

Universidad Veracruzana, Jalapa, Mexico

Lisbeth W. and August O. Uribe, New York, United States

The Vázquez Noris Family, Mexico

Miriam Ramos de Ward, New Mexico, United States

Fig. 2 Curatorial team with Argentinean colleagues, Buenos Aires, August 2002

sions that give each place special character, the common veneer of *Hispanidad* sets it apart from other regions of the world. The same can be seen in terms of portraiture. While each country may have its own way of rendering its local heroes and distinguished citizens, portraiture often enters into larger artistic currents that run through all of Latin America. We hope those who see the exhibition will come away with the sense that Latin America is a place where certain manifestations of the portrait genre are distinctive as well as related.

Retratos comprises more than 100 works of art, most of which are paintings. While some are monumental in size, others are rendered in miniature. Some are solemn, and some are amusing, but we hope that all are engaging. For conservation reasons, works on paper—prints, drawings, and photographs—have usually not been included.

The Curatorial Team

A project of this breadth and depth is beyond the range of possibility of any one individual. From the project's official beginning in the summer of 2002, we conceived of the exhibition and catalogue as a collaborative enterprise, co-curated by a team of scholars and museum professionals, each bringing his or her special experiences, skills, talents, and perspectives to the mix (fig. 2). My own background is in anthropology and folk art, and I came to the world of fine arts relatively late in my professional life. Most of my research has been in Mexico and Spain, although I have also worked briefly in other parts of Latin America. I had always been interested in portraiture and had included Latin American portraits in many exhibitions over the years, but my understanding of the complexity and importance of the genre was little more than passing. Furthermore, my previous pan–Latin American projects had focused on folk art (*arte popular*), and I was unfamiliar with many of the great fine art collections in Latin America that this project would uncover. In short, I needed the help and insight of others.

The first person to join the team was Miguel Bretos, senior scholar at the Smithsonian Institution's National Portrait Gallery. Miguel and I had been thinking along parallel lines for several years. When we met to discuss this project, he had already begun formulating plans for an exhibition on Latin American portraiture. A Cuban American who has worked throughout Latin America, Europe, and Australia, Miguel has developed invaluable contacts with academics, collectors, museum professionals, and others in the region. A scholar of Latin America and its institutions, he became an intellectual touchstone for the rest of us.

Co-curator Carolyn Kinder Carr, deputy director and chief curator of the National Portrait Gallery, is a well-respected art historian. She was fascinated by Latin America and brought to the project a keen eye and important comparative dimensions that would have otherwise have been missed. Carolyn had started to develop an interest in Latin America following a research trip to Mexico City to explore the possibilities of organizing an exhibition on Mexican portraiture. She has organized dozens of exhibitions over the years dealing mainly with modern and contemporary art and more recently has focused almost exclusively on American portraiture. As a key player for the only museum in the United States that specializes in portraiture, she has also brought enormous influence to the project in terms of negotiating loans.

Brazilian art historian Fatima Bercht is a highly respected and energetic field worker who received her academic training in Latin American art history and has spent more than ten years organizing exhibitions of Latin American art in New York. Fatima knew many of the museum people we needed to meet, especially in the areas of modern and contemporary art, and her wide range of valuable contacts has benefited the project.

Since so little has been published on Latin American portraiture, we understood from the outset that we would have to travel to see what might be available and appropriate for the exhibition. The curatorial team organized three major research trips to Latin America, visiting museums and private collections in Brazil, Argentina, Chile, Peru, Ecuador, and Mexico. Over the past two years, each of us has also traveled individually to other Latin American countries to follow up on different aspects of the project. By the time we had completed these research trips, the team had seen and photographed more than 1,000 images worthy of consideration for inclusion in the exhibition. Because we were working with such high-quality portraits, paring down our list was especially difficult—we would have liked to have included many more works.

The Catalogue

This catalogue, like the exhibition, is designed to provide an overview of Latin American portraiture. But instead of simply supplementing the exhibition, the publication is designed to stand on its own, long after the exhibition has closed. We have invited specialists from throughout Latin America, the United States, and Spain to share their thoughts on portraiture. Some of the essayists were asked to write broad overview articles about specific periods in the exhibition, and others were asked to discuss a specific artist or particular tradition in some depth. While essays appear in close proximity to relevant exhibition plates, contributors do not necessarily reference them all. As a prelude, co-curator Carolyn Carr compares Latin American portraiture with portraiture in the United States. In Section I, co-curator Miguel Bretos provides a sweeping overview of Latin American portraiture. Section II contains two essays on Precolumbian portraiture: art historian Elizabeth Benson provides a broad discussion of the genre among Precolumbian people, and Christopher Donnan examines the portrait tradition among the Moche of northern Peru. In Section III, Spanish curator María Concepción García Sáiz discusses religious and secular portraiture during the viceregal period. This important overview is followed by two detailed essays, one on portraiture within the context of the cloistered life by Kirsten Hammer, and the other on the life of the great mulatto Puerto Rican artist José Campeche by Teodoro Vidal. Section IV comprises Miguel Bretos's illuminating essay of portraiture during the independence period. In Section V, Luis-Martín Lozano summarizes modernist portraiture during the first half of the twentieth century, followed by art historian Renato González Mello's focused article on Diego Rivera as a portraitist. Finally, in Section VI, poet and art historian Luis Pérez-Oramas considers portraiture in contemporary Latin America.

The Tour

The *Retratos* tour includes five venues in all: El Museo del Barrio in New York City, the San Diego Museum of Art in California, the Bass Museum of Art in Miami Beach, the National Portrait Gallery at the S. Dillon Ripley Center in Washington, D.C., and the San Antonio Museum of Art in Texas. *Retratos* will therefore be seen in cities with deep cultural roots in Latin America and vibrant Latino populations.

Retratos: 2,000 Years of Latin American Portraits will, we hope, provide an exciting overview of Latin American portraiture and will alert the public to the many common artistic threads that connect the genre throughout the entire region and hemisphere. Finally, the portraits presented here will open an important window on Latin American history and society and provide us with tools for a better understanding of the art and culture of that wonderful and exciting region.

Portraiture has existed for at least 5,000 years, and today there is no country that does not embrace some form of this tradition. The Egyptians, who employed this genre and used it extensively, believed that a portrait of an individual assured his or her continued existence in an afterlife. They depicted pharaohs and their queens as well as slaves, for it was assumed that a noble family would need its extensive retinue as much in the hereafter as in the present. Today we may not believe that a portrait guarantees eternal life, but we cling to the notion that a portrait assures a sitter a place in the memory of those in both contemporary and successive generations.

A portrait can tell the viewer about the subject, about the society of which the sitter was a part, and about the artist. The look of portraiture has changed over time, and the focus on particular kinds of individuals varies, depending on the priorities of a particular culture. Some artists sought to represent only the country's leadership; others were far more inclusive and documented the populace at large. But the desire to pay homage and to forever fix the essence of an individual has remained constant, whether the maker is commemorating the deeds of an august leader with a formal oil painting or capturing the first footsteps of a young child digitally.

As Christopher Donnan and Elizabeth Benson's essays in this book demonstrate, the tradition of portraiture existed in Latin America long before the arrival of the Europeans. A series of Moche vessels made in Peru before A.D. 600 that follow a man from youth through illness to old age is not unlike a family album, recording significant events in the life of an individual (see p. 62). In Mexico, Mayan and Aztec reliefs reveal societies keen on recording not only the power of their leaders, but also the physical trials by which they ritualistically established their right to rule.

When the Spanish and Portuguese established political and religious control over Latin America in the sixteenth century, they brought with them Continental traditions of portraiture. Oil paintings, new to the area, represented the elite religious, political, and social leaders. On occasion, images of notables were imported from Europe, but the vast majority of portraits were made by artists who had emigrated from the old world to the new. Initially brought to Latin America to work on elaborate theological programs for church interiors, these artists not only augmented their oeuvre with secular images, but they succeeded in developing a core of native-born apprentices who rapidly learned the hallmarks of European styles.

Throughout the nineteenth century, portraiture in Latin America was made by a mélange of artists consisting of newly arrived, highly skilled immigrants; native-born painters and sculptors—technically adept, highly trained, and highly proficient individuals who sought to further their careers, both at home and abroad, by studying and exhibiting in Europe; and those native-born artists who were self-taught. With the exception of the latter

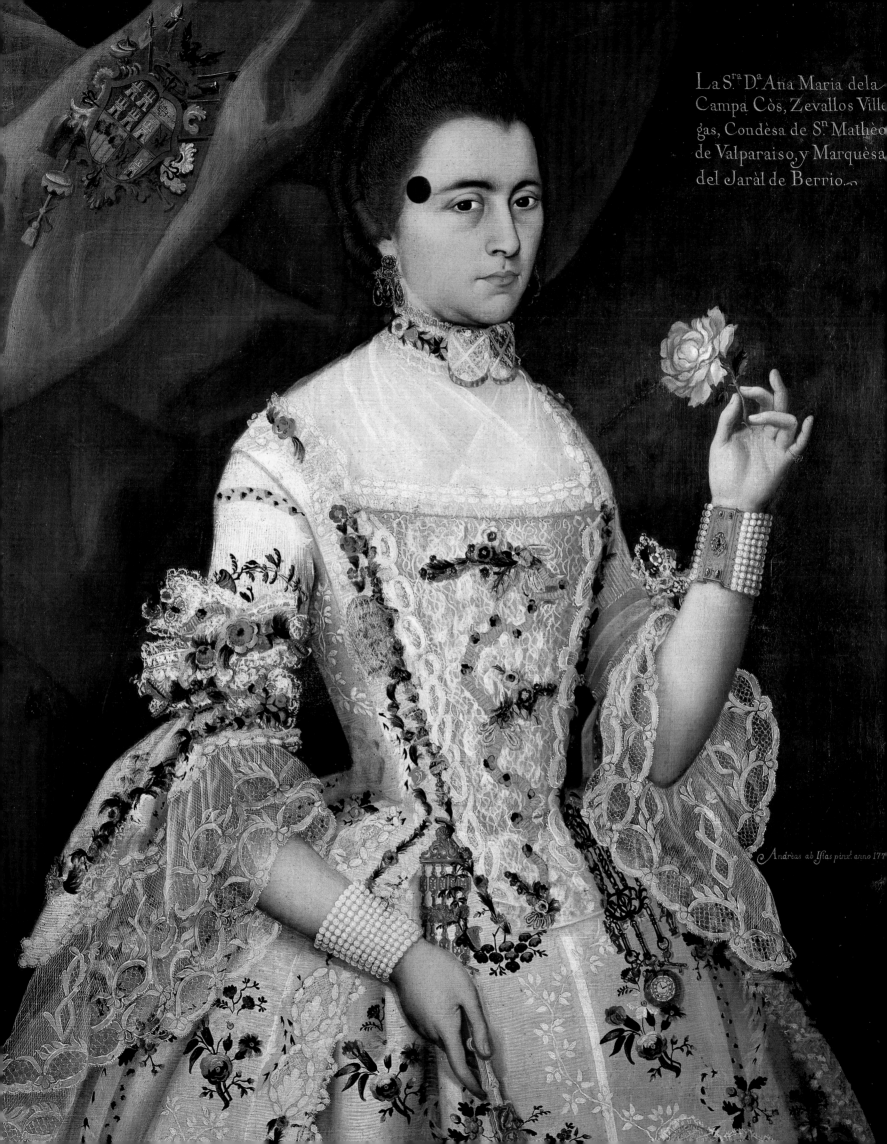

La S.ra D.a Ana Maria dela
Campa Còs, Zevallos Ville
gas, Condèsa de S.n Mathèo
de Valparaiso, y Marquèsa
del Jaràl de Berrio.

Andrèas ab Ifsas pinx.t anno 177

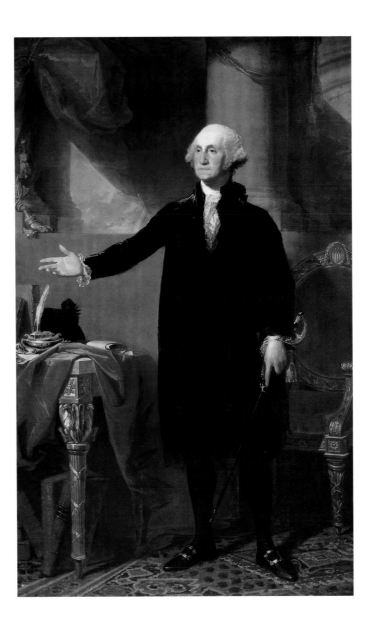

group, these artists and their twentieth-century successors brought to Latin American art a persistent element of internationalism.

Art historians delight in distinguishing those features in a work of art that point to its country of origin, speak to a particular point in time, reflect the hand of an artist, and identify the moment within an artist's career that he or she created a particular object. In *Retratos: 2,000 Years of Latin American Portraits,* the curators have been less concerned with the uniqueness of a particular object than with those elements that speak to the commonality of portrait traditions throughout South America, Mexico, and the Caribbean, from the viceregal period to the present. I would like to carry this element one step further and note some interesting similarities between portraiture in Latin America and the United States at comparable moments in time. Although differences in detail are immediately apparent—and North America has no tradition of portraits of crowned nuns—broad correspondences are remarkable.

Compare, for instance, Gilbert Stuart's "Lansdowne" portrait of George Washington, painted in 1796 as this Revolutionary War hero was completing the second of his two terms as the first President of the United States (fig. 1), with the portrait of Teodoro de Croix (pl. 24), who was appointed general commandant of the Provincias Internas (the tier of

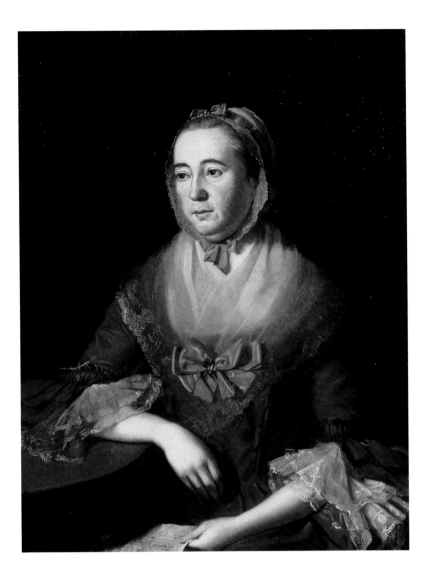

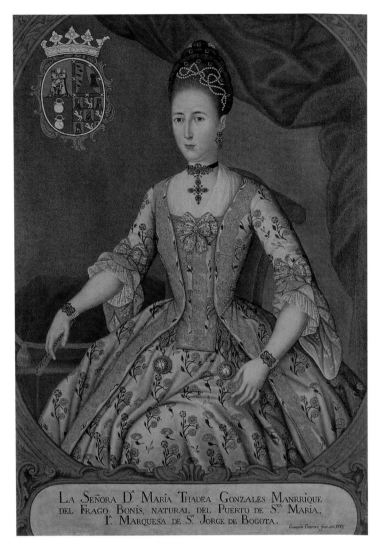

LA SEÑORA Dᵃ MARÍA THADEA GONZALES MANRRIQUE DEL FRAGO BONÍS, NATURAL DEL PUERTO DE Sᵀᵃ MARÍA, Iᵃ MARQUESA DE Sᴺ JORGE DE BOGOTA.

Fig. 2 *Anne Catherine Green* by Charles Willson Peale. Oil on canvas, 1769. National Portrait Gallery, Smithsonian Institution, Washington, D.C.; Gallery purchase with funding from the Smithsonian Collections Acquisitions Program and gift from the Governor's Mansion Foundation of Maryland

Fig. 3 *Marquesa de San Jorge* by Joaquín Gutiérrez. Oil on canvas, 1775. Museo de Arte Colonial, Bogota, Colombia

states bordering on the U.S.-Mexico frontier) in 1777, and later, in 1784, viceroy of Peru. Both portraits are large, and they each show a standing figure whose pose and surrounding attributes immediately convey the power and status of the two sitters. These two glorious images are linked by the fact that both artists have derived their inspiration from a common model: essentially, both are based on the traditional representation of European monarchs in the seventeenth and early eighteenth centuries.

These two portraits are not an exception. Charles Willson Peale's 1769 portrait of Anne Green (fig. 2), Colombian-based Joaquín Guitérrez's 1775 portrait of the marchioness of San Jorge (fig. 3), and the Mexican Andrés de Islas's 1776 portrait of Ana María de la Campa y Cos (pl. 15) utilize similar poses and costumes. There is no question, of course, where these works were created. The dress of the Baltimore, Maryland, matron reveals a level of restraint that reflects the Anglo-Puritan tradition that permeated the British colonies in North America; the dresses of the other two demonstrate the more lavish Spanish court heritage that was fundamental to Latin American portraiture at this time. Again, as with the portraits of Washington and de Croix, the link between these three geographically distant works is that each was produced in a colonial country that continued to look to its European roots for artistic inspiration.

In the first decades of the nineteenth century a complex series of political reasons led to the taste for things French among the fashionable throughout Latin America and the

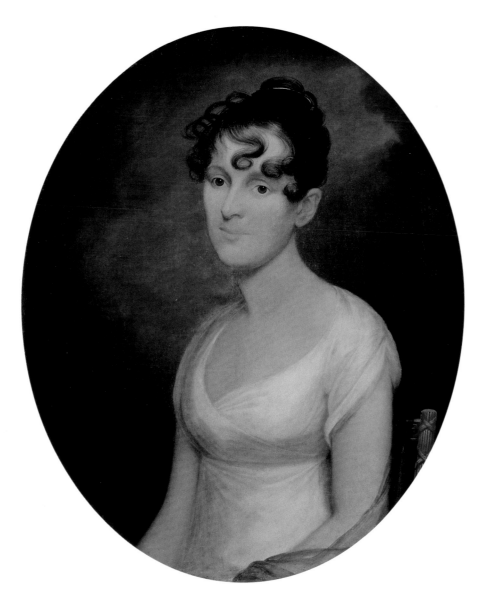

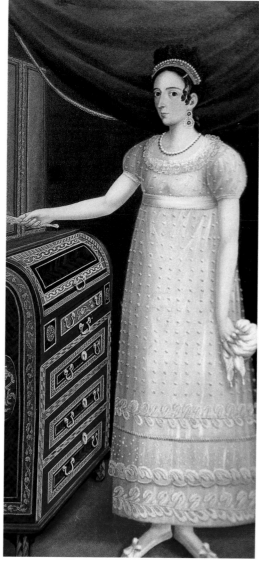

Fig. 4 *Elizabeth Washington Gamble Wirt* by
Cephas Thompson. Oil on canvas, c. 1810.
National Portrait Gallery, Smithsonian Insti-
tution, Washington, D.C.

Fig. 5 *María de los Dolores Ignacia Rosa Loreto
Gomez de Cervantes* by an unidentified artist.
Oil on canvas, 1810–15. Private collection,
Mexico

eastern coastal areas of the United States. The pervasive influence of the Empire style, sig-
nified by the neoclassical dress of each of the sitters, is readily apparent in the portraits of
Elizabeth Wirt, wife of an important Virginian who served as United States attorney general
from 1817 to 1829 (fig. 4); that of Lucía Petrona Riera de López, the wife of an Argentinian
patriot (pl. 41); and an exquisite portrait now in a Mexican private collection (fig. 5).

But by the second quarter of the century, the success of the independence movements
throughout the Americas, along with growing national pride, revealed itself artistically. In-
creasingly, the subjects portrayed were native born and of more humble origins than previ-
ously, and many of the artists who created these portraits were self-taught. Three examples
of this phenomena come readily to mind: José Gil de Castro, the Peruvian-born painter
who made his reputation in Chile (pls. 43, 51); Ammi Phillips (fig. 6), the prolific limner
who created more than 500 portraits in New York and the Connecticut Valley; and José
María Estrada, a Guadalajara native (fig. 7 and pl. 52). The work of each of these men, as
well as that of various anonymous artists (pl. 53), is characterized by hard-edged, linear
precision in the rendering of both figure and objects, a lack of traditional modeling, the
disposition of the figure in a shallow space, and a delight in decorative patterning.

As is evident in this exhibition, the nineteenth century is marked by rapid artistic change, and by the second half of this century many artists, aware of their talent and often encouraged by their professors at national art schools, sought to assert national pride by competing directly with European artists. By 1870 a groundswell of artists in both the United States and Latin America sought to polish their artistic skills abroad—some in Italy, some in Germany, but most in France—and compete with the most renowned artists on the far side of the Atlantic. A casual glance at the portrait of Don Guillermo Puelma Tupper by Chilean Pedro Lira (pl. 84)—who left for ten years of study in France in 1873 and exhibited his work in the 1889 Salon—with that of New England sculptor Paul Wayland Bartlett by Bostonian Charles Sprague Pearce (fig. 8)—done in Paris and exhibited at the 1892 Salon organized by the Société Nationale des Beaux-Arts—reveals that they both were influenced by French realists such as Jules Bastien-Lepage and Joseph Florentin Léon Bonnat. Peruvian Carlos Baca Flor, who first traveled to France in 1890 and returned there for the last decade of his life, was enchanted by and absorbed the loose, painterly style of the impressionists (pl. 82).

Europe, particularly Paris, continued to exert a magical hold on artists throughout the Americas who came to maturity in the early twentieth century. Mexicans Diego Rivera (pl. 85), Adolfo Best Maugard (see p. 222), Amado de la Cueva (pl. 87), and David Alfaro Siqueiros (pl. 87), and Brazilian Vicente do Rêgo Monteiro (pl. 91)—to name only a

Fig. 6 *The Strawberry Girl* by Ammi Phillips. Oil on canvas, c. 1830. National Gallery of Art, Washington, D.C.; gift of Edgar William and Bernice Chrysler Garbisch

Fig. 7 *María Arochi y Baeza* by José María Estrada. Oil on canvas, mid-nineteenth century. Museo Nacional de Arte, CONACULTA-INBA, Mexico, D.F.

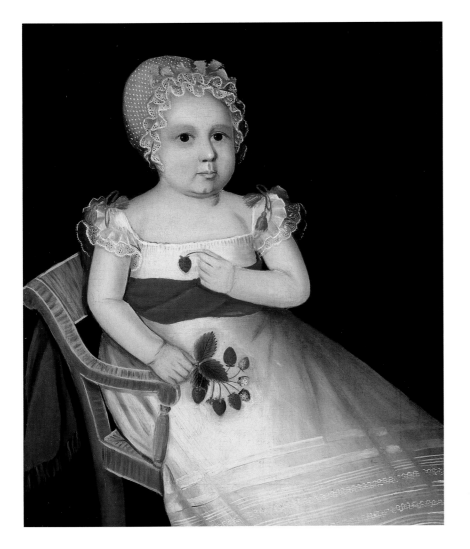

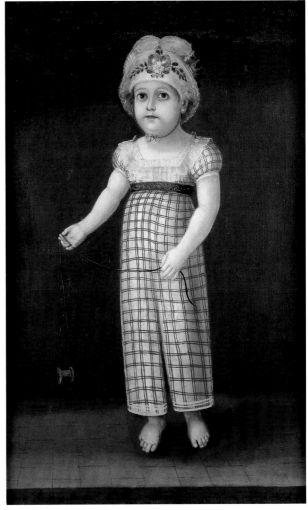

few—sought out Paris to see and absorb the many new aesthetic currents flourishing
there, including cubism and expressionism. Lithuanian-born, Brazilian-based Lasar Segall
(pl. 90) preferred training in Berlin at the Royal Academy, as did Anita Malfatti (pl. 88).
She also kept abreast of the latest stylistic currents in Europe through a brief sojourn in
the United States, where the Armory show and travel to Europe had informed young
New Yorkers, such as Willard Huntington Wright and Marguerite Zorach, about the new
modernist trends. By the 1920s and 1930s, however, the worldwide depression was accom-
panied by a stylistic retrenchment and antimodernist realism, as evidenced in the work of
Argentinians Antonio Berni (pl. 96) and Lino Spilimbergo and that of Missourian Thomas
Hart Benton.

In the years after World War II, abstraction became the dominant genre among the
avant-garde. Portraiture was no longer seen as cutting-edge subject matter. And yet great
portraits continued to be made: witness the work of Pennsylvanians Andrew and Jamie
Wyeth, or New Mexico–based Peter Hurd (fig. 9), or Colombian-born Fernando Botero
(pl. 102). Today, however, portraiture has become a leading vehicle for artists to explore
their philosophical and ideological concerns. Exhibitions utilizing this subject matter are
everywhere. Among contemporary artists, issues of identity are a driving force. Explora-
tions of the self, the essence of the other, the artist's relationship to others, and the other's

Fig. 9 *Alice Roosevelt Longworth* by Peter Hurd. Tempera on Masonite, 1965. National Portrait Gallery, Smithsonian Institution, Washington, D.C.; gift of Joanna Sturm

relationship to those around him or her are presented in myriad mediums and in a variety of stylistic approaches. In this exhibition, Mexican Nahum Zenil (pl. 104), Brazilian Adriana Varejão (pl. 110), and Spanish-born, Venezuelan-bred, Chicago-dwelling Iñigo Manglano-Ovalle (pl. 113)—whose DNA portraits take this concern to its molecular roots—share this international interest.

Retratos: 2,000 Years of Latin American Portraiture is the first exhibition in the United States to focus exclusively on the topic of portraiture in Mexico, South America, and the Caribbean. It incorporates a fascinating kaleidoscope of images. These portraits speak not only to the personalities represented and the hand of the artists that created them, but to the history of the countries from which they emerged. They also reflect the manner in which Latin American portraiture has been in touch with international taste and trends.

MIGUEL A. BRETOS

I

From Prehispanic to Post-Romantic:
Latin America in Portraits, 500 B.C.–A.D. 1910

Este, que ves, engaño colorido,
que del arte ostentando los primores,
con falsos silogismos de colores,
es cauteloso engaño del sentido.[1]

Sor Juana Inés de la Cruz

"What you see here, a colorful deceit contrived with precious artifice and false color syllogisms, is an adroit counterfeit to the senses," wrote Sor Juana Inés de la Cruz (1651–1695) of her portrait in a famous sonnet. Although art's flattery may disguise the ravages of time or wipe out the rigors of aging, a portrait is a vain pursuit, for in the end—the closing line is borrowed from the poet Luis de Góngora—we are naught but "a corpse, dust, shadows, nothing."

This pessimistic view did not keep Sor Juana from sitting for several portraits in her lifetime, including a possible self-portrait. Only posthumous copies survive, unfortunately. The earliest one, attributed to Juan de Miranda (active c. 1680–d. after 1714), and a later one by Andrés de Islas (pl. 21) show the nun-poet in her study. Miranda's hangs, quite appropriately, in the rector's office at the National Autonomous University of Mexico. Would Sor Juana have become a global icon without her elegant presence, captured on canvas for the ages? One wonders.

One of the reasons that people sit for their portraits—there are many—is to cheat oblivion: to fix their image and likeness on a medium more durable than mortal flesh. Portraits cannot arrest youth or delay death for an instant, but they can confer a measure of immortality.

Prehispanic Portraiture

The Moche people of ancient Peru struck one such bargain with time. Moche ceramists deftly captured the living features of people buried more than two millennia ago in Peru's narrow coastal valleys. They stare at us from their effigy vessels, nameless but unforgettable. Moche vessels are venerably old, yet strikingly contemporary. One can find with ease their subjects' look-alikes, doubtlessly their remote descendants, on the streets of present-day Lima or Trujillo. These are surely among the first portraits to be produced in what is now Latin America and are still among the best. They are therefore a fitting point of departure for this book and exhibition.

There is more, of course, although no other Prehispanic people approached the lifelike quality of Moche portraits. Even earlier than the Moche, the Olmec had documented and

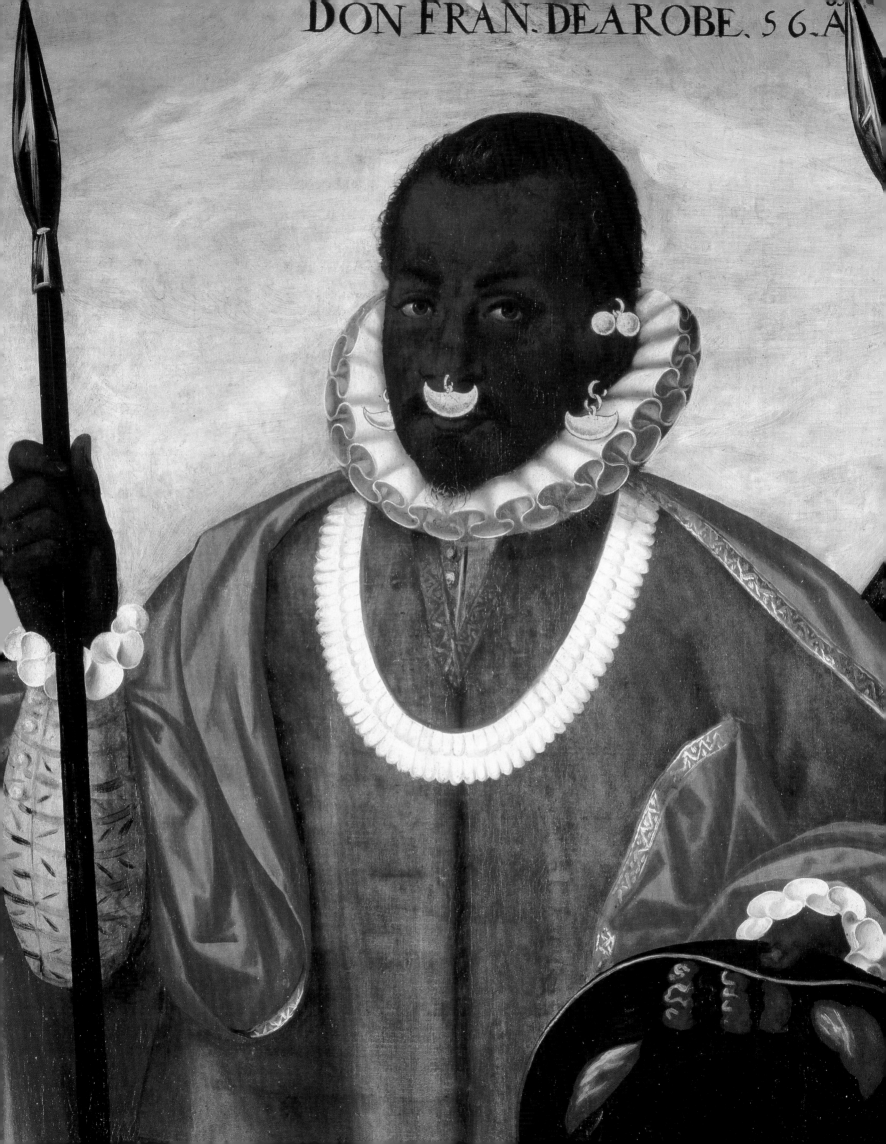

celebrated individuality in their art. Maya monumental statuary commemorates the deeds of rulers, their victories in battle, their life events, and their ritual solemnities. Prehispanic Mesoamerican pictorial manuscripts or codices contain numerous representations of individuals. A sculpted representation of Moctezuma, the Aztec "emperor" of conquest fame, was erected at Chapultepec a few years before the fateful coming of the Spanish in 1519. Aztec art scholar Esther Pasztory has no trouble in calling it what it was: a portrait.[2] Elizabeth Benson explores Prehispanic portraiture elegantly in a subsequent chapter of this volume.

Portraits Tell Stories

Portraits contain much information. Christopher Donnan, a scholar at UCLA, has been able to identify and follow a single Moche individual throughout his life as depicted in sequential effigies. Moche vessels have provided evidence for studies of ancient pathology, so faithful is the depiction of the signs of disease. This man is blind; another one has a harelip; yet another shows clear evidence of warts or a cranial deformity. Donnan's illuminating article is featured in this catalogue.

Islas's portrait of Sor Juana, although a copy, documents a great deal besides her looks. Her Hieronymite habit is definitely smart. Notice the elegantly draping sleeves, graciously contrived veil, and rosary cross almost coquettishly slung over the shoulder. The Hieronymites were a fashionable order, reserved for people of quality who could afford the high dowries required to profess. Sor Juana is literally surrounded by clues and bits of information about her. A desk, books, and an *escribanía* (inkwell) speak of her intellectual vocation. The portrait's prolix legend contains what is in essence a curriculum vitae.

Latin American portraits can be excruciatingly informative. The custom of including extensive legends with pictorial elements was endemic in Spanish colonial portraiture. What good is a portrait if you do not know whose it is? It is important, therefore, that the viewer is informed about the sitter: identity, biography, and sundry details. This custom survived sporadically into the nineteenth century and in such popular pieces as ex-votos. In a touching portrait of the child José Raymundo Juan Nepomuceno de Figueroa y Araoz (pl. 43), José Gil de Castro informs us that the subject was depicted holding a ball at his own request. In the twentieth century, Frida Kahlo inserted textuality as a self-conscious historicist device.

It pays to read the small print. Bogota painter Pedro José Figueroa (1770–1836), no friend of the Colombian vice president, Francisco de Paula Santander, cleverly booby-trapped the vice president's portrait, now on display at Colombia's national museum in Bogota. Ponder the legend: "Francisco de Paula Santander . . . *encarcagado* del poder ejecutivo." One additional syllable does the trick: instead of being *encargado,* "in charge of" the executive power, Santander is, well, full of shit. Could this be a spelling mistake? Hardly.

The Latin American Portrait

As this exhibition shows, Latin America has produced great portraits. Can we say that there is a Latin American portrait tradition, however? Can it be discerned? What possible connection is there between the Moche, Andrés de Islas, Pedro José Figueroa, Lasar Segall, and Frida Kahlo? Those questions must be answered cautiously.

The Prehispanic portraiture traditions do not necessarily intersect. The Maya never met the Moche—only posterity can make connections. There is a very distinctive tradition of colonial—let us call it "viceregal"—painting that adroitly cultivated portraiture. Viceregal art shows remarkable regional variations, whether we are looking at it from the perspective of Mexico City, Cuzco, or Bahía.

Following independence, the Spanish and Portuguese Americas connected with a world that was larger and far more diverse than hitherto. In the future, what happened in Europe and North America was certain to affect developments in Latin America also. Foreigners came over, and Latin American artists crossed the ocean in the other direction in search of instruction and experience. Romanticism and academicism flourished on both sides of the Atlantic. Just as there was impressionist and cubist art in Europe, so there was in Latin America. Diego Rivera learned in Europe and went on to become a world-class painter of considerable influence.

Unquestionably, Latin America has a magnificent vernacular tradition. Latin American folk and popular portraits are truly exceptional, and much of that work is anonymous. Two of the most significant Latin American portrait artists of all time, Mexico's Hermenegildo Bustos and Peru's José Gil de Castro, are essentially "popular" painters. Much research remains to be done about this rich and fascinating heritage.

Is there a Latin American face in the sense that some have argued there is an English face? Hardly, for Latin America has many faces. José Vasconcelos, the twentieth-century Mexican intellectual widely hailed as the father of Mexican muralism, argued that Latin America was the home of the "cosmic race." By that he meant that Latin America's population was inextricably mixed, subsuming all races. The Vasconcelian cosmic race has many faces, comes in many sizes, and features noses of every description and shape.[3]

European Art Enters the New World

European art entered the colonial world of the Americas with the Spanish and Portuguese conquerors. What came initially was—had to be—portable. Seville, Spain's gateway to the overseas empire, became a great exporter of art to the colonies. Francisco de Zurbarán (1598–1664) and Juan Martínez Montañés (1568–1649) produced work on commission for New World clients. Particularly during the seventeenth century, numerous lesser Seville workshops catered primarily to the colonial trade. There is no doubt that they dealt in portraits. In October of 1660, for example, Juan de Luzón shipped to the Indies, "on his account and at his risk," twelve portraits of famous men, eighteen Virgins, twenty-six angels, thirty-six child martyrs, and nine still-lifes (*fruteros*), all on canvas.[4]

What Seville did for easel painting, the Low Countries did for the printed image. The Plantin family of Antwerp enjoyed a royal appointment from Philip II to produce religious and liturgical books and engravings. Thousands upon thousands of copies traveled from the Plantin presses in Antwerp and Leyden to the New World viceroyalties. Images thus transported became the source of much of the decoration for secular and religious buildings.[5]

Native Artists

During the sixteenth and early seventeenth centuries, European-trained artists entered the Indies.[6] Much of the earliest painting in the European tradition produced in the Spanish colonial empire, however, was the output of native artists trained by missionary friars.[7] The overwhelming majority of those artists have remained anonymous. Their medium was dry fresco, and their canvas the walls of convents and churches. Their production included portraits, like the mid-sixteenth-century mural of Fray Diego de Betanzos at the Dominican monastery in Tepetlaóztoc, in the state of Mexico. The portraits of illustrious members of the great mendicant orders, such as the Franciscans, the Dominicans, and the Augustinians, would be frequently painted on cloister walls for the edification of the friars. Evidence of one such series survives within the cloister of Santiago de Chile's handsome Franciscan monastery. The *iglesia doctrinera* (mission church) of Sutatausa, Cundinamarca, Colombia

episcopal portraiture. Composition and details, however, are treated with a master's touch. Fray García, who served as viceroy of New Spain for two years, is shown standing in his sparkling white Dominican habit and black cape. He is dramatically set off against a cleverly understated background. Instead of red or green, the parting curtain behind him is black. The prelate's visage—hair worn in a fringe, piercing eyes, hard expression, the shadow of a beard—is that of a man in control. The ubiquitous episcopal arms are cleverly embroidered on the fringed red tablecloth.

In 1801, almost two hundred years after Fray García sat for his portrait in Mexico City, Luis María Ignacio de Peñalver y Cárdenas, the first bishop of Louisiana and the Floridas, sat for his in New Orleans (Cabildo Museum). Peñalver, a Havana aristocrat, had been appointed to the new bishopric in 1793. One year after the bishop sat for his portrait, Louisiana reverted to France, and Napoleon Bonaparte promptly sold it to the United States in one of the most remarkable real-estate deals in history. In 1801, however, Peñalver was the highest-ranking prelate in a Spanish imperial domain stretching from the Florida Keys to the Pacific. The painter was a remarkable émigré from Yucatán, José de Salazar y Mendoza (active 1782–1802). Salazar, his daughter Francisca (also a painter), and his disciples did numerous portraits for the elite of Spanish Louisiana.[14]

The portrait of Bishop Peñalver is true to type. The prelate stands erect, wearing a cassock, surplice, and cope. His right hand is raised in blessing while his left holds his *biretta*. On the table next to him are two miters and an inkwell. The formula was durable. In 1902, yet another century into the future, Francisco Orozco y Jiménez, bishop of Chiapas, posed for a photographer. He stands in front of a painted drape. A table supports a miter and a crosier. The good bishop—he did much to preserve then-extant colonial Maya manuscripts—is ramrod straight. A hand holds his train, which drapes elegantly around his feet; another holds a book—a colonial tableau captured on photographic emulsion.[15]

Nuns, Alive or Dead

Convents were an important part of the religious and social life of colonial Latin America. Cities of some consequence prided themselves on having at least one, while capitals and important regional centers would have several. Convents served multiple functions. Their spiritual mission is self-evident: they were communities of virgins dedicated to God and praying for all. They dealt therefore in the sanctification of the individual and the well-being—and hopefully the salvation as well—of the entire community. In addition, they fulfilled numerous practical social functions, from education to finance. For unmarried daughters, embracing the religious state saved them from onerous spinsterhood—never mind the world's temptations—and brought honor to the family. All of this came at a cost, of course: marriage in the colonial period—a mystical marriage was no exception—required a dowry.[16]

Nuns, alive or dead, were important subjects of viceregal portraiture. As Kirsten Hammer tells us in her essay, in colonial Latin America it was customary to portray nuns at the time of their final profession (*profesión de coro y velo*). Mexico holds the lion's share of this genre. The sisters would be depicted crowned and garlanded with flowers, dressed in fancifully decorated habits, and bearing candles, religious images, and other attributes of their faith. These are the "crowned nuns" who appear in New Spain in the seventeenth century and last to the end of the viceregal period and beyond (pl. 34). Abbesses, superiors, or those who had distinguished themselves in the religious life would often be portrayed posthumously. The latter variant—*monjas muertas,* or portraits of dead nuns (pl. 39)—was strongly represented in New Granada (present-day Colombia), and lasted well into the nineteenth century. Of course, one will find specimens of both variants throughout the region.[17]

From today's perspective, crowned nuns would seem outlandish and dead ones macabre, which goes once again to prove that each historical era has its own ways. Both kinds of portraits were usually painted by commission. Crowned nuns' portraits were ordered by families that wished to keep a memento of the daughter who would disappear from view behind a cloistered enclosure.

The floral ornaments suggested a bride at the time of her marriage. Profession was, in fact, a mystical marriage to Christ. Final profession was also tantamount to civil death. The professant was born with a new name, signifying her transit from the mundane to her new spiritual life. To drive the point home, the rite of profession includes a symbolic funeral. The crown and flowery garlands, therefore, must be read also in the context of a shroud.

Religious communities would commission portraits of dead sisters, invariably lying in state and bedecked with floral crowns and garlands. Unlike the large portraits of crowned nuns, portraits of dead nuns appear in a small format, usually head-and-shoulders only. Their efficacy as mementa mori and memorials to exemplary emeritae is obvious.

Beyond the dead nuns, depictions of the dead are a minor, if notable, component of the repertoire of Latin American portraiture down to the present. The subgenre has a name. Death portraits are called *repentinos,* and they range from the monumental to the intimate. Among the former is the death portrait of the count of Sierra Gorda, Joseph de Escandón y Helguera (pl. 14), lying in state, draped with his knight's habit of the Order of Santiago. Among the latter is the equally moving 1846 portrait of the dead youth Francisco Torres by José María Estrada.

Portraits of dead children are especially poignant. One encounters them throughout Latin America. The advent of photography made these macabre but moving mementos accessible to many a grieving parent. Frida Kahlo made a contribution to the genre with her death portrait of the child Dimas Rosas (Museo Dolores Olmedo Patiño, Mexico, D.F.), crowned with a paper crown and laid to rest on a *petate.* The grandest statement of the theme, although not a portrait, is Francisco Oller's masterpiece *Velorio (The Wake,* c. 1893, Museo de la Universidad de Puerto Rico, Rio Piedras), one of the most important paintings ever created in Puerto Rico.[18]

Secular Portraiture

The government, like the church, was an avid consumer of images. A key political and psychological problem in the governance of the Iberian colonial empires was how to overcome the king's remoteness, hence the numerous civic liturgies that evoked and celebrated the monarchy's abiding, if unseen, charisma. The faraway monarch's accession, birthdays, marriages, children, and, of course, death was commemorated in the colonies with intensely focused attention. The royal state portrait, either sent over from the mother country or produced in the Indies, was central to this pursuit, as were the numerous and repetitive statements of royal authority, such as the ubiquitous display of the royal arms and emblems.[19]

A clever invention of the Iberian colonial empires was the viceroy as a stand-in, an analogue, for the powerful but distant ruler: a tangible presence of the king's remote majesty. The viceroy was surrounded by a protocol that was regal in every sense. Viceroys and colonial governors had their portraits painted almost as a matter of course. Just as the viceroy was the king's alter ego, his portrait was a substitute for the viceregal person, an expression of the royal majesty that he vicariously embodied. What was true for viceroys, of course, was equally true of high officers holding their commissions on behalf of the Crown.

Viceregal state portraiture shows a remarkable diversity. The count of Lemos, viceroy of Peru between 1667 and 1672, is represented on horseback in an anonymous painting at the Museo de Arte Español Enrique Larreta in Buenos Aires.[20] The portrait is in the style of late-seventeenth-century Andean painting. The richly caparisoned horse rears while the viceroy's right hand holds an embroidered standard of the Virgin. The sitter's laced garments, rendered in exquisite, opulent, and painstaking detail, are flat and two-dimensional. Almost a century later, Bernardo de Gálvez, count of Gálvez and viceroy of New Spain, is the subject of another equestrian portrait kept at Chapultepec Castle. The painting is remarkable for the unique rendering of the horse in elaborate calligraphy executed in white against a black background. The enormous canvas gives the impression of a vast exercise in penmanship.

While individual viceregal state portraits celebrated the office and its holder, other series of such portraits celebrated the unbroken continuity of royal rule. The series of viceroys of New Spain is exceptionally complete. In the first third of the nineteenth century, the Cuban mulatto painter Vicente Escobar (1762–1834) produced a series of portraits of captains-general of Cuba that was widely disseminated in the form of engravings. A particularly notable series of late-eighteenth-century viceroys of New Granada by Joaquín Gutiérrez hangs today in the Museo Nacional de Colombia in Bogota.

Prosperity and Portraiture: The Eighteenth Century

The Latin American colonies in the eighteenth century reached an unprecedented level of economic development.[21] The growth of the mining industry in both Mexico and Brazil was spectacular. Mexican silver paid for the great votive church of San Sebastián and Santa Prisca in Taxco, one of the jewels of Mexican art (not to mention José de Alcíbar's superb portrait of Manuel de la Borda y Verdugo, priest, bon vivant, son and heir of the mining magnate and church patron José de la Borda, now in the chapter room at the church).[22] Brazilian gold and diamonds paid for Vila Rica de Ouro Preto in Minas Geraes ("General Mines") and the magnificent sculptures by Aleijandinho. Mining injected vast amounts of cash into the colonial economies, helping make the eighteenth century—especially the second half—the golden age of colonial portraiture.

Portraiture served the purposes of the Latin American colonial elite in much the same way it has served the purposes of elites throughout history. It was both an ego reward and a reaffirmation of status, both personal and familial. After all, nothing quite projects gentility as the family gallery. Demand met suitable providers, for this period marks the heyday of portrait painters such as Miguel Cabrera (1695–1768) and Ignacio María Barreda in Mexico, Joaquín Gutiérrez (1715–1805) in Colombia, and others.

A conspicuous, eyecatching feature in Gutiérrez's portrait of the marchioness of San Jorge (see p. 23) is the fact that the lady has not one, but two watches dangling from her waist. This extravagant detail is not at all unusual. A single watch dangling from the waist appears in Velázquez's portrait of Mariana of Austria in Vienna's Kunsthistorisches Museum. The subjects of numerous feminine portraits in late-eighteenth-century Spanish America wear one or two watches. José Campeche's 1792 portrait of Doña María Catalina de Urrutia and her young son shows the main subject wearing two watches (Brooklyn Museum of Art). The superb portrait of Lima's Mariana Belsunce y Salazar (Brooklyn Museum of Art) shows her wearing one elaborate timepiece. This feature is conspicuously absent in the British colonies of North America, where no portraits of ladies wearing one watch—let alone two—are known.[23]

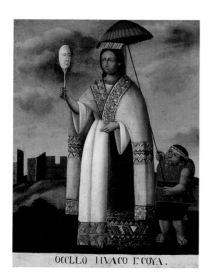

Fig. 2 *Occllo Huaco, 1st Coya,* by an unidentified artist (Cuzco school). Oil on canvas, c. 1800. San Antonio Museum of Art, Texas

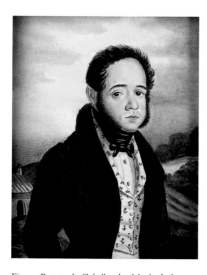

Fig. 3 *Retrato de Caballero* by María de Jesus Ponce de Ibarrarán. Gouache on paper, 1830. Museo Soumaya, Mexico, D.F.

This peculiar fashion, like so much else, comes from Europe. Wearing two watches became the acme of high fashion in the foppish France and England of the latter part of the century. This was the age, after all, that spawned the *macaronis, incroyables,* and *petimetres,* the fantastic, almost comical, fashion plates of the age. What is extraordinary is how far and wide European fashion should have permeated the aesthetics and the expectations of the colonial Latin American upper class, presumably far removed from the main currents of avant-garde fashion.

Racial Mixes and Inca Monarchs

Although not exactly portraits except in a collective and generic sense, *pinturas de castas* are a significant and uniquely Latin American invention.[24] The genre was especially cultivated in the viceroyalty of New Spain, from where numerous series of *castas* paintings survive. The *castas* tradition was essentially a taxonomic effort seeking to illustrate the miscegenation (*meztizaje*) that was relentlessly creating Latin America's innumerable racial types and combinations. An analogous body of work is the watercolors of the Italian Carlo Giuliani (1740–1811)—Carlos Julião to Brazilians—who documented both black and white types in Rio de Janeiro toward the latter part of the eighteenth century and the early years of the nineteenth.[25]

Pinturas de castas offer an extraordinary and often exquisite documentation of inestimable value to social historians and are much appreciated and sought after. Are they true portraits? Clearly this is problematic, for this is a case where individual identity and social typology intersect to create remarkably rich imagery. Just enjoy them, for they are as delightful in the form as they are—to our age, at least—disturbing in the concept.

Another significant group of "portraits," especially popular in the viceroyalty of Peru during the seventeenth and eighteenth centuries, were the purported series of Inca monarchs (fig. 2). One of the first such, undoubtedly the best known, appears in Felipe Guamán Poma de Ayala's 1615 *Nueva corónica y buen gobierno.*[26] Obviously, no native ruler of Prehispanic Peru ever posed for a portrait in the Western sense: such images are all fantasies.

In the colonial period it was not uncommon to represent the Inca monarchical succession flowing seamlessly into the Spanish one in terms of successive portraits. The political rationale for this practice is obvious enough: the Spanish monarch was also the ruler of Peru by old and lawful succession, sovereignty having been transferred at the time of the conquest. A lengthy appendix and elegant foldout page in Jorge Juan and Antonio de Ulloa's official 1748 *Relación histórica del viage a la América meridional* makes the point neatly: Manco Cápac to Ferdinand VI without missing a beat.[27] This, of course, was a double-edged sword, for the same argument that legitimized the Spanish claim to the ancient Inca throne validated Inca sovereignty and, consequently, the surviving Inca heirs' claim to their alienated patrimony. The Túpac Amaru revolt of 1781, which almost succeeded in driving the Spanish from the country, revealed to the conquerors the dangers of this ambivalence.

Independence came to the Spanish and Portuguese colonies in the Americas almost by stealth. Napoleon's invasion of the Iberian peninsula essentially launched a series of movements throughout the Iberian colonial world that would in time lead to the creation of a family of sovereign states. The age of Latin American independence produced a larger-than-life cast of characters. Ironically, it heralded a vogue in miniature portraits (fig. 3), a genre that was exceptionally well-served by artists throughout the region. I discuss the portraiture of the age of independence in further detail in a following chapter.

The great winners of the independence wars were the *criollos,* the colonial-born whites. The nineteenth century belonged essentially to them. The great losers were the natives. Spanish colonial law had guaranteed a measure of native self-government and kept native lands effectively, if precariously, in native hands. This paternalistic arrangement struck nineteenth-century liberal nation-builders as obsolete. Its demise dealt a blow to native communities and put vast amounts of land in circulation. All the while natives— long-dead ones, to be sure—became part and parcel of the romantic nationalistic discourse of nineteenth-century Latin America. The native American legacy became an instrument of nation-building, but it was best if the natives celebrated were well and truly dead, like Moctezuma, Cuauhtémoc, and Atahualpa.

Academic Portraits

Portraiture in post-independence Latin America developed along two main watersheds: one "academic" and the other "popular." Art academies had existed in Latin America since the foundation of the Real Academia de San Carlos in Mexico City in 1785.[28] The second Latin American academy, San Alejandro, was established in Havana in 1818. Throughout the nineteenth century, academies were established in many, if not most, Latin American countries. Many Latin American artists traveled to Europe, especially to France, in search of instruction and experience.

The history of art pedagogy and the development of academicism in Latin America is checkered and diverse. In some countries, notably Brazil, academies were established during the age of independence itself. João VI of Portugal brought to his exile in Rio an extensive and influential cultural retinue. Chile had its Academia de Pintura by 1849, established by the Italian artist Alejandro Ciccarelli.[29] A relative latecomer, Colombia's was founded as the century drew to a close.

Academic painting in nineteenth-century Latin America went hand-in-hand with the search for national identity. The connection was clear and often explicit. Venezuela's "Civilizing Autocrat," Antonio Guzmán Blanco, supported the career of Martín Tovar y Tovar (1827–1907) in the clear expectation that the latter would execute the kind of mammoth history paintings and heroic portrait galleries that were crucial to the dictator's nation-building efforts. *The Signing of the Declaration of Independence,* commissioned by Guzmán for the centennial of Bolívar's birth in 1883, and *The Battle of Carabobo,* installed in Caracas's Federal Palace, are two significant instances of that collaboration.[30] Some of Prilidiano Pueyrredón's (1823–1870) best-known work was executed under the patronage of the Argentine nationalist dictator Juan Manuel de Rosas, including his portrait of Rosas himself and of Rosas's daughter, Manuela, in a dramatic red dress, the color of her father's "Federal" Party.[31]

Juan Cordero (1822–1884) was one of Mexico's outstanding academic painters of the nineteenth century. Less well known is the fact that he was also a pioneer of modern Mexican *muralismo.* Several important church murals are to Cordero's credit. Almost three-quarters of a century before Diego Rivera, José Clemente Orozco, and David Alfaro Siqueiros, Cordero painted Mexico's first modern secular public mural at the behest of education minister Gabino Barreda on the walls of the Escuela Nacional Preparatoria.[32]

Like Tovar y Tovar in Caracas and Pueyrredón in Buenos Aires, Cordero sought the protection of those in power. His portrait of General Antonio López de Santa Anna on horseback and of his wife, Dolores Tosta de Santa Anna (at Chapultepec Castle and the Museo Nacional de Arte, respectively), were shrewd moves in a campaign to become director of the Academia de San Carlos. The portraits were successful, especially the first lady's,

in a stunning gown embroidered with pearls. The campaign was a failure, however. The academy's faculty rallied around the incumbent, the Spaniard Pelegrín Clavé, an eminent portrait painter in his own right, and Cordero's appointment got nowhere.

This connection between academicism and nationalism is nowhere more evident than in the career of Uruguay's Juan Manuel Blanes (1830–1901).[33] Blanes saw himself as the painter of his country's national epic, whose task it was to contribute powerful images to the nation's visual patrimony and civic culture. His portrait of Uruguay's national hero, José Gervasio Artigas, at the Ciudadela, is certainly in that class, as is his depiction of the rebellion of the "Thirty-Three Orientals" that led to his country's freedom. Artigas's portrait was based on earlier images and sources—the hero had passed away in 1850, some twenty years before Blanes produced his standard image. Blanes also contributed important historic canvases dealing with Argentine and Chilean patriotic themes.

Pedro Américo de Figueiredo e Melo (1843–1905) was "discovered" by Pedro II, who assigned to him a scholarship to study in France's Académie des Beaux-Arts and the Sorbonne.[34] Back in Brazil, the gifted young artist became in effect the monarch's court painter. He busied himself imaging Brazil's great battles and historical turning points. His epic *Grito de Ypiranga* (Museu Paulista, Universidade de São Paulo) depicting the first Pedro proclaiming Brazilian independence in 1823, has become one of Brazil's historical icons. It is the Brazilian equivalent of Emanuel Leutze's *Washington Crossing the Delaware.*

If *Ypiranga* is the equivalent of *Washington Crossing the Delaware,* Pedro Américo's portrait of Dom Pedro opening the parliament in 1872 (Museu Imperial, Petrópolis, Brazil) is analogous to the National Portrait Gallery's "Lansdowne" portrait of George Washington by Gilbert Stuart (see p. 22). The emperor is represented in three-quarter profile in full regalia with crown and scepter, wearing a stunning imperial mantle embroidered with toucan feathers. All this imperial finery contrasts with Washington's sober black cassock, but the affinities between both representations are, to say the least, profound.

However much academic artists may have approached the theme of national grandeur, their bread and butter came from the old staples: landscapes, still-lifes, and portraits. (In Chile, an emerging maritime nation, seascapes seem to have been rather popular also.)

Blanes's portrait of Carlota Ferreira (Museo Nacional de Arte Visuales, Montevideo, Uruguay) has been hailed as the best Uruguayan portrait ever. The subject, a not–so–young woman—forty-something?—well on her way to severe overweight, stands powerfully in front of a wall covered with a green silken fabric. The opulent brocaded design on the fabric is painstakingly, almost hyperrealistically rendered. So is the lace dress, down to the eight-rose corsage she wears on her bosom. She is not beautiful, but she has a commanding presence and is clearly a person of quality.

The Popular Tradition

The subject is a serious young man. His left hand holds his lapel between the thumb and the forefinger. Where his right arm would have been there is an empty sleeve. He probably would not want us to know that he is an amputee—he lost his arm to gangrene at the Battle of Curupaity in September of 1866—so he has artfully posed himself showing only his left side in three-quarter profile.[35] There is an air of sadness about him.

The conflict where Cándido López (1840–1902) lost his arm was the War of the Triple Alliance, fought by Argentina, Brazil, and Uruguay against landlocked Paraguay (fig. 4). It was supposed to last for three months but lasted instead for five years, between 1865 and 1870, coming close to doing away with Paraguay as a viable state. López left us a unique visual documentation of the war. His modest reputation rested for years on his battle scenes

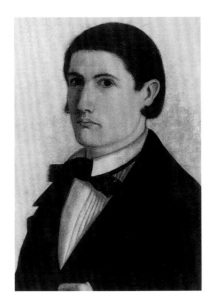

Fig. 4 *Cándido López* self-portrait. Oil on cardboard, c. 1850. Museo Nacional de Bellas Artes, Buenos Aires, Argentina

set against a landscape so imposing that soldiers look like ants on the move. Today López has been reevaluated as one of Argentina's greatest nineteenth-century painters. He did not attend an art academy: He learned his craft through a local apprenticeship and as a daguerrotype photographer.

López is part of a tradition that found distinguished practitioners throughout nineteenth-century Latin America. Spontaneous, naive at times, and distinctly original, the tradition of modern Latin American popular portraiture is rooted in the colonial experience, continues with the independence generation, and carries on through to the twentieth century. It includes such figures as José María Estrada (c. 1810–c. 1862)[36] and Hermenegildo Bustos (1832–1907) in Mexico,[37] López in Argentina, Manuel Dositeo (actually "Doroteo") Carvajal (1818–1872) in Colombia,[38] and Miguel Arcanjo Benício d'Assumpção Dutra, better known as "Miguelzinho" (1810–1875) in Brazil.[39] Of course, they were not the only ones. Many popular portraitists remain anonymous, known only by their works.

José María Estrada was born in Guadalajara, Jalisco, and spent most of his life there. He did not attend an art school but took lessons from a local painter, José María Uriarte. Estrada was reasonably well known as a painter at the time of his death, for he was reported by Ventura Reyes y Zavala in his 1882 history of painting in Jalisco as *"un pintor mediano, pero excelente fisionomista"* (a middling painter but a great physiognomist).[40] Some two hundred works are known from Estrada's hands, enough to establish his reputation as one of Mexico's outstanding portrait artists.

Estrada's subjects were the provincial elite of Jalisco—men, women, and children (see p. 25), the living and the dead. Several remarkable portraits of dead people (*repentinos*) are known from his hand. The one of Francisco Torres is especially arresting. The subject is shown upright, his eyes closed, crowned with a garland of flowers. (The affinity with colonial dead nuns is undeniable.)

Two portraits of Don Secundino González made in 1834 show the subject in contrasting poses and attitudes. One shows him from the waist up, wearing an open shirt, his right hand resting on his chest while his left holds an orange. The other shows him formally dressed and standing next to a table with an inkwell. Manuela Gutiérrez (pl. 52) is shown at age one-and-a-half, wearing a *bata,* holding a doll, and pointing at her little dog. Doña María Tomasa García Aguirre is depicted in the flower of womanhood, cradling an image of the child Jesus. All three sitters are shown in quarter profile, looking to the right. For all their differences of age and gender, their noses look strangely alike.

Mexico's other giant among nineteenth-century popular portrait painters, an improbable genius called Hermenegildo Bustos, saw the first light not very far from Estrada's hometown. The village of La Purísima del Rincón, Guanajuato, was founded in 1603 with Tarascan and Otomí natives. In 1832, when Bustos was born, it was a prosperous, conservative farming community. Bustos, a deeply pious eccentric who dressed in uniforms of his own design, was reputed to be a restless tinkerer and handyman, and played several instruments—all self-taught. He also painted portraits (pl. 75) and ex-votos (pl. 74). It was in the latter pursuit that he would achieve remarkable posthumous fame.[41]

Like so many popular painters in Mexico and elsewhere, Bustos was quite forgotten after his death. In 1933, Bustos's portrait of his wife, Joaquina Rios, was published as "anonymous." His "discovery," however, occurred by leaps and bounds over the next few years, leading to a one-person retrospective at the Museo Nacional de Arte in 1951.

Portraiture and the Belle Epoque

In many ways, the nineteenth century ended in Spanish America in 1910, a year that marked simultaneously the centennial of independence and beginning of the region's first major social revolution. The overthrow of General Porfirio Díaz in Mexico opened the way to profound changes. The fallout from the Mexican revolutionary upheaval would not begin to settle down until the 1940s, with very significant consequences for the fine arts. In Brazil, the empire was overthrown in 1889 by the army. A republic was proclaimed in its place, imbued with the ideology of positivism.[42] Positivism, in fact, was the philosophical *vade mecum* of fin-de-siècle Latin American modernizers such as Mexico's General Díaz, the generals who ran post-imperial Brazil, and civilian reformers such as Marcelo T. de Alvear, the founder of Argentina's Radical Party.

Whether they expressed themselves in Spanish or Portuguese, politically and philosophically the elites who presided over Latin America's equivalent of the "Belle Epoque"—or, if you prefer, "Gilded Age"—were cut from the same cloth. Brazil's Republican motto just about captured their program: *"Ordem e Progresso."* Keep order and secure material progress and—by Comte and Spencer!—social development will follow. For most people in Latin America, the epoch was nowhere as "belle" as one might think, for rapid material progress often exacerbated profound social inequities. By the same token, the age was not as "gilded" as its United States analogue. Trains were built and cities modernized, and fabulously wealthy Argentines could have their portraits done by Joaquín Sorolla and send their dry cleaning to Europe (often in the same steamboats which, laden with frozen beef, ensured the nation's prosperity). But development directed from above privileged foreign investment capital and accelerated Latin America's tendency toward single-crop economies: sugar from Cuba, coffee from Brazil, nitrates from Chile, and bananas from Central America.

A further, key development of the age was the entry of the United States as a major colonial power on the global scene. It all happened in a short few months between 1898 and 1899. The Spanish-American War placed Cuba and Puerto Rico under the American flag and turned the Caribbean into the proverbial "American lake." Three years later, the United States pried Panama from Colombia and built the canal. "I took Panama," said Teddy Roosevelt, and that was that.

Puerto Rico's Francisco Oller (1833–1917) was literally caught between and betwixt.[43] As a portraitist (pl. 81), he evolved from colonial convention, through chiaroscuro, to a mature style influenced by impressionism. Oller produced what has been called "nationalist art." The nationalist content was not, as in the case of Uruguay's Blanes, visualizing a national epic—there was none in Puerto Rico. Rather, it consisted of a celebration of the island's natural beauty and its vernacular culture. One need only look at Oller's painting of a raceme of plantains to get the point. A cosmopolitan, European-oriented painter of the island's nineteenth-century military and political figures, Oller did the portraits of the new American rulers of Puerto Rico as well: General George M. Davis, the last military governor of the island, and William H. Hunt, the first civilian governor. Ironically, those of the Yankee viceroys are among his best portraits.

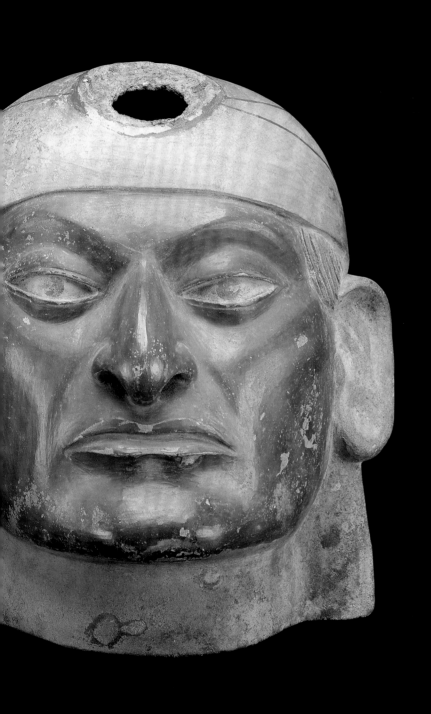

II

FACES OF PRECOLUMBIAN SOCIETY

True, Ethnic, and Official Portraits: Olmec, Maya, and Moche

The human body is the basis of art in the ancient Americas. Thousands of depictions of human beings and supernatural beings in essentially human form are known in Precolumbian art. Most human figures have a generalized, often idealized, face and a body that makes ritual gestures or supports significant garments. Moreover, each ethnic group has a typical face and style of presentation. In many Precolumbian cultures, certain faces possess an intense, lifelike quality, and at least some of these surely portray real people; however, other Precolumbian cultures rarely show human beings. A significant sample of what seems to be portraiture in the strict sense comes from only three Precolumbian groups—Olmec, Maya, and Moche, the first two in the region archaeologists call Mesoamerica, the third in the Andes.

Many of the true and ethnic portraits are official portraits. All over the world, important people in official portraits are often recognized not so much by facial likeness as by headgear, garments, carried objects, and contexts that declare the power of office. Portraits were statements of status and power also in the ancient Americas. The regalia proclaim the wearer's position and, perhaps more critical, his connections with gods, ancestors, and the powers believed to control such natural events as rainfall, earthquakes, and volcanic eruptions. Clad in iconographic garments and accessories, he (and occasionally she) may hold or wear the images or attributes of gods or emerge from a cosmic monster (fig. 1); such traits constitute evidence for divine kings in Precolumbian America.

Official portraits can be anything from a monument to a small jade carving or a clay figurine. In Mexico, such portrayals date back at least as far as the first millennium B.C.—what is known as the Preclassic period. The massive Olmec Stela 2 from La Venta, on the coastal lowlands of Tabasco, shows an eroded central figure wearing and holding kingly paraphernalia and surrounded by small supernatural beings.[1] Another, more unusual, form of Olmec official portrait is a multi-ton colossal head, helmeted and individualized; the monumental size alone was a clear statement of the individual's power. Some seventeen heads have been found at several sites.[2] Those from San Lorenzo have a family resemblance that suggests a dynastic relationship. Their identity is not known: the heads might commemorate kings, ancestors, valuable sacrifices, or allegories;[3] but they look like portraits.

Most Olmec human depictions have Olmec faces that are not individualized. Of those that seem to be true portraits, some of the most lifelike are simply dressed. A small gray-stone figure of a kneeling man has designs incised on his bare head and virtually no clothing (fig. 2).[4] His face, that of a serious man of a certain age and status, is not typically Olmec. He may be a ruler or a priest—they were not necessarily different—in an intense ritual

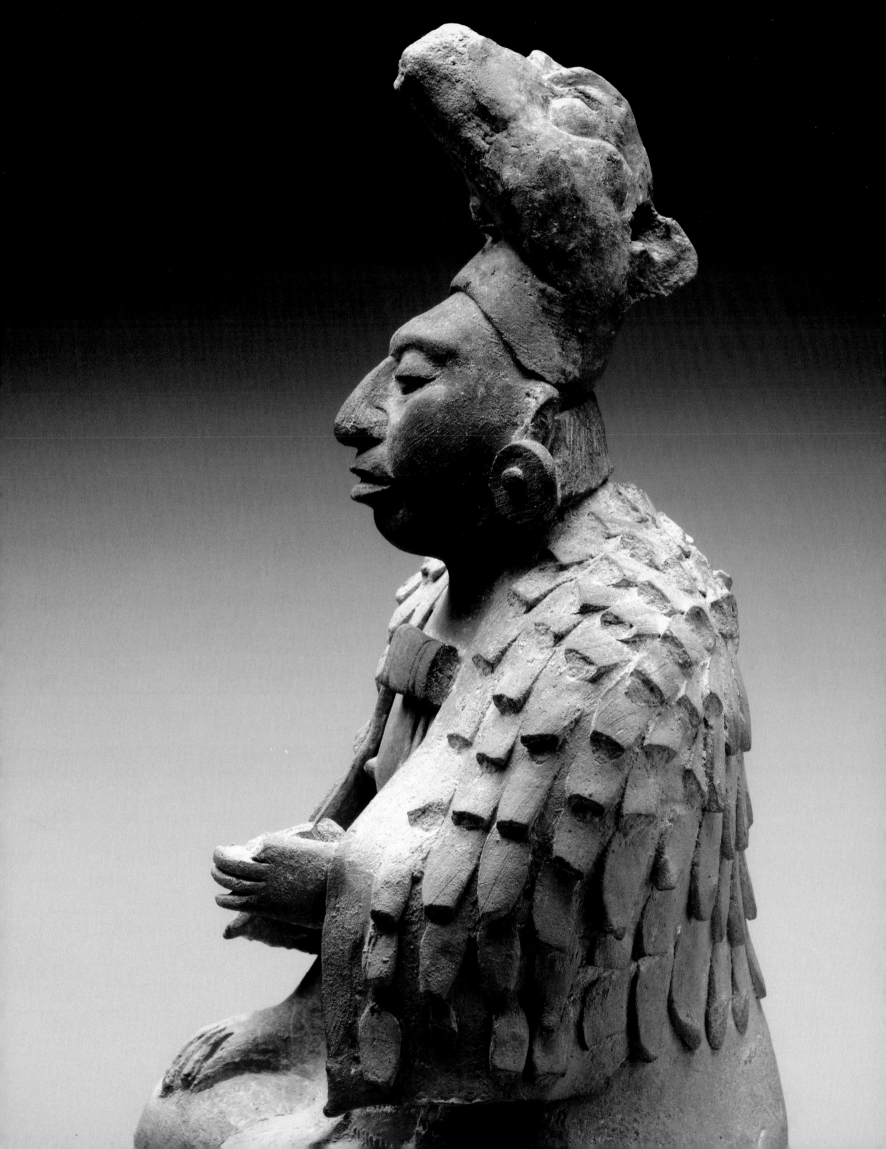

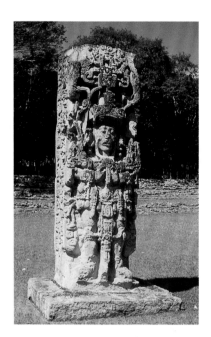

Fig. 1 Portrait of the ruler Waxaklajuun Ub'aah K'awiil, in the Great Plaza. Maya; Copan, Honduras, Stela B. Stone, A.D. 731

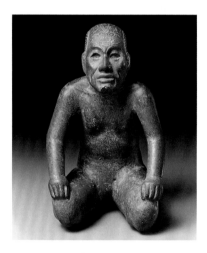

Fig. 2 Kneeling figure with incised design on forehead. Olmec, Veracruz, Mexico. Gray stone with traces of polychrome, 900–600 B.C. Princeton University Art Museum, New Jersey; Museum purchase, gift of Mrs. Gerard B. Lambert by exchange

state, achieved perhaps by means of incantation, concentration, or the taking of a psychoactive substance. An extraordinary head, broken from a figurine of fine dark-green jadite, is only two-and-one-half inches high, but a slide of it projected on a screen, magnified two hundred times, reads as strongly as a colossal head.[5] The face is that of a mature man with frown lines and wrinkles, a man accustomed to power and responsibility. Although he was worthy of one of the finest carvings in Olmec art—in precious, hard-to-work jadite—he has no trappings of office. He is bare-haired and bare-shouldered. A particularly engaging Olmec portrayal is a small jadite seated figure from a tomb at La Venta.[6] Often considered to be a female, it is possibly a bare-headed young boy of a royal family. Around the neck hangs a hematite mirror, a royal symbol. Another seated young man, carved in jadite, wears garments embellished with carved and incised designs of preternatural power.[7] The symmetrical body and clothing, however, are small in proportion to the head, and they function only as surfaces on which to make power statements. His slightly asymmetrical face is carved with loving care and skill to look real and individual, as the face of a young person of worldly and supernatural importance, perhaps at the time of an accession rite. All of these remarkable portraits were worked with stone and bone tools.

In the Classic period (most of the first millennium A.D.), Maya stone stelas and lintels presented official images of rulers, usually in low relief. Both Olmec and Maya sculptures can show a king within the embrace of a great, zoomorphic monster; for the Maya, it is usually his headdress. Most have a typical Maya face—flattened skull, high, sloping brow, and roman nose—surrounded by an assemblage of ritual dress and paraphernalia, which are symbols of gods and the supernatural, sources of royal power (see fig. 1). A Maya ruler had regal, military, and priestly aspects. Like Olmec subjects, Maya portraits can be seen in the simple dress associated with certain rites, as well as in official regalia.

One Maya sculpture profile looks much like another, but examination of six profiles on a Palenque Temple XIX relief reveals subtle differences.[8] Whether or not the men resemble actual people, the faces have been made to look individual. True Maya portraits were produced in stucco at the site of Palenque, in the forested lowlands of Chiapas. It has been suggested that portraiture at Palenque lasted a relatively short time; there may have been one sculptor who arrived during the reign of the great king Pacal and worked into the reign of his son, Kan Balam (Chan Bahlum, A.D. 684–702).[9] Kan Balam's face is distinctive, with a large, long nose and pendulous lower lip; his body is notable, too, for he had six toes and six fingers, which appear in relief sculptures on Palenque architecture.[10] Other Palenque heads are mostly unidentified, but a few of them are remarkably strong and seem to be true portraits.[11] There may be portraits of Pacal. Two stucco heads (from an architectural setting) found in his tomb either show an idealized face or depict him as a young man;[12] Pacal was eighty when he died.

Masks, usually of jadite or other green stone, are a source of what appear to be true Olmec and Maya portraits. The most beautiful and lifelike Olmec masks, carved from a single piece of stone, come from the Rio Pesquero (Veracruz), a river that changed course and cut through an ancient site.[13] Many Olmec faces have a profile head of a god incised on either cheek, as if to protect, ennoble, or consecrate the wearer (figs. 2 and 3). Frequent symbolic markings at the mouth, denoting a dragon of earth and caves, seem to express the ruler's responsibility for agriculture and the feeding of his population. David Joralemon opines that the masks are portraits of rulers. He thinks that they had funerary associations and may have been kept and used in lineage and ancestor-evoking rites long after the disposition of the body.[14] An Olmec-style maskette, conventional but almost portraitlike, was excavated in an offering in the much-later Aztec Templo Mayor in the faraway Aztec capital that is now Mexico City.[15]

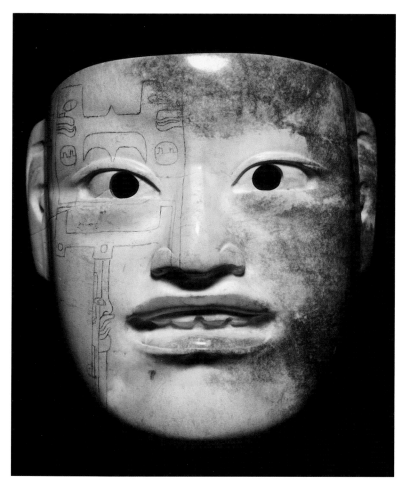

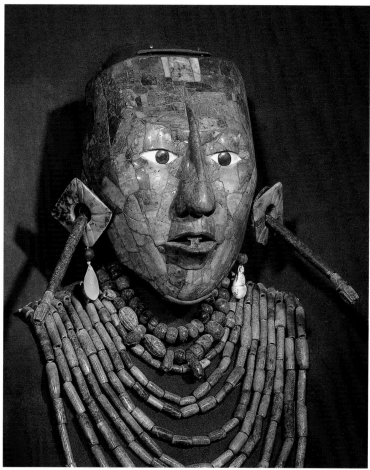

Fig. 3 Human mask with incised design. Olmec, Rio Pesquero, Veracruz, Mexico. Jadeite, 900–600 B.C. Private collection

Fig. 4 Recently restored mosaic funerary mask from the tomb of the ruler K'inich Janaab' Pacal I. Palenque, Mexico. Jadeite, A.D. 683. Museo Nacional de Antropología e Historia, Mexico, D.F.

Maya green-stone masks, like Olmec masks, seem to be some of the truest portraits. Unlike Olmec masks, these are usually a mosaic of pieces of jadite (and sometimes shell and obsidian); only a few small, early ones are worked from a single piece of stone. It would not be easy to create a likeness in mosaic, yet these masks seem to be individual images. The one found near Pacal's face in his tomb shows him in old age (fig. 4), as does another mask from an offering in the tomb.[16] A mask from a royal tomb at Calakmul (in Mexico, north of Tikal) may be idealized, but it is very realistic and is thought to be a portrait of the man with whom it was found.[17] The Olmec and Maya jadite pieces were burial masks that would take the image of the deceased king to the other world. Some masks, however, show supernatural faces that would have transformed the wearer. These convey a different concept and may have been made for nonfunerary rituals.

Masklike stone objects from Teotihuacan, in the central Mexican highlands, are very different; they are neither wearable nor individualized.[18] Carved from a single piece of stone, all have essentially the same conventional, idealized face with no added ornaments, except that eyes were usually inlaid and the open mouth sometimes had inlaid teeth. Few of these masks have been legally excavated, but some have been found in graves. In addition to the actual objects, masks are depicted in ritual contexts in murals.[19] The same face appears on clay masks, often with nose and ear ornaments, and on complicated ceramic censers, surrounded by glyphic elements. A similar face is seen on small stone carvings and clay figurines.

True portraiture is rare in the Andes, but at the time of the Classic period in Meso-america, the Moche, on the north coast of Peru, developed the most individualized portraiture in the Americas. (Christopher Donnan addresses this subject in depth in his essay.)

Given the scarcity of stone and wood in the coastal desert, true and official Moche portraits take the form of ceramic bottles. In the early Moche period, there were probably no true portraits. In the middle Moche era, men in priestly cloth garments appear as true portraits. The bottles presenting the most richly dressed men are not true portraits, but they doubtless portray leaders. Apparently, at a certain point, priests became particularly powerful, probably because of their charisma and connections with the other world, and serious portraiture developed to depict them. By the late Moche period, when their world was coming to an end, there are few human representations, let alone portraits. The Moche culture, which surely produced more portraits than any other group in the ancient Americas, ultimately rejected them.

Moche and Maya had many similar attitudes and beliefs. Both produced scenes of remarkably individual naturalism. Moche, too, had a symbolic language of power symbols, but it is much less baroque than most Maya symbolism. A simple helmet, a feline head on a headdress, or a pair of step motifs and a knife supplanted the complex concoctions of feathers, monster heads, and symbols from which a Maya ruler's head emerged.

Most Andean peoples provide a face or set of faces that are typical for the culture but are not individual portraits. The early cultures of Chavín and Paracas probably never represented real human beings. And later Inca art is essentially nonfigurative; a few stone faces are said to be Inca, but there is doubt about their provenance.

Generic Portraits

Generic portrayals show people with certain traits or roles. Dwarfs and hunchbacks, which appear in Preclassic and Classic Mesoamerican cultures, might be classed as generic portrayals.[20] In the Andes, the blind are fairly frequently represented, and Moche art shows people missing a leg, possibly removed in sacrifice. Diseased people are seen in Moche and some other Andean art, notably in Ecuador and southern Colombia.[21] Most of these representations probably had a religious, magical, and/or curative function.

Old men are common in Precolumbian art. Because they look realistically aged, they seem to be individuals, and may, in fact, be; their age was a likely qualification for their portrayal as ancestors or men in priestly or shamanic roles. Ancestors were sacred, even divine, in many Precolumbian societies. Old gods also appear in most cultures, and it can be difficult to tell the divine from the human. The Maya made images of old underworld gods, and an old fire god was significant in many places in Mesoamerica. A few old women appear as Preclassic and Classic Maya figurines.[22] These are probably mythical characters, like most of their later counterparts: an old Maya goddess in the Dresden Codex and the Aztec goddess Coatlicue, for example. Cupisnique, the earliest major culture on the north coast of Peru, provides many quite realistic but impersonal human forms in ceramic; a bottle shaped as a simply dressed old man is a generic or possibly true portrait.[23] Tiwanaku, high in the Bolivian altiplano, a culture with formal, impersonal art, produced a rare possible portrait, a vessel in the form of an old man's head.[24] Olmec art is an exception; the emphasis there is on youth—not only young men but babies, modeled in clay, and royal figures in stone holding babies.[25]

Warriors and captives are categories for individual presentation in most Precolumbian cultures (see Christopher Donnan's essay), for war had a ritual aspect and was part of both political and religious life. Presumably, the captives were to be sacrificed and were depicted because they were significant offerings. On Maya sculpture, some captives are identified as captured kings (fig. 5).[26]

Ball games were significant rituals in Mesoamerica, and ball players are prominent in Maya and other arts; the players may be kings, but their images rarely seem to be likenesses.

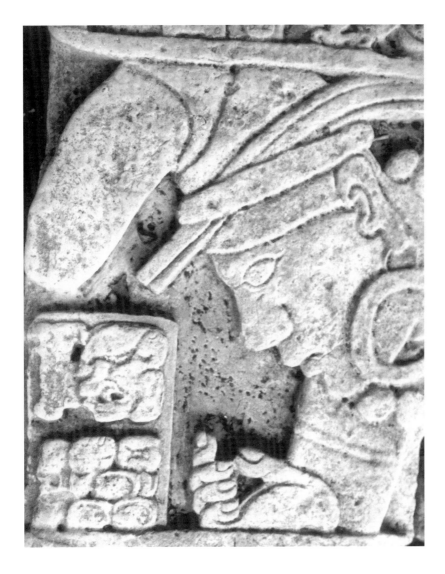

Fig. 5 A ruler of Seibal, who in A.D. 735 was captured by the king of Dos Pilas and beheaded the next day. Maya, Dos Pilas, Guatemala. Stela 16 (detail)

Reliefs at the ball courts of El Tajín, Veracruz, and Chichén Itzá, Yucatán, show men in ritual situations, but the faces are not individualized.

Artists are depicted in both Maya and Moche cultures. Painters and scribes are seen on Maya polychrome vases, and Moche art shows potters as effigy bottles and weavers in scenes painted on spherical bottles. In these cultures, artists and craftsmen surely had high positions in the royal establishment, and in the Maya world they were sometimes royal themselves.[27]

Apparent legendary characters appear in distinctive portrayals. Nasca art, of the south coast of Peru, generally presents conventionalized faces. Yet most examples of a group of ceramic vessels showing a man holding his injured knee have a rather different face, perhaps contorted with pain.[28] He was likely known in legend. A Moche man with a long, white beard was probably a historical character who became legendary; he is dressed in garments associated with a coca-chewing rite. In a population with sparse facial hair, a man who could grow such a beard would have remarkable fame, if not power. Another repeated Moche character is a foreign-looking man with a moustache and goatee, also probably a legendary being; he often appears as a captive (see p. 61).

Many portraits represent supernatural beings. In some cultures, it can be hard to tell whether representations are human or supernatural. Sometimes a supernatural face is simple; often it is partially obscured or altered by face paint or jewelry that transforms it:

nose ornaments or mouth masks or, in late central Mexico, lip plugs. The rain god Tlaloc and humans under his aegis have a goggle encircling each eye. Gods possess visual traits that define them: a fanged mouth, a fish barbel, a foot or belt that is a snake, a patch of jaguar skin, etc. The Aztec god Xipe Totec is dressed in someone else's skin. Stone portrayals of Quetzalcoatl often take the form of a feathered serpent: some are simply a composition of snake attributes and feathers. The god usually has a blandly handsome human face; however, the male gods Tezcatlipoca and Xochipilli, and some of the Aztec female goddesses, can also be portrayed with handsome faces. The young maize god is a Maya example of a god as a beautiful young man.

Possible Portraits and Stereotyped Faces

The literate Maya wrote a great deal about their rulers and, in some instances, made true portraits of them, but the question remains: when is a face simply conventional and ethnic, and when is it a likeness, as some pieces seem to be (figs. 4, 5, pl. 7)? The rulers of Naranjo have distinctive profiles, and there may be portraiture in the sculpture at sites such as Piedras Negras and Yaxchilan.[29] Possible Maya portraits include naturalistic stucco heads from Comalcalco (Tabasco), each showing a man in a certain kind of relatively simple headdress that may have been the royal headgear for that site.[30] Various small Maya jades, especially from Tikal, in lowland Guatemala, are possible portraits: a head on the top of a funerary vessel from a royal tomb in Temple I appears to be that of the interred ruler; a maskette representing the founder of the Tikal dynasty, carved from one piece of jade, is a possible portrait; and another Tikal maskette may also be a royal likeness.[31] The enthroned figures in a palace scene on one of the many Maya cylinder vases might also, in some cases, be true portraits.

Burials on Jaina, an island off the coast of Campeche, are the best-known source of Maya figurines. Many have standard faces, but are the enthroned men in elaborate head-dress idealized or are they likenesses (pl. 8)? What about the warriors, old women, and old men? Many of the more elaborate examples seem to be official portraits, but some figurines from Jaina, Palenque, and other Maya sites may have been true portraits.[32] Portrait figurines from non-Maya cultures may also exist. Preclassic figurines from Xochipala (Guerrero) may include true portraits, including some of bare-chested women.[33] The "smiling face" figurines of Veracruz are friendly but impersonal. However, a head from a large ceramic figure from Veracruz is wonderfully lifelike and may be a real likeness; there may be others.[34]

Teotihuacan is a different story.[35] Figurines there always have the same basic facial type, even though the heads may look slightly different when seen together.[36] Some figurines are fairly richly dressed; some are enthroned, but most are unadorned. They appear in a wide range of poses; some even have movable limbs. Teotihuacan also produced a wealth of mural painting that used a concentrated symbolic language. Most of the murals exhibit elaborately garbed gods or important humans with faces framed in glyphlike iconography of feathers, weapons, and other symbolic paraphernalia. Although the mural figures are usually formal and hierarchic, a few scenes show a crowd of small, simply dressed, very active figures.[37] They stand, sit, or move; they gesture and seem to speak. But they have cartoon faces. The artists rendered the activities of the figures naturalistically—and the line is lively—but the faces are far from portraits.

The Zapotec, Mixtec, and Aztec cultures of Oaxaca and central Mexico carved on sculpture and wrote in books the names of rulers and heroes. The Zapotec people, who lived around the great hilltop site of Monte Albán in the Classic period, produced conventional portraits of those in power on stone sculpture and a few probable true portraits in

Fig. 6 Aztec mask. Oaxaca, Mexico. Wood with traces of gesso, gold leaf, and hematite, A.D. 1350–1521. Princeton University Art Museum, New Jersey; gift of Mrs. Gerard B. Lambert

ceramic, some of which have been found in burial sites.[38] One possible portrait is an early ceramic seated figure with virtually no clothing, probably in a ritual pose.[39] Identified as a young Zapotec lord, he has one date on his chest and another on his simple headgear. The exploits of later Mixtec kings and culture heroes—notably Eight Deer/Tiger Claw—are painted in bark-paper codices, looking rather like figures in comic books, although these are official portraits. Eight Deer/Tiger Claw is bearded and wears an animal helmet and elaborate, symbolic garments. The figures have distinctive helmets, stereotyped faces, and stiff movements. Similarly, Aztec rulers are named, but they rarely show personalized faces.[40] The round sculpture that commemorates the Aztec ruler Tizoc presents a series of Mexica warriors, each holding a captive by the hair; Tizoc wears the biggest headdress and is named. Humans in Aztec art are few and rarely individualized, although some of the masks and masklike heads are rendered with a sense of beauty that gives them life (fig. 6).[41] Most such Aztec objects represent supernatural characters.

Friar Diego Durán, in the sixteenth century, produced a posthumous picture of the Aztec king Moctezuma sitting for a memorial portrait carved on a rock in the Chapultepec gardens.[42] Durán's text, however, states that although the king wanted the sculpture made, he was not present when the work was done. He did, however, go see the carving when it was finished. It has since disappeared and cannot be judged in terms of true portraiture.

In Central America, some Costa Rican ceramic vessels and stone objects are possibly portraits.[43] Panama and most of Colombia seem to lack portraiture; however, in southern Colombia and Ecuador, ceramics were produced with idealized ethnic faces, some of which could be portraits. A partial clay figure from La Tolita, depicting a mature man with clothing only on the lower part of his body, is bareheaded; the remains of his arms extend asymmetrically. He looks like an individual.[44] The early Chorrera culture of Ecuador, contemporary with Cupisnique and Chavín, produced a few possible portraits with alert faces.[45] The faces belonging to later cultures along the coast of Ecuador—Jama Coaque and

Bahía—can be very generalized, but there are possible portraits.[46] A Bahía clay figure of a standing old man, elaborately dressed and carrying a staff, could be a portrait. In general, Ecuador's Precolumbian artists were not interested in faces, and especially not in mouths, but sometimes one of the faces looks very alive and can be very moving.

Concluding Thoughts

The history of portraiture in the ancient Americas is much like that in the rest of the world. Elsewhere, portraits appear at certain times; in Western countries, true portraiture is mainly a product of the sixteenth to twentieth centuries. As many writers have pointed out, classic Greek sculpture idealized human forms, Hellenistic sculpture was more realistic, and many Roman sculptors carved serious portraits. The Middle Ages produced portrayals of saints—not so many of kings, unless they were also saints—and the saint was identified by symbols of his or her martyrdom. The artist who made the images had never seen the saint (the same saint can look very different in different portrayals), and most were painted after the death of the subject. Depictions of a donor and his wife in the corner of a painting of the Madonna are portraits in a sense, but they are peripheral and probably not likenesses. Only in the Renaissance did portraits of prominent people begin to be painted or carved. Western art, of course, does not always produce exact likenesses. Modern portraits often "improve" the sitter, and this may well have happened in many places in the past.

By and large, the Precolumbian human face was treated in a perfunctory manner. Portraits are mostly depictions of the politico-religious paraphernalia that the person was entitled to wear. Likenesses or not, there are some extraordinarily vivid presences. Trying to determine whether or not a Precolumbian depiction is a true portrait may often be subjective and may for the most part depend on how lively and distinctive the face is. But even a distinctive face may not be a true portrait, while some faces that look idealized may have closely resembled the subject. Or they may have resembled the way the subject wanted to look or the way a respectful artist wanted to make him look. The facial appearance may have been a matter of the artist's talent for likeness or the subject's desire for it. Did Olmec men really have faces as beautiful as some of the Rio Pesquero faces (see fig. 3)? How much is this beauty a matter of the eye of one artist or school, or of the desires of the man whose portrait it presumably was? And like the Christian saints, some of the subjects may have been dead before they were immortalized.

Whether or not there was serious portraiture in a particular Precolumbian culture tells much about the politico-religious situation of the culture. In the ancient Americas, it is always hard to disentangle the sacred from the secular. Olmec and Chavín were the two best-known early cultures that put on the grandest displays of stoneworking, but they are very far apart in implications about power. The Olmec made portraits—sometimes monumental—of powerful men; Chavín concentrated on supernatural beings. The few possibly human depictions are not portraits; they may be mythical culture heroes. Even the gods are abstruse images made up of human, animal, and symbolic parts. Cupisnique, the contemporaneous culture on the coast of Peru did, on the other hand, produce human depictions and generally more naturalistic art, but probably no portraits. The contemporary Andean cultures of Moche and Nasca also had quite different patterns of power. While Moche are famous for portraits, Nasca ceramic art presents complicated supernatural beings and humans with conventionalized or masked faces—blank-faced ritualists in a variety of poses, garments, ornaments, and face paint (and sometimes splattered blood?).[47] The most common Nasca human image is a ritually decapitated head.

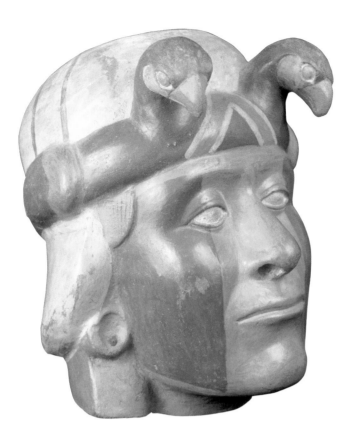

Fig. 1 Portrait of an individual wearing an elaborate bird headdress. Ceramic, c. A.D. 550. Museo Rafael Larco Herrera, Lima, Peru

To make a mold, a thick layer of clay was packed around the exterior of the mold matrix and divided with a vertical cut to make front and back halves. As the clay began to dry, the halves were carefully removed from the mold matrix, allowed to dry completely, and then fired. These two halves then became the mold in which portraits were made.

To create a portrait, soft clay was pressed into each half of the mold, and the halves were then pressed together. An opening at the bottom of the mold allowed the potter to reach inside to bond the two halves together and smooth the seams. Ropes of clay were then added to close the bottom and make it flat. As the moist clay inside the mold began to dry and shrink, the two halves of the mold were removed. The potter would then add a spout to make the newly formed chamber into a bottle, a jar neck to make it into a jar, or simply cut the top open to make it into a bowl.

The chambers of some portraits have projecting elements that could not have been produced in a simple two-piece mold. Some bird heads (fig. 1) were made in other sets of molds and subsequently attached to the portrait.

Nearly all of the portraits were painted with one or more colors of slip while their clay was still moist. After the slip was applied, the portrait vessels were carefully burnished by rubbing the damp surface with a smooth stone or bone. This left the surface smooth and lustrous.

Moche portraits were probably fired in shallow earthen pits, a method that is still utilized widely by traditional Peruvian potters. More than 95 percent of the portraits were fired in an oxidizing atmosphere, which left the unpainted areas an orange to buff color; the red slip became dark red, orange, or reddish brown, and the white slip became gray-white or cream-colored. The slip paints bonded permanently to the surface of the vessels during

the firing. A few ceramic portraits have an overall gray or black color that resulted from a modified firing technique (fig. 2).

After firing, many ceramic portraits were decorated with organic black pigment to make the hair black, or to represent face paint, mustaches, eye elements, and designs in headdresses (see fig. 7). This pigment was most likely a plant extract that was nearly clear when applied to the ceramic surface. When the vessel was heated over an open fire, the organic material scorched to a gray-black or brownish-black color. The pigment is not as permanent as slip, and often only traces of it remain on portrait vessels.

Multiple Portraits of Individuals

It is possible to recognize multiple portraits of many Moche individuals. These portraits are often so similar in size and form that they appear to have been made in the same mold, or in molds made over the same mold matrix. Yet the Moche potters and painters achieved a striking degree of variation in multiple portraits of one individual by altering the head-dress, ornaments, and face paint. This clearly demonstrates that there was no concept of an "official portrait" of an individual, wherein his headdress, ornaments, and face paint were standardized and all portraits of him were to conform to that standard. On the contrary, the variations suggest that these individuals owned and commonly wore a variety of head-dresses, and painted their faces in various ways.[3]

A great variation in multiple portraits of an individual might be expected when different artists made and painted the portraits, but even when several portraits of an individual appear to be the work of the same potter or painter, they can differ significantly. It appears that potters and painters deliberately avoided duplication, and attempted to make each portrait unique.

Warriors and Prisoners

Most, if not all, of the individuals shown in Moche portraits would have been important figures in their society, and probably participated in various ceremonial activities. From their portrait head representations alone, however, it is extremely difficult to determine what those activities may have been. Fortunately, in some instances it is possible to identify individuals who are depicted in portrait head vessels and are also depicted in full-figure portraits. Because the full-figure portraits illustrate how an individual dressed and what he held in his hands, they provide interesting clues about the activities in which that person participated. Full-figure portraits indicate that some of the individuals depicted in portrait head vessels were warriors who participated in ceremonial combat and ultimately suffered capture and ritual sacrifice.

Moche artists frequently depicted warriors and warrior activities, and hundreds of these depictions can be found in museums and private collections today. These can be arranged into a sequence of activities that we refer to as the Warrior Narrative.[4] It begins with paintings of warriors who are ready for combat. They are elegantly dressed in elaborate clothing and ornaments, and generally hold weapons and shields. Some paintings portray the actual fighting, which almost always involved pairs of warriors engaged in hand-to-hand combat. The objective was to capture rather than kill the opponent. Once a warrior was defeated, his clothing, weapons, and ornaments were removed, and he was paraded nude to a ceremonial precinct. There the Sacrifice Ceremony was enacted—the captives had their throats slit to drain their blood, and the blood was consumed from tall goblets by priests and priestesses.

Given the elaborate clothing, weapons, and ornaments of the Moche warriors, they must have been people of high status. In this regard, they were similar to Medieval

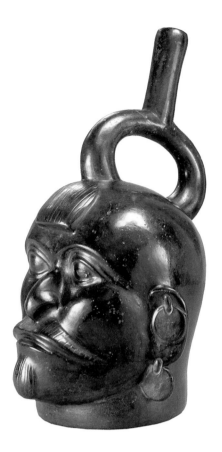

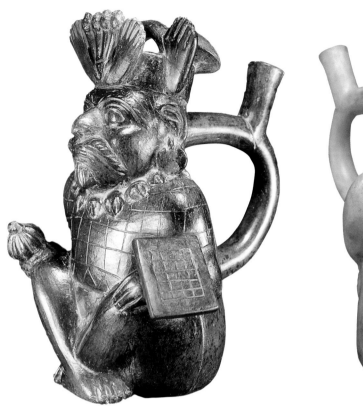

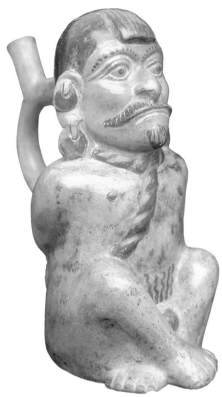

European knights who dressed themselves and their horses at great expense in order to participate in jousting matches with splendid pageantry. In Moche society, the high-status adult males who participated in combat must have done so willingly, even though capture and sacrifice of some of the participants would have been the predictable outcome.

One of these warriors shown in portrait head vessels can be easily recognized by his large, bushy mustache, round goatee, and forelock (fig. 2). I have named him Bigote, the Spanish term for mustache. Some full-figure portraits show Bigote as a warrior holding a war club and shield (fig. 3). Other full-figure portraits show him at a later time, as a captive who had been defeated in combat—nude, with his hands tied behind his back and a rope around his neck (fig. 4).

It is interesting to consider why some of the individuals shown as portrait head vessels, like Bigote, are also shown as nude or seminude captives with ropes around their necks. One possibility is that these individuals were captured from an enemy group, and artists of that group subsequently commemorated the capture by producing portraits of these men as prisoners. But the portraits were not produced in peripheral regions that may have been engaged in warfare with the people of these valleys. All evidence strongly indicates that the portraits of individuals as prisoners were produced by the same group of potters that made the other portraits of them—not by a foreign group.

Portraits of individuals as captives must have been made to commemorate the capture and sacrifice of specific individuals whose role, status, and appearance were well known in Moche society. It is unlikely that their nude portrayal, with ropes around their necks, was demeaning or insulting. On the contrary, it may have been seen as praising or honoring the individual, commemorating the fact that he was ultimately sacrificed for the common good. This concept may be more easily understood if we consider the reasons for producing depictions of the crucifixion of Christ and the emotions that these works engender when viewed by Christians.

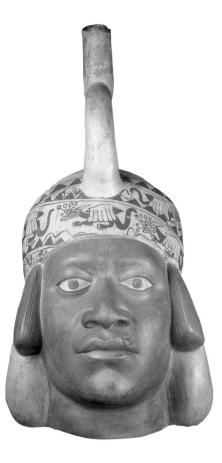

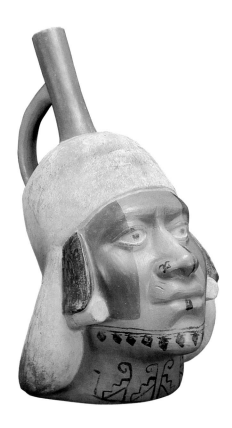

Fig. 5 Portrait of Cut Lip at about ten years of age. Ceramic, c. A.D. 500. Museo Rafael Larco Herrera, Lima, Peru

Fig. 6 Portrait of Cut Lip in his early twenties. Ceramic, c. A.D. 500. Museum Reitberg Zurich, Switzerland; Eduard von der Heydt Collection

Fig. 7 Portrait of Cut Lip in his mid-thirties. Ceramic, c. A.D. 500. Private collection, North Carolina

Individuals Portrayed at Different Ages

In studying Moche portraits, I became intrigued with the possibility of finding portraits of individuals that had been made at different times in their lives, but I wondered how they could be identified.[5] The difficulty is that an individual's appearance changes significantly as he grows older, and a portrait of someone in his youth may have little resemblance to a portrait of that person years later. It occurred to me, however, that facial scars might provide a key—if an individual acquired distinctive facial scars in his youth, and these scars were consistently shown in his portraits, they could be used to identify portraits of him at any later age. With this possibility in mind, I began to search for portraits of individuals with distinctive facial scars.

One individual who has such scars is shown in figure 5. It is fortunate that there are forty-six portraits of him in our sample—the largest number for any individual. Key to his identification is a distinctive scar on the left side of his upper lip. In many of his portraits, this scar consists of two short, slightly converging lines that in some portraits actually merge to form a wishbone shape. Most of his portraits also exhibit two short parallel scars above the right side of his upper lip; some display another short scar there as well. I have named him Cut Lip.

There is no way to determine the precise age of an individual in any Moche portrait. Even estimates are clearly subjective and cannot be verified. Nevertheless, in the discussion that follows, I have suggested Cut Lip's age in each of his portraits, based on the judgments of various people who were asked to arrange photographs of his portraits in sequence from youngest to oldest and assign an age to each. There were some discrepancies in the way people sequenced the portraits and in the ages they assigned to them, but there was considerable consensus in selecting the youngest and oldest portraits, and the overall sequence and approximate ages were similar.

Figure 5 illustrates what appears to be the youngest portrait of Cut Lip. It portrays him as a boy, at perhaps ten years of age. Several images in the sample show him somewhat older, perhaps in his mid-teens, and three others show him in his late teens.

Four portraits show Cut Lip in what may be his early twenties (fig. 6), several more in his mid-twenties, and some in his late twenties. Two portraits also show him in his early thirties. But by far, the greatest number of Cut Lip's portraits depict him in what appears to be his mid-thirties (fig. 7). Since the apparent earliest portrait shows Cut Lip at about age ten, his status was probably inherited rather than acquired; it is unlikely that he could have done anything at such a young age to earn a position of importance in Moche society. It is much more likely that he was ascribed high status in his youth by being part of an elite family. Only later, as he matured into adulthood, would he have assumed important roles.

In many of his portraits Cut Lip wears a tapestry band wrapped around his head. The amount and type of elaboration on the band varies considerably, but the decoration does not become more complex as he ages.

In contrast, the use of ear ornaments does appear to correlate with age. None of the younger portraits—those showing him before his early thirties—have ear ornaments. Yet nearly all portraits of him in his thirties portray him with ear ornaments or with large holes in his earlobes from which ornaments had been removed. Perhaps he did not wear ear ornaments until he was in his thirties.

The use of face paint also appears to correlate with age. None of the portraits of him younger than his early twenties has face paint. From then until his mid-twenties, however, an increasing percentage of portraits show him with red cheek-stripes, and nearly all of his later portraits show him with this type of face paint. Organic black designs painted on his face and neck do not occur on portraits of him until his mid-thirties (fig. 7).

The portraits of Cut Lip probably showed his appearance at the time that each portrait was made. We cannot eliminate the possibility, however, that the portraits of him in his youth were produced when he was considerably older. Still, it is noteworthy that the scar on the left side of his upper lip changes between his earlier and later portraits. All portraits showing him younger than thirty depict the scar with a distinctive wishbone shape, while nearly all showing him after that age depict the scar as two unconnected lines. Part of his scar may have faded over time, thus eventually making it appear as two separate lines. This would imply that his portraits were indeed made as he aged.

We do not know how many other Moche individuals had their portraits made at different stages of their lives. Unusual factors have enabled us to identify portraits of Cut Lip at different ages: he had distinctive facial scars that are shown clearly and consistently, and he acquired these scars early in his life. Without these scars, it would not have been possible to demonstrate conclusively that the youthful portraits were of the same person as the portraits done later in life. This suggests the interesting possibility that some portraits of youths in our sample may be of individuals for whom we also have adult portraits.

Another factor helping us identify portraits of Cut Lip at various ages is that many portraits of him have survived and are available for study. The greater the number of portraits of an individual, the higher the probability that the portraits will show him at different ages.

Observations and Conclusions

It is important to consider how our perception of Moche portrait head vessels is affected by the nature of our sample. Only a small fraction of the portraits that were produced are in museums and private collections today. Most of them were probably broken through

use, and relatively few were put in graves as funerary offerings. Of those that were put in burials, many have been destroyed during looting. Others are undoubtedly in graves that have not yet been excavated.

Perhaps the best evidence of the relatively small size of the existing sample comes from the nature of portrait head production. If only one or two portraits of an individual were to have been produced, it would have been much more efficient simply to hand-model them. Yet highly skilled potters invested considerable time and effort making the mold matrices, and additional time and materials in producing the molds. This would have been warranted only if many copies of the portrait vessel were to be produced. Of the more than 750 distinct individuals included in the sample, however, most are represented by only one portrait. The greatest number of portraits that appear to have come from the same mold is six. Moreover, the sample includes thirteen molds for making portrait head vessels, but only one can be matched with a vessel that was produced in it. The other twelve must have been used to produce many portrait head vessels, but not one example has been located. Clearly, our sample includes only a tiny fraction of the portraits that the Moche produced.

One of the greatest limitations of our sample is the general lack of provenance data. Most of the portrait vessels came from plundered graves; we seldom know even which valley the vessels are from. Without more information on provenance, we are limited in the ability to reconstruct the production and distribution of Moche portraits or to understand how and where distinct portrait styles developed. If sets of portraits could be connected to specific sites, relationships between contemporaneous styles could then be reconstructed and an assessment made of their impact on the development of Moche portraits through time.

Even more could be achieved if the vessels were from archaeologically excavated burials, where the age and sex of the individuals, as well as the full inventory of associated materials, could be documented. Hopefully, such vessels and their associated data will become available for future research.

The existing sample of portrait vessels could potentially provide valuable information through chemical and geological analysis of clays. It would be particularly interesting to know whether the portraits of specific individuals were made of the same clays and whether distinct clays can help determine workshops, or even valleys, in which the portraits were produced.

Nearly everyone who has seen Moche portrait vessels has wondered why the Moche produced them and how these portraits functioned in their society. These questions are not answerable with currently available evidence, but some clues do exist. First, the fact that the portraits were made in molds strongly suggests that they were to be produced in great numbers. When we examine multiple portraits of the same individual that appear to have been made in the same mold, it is often evident that they were produced by more than one potter and painter. This suggests that multiple potters and painters were working together, perhaps in the same workshop, and sharing the available molds.

All this leads us to wonder how these potters and painters were supported, and how the portraits were distributed and used. An important piece of evidence comes from an observation by Rafael Larco, who lived for many years on the north coast of Peru and developed an extraordinary collection of Moche ceramics. He noted that portraits of the same individual could be found at different Moche sites in the same valley and in some instances even in a different valley.[6]

All of the portraits of an individual may have been produced in one locale, and subsequently distributed elsewhere. A plausible explanation for this would be that the potters and painters were supported by the important individuals whose portraits they were producing, and that the portraits were then distributed to other powerful people in order to cement allegiances or demonstrate relationships. Those who received the portraits, whether living

at other sites in the same valley or living in different valleys, would then have a tangible and recognizable object to document their affiliation with the individual whose portrait they possessed.

Alternative scenarios are also possible. Since the portrait molds were produced on mold matrices, multiple molds may have been made for distribution to ceramic workshops in different locations. Portraits of the same individual could then have been made in various workshops, including some that were far apart. If this were the case, however, the distribution of the molds to separate workshops is still likely to have been governed by social and political allegiances, and the possession of portrait vessels may still have been a means of demonstrating affiliation to the person depicted in the portrait.

The evidence of wear and breakage on portrait vessels indicates that they were in active use, presumably in the places where they were distributed. How they ultimately were chosen to be included in someone's grave is impossible to reconstruct on the basis of the information available today. It is clear, however, that the portraits often ended up far from their place of production, or at least in locations different from where the original mold matrix was made.

Curiously, the Moche suddenly stopped producing realistic portraits about A.D. 600, and during the last phase of their civilization they made only generic human-head representations. The sudden loss of realism has interesting parallels with other aspects of Moche art. During the early phases of Moche culture, the predominant subjects in their art were supernatural figures, supernatural activities, and animals. Later, this began to shift to a greater emphasis on human figures and activities. This emphasis peaked at the same time that the greatest quantity and quality of realistic human portraits were produced. At that time, the art focused heavily on the activities of high-status adult males: deer hunting, Ritual Running, ceremonial combat, and the parading and sacrificing of prisoners were among the most frequently depicted activities. When portrait production ended, the predominant focus of Moche art suddenly returned to supernatural figures and activities.[7] This strongly implies that the development of Moche portraiture was closely linked to the emphasis on depiction of high-status males.

The cause of this sudden shift is not clear, but it correlates with other indications of a severe disruption of Moche culture. The Moche suddenly abandoned major settlements that had been occupied for centuries, and they established new centers of power. It has been proposed that a severe and prolonged drought, occurring between A.D. 562 and 594, played a major role in the disruption.[8]

Whatever the cause, Moche art was clearly not immune to the turbulent upheaval within the Moche world that marks this time period. The sudden decrease in representations of high-status adult male activities, along with the sudden end of realistic portraits, strongly indicates a fundamental change in Moche society and in the function of Moche art. The focus on high-status adult males, which had been continually increasing for centuries, suddenly turned away from this evolutionary trajectory. The fact that both portraiture and the overall subject matter of Moche art reverted to what it had been earlier suggests that an archaistic revival was involved—perhaps a deliberate attempt to return to what had worked in earlier times.

The causes of archaistic revivals have been many and varied in human societies, but they generally involve dissatisfaction with present conditions and a longing to recapture the better conditions of a previous time. As more evidence is available, it will be interesting to try to reconstruct the circumstances responsible for the end of portraiture in Moche society. Meanwhile, we are left with a fascinating corpus of portraits whose artistic and technological quality rank them among the most remarkable of the ancient world.

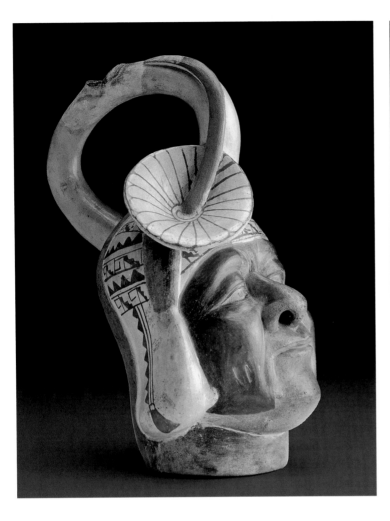

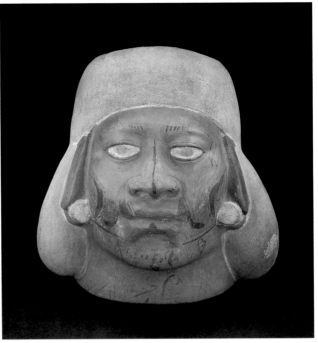

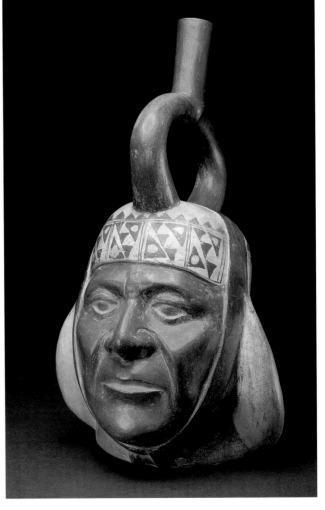

1 *Man with a Flower Headdress*

Unidentified artist (Peruvian, Moche culture)

Painted earthenware, 26 cm (10¼ in.) height, A.D. 100–600
The Art Institute of Chicago, Illinois

2 *Portrait Jar of Man with Scarred Lip*

Unidentified artist (Peruvian, Moche culture)

Painted earthenware, 15 cm (5⅞ in.) height, A.D. 100–600
The Art Institute of Chicago, Illinois

3 *Stirrup Head Vessel*

Unidentified artist (Peruvian, Moche culture)

Painted earthenware, 30 cm (11¹³⁄₁₆ in.) height, A.D. 100–600
The Art Institute of Chicago, Illinois; Buckingham Fund

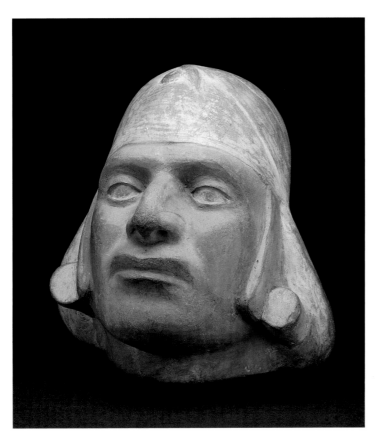 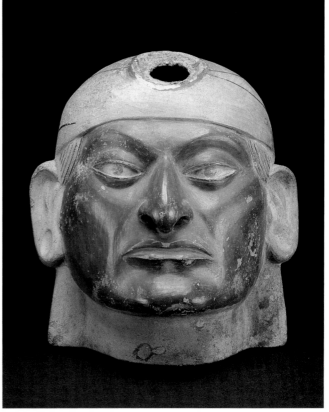

4 *Male Effigy Vessel*

Unidentified artist (Peruvian, Moche culture)

Painted earthenware, 24 cm (9⁷⁄₁₆ in.) height, A.D. 100–600
The Art Institute of Chicago, Illinois; gift of Nathan Cummings

5 *Male Effigy Vessel* (stirrup missing)

Unidentified artist (Peruvian, Moche culture)

Painted earthenware, 10.5 cm (4⅛ in.) height, A.D. 100–600
The Art Institute of Chicago, Illinois; Buckingham Fund

The Moche people of the north coast of Peru were outstanding ceramists and among the earliest portrait-makers in the Americas. Most Moche portraits were integrated into mold-made ceramic stirrup-spout vessels, usually no taller than thirty centimeters. Often they were produced in multiples and distributed over wide distances. In some cases, portraits show the same individual at different ages. Archaeologist Christopher Donnan, an authority on Moche portraits, has stated that Moche potters "excelled at rendering facial features accurately, and did so with such skill that the portraits often provide a sense of the individual's personality."

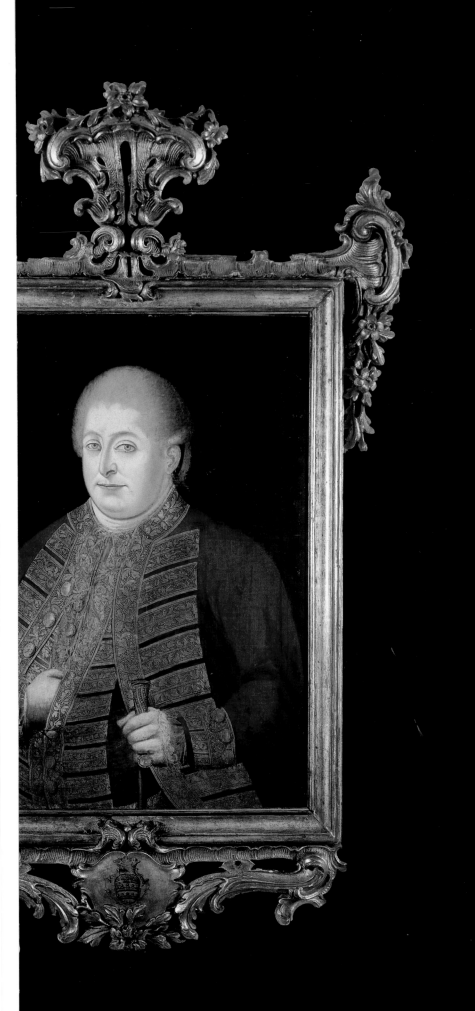

PORTRAITURE DURING THE VICEREGAL ERA (1492–1810)

III *Portraiture in Viceregal America*

Portraiture is one of the least explored areas in the study of art from Latin America's vice-regal period, despite the hundreds of portraits still displayed in numerous museums and private collections, and indeed, in the religious or civil institutions for which they were originally commissioned.[1] This general disdain may well be derived from the incomprehension with which these works are often judged today. They tend to be evaluated from a standpoint of the predominance of the psychological portrait, which, in addition to a physical likeness, demands the depiction of the most intimate characteristics of the sitter's personality. This is difficult to find in the majority of these works, which were intended to fulfill other important functions and were the product of a Hispanic society in which good manners and etiquette required emotions to be contained and movements to be solemn and deliberate.

In the Spanish pictorial culture of the time, the portrait was considered a minor genre, compared with what was known as history painting, which included the narration of events deriving prestige from religion, or classical or contemporary history.[2] The great theoreticians of history painting gave judgments that in most cases were quite ambiguous. On the one hand, they considered portrait painting a proper activity for artists lacking the necessary wit to produce more elaborate compositions, while on the other hand, they praised those magnificent portraits in which fiction outdid nature. Praising the vanity of the clients was a good means for portraitists to obtain an economic return, but it did not help to reinforce the concept of the painter as someone more involved in resolving intellectual questions than in earning money by practicing a craft. Artists themselves also believed that the demands of a capricious clientele could hinder the work of a good painter and cause him "very great fatigue"; the client's expectations would never be satisfied, owing to his ignorance of art rather than to any real defects in the portrait.[3]

This supremacy of narrative, and particularly religious themes, was conveyed from the first moment the Spanish landed in America, where the importance of the evangelization process accentuated still further an interest in matters always heavy with symbolic content. This is the context in which to situate the accusations made in the second half of the sixteenth century against a painter of Flemish origin living in New Spain, where he had arrived in 1566 in the entourage of Viceroy Gastón de Peralta. Simón Pereyns was born in Antwerp and had passed through Lisbon, Toledo, and Madrid. A skilled portrait painter familiar with the best artists of Philip II, he had received permission to reproduce the likenesses of the king and other members of the royal family. Two years after arriving in New Spain, the Inquisition subjected him to an inquiry at which one of his principal accusers, the painter Francisco de Morales, claimed that Pereyns had commented that his father, back in Antwerp, was delighted to hear that the artist had devoted himself "to painting portraits

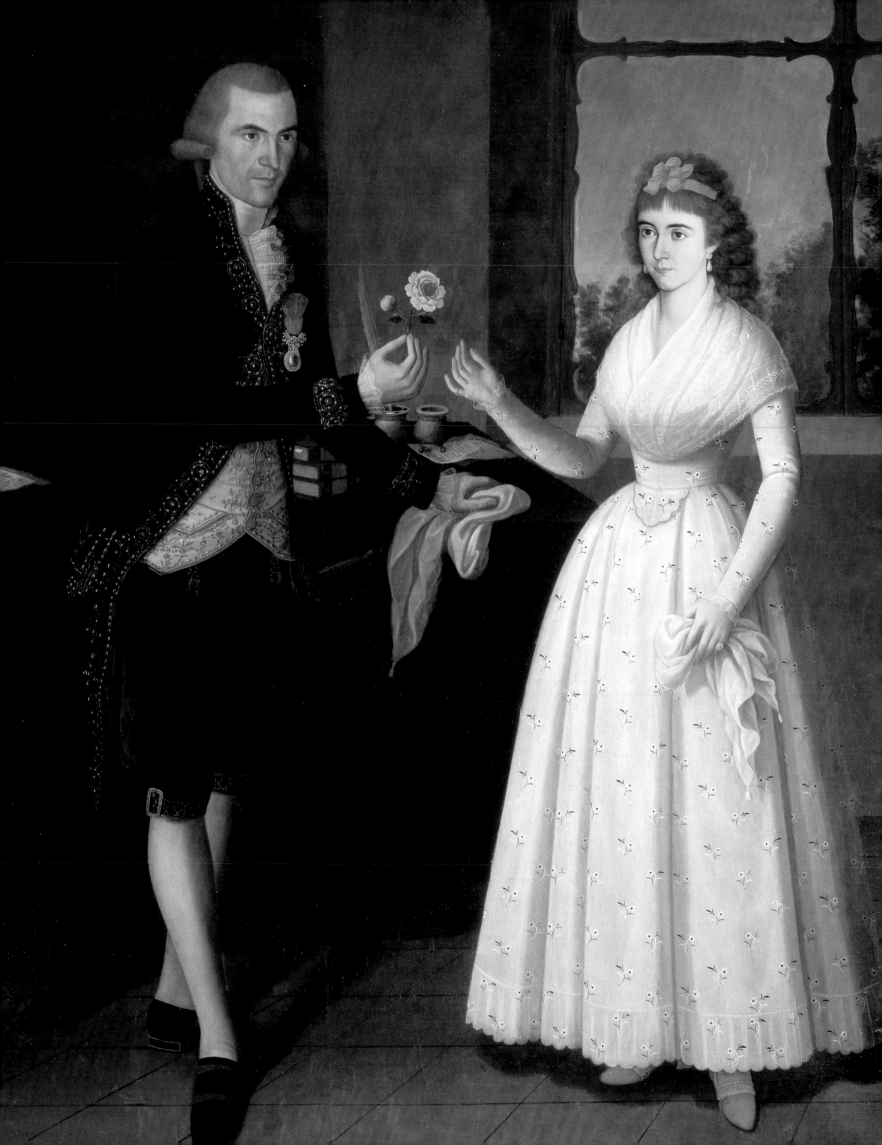

and not saints." In Morales's opinion, this was a clear indication that Pereyns was a Lutheran, and thus a heretic.[4] Pereyns's artistic curriculum, and the declarations of his witnesses, reveal him as an important painter—the best in New Spain according to some of them—basically occupied in painting religious and historical subjects, but also skilled at portraiture.

During this period, portrait painting was dignified basically by the exemplary nature of the sitter. Consequently, the person portrayed must be adorned with virtues worthy of imitation, while at the same time be depicted as someone with power. That power should be reflected in the beauty of their features and the proportion of their bodies. Ideal beauty was associated inevitably with goodness. Thus, those very commentators who require a likeness to the model as a basic feature of the portrait have no hesitation in suggesting that a realism stressing the physical imperfections of the person can—and should—be surpassed by the artist's skill in evoking the dignity of the sitter.[5] In real life, an abuse of this embellishment, sometimes also justified by a desire to present a favorable image for matrimonial purposes between persons whose only acquaintance with each other was through portraits, could on occasion produce disillusionment. This was the case of Maria Antonia of Naples on coming face-to-face with the future Ferdinand VII, whom she was to marry: "I stepped out of the carriage and saw the Prince: I thought I'd faint. In the portrait he looked more tending to ugly than handsome; well, compared to the original, he's an Adonis."[6]

In the context of the Spanish monarchy of the sixteenth and seventeenth centuries, to which belonged all the regions making up the great viceroyalties of New Spain and Peru, piety was undoubtedly the principal moral virtue expected to adorn the person depicted. Therefore, the first to show themselves as pious men, prostrated before sacred images, are the kings themselves. To Simón Pereyns, mentioned above, is attributed a panel painted in Mexico in which Charles V and Philip II appear with their respective wives, Isabel of Portugal and Mariana of Austria, in the lower-right-hand corner of a composition dedicated to Our Lady of the Rosary; on the left are a pope, an archbishop, a cardinal, and a Dominican saint (main altarpiece of the Church of the Convent of Yanhuitlán, Oaxaca, Mexico). All the figures have their hands together and direct their gaze toward the Virgin and child, following the traditional formula for a donor's portrait, which throughout Europe marked the start of representing individuals who could be identified from their features and from elements alluding to their status.[7]

Nevertheless, as Javier Portús has pointed out, "The intromission of a donor in the religious space does not exactly constitute an act of humility (even when appearing kneeling and, in many cases, of a smaller size than the main subject), but rather is a proof of his or her power."[8] Indeed, the persons depicted in these positions do not intend to be overlooked, as they wish to be clearly identified by their contemporaries. A proof of this is that gradually their bodies are turned toward the viewer, until they face him or her completely and turn their back to the sacred image. In this way, they lose the sense of submission, although they maintain the attitude of prayer. These displays of piety are directed both at contemporaries and at posterity, assisted by the inclusion of legends specifying the name of the benefactor. In the early seventeenth century, Hernán Cortés himself was portrayed in this praying position, in a painting attributed to Alonso Vázquez and created for the Church of the Hospital de Jesús in Mexico City (fig. 1). On this occasion, the conquistador is dressed in armor and contemplates an impressive depiction of the martyrdom of Saint Hippolytus, which is heavy with symbolic significance relating to a historical event: the taking of Mexico-Tenochtitlan coincides with the festival of the saint, who was chosen to be its patron.[9]

In that society impregnated with religious sentiment, both popular and official, relationships between mortals and the celestial court were established by means of a constant

Fig. 1 *El martirio de San Hipólito* attributed to Alonso Vázquez. Oil on canvas, c. 1605–7. Museo Nacional de Historia, CONACULTA-INBA, Mexico, D.F.

dialogue, in which the individual was seeking the permanent support of powers beyond his control. This individual or collective protection would be sought through offerings and donations. Therefore, it is not surprising that those who possessed the necessary economic resources had themselves portrayed as protectors of the Church—building churches, contributing to their decoration, or founding convents, brotherhoods, etc.—and also as beneficiaries of this divine patronage.

The identification of such persons does not rest exclusively on their facial features, of ephemeral duration in their relatives' memory, but on a series of elements in which dress occupies a prominent position. Clothing provides a great deal of information on the sitter's status, even when the figure is presented only as a bust. On many occasions the portrayal of the dress and hairstyle of the sitter allows us to decide whether he or she is a member of the native nobility incorporated into the structure of viceregal society, a *mestizo* (person of mixed blood), a *criollo* (person of Spanish ancestry born in the Indies), or a Spaniard. The continuing use of certain items of clothing and hairstyles of Prehispanic origin, with natural transformations owing to the incorporation of European fabrics, textile techniques, and ornamental models, served as a clear sign of the sitter's identity.[10]

In the mid-eighteenth century, an artist from Cuzco, Marcos Zapata or someone working close to him, produced one of the most interesting series of paintings of this type for the Church of El Triunfo, attached to Cuzco Cathedral. The large canvases show various

Fig. 2 *La Virgen del Sunturhuasi* by the circle of Marcos Zapata. Oil on linen, mid-eighteenth century. Templo del Triunfo, Cuzco, Peru

episodes from the life of Christ, and particularly the miraculous apparition of the Virgin in the Sunturhuasi (fig. 2). A large area of this canvas is reserved for the figures of the donors who, viewed from the perspective of the faithful, acquire a degree of prominence unknown in most of the examples identified. The members of the native nobility who paid for this decoration occupy almost half of the lower part of the picture, the most visible area because of the considerable height at which the works are displayed. There we see them in the traditional position, kneeling and holding candles, the men to the left and the women to the right. They are all dressed and adorned with elements adapted to the interests of the group during the first half of the eighteenth century, while at the same time carrying the traditional symbols of power inherited from the Inca world. Particularly prominent are the *llautu* and the *mascapaycha*—which make up the headdress—items originally reserved for the Inca himself but extended to the other Inca nobility during the viceregal period.[11] It should be remembered that these works permit the visualization of native religious patronage, which not only served as a means of social and political integration but also contributes to our understanding of the development of society in viceregal times. Therefore, the appearance of native donors in religious compositions is a constant to all the viceroyalties throughout this period.[12]

To achieve contact with the heavenly world, pious and powerful men claimed also equality with the saints by making up the "sacred conversations"—compositions in which several saints (men and women of different periods) surrounded the sacred images. And just as these saints are accompanied by objects allowing them to be identified—the well-known "speaking symbols"—the devotees are individualized by means of a series of elements alluding to them symbolically, and in many cases to their family lineage. The representation of contemporary figures as saints and devotees is considered to be within the bounds of common practice in portraiture by the dictionaries of the period. Documents often employ the word "portrait" when referring to a visual representation of these images, with the explanation *"verdadero retrato"* (true portrait) for the reproduction of both sacred images and a great diversity of individuals living or dead.[13]

The reuse of religious iconographic models in these works gave origin to a type of painting accepted by the Church only on rare occasions and in very special circumstances: the so-called *retrato a lo divino*. This term, derived from a Central European tradition, describes compositions in which a well-known contemporary person lends his or her face to serve as an image of the holy figures, saints, or those participating in scenes relating to their lives and miracles. The monarchs and members of the royal family are the main protagonists of this type of painting, but this practice must have more common than we often imagine, given the reiteration of ecclesiastical prohibitions of all such styles that "updated" the saints by dressing them according to the current fashion and giving them recognizable faces.

Clearly the acceptance of the divine origin of the power transmitted to kings justified the use of this formula. Nothing could be said against Emperor Charles V being represented as Saint Sebastian, Queen Margarita as her saint namesake, and Juana, Princess of Portugal, as the Virgin of Peace, or against Queen Margarita and the Infanta Ana being models for, respectively, the Virgin and the angel of the Annunciation. Equally, we find numerous members of the royal family playing active roles in the nativity of the Virgin and the nativity of Christ in a work by Pantoja de la Cruz painted at the wish of the wife of Philip III. For a painting for her private oratory in the Royal Palace at Valladolid, the same queen wished her mother, Mary of Bavaria, and her daughters, Leonor and Catalina Renata, to appear as midwives of the Virgin, while she, along with her husband and her brothers, are seen as shepherds coming to adore the infant Jesus.[14] However, the situation

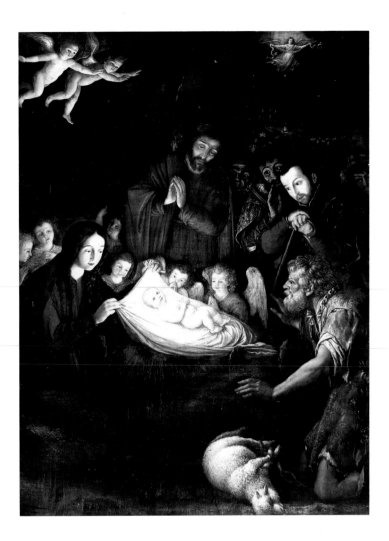

Fig. 3 *Adoración de los pastores* by Pedro García Ferrer. Oil on linen, c. 1646–49. Retablo de los Reyes, Catedral, Puebla, Mexico

changed for those such as the judge Juan Maldonado de Paz, who in Santiago de Guatamala had Francisco de Montúfar paint him as Saint John the Baptist, with his children representing Saint Stephen and Saint Lucy, all of whom appear around the Virgin. In a document found by Mexican researchers Jaime Morera and Nuria Salazar, a canon of the cathedral and chaplain to the holy office made an accusation against Maldonado based on this painting, which was familiar to many because of its exhibition at religious festivals, both inside churches and in processions, particularly that of Corpus Christi.[15] The work of Montúfar dates from approximately 1613, and those of Pantoja de la Cruz are situated between 1603 and 1615.

Probably many of the figures that look to the viewer in religious paintings have the same intent. Such figures have usually been considered self-portraits of the artists themselves.[16] But even accepting this possibility, in many cases we find a contemporary person—the painter or someone else—portrayed *a lo divino,* for example, one of the apostles present at the descent of the Holy Spirit in Pentecost (Church of La Profesa, Mexico City) or taking part in the Last Supper (Cathedral of Texcoco, Mexico State, Mexico). The artist, Baltasar de Echave Orio, also produced both of these works in the first decades of the seventeenth century. Similarly, Pedro García Ferrer (1600–1660), an artist who was closely linked to Archbishop Juan Palafox, introduced the prelate into the *Adoration of the Shepherds* (fig. 3), just as we have seen Philip III and some of his family appear. Similar comments could be made on works such as *The Imposition of the Chasuble on Saint Ildefonso* (Church of Santo

Domingo, Mexico, D.F.), attributed to Alonso López de Herrera, a Spanish artist living in New Spain. In this painting we can see an elderly lady kneeling and holding a candle, facing the viewer and appearing almost detached from the events she is witnessing. For many years, this was presumed to be a portrait of the donor,[17] although in reality many examples of this subject in seventeenth-century Spanish painting include this figure as being present at the miracle in Toledo Cathedral (in other words, as an integral part of the iconographic description of the event).[18] Nevertheless, the strong personality of the face and the placement of the figure induce us to think of a portrait *a lo divino,* in which the pious donor also wished to be present as a witness to the miraculous apparition, as occurred with the preceding examples.

Generally, a woman had no other reason to have herself portrayed than for the demonstration of her piety, shared in most cases with her husband. Barred from undertaking functions that could attract the recognition of merits valued by society, women were expected to pass through life as a kind of invisible package, described by moralists by means of negations. "A woman smells well when she smells of nothing," recalled Luis Vives in 1524.[19] Arias Gonzalo and Antonio de León Pinelo, in the first half of the seventeenth century, defended the use of the farthingale and the veil, which were prohibited even by royal orders, because they obstructed women's movements—"in this way they will walk little and not run,"[20]—and prevented them "from seeing and being seen." León Pinelo used the authority of testimonies from antiquity to declare, "Who would dare (says Tertulian) to attack, or to harass with his eyes, a covered face, a face that does not feel; a face that could be called sad? Any evil thought is broken, or fades away at the gravity and severity of the veil."[21] Only when a woman entered into religion did she fulfill a specific role, and indeed portraits of nuns, almost always commemorating the day of their profession, are the most numerous, particularly in the viceregal period of New Spain (see Kirsten Hammer's essay).[22]

Nevertheless, during the eighteenth century, and particularly in the second half of that century, innumerable portraits of women were painted. In them, the sitter appears alone or accompanied by her small children, but her solitude no longer situates her outside of society. On the contrary, now she must be accompanied by all the elements defining her as a member of an important family—great coats-of-arms, full biographical notices, grand surroundings (on a scale that in no way corresponded to reality), and other features that proclaim wealth and nobility: a profusion of jewels, luxurious dresses, and elaborate hairstyles. These works clearly show that women had acquired undeniable social prominence: by now, in addition to seeing, they wanted to be seen, and with objects indicating their personal tastes or their refined education in the practice of music or the art of drawing.

A painting summarizing much of these traits is preserved at the Torre Tagle Palace in Lima—*Doña María Josefa de Isásaga Muxica y Guevara, Arrue y Vázquez de Acuña, Señora de Sajuela y de la Casa de Isásaga, de la de Muxica y Guevara y de la de Arrue, Marquesa de Torre Tagle, y Co-patrona de la Obra Pía de Dotes como Mayorazgo de la Casa y Familia de Francia,* painted around 1745. Born in 1727, Doña María Josefa was the wife of the second marquis de Torre Tagle, whom she married at the age of sixteen. In reality, the young marchioness is depicted virtually as an infanta of Spain, in a spectacular interior with red curtains that cover a large part of the space, but reveal a French garden at the rear, two pilasters on a high base, and, above them, the family crest. The figure of Doña María Josefa is at the center of the composition, with the rigidity of her grandiose costume and a certain lack of proportion between the head and the rest of the body leading us to suspect that the latter was in fact a mannequin, a resource often employed by artists in order to complete their works without subjecting their clients to repeated sittings.

Fig. 4 *Retrato de su esposa* by Francisco Eduardo Tresguerras. Oil on canvas, 1797. Museo Nacional de Historia, CONACULTA-INBA, Mexico, D.F.

As a companion to this painting we could take *Doña María de los Dolores Martínez de Carvajal* (see p. 105), the wife of Captain Ramón Carvajal of the Fixed Infantry Regiment of Puerto Rico, a work painted around 1792 by the Puerto Rican artist José Campeche (1751–1809). A disciple of the Spaniard Luis Paret during the years when he was banished to the island, Campeche became a magnificent painter of women, the most celebrated in the whole of Hispanic America.[23] We have here a formal portrait, but in this case it is accompanied by an air of verisimilitude clearly lacking in Doña María Josefa's portrait. Doña María Dolores is at the center of a room with perfectly integrated rococo furnishings, doubtless an artifice that Campeche created to convey greater dignity to his subject. He also surrounded her with fashionable features, including her costume and particularly her oversized hairstyle, surmounted by an even more abundant hat overflowing with feathers, ribbons, and flowers. Campeche has not renounced certain conventional elements, such as the inevitable curtain (considerably reduced in its spread), but he has introduced a clavichord alluding to the sitter's musical tastes, tastes that might be as unreal as the instrument itself, since the artist has reproduced it with evident defects.

The differences between the two works refer not only to the manner of treating the person portrayed, but also more particularly to the way in which the physical space in which the figure is situated has been re-created. Campeche's women are still social models, but now they are more identified with social practices: musical soirées, as suggested in this work, or horse races, as shown in the magnificent portraits of female riders that he painted on several occasions (pl. 27 and p. 108).[24] The New Spanish artist Francisco Eduardo Tresguerras (1759–1833) offers an ideal counterpoint to these works: the portrait of his wife, María Guadalupe Ramírez, painted in 1797 (fig. 4). At last the sitter appears as what she is, a nineteen-year-old housewife, who, by the fiction of art, has been "surprised" in a moment of her daily life. The painting illustrates a total economy of symbolic or complementary elements: there is no furniture intended to create an atmosphere of luxury, or even of well-being, and the sitter's clothes are perfectly appropriate to the function she is supposedly undertaking when preparing to leave the room.[25]

Meanwhile, over these three centuries, the fathers, brothers, husbands, and sons of these women continued to be portrayed as celebrated men of law, pious and all-powerful clerics, valiant sea captains, just governors, and fortunate ennobled merchants and miners, when personal enrichment had replaced other moral values of service to the republic: that is to say, as active and meritorious members of society. Consequently, the images of men maintain a consistency for much longer; only the eruption of Bourbon fashions in the early eighteenth century broke the monotony of the color and the stiffness of the bodies.

Among the magnificent portraits by Juan Rodríguez Juárez (1675–1728), probably the best portrait painter of the viceregal era in New Spain, two examples of outstanding quality should be mentioned. The first is of Juan Escalante Colombres de Mendoza (pl. 11), signed and dated by the artist in 1697. It is arranged in the same manner, with some variations in the items surrounding the sitter, as Alonso López de Herrera's portrait of Fray García Guerra (pl. 10), painted some ninety years earlier: the judge is standing, turning slightly to his right, which allows him to rest his hand on a table covered with a velvet cloth, on which appear objects closely linked to his activity as a judge, first in the Real Audiencia of Santa Fe and later in the Real Cancillería of New Spain. Also close to him is a curtain (in the same place and almost of the same size), coat-of-arms, and biographical text. Fourteen or fifteen years later, Rodríguez Juárez would paint a portrait of the viceroy, the duke of Linares (Museo Nacional de Arte, Mexico), wearing a Bourbon wig and dressed in the French manner, as required by the new etiquette. However, there again is the table, now

Fig. 5 *El Virrey Conde de Superunda* by Cristóbal Lozano. Oil on canvas, 1746. Museo de América, Madrid, Spain

bare to reveal its baroque shape, the curtain, the column, the coat-of-arms, the sign with biographical details, even the same posture of the figure, who is also holding his gloves in his left hand, as Fray García had done: the former with a firmness revealed in his expression, the latter with a certain gentleness also transmitted by his languid expression. Fray García, who was an archbishop, is wearing a Dominican habit; Don Juan Escalante is in black with a ruff—as was the usual attire among lawyers and numerous royal officials, who adopted it as befitting their dignity, unlike the newer fashions.

As the eighteenth century advanced, portraits of viceroys and governors acquired greater complexity, abandoning the impersonal setting of offices for scenes describing their most important achievements. In 1746, the viceroy, the count of Superunda, was portrayed on horseback in the open air, on the outskirts of Lima (fig. 5). This was a novelty in the eighteenth century, for not until 1796 do we again find an equestrian portrait of a viceroy, this time the count of Gálvez by Fray Pablo de Jesús (Museo Nacional de Historia, Mexico, D.F.). In 1746 the idealized city of Lima, in the background, suffered the destructive effects of a serious earthquake that devastated the port of Callao. Manso de Velasco set about the rebuilding for which, two years later, he received the title of count of Superunda, in a clear allusion to his dominion over nature. The artist of this portrait was Cristóbal Lozano, who painted several portraits of this viceroy, as well as other members of Lima's elite (see pl. 12).[26]

These portraits—and hundreds of similar works making up numerous series of founders, rectors, bishops, archbishops, members of brotherhoods and of councils, presidents of *audiencias,* and viceroys, among many others—were destined to configure the historical memory of these institutions to which they gave continuity and, consequently, to define local memories. In a certain sense, they form galleries of illustrious men who in the vice-regal era were of great importance, being considered not only models for emulation but also, once again, vehicles for incorporating the native nobility into the new society. Thus, the members of the republic of Tlaxcala, great allies of Hernán Cortés in the conquest of the Aztec empire, had portraits painted to make up dynastic genealogies providing evidence of the privileges they acquired at the very beginning of the kingdom.[27] The Curacas of Cuzco reaffirmed their role as heirs of the Inca tradition within the structures created by the colonial power.[28]

These portraits generally maintain the well-known conventions: identification is achieved not by detailed, expressive facial features, but rather by items permitting the spectator to recognize the person's place in society. Once again, the clothing is a fundamental element. The coat-of-arms is also essential, as it displays both the ancestry of the indigenous community as well as something more important: that this lineage, sometimes reworked without total historical precision, guarantees the maintenance of privileges recognized by the colonial power.[29] Don Nicolás de San Luis Montañés (Museo Regional de Querétaro, Mexico) was immortalized by his portrait given in 1807 to the Colegio de Propaganda Fide by one of his descendants, Ignacio Montañés. The inscription informs us that General Nicolás was an *indio cacique* (an Indian chief) and "Lord of Tula," an ally of the Spaniards and responsible for the victory of the Christian army in the battle of June 25, 1531, against the "barbarian Indians of the Chichimeca nation," for which purpose he received the support of the Apostle Santiago (Saint James the Great). The artist shows the general dressed entirely in the Spanish manner, in the fashion of the sixteenth century—wearing armor and the white cloak of the Order of Santiago and holding a general's baton. A helmet on the table emphasizes the sitter's military character, while in the background through a window, the hard-fought battle is relived with the miraculous apparitions of Saint James and of the cross.[30] The Museo Inka of Cuzco contains the portrait of Don Marcos Chiquathopa, a member of the Cuzco elite, as a descendant of the third Inca, "a Catholic gentleman by the grace of God," and *alférez real,* who received numerous privileges from the Spanish Crown, as detailed in the inscription. He also is dressed in the Spanish manner, although in the fashion of the second half of the seventeenth century, with a ruff and cut sleeves revealing the lacework on the shirt and on the end of the stockings. Don Marcos is also portrayed with the *llautu* and the *mascapaycha,* Incan symbols of nobility.[31]

In most of these works, the family memory and the historical memory are linked to convey a clear aim of propaganda, sustained by these sitters' exemplary nature. The models emanate clearly from the key figure of the king, who, as moralists constantly reiterated through the literature devoted to the education of princes, should be the personification of those virtues—such as piety and prudence—that lead to good government and inspire the people.[32] To belong, really or allegorically, to one of the most respected lineages was an inevitable aspiration of all these individuals, as they based their rights and privileges on the authority of antiquity. Therefore, the portraits, faithful to the features of the sitter or idealized by distance, respect, or simply the artist's lack of skill, are veritable declarations of the principles of the society in which they are created.

Throughout the viceregal period, the Spanish kings were represented in America by their viceroys, habitually known as the alter ego of the king. However, in no case did their

portraits replace that of the monarch, which appeared at all types of public events, on official premises, and even on private ones, presiding over rooms where hosts and their guests could respectfully renew their fidelity for a great variety of motives. The much-repeated maxim that "God is in heaven, the king is far away, and I am here," with which local authorities justified the need to act freely in many governmental matters because of their knowledge of the local situation, is a clear expression of an unquestionable fact.

The kings were indeed very far away, and both they and their political structure were aware of this. Therefore, different strategies of proximity were devised in which the portrait played a fundamental role. The most interesting of these strategies gave rise to the series of pictures—on one canvas or several—in which the Incas and the Spanish monarchs formed a single dynastic line. All of these portraits were evidently derived from previous images (engravings, coins, medals, and paintings circulating on a permanent basis), which in the case of the Incas had no known origin.[33] The most frequently repeated model reproduced a print of Alonso de la Cueva of around 1725. The print was transferred to canvas on several occasions, with inscriptions in which the Emperor Charles V appears as the "rey XV del Peru," followed by all his descendants until Philip V "rey XXII del Peru" (Convento de San Francisco, Ayacucho), or even until Ferdinand VII (Beaterio de Copacabana, Lima).[34] The Spanish monarchs, like other European rulers, based their possession of the different kingdoms making up their crown by claiming dynastic rights that continually had to be defended against other claimants. Thus, incorporating the kingdom of Peru into the Habsburg dynasty through complex symbolism was an undertaking of great significance.

Finally, let us examine works in which an attempt is made to give an image (thus assuming its real existence) to the member of an alien cultural world, so commencing the complex process of incorporation into a shared history. In the spring of 1519, Hernán Cortés arrived on the coast of Mexico and established contact with emissaries of Moctezuma, the great Aztec emperor, with whom he exchanged various gifts. Fifty years later, one of his companions, Bernal Díaz del Castillo, chronicled the epic campaign leading to the conquest of the Mexican empire. As a direct witness, he narrated the events that were to change history, including anecdotes that help us to assign a (literary) image to many of the people taking part. From him, and from other native and Spanish chroniclers, we know of Moctezuma's anxiety to know who these new arrivals from beyond the sea were, what they looked like, and how they behaved. Therefore, it is not surprising that the great *tlatoani* (lord) sent his *tlacuilos* (painters) to portray the situation. Bernal tells us that these "great painters," whom "Moctezuma ordered to paint from nature the face, body and features of Cortés and of all the captains and soldiers . . . and of Doña Marina and Aguilar," were so faithful in capturing a likeness that a few days later Moctezuma's envoy, Tendile, returned to the Spanish camp accompanied by more than a hundred natives and by one Quintalbor, "a great Mexican *cacique*," who "in his face, features and body . . . resembled Captain Cortés." The resemblance was such that the Spaniards called Cortés to come to see the envoy. Thus, we must suppose that Quintalbor was a man of "good stature and body, well-proportioned and robust in his members, and the complexion tending to ashen, and not very cheerful; and if the face was longer, all the better; and his eyes amorous in their expression, and yet serious; the beard was rather short and thin and sparse, and the hairstyle he was using at that time was of the same manner as his beard, and he had a high chest and good shoulders, and he had bushy eyebrows and not much belly and was rather bowlegged, his legs and thighs well formed,"[35] according to the description that Bernal himself gave later of his captain.

The events narrated by this soldier-chronicler should be understood as filtered by distance and especially by a westernized interpretation of reality. This painting "from nature

the face, body" is undoubtedly the result of the value given to the portrait in the European culture at the beginning of the second half of the sixteenth century, and very different from the symbolic representations characteristic of the Aztec world. Moreover, the appearance of the *cacique* as a look-alike of Cortés underscores how important it was for the image to be faithful to the model, one of the recurrent themes in the history of all of Western portraiture. Quintalbor is a speaking portrait who takes on life, the ultimate aspiration of artists and their clients. The native painters sent their lord the truthful images of those "strange people with flesh very white, more than our flesh, most of them with long beards and their hair grows down to their ears. . . . All parts of their bodies are covered, only their faces appear. They are white, as though made of lime. They have yellow hair, though some have it black. Long the beard is, and yellow as well; they also have yellow moustaches. They have fine curly hair, a little twisted."[36]

These images have not come down to us, although we do have a large number of illustrated documents in which the European figurative aesthetic is reinterpreted by the native painters, who move easily in both languages of visual representation. However, if we do not have the portraits of Cortés and some of his companions by the Aztec artists, we can contemplate several depictions of the great Moctezuma produced by artists of New Spain at dates considerably removed from the monarch's lifetime. The best known of these is in the Museo degli Argenti of Florence, having been sent to Cosmo III, duke of Tuscany, in the second half of the seventeenth century. On this canvas, Moctezuma appears clothed as a warrior and maintains a dignity and distinction appropriate to the "heroic" portrait, as it has been defined.[37] In 1599, the Quito artist Andrés Sánchez Galque painted portraits of Don Francisco de Arobe and his sons Pedro and Domingo, depicted with equal dignity. This painting was commissioned by the judge Juan del Barrio Sepúlveda, who wanted to send Philip III some proof of the pacification of a highly conflicted area—the Ecuadorian coast of Esmeraldas—hence the name by which the painting has traditionally been known, *Los Mulatos de Esmeraldas* (pl. 9). For this purpose, and following the judge's instructions, Sánchez Galque painted a very unusual portrait. Unlike the Moctezuma portrait, the protagonists were known to the artist and painted from life. Juan del Barrio thought that his king "would like to see these barbarians portrayed, who until now have been invincible . . . men ready, agile and very daring. Their usual custom is to wear flat gold rings around the neck, and nose-rings, ear-rings, lip-pins and finger rings, all in gold. . . . They normally carry little lances in their hands and three and four darts of strong wood and, though with no iron, very sharp. All their portraits are very much the way they are and how they go about habitually, except the clothing. . . . For they are not polite people, and their land is hot, they do not make anything but blankets and shirts, like the other Indians. They have good understanding and are very astute and shrewd."[38]

The "principle of similarity" that ordinarily informs how a portrait is assessed is thus overtaken in many cases by references that have nothing to do with the realism of the representation. The prospects of manipulating the image as a function of intent are numerous and take into account not only the standards of beauty proper to an era but also the canon that conditions the portraits' range of gestures. The resulting image accords with each epoch's standard of beauty and the role that the images play as icons in society.

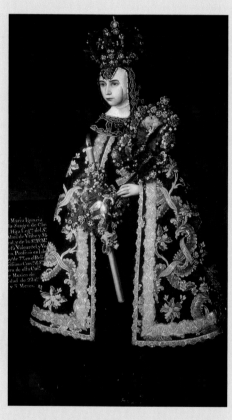

Fig. 1 *Sor María Ignacia de la Sangre de Cristo* by José de Alcíbar. Oil on canvas, 1777. Museo Nacional de Historia, CONACULTA-INBA, Mexico, D.F.

The face of a young woman materializes from within a gown that seems to hover above the dark floorboards. Her hands sustain an exuberant burst of flowers, a crucifix, an image of the Immaculate Conception, and a long candle to which is attached the image of a pelican tearing its breast. The patterns on the woman's blue cloak swirl in silver embroidery and rows of painted pearls. On her head, an open crown covered in flowers rests impossibly precariously, but the woman seems unconcerned. Her regal bearing suggests the status of a queen on earth or in heaven. At first glance, she might be mistaken for the Virgin Mary. But this is the portrait of Sor María Ignacia de la Sangre de Cristo, a Mexican nun who entered the convent of Santa Clara in 1777. Her portrait is a striking example of a genre unique to Mexico and known as *monjas coronadas:* crowned nuns (fig. 1).

Centuries before Frida Kahlo crowned herself with lace, scores of prominent colonial families commemorated the crowning of their daughters upon taking their monastic vows. The intricate ornamentation of Sor María Ignacia's portrait seems to revel in its own beauty but also manifests colonial Mexico's deep religiosity. It expresses the celebration surrounding a young woman's religious profession in a devoutly Catholic culture. These portraits reveal concerns emblematic of the tensions in late baroque New Spain: the pull between the modern and medieval, between art and religion, between colonial duty and national independence. Beneath the explosion of flowers, Sor María Ignacia's spartan habit is almost invisible, but the viewer cannot forget the strength of its presence any more than one can ignore the haunting eyes glowing from beneath her flowering crown.

Images of crowned nuns commemorating the entrance of a young woman into the convent were painted in the eighteenth and nineteenth centuries, sometimes by Mexico's most illustrious painters, but also by less distinguished, even anonymous, artists. The paintings testify to the social status of the families able to commission them. All the women thus depicted belong to distinguished families of the viceregal court; many bear names identifiable in the lists of colonial nobility. The regal style of the paintings demonstrates the attempt by colonial families to reaffirm their connections with the church and to advertise their own social and moral distinction.

The size of the *monjas coronadas* paintings varies. Most common are full-length portraits on canvases roughly six feet high. Three-quarter figures and busts also exist in compositions some three to five feet high. Nearly all are vertically oriented, the only exceptions being death portraits of nuns crowned before burial (which are related to, but distinct from, crowned profession portraits and are not unique to Mexico). Profession portraits, which make up the bulk of the genre, are frontal presentations of the nuns accoutred with the liturgical objects used in the profession ceremony. These objects include candles, ornamental palm branches, and crowns, all of which may be interwoven with flowers and fruit. Other

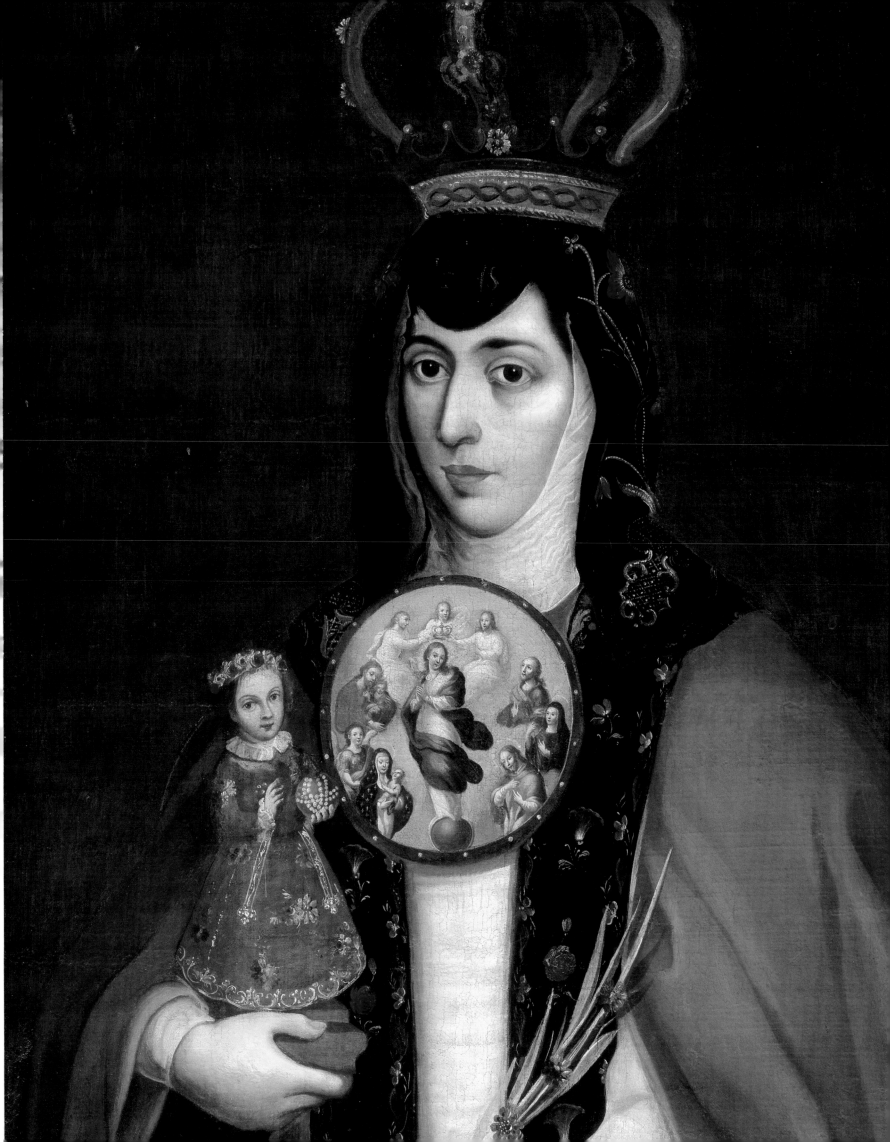

Fig. 2 *Indumentaria de las monjas novo-hispanas* by an unidentified artist. Oil on canvas, eighteenth century. Museo Nacional del Virreinato, CONACULTA-INAH, Tepozotlán, Mexico

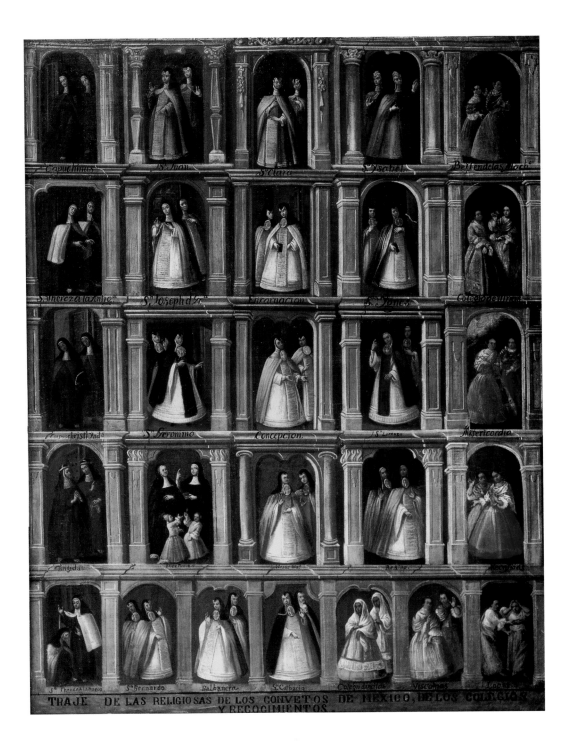

Franciscans observing Saint Clare's rule also chose brown, but of the coarsest fabrics attainable in order to mortify the flesh as much as possible. The Franciscan nuns who adopted the less-stringent guidelines of Pope Urban VIII dressed in luxurious grays, and, later, blues, much like the Conceptionists. Nuns of La Ensenanza (the Company of Mary), an order late to the colonies and dedicated to labor, dressed in severe black, their faces covered with a short veil.

The Veil

The black veil that covers the head is the outward symbol of the permanence of the nun's profession. In practice, it denotes her rank in the convent and, by extension, her social status "in the world." Only women of high standing and European lineage outside the convent could assume the black veil. Many of the portraits of *monjas coronadas* bear inscriptions

indicating that the woman portrayed is a nun of the black veil. For example, the inscription on José de Alcíbar's portrait of a young Conceptionist nun reads, "M. Soror Maria Josepha Ildefonza de San Juan Bautista en el siglo Alvarez y Glavez N. de San Angel . . . tomo el Habito de Religiosa de Coro y Velo Negro." In addition to this honor, the inscription goes on to list her distinguished patrons and family connections.

The black veil itself is one of the few trappings of the ceremony that the nun would wear throughout her life, the others being ceremonial and too ostentatious for daily use under a vow of poverty. The crown and candle would be set aside and preserved in a trunk at the foot of her bed, to be used again at the time of her burial. But the nun would wear a veil for the rest of her life. The veil shown in the profession paintings, however, was not the one worn in daily use. For the ceremony and for the portrait that commemorated it, the veil, scapular, and cape were transformed by silk embroidery, gold, pearls, and anything else the nuns could imagine, into an explosion of baroque whorls, suggesting a secular wedding gown, or perhaps, a garment fit for a Queen of Heaven. The clothes would have been made especially for the profession in the form and function of veil, cape, and scapular with ceremonial adornments particular to this event.

The Ring

With her ceremonial gown sweeping the floor, the nun was married to Jesus. As she sang, "I am the bride of Him whom the angels serve, of Him in whose beauty the sun and moon are reflected," the priest slipped the ring onto her finger (fig. 3).[3] Curiously, this ring appears in few portraits of crowned nuns. This creates an obvious problem with the traditional assumption that these profession portraits were painted after the ceremony they commemorate. Josefina Muriel, whose groundbreaking work has been the starting point for most later studies of female religious life in New Spain, asserts that the *monjas coronadas* sat for their portraits the afternoon of their profession, much as modern brides pose for photos taken immediately after their wedding ceremony. If this is so, it is strange that so few of these women display their rings in the portraits.

It seems possible then that at least some of these portraits were painted before the ceremony. The crown and ceremonial garments were important elements of the nun's dress on the day of her profession, but ultimately these were secondary to the central symbol of the ring, which perhaps was reserved for the true moment of the spiritual marriage. The crown, the palm branch, and the candle, for example, were prepared by the nuns in the months preceding her final vows, but the ring was not truly her own until the moment she spoke them.

In less strict orders, when the wedding ring does appear, it may be accompanied by other rings with less spiritual significance. Muriel notes, "A ring was a symbol, but before that came adornment so that, in addition to the one given her by the priest, the nuns added two or three more, and of course, the hand graced by rings should also sport bracelets."[4] Of course, ornament can be read as celebrating the glory of God. But the baubles worn by some of the *monjas coronadas* are too similar to the trinkets of fashionable court ladies to have real religious significance.

Images of Christ

Surprisingly, the crucifix is one of the least common of the liturgical objects to appear in these paintings. In lusher images it is superseded by more dramatic candles, crests, palms, miniatures, and flowering crowns. In starker images, the subject is stripped to a minimum of ornamental detail, and the crucifix is often omitted. Its inclusion depends primarily on the

Fig. 3 Detail of ring from *Sor María Ignacia de la Sangre de Cristo* by José de Alcíbar. Oil on canvas, 1777. Museo Nacional de Historia, CONACULTA-INBA, Mexico, D.F.

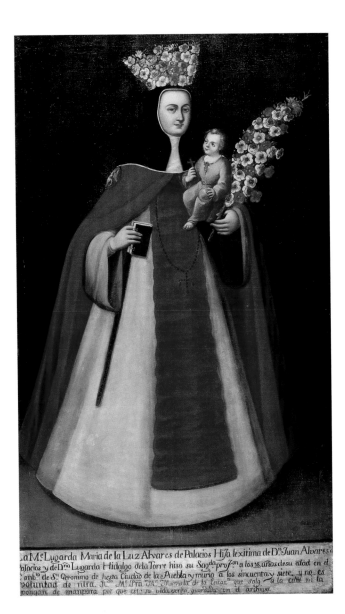

Fig. 4 *Madre Lugarda María de la Luz*
attributed to (Francisco Javier?) Salazar.
Oil on canvas, eighteenth century. Museo
Nacional del Virreinato, CONACULTA-
INAH, Tepozotlán, Mexico

religious order. The women of stricter orders, such as the Carmelites, who were dedicated
to following Christ's example of work and sacrifice, tend to carry the crucifix. It may be
turned inward, to connote contemplation of religious sacrifice, or displayed to the viewer.
Most appear to be carved from wood, but some suggest the warmth and delicate carving
of Philippine ivory.

More common among Conceptionists and Hieronymites are small statues of the infant
Jesus (fig. 4). The tenderness of these little statues, cradled like dolls, reflects these orders'
dedication to the contemplation of the Immaculate Conception and Virgin birth, rather
than the less comforting, more demanding reminder of the Crucifixion contemplated by
their Carmelite sisters. Typically, a nun depicted holding a statue of the infant Jesus belongs
to a less strict order. The doll or statue may appear static or animated, much as the Child
in altar statues may appear to sit still or reach out to his mother or the viewer. The image
of the nun cradling the statue re-creates the standard Madonna and child composition and
reaffirms the nun's identification with Mary.

These little statues recall the widespread monastic tradition of dressing and caring for
dolls. Christiane Klapisch-Zuber has described the custom and the presence of similar dolls
in Renaissance Italy.[5] In Florence, both brides and nuns carried richly dressed *bambini* with
them as part of their dowry. Klapisch-Zuber relates them to rituals of identifying with the

Christ child through mediation upon his image. Babies with glass eyes, dressed in the style of wealthy Florentines, were also carried in Passion plays, another tradition carried to the New World and practiced in Mexico.[6]

In New Spain, nuns were also said to play with dolls, transferring their own religious training onto them. In addition to the babies discernable in the profession portraits, figurines representing nuns were commonly kept in monastic cells. Nuns were expected to make clothes for these dolls, much as they dressed altar statues and much as they themselves were costumed for their profession.

The babies held by *monjas coronadas* appear to be about eight to twelve inches high. Usually their feet are attached to a wooden base. Like the myriad statues of the Christ child gracing New Spanish churches, these delicate dolls wear finely embroidered gowns finished with lace and jewels. The impression of psychological transference onto the dolls is underscored by the fact that while the nuns holding them rarely carry the crucifix, the dolls themselves often do. The dolls thus vicariously display some of the elements appropriate to the profession portrait, assisting the nun in displaying her ritual objects.

The Candle
The lighted candle corresponds to the biblical parable recorded in Matthew 25:1–10.

> Then the kingdom of heaven shall be compared to ten maidens who took their lamps and went to meet the bridegroom. Five of them were foolish and five were wise. For when the foolish took their lamps they took no oil with them; but the wise took flasks of oil with their lamps. . . . At midnight there was a cry, "Behold, the bridegroom! Come out to meet him." Then all those maidens rose and trimmed their lamps. And the foolish said to the wise, "Give us some of your oil, for our lamps have gone out." But the wise replied, "Perhaps there will not be enough for us and for you; go rather to the dealers and buy for yourselves." And while they went to buy, the bridegroom came, and those who were ready went in with him to the marriage feast; and the door was shut.

In calling out, "Come, bride of Christ," the priest signaled that by choosing the religious life, the nun prepared herself to receive the word of the opening of a figurative wedding. It underscored the theme of spiritual union alluded to by many of the objects the nun carried in the ceremony and that appear in her portrait. She literally enters a privileged space—the cloister—analogous to the passage into the marriage feast.

The candles depicted in the paintings vary in size and design. Some are short and nearly (though never entirely) naked of ornament. María del Carmen Sebastiana del Espiritu Santo, painted in 1795, holds a simple, elegant candle, with only one small painted image set into it. Others hold ostentatious candles as tall as their own bodies, with profusions of silk or wax flowers and painted miniatures. Such is the case of the portrait of the Conceptionist nun Ana Teresa de la Asunción, in which flowers burst out from the core of the candle. The candles burn in the paintings, recalling the significance of the biblical parable.

Often embedded in the wax or attached by metal tiers were miniature oil paintings or shallow carvings significant to the identity of the nun or her convent: the crest of the order, the pelican, and, in at least one case, a painted image of the miraculous Virgin of Guadalupe (fig. 5). The dedicatory text of that circa 1805 painting reads, "La R. M. Maria Petronila de Guadalupe . . . en el siglo Maria Petronila Winthuyssen y Urbina" (The

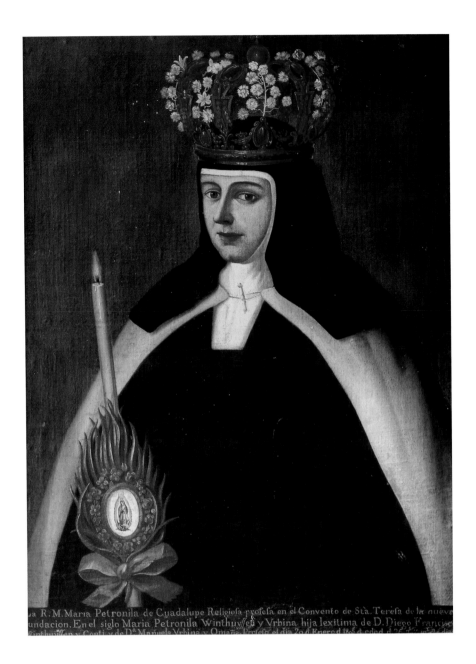

reverend mother María Petronila of Guadalupe . . . formerly María Petronila Winthuyssen y Urbina). The *leyenda* informs us that she chose the name Guadalupe at the time of her profession. María Petronila carries the crest of her patroness, finished with a wide red ribbon, as one of the few embellishments to an otherwise restrained example of the genre's late style.

The Palm

The ceremony of profession defines the palm as a symbol of the young nun's virginity. At least two additional biblical references are evidenced by particular treatment of the *monjas coronadas*. The first, of course, is a reference to Jesus' entrance into Jerusalem. The gospel writer John records the scene in which a great crowd took "branches of palm trees and went out to meet Him crying Hosanna! Blessed is he who comes in the name of the Lord, even the king of Israel!" The palm (fig. 6) thus symbolizes the young woman's entrance into the kingdom of heaven, drawing her closer to Catholic ideas of purity by entering the monastery. Together with the candle, the palm signals the novice's preparedness to receive and welcome Jesus.

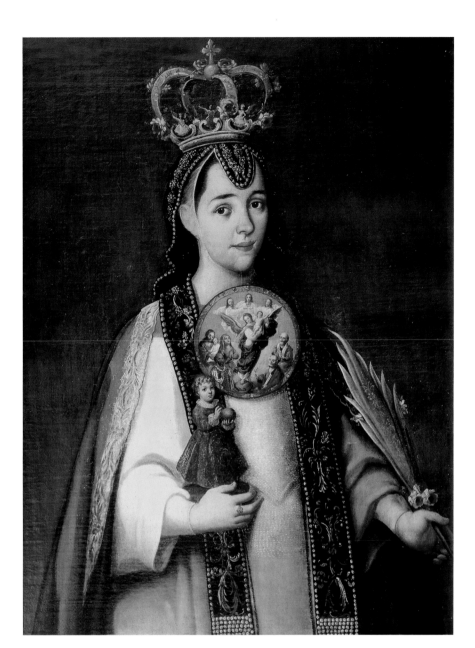

Some of the painted palms are visually clear, such as the one held by Sor María Gertrudis del Corazón de Jesús, painted in about 1803 (fig. 7). But many of them are almost unrecognizable as palms, suggesting a second metaphorical association. Their profusions of flowers seem to transform the liturgical objects into an allusion to Joseph's flowering staff. As a patron of Mexico and protector of the Christ child, Saint Joseph was a favorite patron among Mexican nuns. At least eight of the nuns in this study bear his name in one form or another. It is also important to remember that for their professions and portraits the nuns chose symbolic artistic references to their own names. Sor María Josefa Lino de la Canal holds a palm into which is set an image of the Virgin of Querétaro, her family's patroness.[7] The palm of Sor María Josefa Ildefonsa de San Juan Bautista includes a relief of Saint John the Baptist for more obvious reasons. Given the popularity of allegory in New Spain and the emphasis placed on artistic symbolism in these portraits of crowned nuns, it is certain that a young nun, or a painter specializing in religious portraiture, would draw the relationship between Saint Joseph and the flowering palm or staff.

The Hieronymite María Josepha de Santa Gertrudis holds a palm whose branches drip with full-blown baroque sprays of flowers—daisies, carnations, roses—which in turn

Fig. 7 *Sor María Gertrudis del Corazón de Jesús* by an unidentified artist. Oil on canvas, c. 1803. Museo Nacional del Virreinato, CONACULTA-INAH, Tepozotlán, Mexico

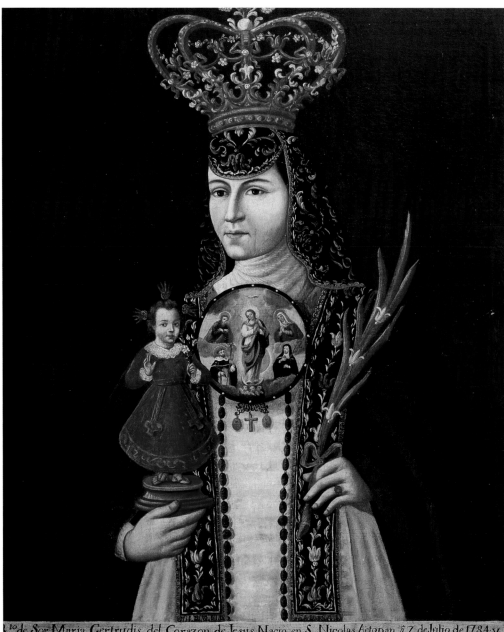

spring shoots higher and wider at each tier. Sor María Francisca Josepha de San Felipe Neri (Museo Nacional de la Historia, Mexico, D.F.), a *poblana* nun of the same order painted in 1769, carries a similar palm, the flowers arranged in a series of crosses like a blossoming Christmas tree. At this level of embellishment, without an awareness of the profession ceremony, the branch would be unrecognizable as a palm and its symbolism lost. These fecund sprays hardly remind one of virginal solitude alluded to in the ritual.

Rather, like the candle that reminds us of the nun's preparation to receive her spiritual bridegroom, the flowering staff recalls another biblical wedding: that of Joseph and Mary. Many of the miniatures set within candles allude to the Immaculate Conception and Annunciation, furthering the marriage theme. Certainly it is a wedding filtered through ritual and cleansed of overt sexuality. But the flowering branches are anything but sterile.

The Crown

Of all the recognizable elements found in profession portraits of nuns, the crown alone gives its name to the genre. It defines the profession portrait and is the element most closely linked to images of the Virgin in other genres. In some crowns the metalwork is the important aspect, and in this literally shines through. These examples tend to belong to nuns living in the convent of Jesús María and La Concepción in Mexico City, located in the same neighborhood as a confraternity of silversmiths. But for most crowns, the metalwork is merely the base or armature to which the nuns attached designs of imagination and personal significance.

Judging from the portraits of *monjas coronadas,* crowns followed two common designs. In one, the metal frame is entirely obscured by flowers that shoot out diagonally from the head. The other, more common, especially in later years, consists of an open metal crown interwoven with delicate blossoms. The latter is perhaps less extravagant—yet more regal—than the outward explosion of the early crowns, and it reflects the more sedate taste of the later period (pls. 34, 55).

According to the liturgy, the crown alludes to the one laid on Jesus' head as he went to his death. But as Josefina Muriel exclaims, "Who could dream that these enormous crowns could signify the Crown of Thorns! The symbol is respected; they are crowns, but . . . made of flowers or of metal and made with all the overwrought fantasy of the baroque."[8] Although the ceremony mentions the crown of thorns, the visual reference is to a crown, to the glory of immortality won by chastity and, more specifically, to the coronation of another virgin, the Virgin Mary. This crown, not the crown of thorns, is the one resting on the heads of the *monjas coronadas.*

For example, Madre María del Rosario (Convento de Santa Monica, Puebla, Mexico), an Augustinian nun from Puebla, wears a crown in which rest three wax figures. The central image represents the Immaculate Conception. Two allegorical figures representing the nun's religious vows flank Mary. The winged figurines bear scrolls that read *"Clausura"* (claustration) and *"Pobreza"* (poverty).

Escudos de monja

The *escudo* is not an object particular to the profession but rather an element of the habit worn by some orders. It is often visible in profession portraits, and these crests clearly follow a symbolic artistic vocabulary echoed in the portraits of crowned nuns. *Escudos de monjas* (nuns' shields or crests) are circular or oval badges, approximately fifteen to twenty centimeters across, worn over the scapular, covering the sternum and nearly scraping the chin (fig. 8). They are painted miniatures, usually on copper but occasionally on parchment. Typically they rest in silver or tortoiseshell frames. The first nuns to wear them were Peruvian Conceptionists in the seventeenth century. They were soon after adopted by nuns in New Spain, not just the Conceptionists and their affiliates (the Hieronymites of Mexico City and Puebla, for example), but occasionally by others, according to Muriel.

By far the most famous image of a nun wearing her *escudo* is the late-seventeenth-century portrait of Sor Juana Inés de la Cruz (pl. 21), the Phoenix of America. Like many extant *escudos,* the one worn by the famous writer depicts the Annunciation.

The *escudos* were painted with scenes of particular importance to women wearing them, but their central theme nearly always depicts an episode in the life of the Virgin Mary. Typically, the central figure is Our Lady in one of her advocations (the one most important to the nun wearing the *escudo*), accompanied by angels and saints of special

Fig. 8 Detail of *escudo* from *Crowned Nun* by an unidentified artist, late eighteenth century (see pl. 34). Private collection, Monterrey, Mexico

significance and devotion for the nun. In addition to the Annunciation, common motifs include the Assumption, the Apocalypse, the Rosario, the Immaculate Conception, and the Virgin of Guadalupe. The Coronation of the Virgin was a favorite subject and underscores the associations between the *monjas coronadas* and the Virgin Mary.

There is some question as to who first imagined the fantastic touches of the crowned nuns' attire. Were they designed by the novices in the year before taking their vows, or invented by portraitists to strengthen the symbolic message of the painting? It is uncertain who designed the spiraling crowns and branches of blossoms, but many of the *escudos* can be traced to their creator. In many cases we may assume that the same artist painted both the original *escudo* and the portrait of a young woman wearing it. *Escudos* by Miguel Cabrera and José de Alcíbar survive, as do their portraits of nuns. It is therefore quite possible that in painting the profession portrait an artist sometimes copied his own work. Although Alcíbar's best-known *monja coronada,* the Poor Clare María Ignacia (see fig. 1), does not wear an *escudo,* his 1771 portrait of a Conceptionist (coincidentally also adopting the name María Ignacia de la Sangre de Cristo) does display a large *escudo* resting just under her chin. This crest depicts the Immaculate Conception, a favorite motif of the Conceptionist order. His painting of Sor María Josefa Ildefonsa de San Juan Bautista, done ten years later, also includes an *escudo* portraying the Coronation of the Virgin. Thus the viewer looks at a Coronation of the Virgin painted in oil on the breast of a crowned virgin painted in oil, both very probably rendered by the same man.

All the objects contained in the portraits of crowned nuns have symbolic importance. But the *escudos* most clearly highlight the links between the *monjas coronadas* and similar treatments of the Virgin in other genres by presenting clearly translatable images. Simultaneously, they create a double reflection of the image: a crowned virgin worn on the breast of a crowned nun. An *escudo de monja* is essentially an allegorical portrait—its images refer directly to the nun wearing it without portraying her physically. It reminds us that the crowned nuns strove to emulate Mary and that painters strove to apply to these living women the grace and likeness of the Queen of Heaven.

The Text

Having described some of the most common motifs included in the *monjas coronadas,* a final word should also be said about the dedicatory *leyenda* included in almost all the profession portraits. These texts provide virtually our only clues as to the precise identity of the sitter, and they are analogous to the texts explaining miracle paintings of the same period. Statue painting dedications record in words the miraculous events commemorated in the painted scene, identifying the particular advocation or title of the Virgin. The texts of profession paintings serve a similar function. They provide just enough information to orient us with respect to date, identity, and location. The device is not uncommon in Mexican secular portraiture. In the case of the *monjas coronadas,* the text fulfills both social and religious functions.

Sometimes the artist sets the text apart from the general composition, placing it in a box beneath the image. In other cases, the words form part of the dark background, running vertically alongside the portrait. The dedications are as varied as the liturgical objects chosen for the painting but commonly list the nun's religious name, her family name, and the titles of her parents. Often they describe distinguished godparents or patrons. The city in which the nun was born, the convent that she has entered, and the date of her profession are also among the most common facts mentioned. Occasionally, if she was a distinguished student, her educational background is noted. When the artist signs the portrait,

his signature usually appears at the bottom of this narrative. In other cases, points about the nun's rank and duties in the convent are included. As these could not have been known at the time of the profession, one has to assume that this text was added later or, perhaps, that the portrait itself was painted after the nun had achieved some religious distinction and was then styled to look like a profession portrait.

Las monjas muertas

There exists a group of paintings in a style similar to that of the crowned profession portraits but created under very different circumstances. These are the death portraits of nuns, often known as *monjas muertas* or *monjas difuntas.* The subjects are celebrated members of the monastic community. In most examples, the deceased nun appears lying on her deathbed with her eyes closed. Unlike crowned profession portraits, which seem to be unique to Mexico, these death portraits are not limited to a single region; their themes are frequently repeated throughout Latin America and Europe. In them, the nun is dressed in her habit and again wears her flowering crown. In a personal conversation, a contemporary Mexican nun noted that to this day, women in her convent preserve the simple flowered crowns—which they still wear on the day of their profession—in a dowry box at the foot of their bed. When the nun dies, her sisters dress her for burial, and again crown her with the symbol of her profession. In convent life, the death of a nun was nearly as important as her profession and signified much the same thing: it was yet another spiritual birth—a reunion with the bridegroom—and she was attired accordingly.

Rogelio Ruiz Gomar has asserted that both these death portraits and the profession portraits may have evolved from a common inspiration. He points out that in both cases the women depicted are dressed in honor of the bridegroom: in one case for the mystic marriage, in the other, in preparation to meet him in the next world. Perhaps they evolved from images of the Dormition that were common in New Spain from the late seventeenth century onward. Certainly the *monjas muertas* bear a strong enough resemblance to scenes of the Dormition. But it seems unlikely that the profession portraits, with their references to the Coronation, postdated the death portraits. Moreover, the death portraits seem to emerge as late as the nineteenth century, while crowned profession portraits occur as early as the first decade of the eighteenth century.

The *monjas muertas* were intended to "freeze not only traces of the person, but also an aspect of life in New Spain."[9] Macabre as it may seem, the rigor mortis observable in some of the *monjas muertas* parallels the frozen, statuesque postures of the *monjas coronadas.* The fact that they were dressed by their sisters after death heightens the illusion that the crowned nuns costumed themselves in the guise of the Virgin Mary in the same way that they dressed statues and dolls inside the convent.

Conclusion

The *monjas coronadas* are not Mexico's only portraits of nuns. Images of virtuous nuns can be observed throughout the Catholic world. These resemble more standard European portraits of nuns and emphasize contemplation or inspiration rather than festivity. In them, the painter usually depicts the nun in a private moment in which both the setting and the clothing are restrained. These more conventional portraits have no particular link to place or time, being neither peculiarly Mexican nor limited to the late colonial period. The *monjas coronadas,* in contrast, are distinct from other religious portraits in that they are unique to late colonial Mexico and, bursting with color and ornament, reflect the *churrigueresque* tastes of a particular moment in religious expression.

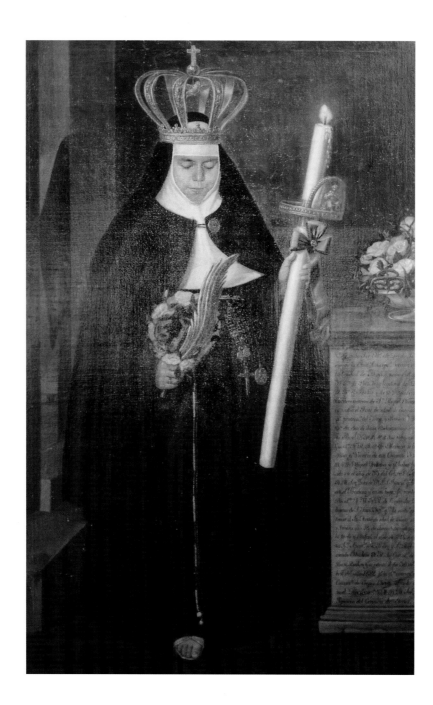

Although we recognize the *monjas coronadas* by their accoutrements and their emulation of the Virgin, these women bear their own features. They are, after all, portraits, not universalized images of the Holy Mother. A striking paradox frames the *monjas coronadas.* A model developed over centuries to represent universal beauty and virtue is being applied to the portraits of living women. The *monjas coronadas* represent an unusual blending of portraiture and allegory. Outwardly, in their dress they are identified by shared liturgical signifiers. But within the dress, unlike in canonical images of Mary, hides the face of a living, breathing, recognizable woman known to her portraitist (fig. 9).

There were eight monastic orders for women in New Spain. The first, founded by the Conceptionists in 1521, exemplified the luxurious style of life enjoyed by women born to courtly families. The last, the Company of Mary, a teaching order founded in Mexico in 1753, lived by the utilitarian ideals that would undermine the vision of nuns as distant

and statuesque—offering in its place a model of rigorous labor and intense spirituality. But ultimately this more human face of monasticism reflected the slow decline of the magnificent colonial cities of women dedicated to prayer and contemplation.

In the late eighteenth and early nineteenth centuries, as neoclassical restraint replaced lavish baroque expression, the era of the *monjas coronadas* faded and finally disappeared. Late examples of the genre began to show the transition, becoming more restrained in their embellishment. In tracing the history of the paintings' style, we also trace the history of female religious life in Mexico, as the lives and social roles of these women evolved during an era of increasing political and personal independence. When they ceased to be valued for possessing a rarified similarity to the Virgin Mary, they stepped down from the pedestals they had occupied as *monjas coronadas* and began to inhabit the world of the living.

Latin American portrait painting attained particular relevance in San Juan de Puerto Rico during the late eighteenth and early nineteenth centuries with the magnificent pictorial output of José Campeche y Jordán. This colonial artist bequeathed to his country and to the hemisphere a precious collection of oil paintings, among the best produced at that time in Ibero-America. They are worthy of commentary to stress their significance and beauty, and make them better known beyond the limits of Puerto Rico.

This San Juan artist is distinguished by his lifelong dedication to the arts and by his many aptitudes, evoking the multifaceted spirit of the Renaissance genius. Apart from his easel painting, Campeche was a consummate player of keyboard and wind instruments, sang in ecclesiastical processions, repaired organs, and gave music lessons. His versatility was equally manifest in the design of architectural works, pyrotechnics, the construction of frames for some of his paintings, the preparation of catafalques for royal and pontifical funerals, and other activities of a similar nature.

Nevertheless, José Campeche's most outstanding achievement undoubtedly lies in the field of painting. He made watercolors and drawings, achieving special prominence in the field of oil painting, especially in portraits taken from life. With admirable sensibility and with meticulous and attractive color, his brush captures the diverse San Juan personalities who constitute an eloquent image of the society of that epoch of deep historical significance. His work brought the rhythms of contemporary Western visual art to Puerto Rico, and his talent, deep religious character, and exemplary life inspired such admiration among his compatriots that he is justly regarded as one of the cornerstones of Puerto Rico's national identity. For their part, art critics warmly praise his paintings. By way of example, René Taylor, who made a thorough study of his works, considers Campeche "the most outstanding 18th-century painter in Latin America."[1] Similarly, Spanish art critic Juan Antonio Gaya Nuño notes that Campeche is "a great painter in a small country"[2] and, like Taylor, considers him "the principal [Hispanic-]American eighteenth-century painter."[3]

Campeche was born in the capital city of San Juan Bautista de Puerto Rico, on December 23, 1751, and was baptized in the Metropolitan Cathedral on January 6, 1752, the feast of the Epiphany.[4] Like most other colonial Latin American artists, he came from a family with limited economic resources. He was the fifth son of Tomás Campeche y Rivafrecha, a freed slave of Don Juan de Rivafrecha, the canon of the Cathedral of San Juan. Tomás Campeche was a craftsman of modest capabilities who worked in San Juan as a "gilder, decorator and painter."[5] José's mother, María Josefa Jordán, a white woman of humble lineage, was born on Tenerife, in the Canary Isles. José's first Puerto Rican ancestor, his paternal great-grandfather Eusebio Campeche, was married to Juana de Osorio, baptized in the cathedral in 1673, and served as a slave of an old San Juan family of the same surname.[6]

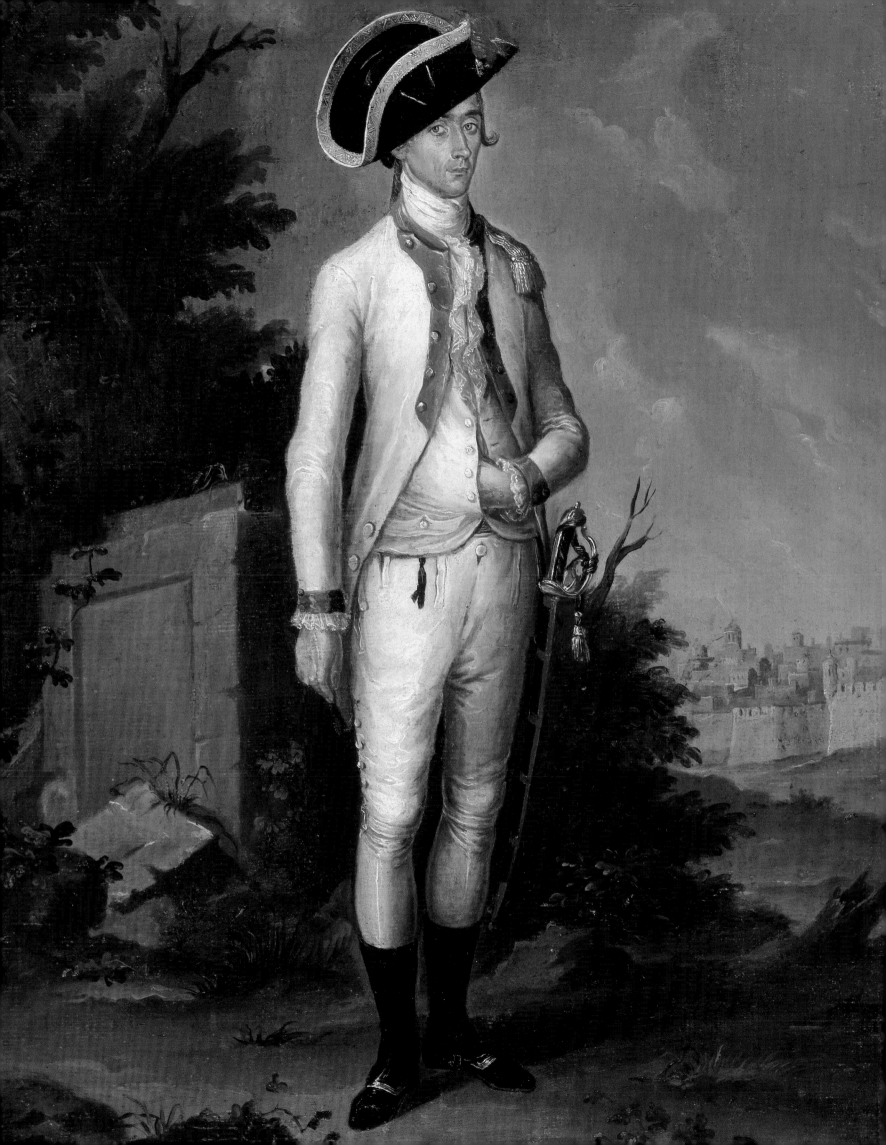

José never left his native land. He lived a deeply religious and ascetic life dedicated to the service of art. His brothers Miguel and Ignacio collaborated with him, as did his nephew Silvestre Andino and several other relations. All were free mulattos in the workshop of their house—which still exists—located in Calle de la Cruz on the corner of Calle de San Sebastián, in the walled quarter of the city. Upon his father's death in 1780, José took charge of the large family to whose support he devoted the fruits of his constant labor. He provided for many other poor relations, and on this point his sisters indicate in a notarial document that "if at any time he thought of marriage, he banished the idea in order not to deprive of support the family of which he took charge with the functions of a father."[7] In the same document, the artist's sisters declare that despite the numerous commissions José received, sometimes more than he could handle, the remuneration was usually very modest. He undertook much work free of charge, and they add that he received only small payments for other work; his main desire was to offer satisfaction to those who asked for his services.[8] Shortly before reaching the age of fifty-eight, Campeche died in San Juan on November 7, 1809, apparently of pulmonary tuberculosis. He was buried at the Dominican monastery of Santo Tomás de Aquino, with which he had been connected since childhood, having become a member of the Venerable Third Order of Saint Dominic.

In the history of Ibero-American art of the colonial period, José Campeche is the only artist to have received lessons from one of the great masters of European painting of his time. However, it is logical to suppose that he took the first steps in the technique of oil painting in his father's workshop, although his training also included studies in the Royal Convent of Santo Tomás de Aquino, in the walled quarter of the city. In 1775, having worked for some time as an easel painter, destiny offered him a singular opportunity to develop his talent with the arrival in San Juan of Luis Paret y Alcázar (1746–1799), painter by appointment to the Infante Luis Antonio de Borbón, brother to the king. Paret was a Madrid artist (now exiled from Spain), prolific and significant, with a thorough intellectual training. After his contemporary, Goya, art critics consider him the best eighteenth-century painter in Spain and the principal exponent there of the rococo style.

Scholars have rightly observed that Campeche's production was clearly influenced by Paret's stay in San Juan. Afterward, his palette reveals the soft tones of the rococo style, with good control in the handling of colors and meticulous care in the details, a clear reflection of the training he received. From this time onward, as Spanish art historian María Concepción García Sáiz correctly states, "the teaching received in a minimal time converted him with every right into a great figure of Spanish art of the Viceregal period."[9]

Campeche's artistic activity continued apparently quite close to his death in 1809 and covered approximately forty years, from the last third of the eighteenth century until the first decade of the nineteenth. During this time, his output dominated the artistic panorama of San Juan and was characterized by its diversity. His skills also included work in the field of uniform design. Watercolors submitted to the Crown for Puerto Rican military uniforms are undoubtedly his.

Music, as already indicated, occupied a prominent position among Campeche's numerous activities, and the various instruments he played skillfully included the organ (frequently played in churches), the oboe, and the flute. He achieved similar dexterity in playing the *chirimía* or flageolet, an ancient wind instrument that resembles the clarinet, and as a result of this skill he was granted a post in the band of the Fixed Infantry Regiment of Puerto Rico. Campeche also sang in religious processions and gave lessons in piano, organ, and sacred singing to the Carmelite nuns. Furthermore, he was music master to the daughters of some of the leading San Juan families, a fact that seems to be implied in some of his

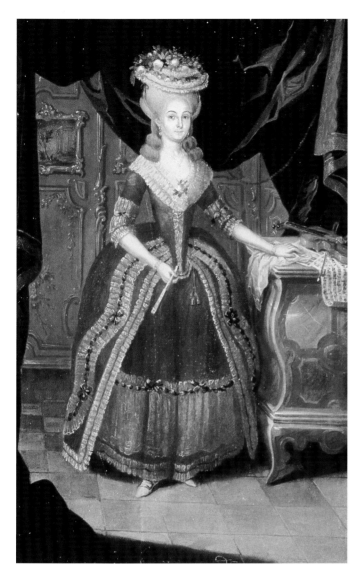

Fig. 1 *Wife of a Captain of the Regiment of Vitoria* by José Campeche. Oil on wood, c. 1782. Museo de Historia, Antropología y Arte, Universidad de Puerto Rico, Recinto de Río Piedras

Fig. 2 *Doña María de los Dolores Martínez de Carvajal,* by José Campeche. Oil on wood, c. 1791–92. Private collection

female portraits, such as the *Wife of a Captain of the Regiment of Vitoria* and *Doña María de los Dolores Martínez de Carvajal* (figs. 1 and 2).

In terms of subject matter, Campeche's paintings can be grouped into two main categories: religious works and portraits. His religious works are the most abundant part of his known production. Generally inspired by devotional prints and by the illustrations in religious books, his paintings of mystical matters—virgins and saints—are very attractive due to their fine technique, lively color, and meticulous touches. As author of these works, Campeche rendered inestimable services to the Catholic Church, his principal client throughout his life. He received frequent commissions from the Cathedral of San Juan, the three local monasteries with their respective conventual churches, several *ermitas,* or chapels, and various parish churches in the interior of the island. The painter also helped to satisfy the demands of the inhabitants of the capital and its surrounding areas for works of a religious nature intended for private devotion. In all these works, Campeche has left Puerto Rico and the Hispanic world a precious artistic legacy that has the additional value of reflecting the religious atmosphere of his country at that time, and particularly of the city of San Juan.

Also significant and worthy of mention is the demand for Campeche's religious works from the neighboring captaincy general of Venezuela, and from some of the Spanish

Antilles. Venezuelan demand arose in the years following the death of noted colonial painter Juan Pedro López (1724–1787). On his death in Caracas, there seems to have been no one available to supply the services he had rendered to a large clientele. Campeche received important commissions from Venezuela, a fine example being *La piedad* (Pietà), a large canvas preserved in the sacristy of Caracas Cathedral that can be considered among the best religious works produced at that time in Latin America. Caracas art historian Alfred Boulton has emphasized that Campeche's numerous oil paintings enriched Venezuela's artistic patrimony "to the point that his influence can be noted in the paintings of Mateo Moreno, Francisco Contreras, Manuel Zenón and other painters."[10] Orders from the ecclesiastical authorities and prominent Venezuelan families undoubtedly constitute proof of the deep appreciation his production enjoyed among his contemporaries, even beyond the limits of his own land.

Although portraits do not form as large a proportion of Campeche's total output as his paintings on sacred themes, they are the most notable aspect of his work and the area in which his talent is best displayed. He is the first Puerto Rican artist to cultivate this genre, and apart from their artistic merit, his paintings have the added interest of portraying a considerable sector of contemporary San Juan society.

It must be kept in mind that toward the last third of the eighteenth century, Puerto Rico began to experience some significant economic and social improvements. These were due in part to the enlightened reforms of the reign of Charles III of Spain, undertaken after the visit of his diligent inspector general and field marshal Alejandro O'Reilly. Important events included the liberalization of foreign trade and the renewal of the defenses of Puerto Rico as a bastion of the first magnitude, with a splendid military engineering program undertaken to increase the city's fortifications. This climate of progress must have encouraged persons of high social and economic standing in San Juan to have their appearance recorded in oil paintings at a time when portraiture attained unprecedented popularity in Europe.

In those years, Campeche began to produce a magnificent series of oil paintings of personalities from the island's capital, undoubtedly moved by his natural inclination to the art of portraiture, and possibly encouraged by Luis Paret himself. A good number of these works survive to the present day. While the young artist had previously painted a posthumous portrait of Bishop Fray Sebastián Lorenzo Pizarro (c. 1773–74, Archbishop's Palace, San Juan), his new paintings of prominent contemporary figures, taken from life, constitute a remarkable development in the artistic panorama of his country and of Latin America. Finely and delicately executed, with beautiful colors and a great likeness to the sitter, these works underline the distinction of the person represented and often contain allegorical elements of deep significance for the sitter and those close to him. The execution of these elements displays the artist's qualities as a portrait painter, and in turn this would have encouraged others to have their image perpetuated by such an excellent hand. Campeche not only satisfied the demand, but created it, and the fact that such commissions continued until the end of his days, often coming from prominent individuals, reflects the appreciation in which his work was held.

Among Campeche's portraits, those of female sitters are particularly charming and undoubtedly constitute the most exquisite part of his production. His works dating from the last years of the eighteenth century are especially delightful: the women are wearing attractive clothes of French inspiration, with delicate lace trimmings, high powdered wigs, fine silks, feathers, accessories in precious metals, and other adornments revealing the artist's meticulous care in representing high-quality materials. The rich backgrounds of some of

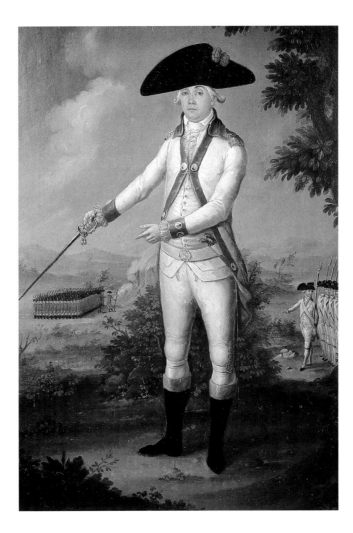

Fig. 3 *Segundo Capitán don Ramón Carvajal y Cid,* by José Campeche. Oil on wood, c. 1791–92. Private collection

these paintings harmonize perfectly with the attire, and they help to characterize the sitter and stress her elegance and distinction. The symbolism in some of these works also adds to their ineffable charm.

An example of the foregoing is his portrait *Wife of a Captain of the Regiment of Vitoria* (see fig. 1). The sitter, standing in an exquisite eighteenth-century boudoir of rococo flavor, is wearing a striking dress that is enhanced by the richness of its lace and other trimmings and by the splendid brown color of the silk from which it is made. Other magnificent examples are the portraits of Doña María Catalina de Urrutia (1788, Museo de Arte de Ponce, Puerto Rico), the wife of Governor Don Juan Dabán; Doña María Manuela Díez de Barrio de Martínez (1791, Cunningham Collection, Texas), the wife of Mayor Don Valentín Martínez; and Doña María del Rosario de Quiñones de Boguslausky (c. 1783–89, Calvetó Collection, Florida), the Puerto Rican wife of Captain Adalberto Boguslausky, an officer of Polish origin who served in the garrison of San Juan.

Another of Campeche's charming portraits of women is the painting of Doña María de los Dolores Martínez de Carvajal (see fig. 2). It is worthy of comment because of the especially attractive sitter and because it is one of the paintings that best displays the artist's gifts as a portrait painter.

It must have been on the occasion of the young lady's marriage to Second Captain Ramón Carvajal y Cid (fig. 3)[11] that the artist was commissioned to paint this work, which is a pendant to that of her husband. Portraits of married couples are frequent in Campeche's

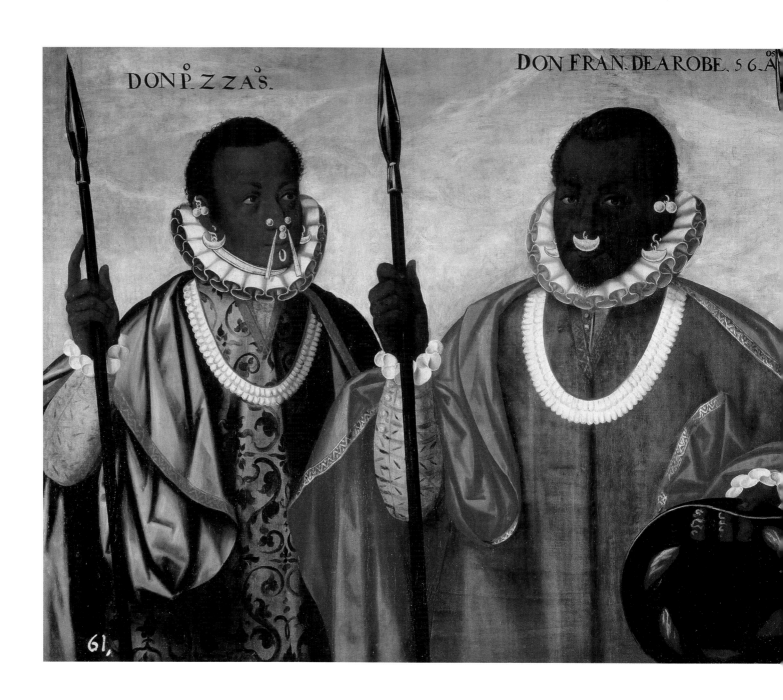

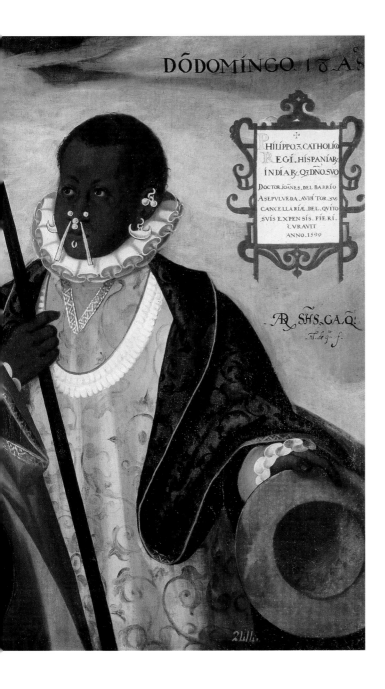

9 *Los Mulatos de Esmeraldas*
The Mulattoes of Esmeraldas

Andrés Sánchez Galque (birthplace and lifedates unknown)

Oil on canvas, 92 × 175 cm (36¼ × 68⅞ in.), 1599
Museo Nacional del Prado, Madrid, Spain

As if the theme of this stunning 1599 group portrait were not enough to secure its importance, it may well be the oldest known signed portrait in South America. It is also Andrés Sánchez Galque's only known work.

Don Francisco de Arobe and his companions descended from African slaves shipwrecked on the wild Esmeraldas shore of what is now Ecuador. Their mixture with the local natives produced a *zambo* (mixed African and native) elite that essentially ran the coastal settlements. Their conversion to Christianity and their acceptance of Spanish sovereignty account for their presence at the solemn proclamation of Philip III's accession in Quito, at which time this portrait was made. The attire and equipment of these leaders—spears, Spanish finery, and native *tumbaga* jewelry—bear witness to the dynamic intercultural transactions taking place throughout the Spanish empire during the early colonial period.

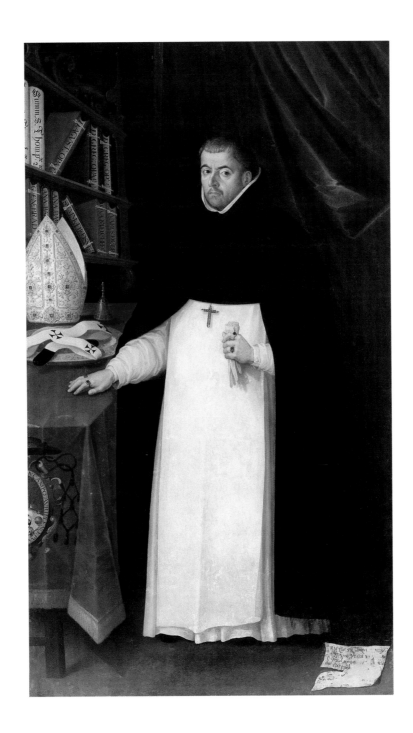

10 *Fray García Guerra*

Alonso López de Herrera (Spanish, working in Mexico, 1579–1660)

Oil on canvas, 215 × 125.5 cm (84⅝ × 49⅞₁₆ in.), 1609
Museo Nacional del Virreinato, CONACULTA-INAH, Tepozotlán, Mexico

Born in Palencia, Spain, Fray García Guerra (1560–1612) professed in the Dominican order at the Church of San Pablo in Valladolid, Spain. In 1608 he was appointed archbishop of Mexico. Three years later, he became viceroy but died shortly thereafter.

Alonso López de Herrera was born in Valladolid and came to Mexico in 1608 with his patron, Fray García. He was among the earliest Spanish artists to teach painting techniques in New Spain. His portrait of the archbishop-viceroy shows the latter dressed in the habit of the Dominican order. On the table is a bishop's miter, a ritual bell, and a gold platter on which rests the *pallium* worn by archbishops.

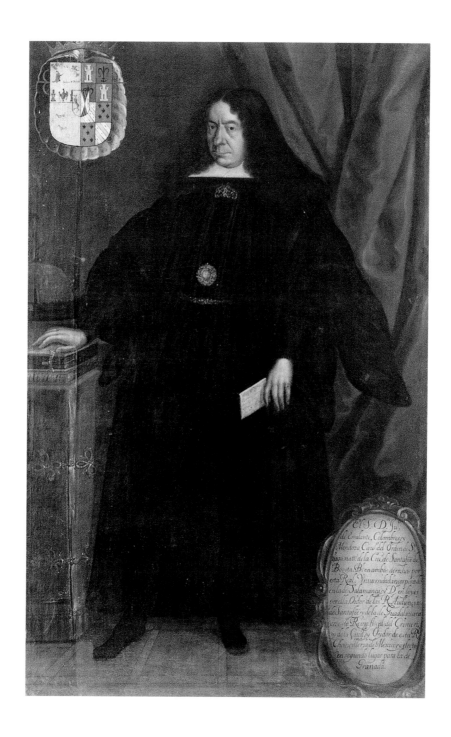

11 *Juan Escalante Colombres de Mendoza*

Juan Rodríguez Juárez (Mexican, 1675–1728)

Oil on canvas, 195 × 120 cm (76¾ × 47¼ in.), 1697
Museo Nacional del Virreinato, CONACULTA-INAH, Tepozotlán, Mexico

Juan Rodríguez Juárez was born in Mexico City to an illustrious family of painters and schooled initially by his father. He was an important influence on both his contemporaries and artists of the following generation, such as José de Ibarra (1688–1756) and Miguel Cabrera (1695–1768).

Juan Escalante Colombres de Mendoza (b. 1647) was born in New Granada and received a degree in civil and canon law from the University of Salamanca in Spain. He had a distinguished career in the judiciary, crowning his service with the presidency of the Audiencia of Guadalajara (1703–8). In this painting, he wears a loose cloak over a flannel suit and a *golilla,* a small starched collar. At his waist is a miniature showing the sword of the Order of Santiago, of which he was a member.

R.P.D. Martín de Andrés Pérez

12 Attributed to Cristóbal Lozano (Peruvian, d. 1776)

Oil on canvas, 167 × 124 cm (65¾ × 48¹³⁄₁₆ in.), 1754
Museo de Arte de la Universidad Nacional Mayor de San Marcos, Lima, Peru

The Camillian fathers, known for their care of the terminally ill, settled in Peru in 1709. The Spanish-born Martín de Andrés Pérez became the head of the order after his arrival there in 1737. In this portrait attributed to Cristóbal Lozano, a print on the bookshelf shows Saint Camillus praying to the Virgin and Christ child. The headdress on the table refers to the sitter's status as professor of moral theology at the University of San Marcos, established in the mid-sixteenth century. The architectural elements shown in the background may be from the university.

Lozano was born in Lima and was among the most important Peruvian painters of the eighteenth century. Many of his works were sent back to Spain. He did numerous viceregal portraits, and between 1762 and his death, he undertook a variety of commissions for the major Camillian convent, Buena Muerte de Lima.

Mujer Indigena, Hija de un Cacique

13 *Indian Lady, Daughter of a Cacique*

Unidentified artist (Mexican school)

Oil on canvas, 67 × 56 cm (26⅜ × 22⅛ in.), 1757
Museo Franz Mayer, Mexico, D.F.

This rare portrait of a sixteen-year-old *mestizo* was done for her family just before she entered the convent of Corpus Christi, founded in Mexico in 1724 exclusively for indigenous women. The sitter's mixed heritage is reflected not only in her facial features, but also in her costume. She is dressed in a *huipil,* a blouse worn by indigenous Mexicans, which is then covered with a European-style garment decorated with seed pearls and Chinese silk galloons. The escutcheon tells us the subject's name and age—Sebastiana Ynés Josepha de San Agustín, age sixteen—and the names of her parents—Mathías Alexo Martínez and Thomasa de Dios y Mendiola. Her father served as a provincial governor and, judging from his daughter's portrait, was a wealthy man.

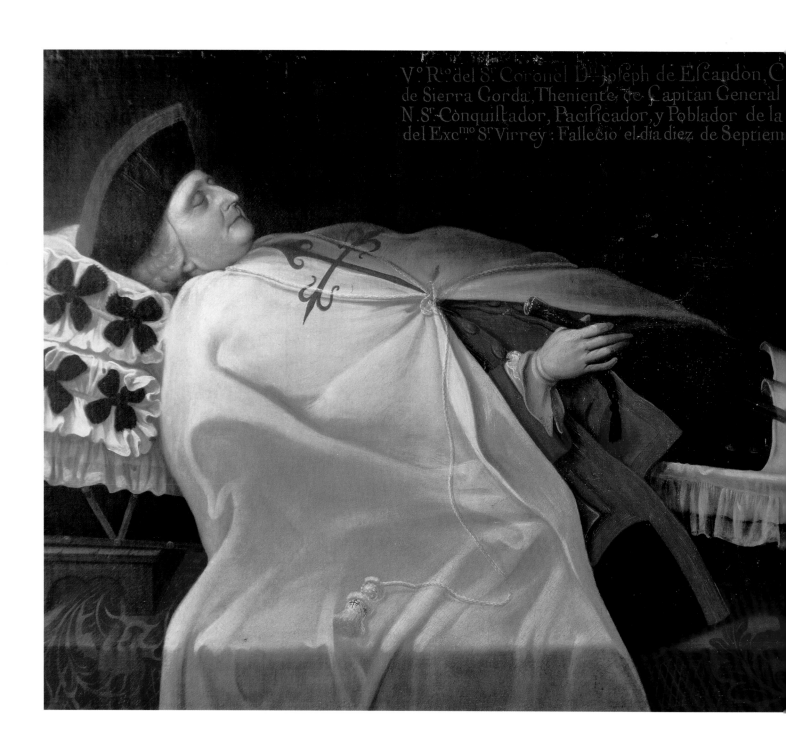

V.º R.to del S.r Coronel D.n Joseph de Escandòn, C
de Sierra Gorda, Theniente de Capitan General
N. S.r Conquistador, Pacificador, y Poblador de la
del Exe.mo S.r Virrey: Fallecio el dia diez de Septiem

14 *Don Joseph de Escandón y Helguera, Conde de Sierra Gorda*

Andrés de Islas (Mexican, active second half of eighteenth century)

Oil on canvas, 121 × 205 cm (47⅝ × 80¹¹⁄₁₆ in.), 1770
Museo Regional de Querétaro, CONACULTA-INAH, Mexico

Andrés de Islas left an impressive legacy of portraits of important colonial figures (see pls. 15, 16), but little is known about his life and training. It is possible that he was a pupil of Miguel Cabrera. Islas was a founder of the short-lived Academia de Pintores de México in 1753, and he was also well known for his costume design.

Joseph de Escandón's (1700–1770) powerful death portrait is one of Islas's greatest works. The count was the governor of Nuevo Santander, which included portions of present-day Texas. Here, he lies in state; his shroud bespeaks his aristocratic standing. The count wears the cape of the Order of Santiago and holds the staff of his political office. The lengthy inscription gives the sitter's name and his accomplishments.

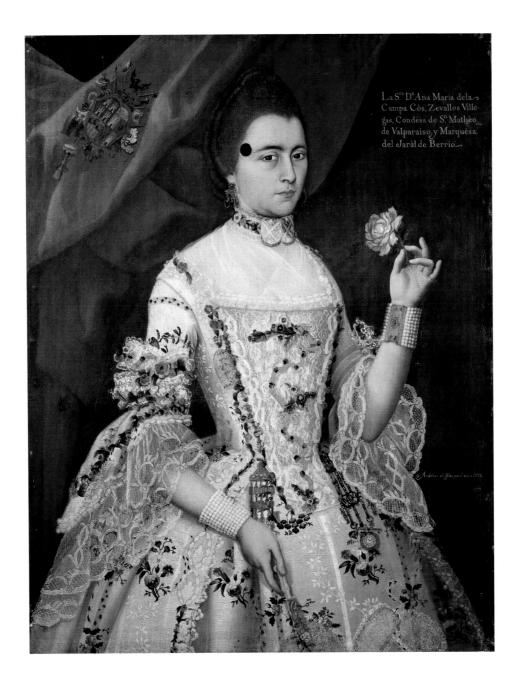

La S.^ta D.^a Ana Maria de la
Campa Cos, Zevallos Ville-
gas, Condesa de S.^n Matheo
de Valparaiso, y Marquesa
del Jaral de Berrio.

15 *Ana María de la Campa y Cos y Ceballos*

Andrés de Islas (Mexican, active second half of eighteenth century)

Oil on canvas, 107 × 82 cm (42⅛ × 32¼ in.), 1776
Rodrigo Rivero-Lake, Antigüedades, Mexico, D.F.

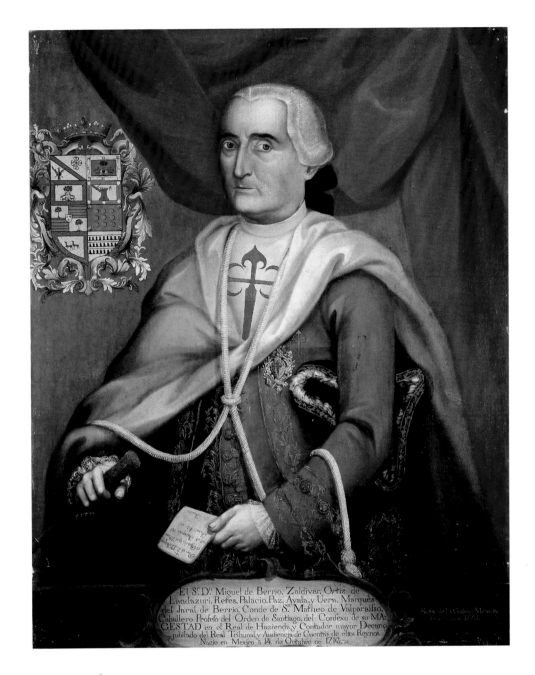

16 *Miguel de Berrio y Saldívar*

José Mariano Farfán de los Godos y Miranda (Spanish, eighteenth century)

Oil on canvas, 106.5 × 85 cm (41¹⁵⁄₁₆ × 33⁷⁄₁₆ in.), 1776
Rodrigo Rivero-Lake, Antigüedades, Mexico, D.F.

The marriage of Ana María de la Campa y Cos y Ceballos (1716–1799) (pl. 15) and Miguel de Berrio y Saldívar (1716–1779) joined two of late colonial Mexico's most powerful families. The bride inherited vast estates and the title of countess of San Mateo de Valparaiso. The groom parlayed a mining-based fortune into one based on land and agriculture and became the first marquis of Jaral de Berrio.

The marquis and marchioness are depicted as fashionable aristocrats. He wears the habit of the Order of Santiago with its symbolic Cross of Saint James (the conflation of a cross and a sword). The marchioness wears a *chiqueador*—a faux birthmark—on her face.

They were not a model couple. Their quarrels were famous, but their taste in building was impeccable. Their palace, now known as the Palacio de Iturbide, is one of Mexico City's monumental gems. Mexico's independence was proclaimed from its balcony, and Agustín de Iturbide used it as his imperial abode. It is now the home of Fomento Cultural Banamex.

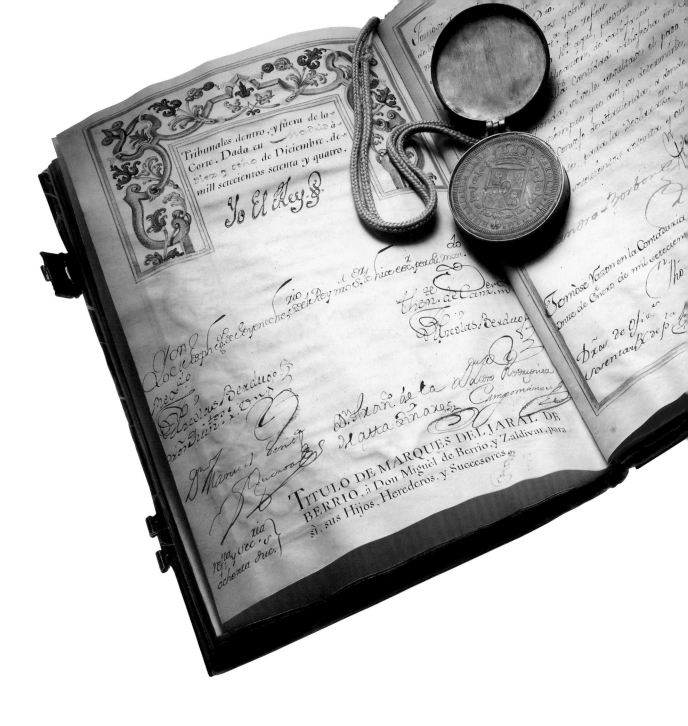

17 Libro del Título Nobiliario de los Marqueses de Jaral de Berrio
Book of Nobility for the Marquises of Jaral de Berrio

Unidentified artist (Mexican school)

Oil and ink on parchment, 31 × 21.5 cm (12³⁄₁₆ × 8⁷⁄₁₆ in.) closed, 1774
Rodrigo Rivero-Lake, Antigüedades, Mexico, D.F.

The grant of, and succession to, titles involved major expenditures from the recipients. Certain taxes had to be paid. The candidate's worthiness and lawful descent had to be established. Genealogies were prepared in order to demonstrate *hidalguía* (the noble condition of the beneficiary) and certify *limpieza de sangre* (the honoree's unpolluted lineage and ancestral commitment to the Catholic faith). The tangible product at the end of the process was a luxuriously bound and illuminated document whereby the king himself bestowed the honor. The instant the royal signature was affixed—by custom "Yo el Rey," regardless of who the monarch was—a person was elevated to social eminence. We can only imagine the eager anticipation with which Miguel de Berrio y Saldívar (pl. 16) received this elegant document when it finally arrived in Mexico after a lengthy ocean crossing. Was it worth all the trouble and the expense? Did it make a difference? Indeed it did.

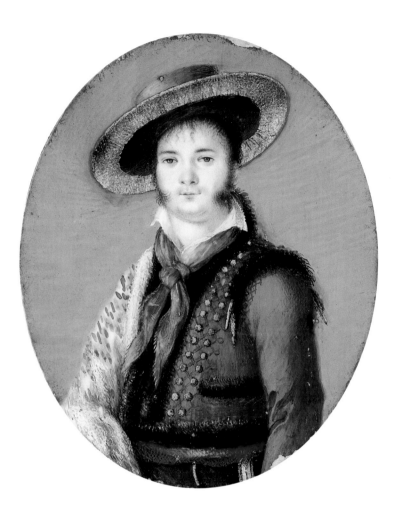

18 *Juan Nepomuceno de Moncada y Berrio*

Unidentified artist (Mexican school)

Oil on canvas, 9.2 × 6.6 cm (3⅝ × 2⅝ in.), c. 1800
Rodrigo Rivero-Lake, Antigüedades, Mexico, D.F.

19 *Juan Nepomuceno de Moncada y Berrio*

Unidentified artist (Mexican school)

Oil on canvas, 6.6 cm (2⅝ in.) diameter, c. 1820
Rodrigo Rivero-Lake, Antigüedades, Mexico, D.F.

These two miniatures depict Juan Nepomuceno de Moncada y Berrio, the grandson of the first marquis and marchioness of Jaral de Berrio (pls. 15, 16), at different stages of his life. He inherited the family's titles through his mother, Mariana de Berrio y de la Campa y Cos. She had married an Italian nobleman, the marquis of Moncada and Vilafont, in a notoriously dysfunctional match leading to a legal separation in 1792. That notwithstanding, their son inherited a vast accumulation of privilege, ironically at the dawn of independence, a time of rapid change in Mexico's social and political landscape.

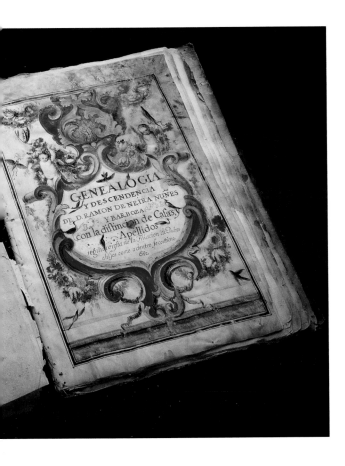

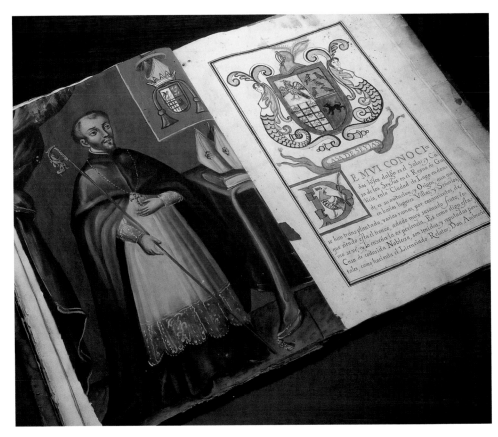

Genealogía y Descendencia de Don Ramón Neira Nuñez y Barbosa

20 *Genealogy and Ancestry of Don Ramón Neira Nuñez y Barbosa*

Unidentified artist (Mexican school)

Oil on paper, 65 × 42 cm (25⅝ × 16½ in.) closed, eighteenth century
Amando Ayala Anguiano, Mexico

This lavishly illuminated genealogy tracing the ancestry and descent of Don Ramón Neira Nuñez y Barbosa underscores Latin American colonial gentry's preoccupation with lineage. Don Ramón married Doña Maria Josepha de Mata y Villaseñor at the parish of the Assumption in Mexico on February 15, 1733. A family connection was none other than Francisco de Aguiar y Seijas, archbishop of Mexico between 1680 and 1698, whose full-length portrait is featured in the document. The prelate was notorious for his zealotry, his dyed-in-the-wool misogyny, and his antipathy for the famous nun-poet Sor Juana Inés de la Cruz (pl. 21).

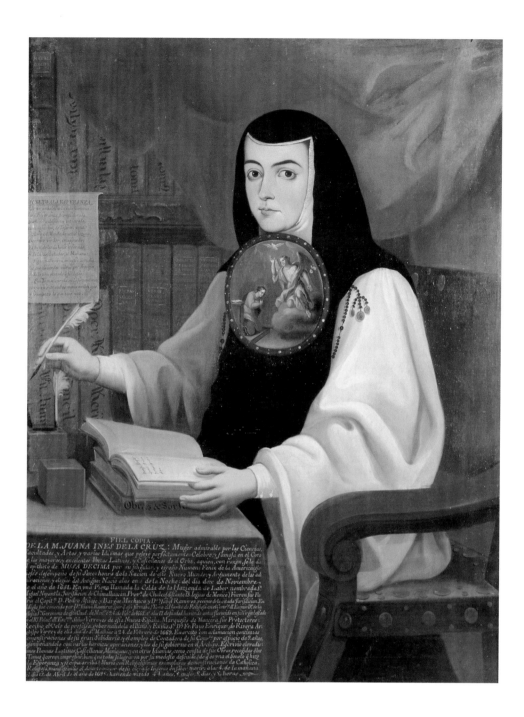

21 *Sor Juana Inés de la Cruz*

Andrés de Islas (Mexican, active second half of eighteenth century)
Oil on canvas, 105 × 84 cm (41⁵⁄₁₆ × 33¹⁄₁₆ in.), 1772
Museo de América, Madrid, Spain

Andrés de Islas was one of several important colonial artists who copied portraits of Mexico's famous poet, Sor Juana Inés de la Cruz (1651–1695). This image may have been based on an earlier portrait of her by Juan de Miranda (active c. 1680–d. after 1714). Called the "tenth muse," Sor Juana was born in the village of Nepantla and educated in part by her maternal grandfather. In 1656 she moved to Mexico City and was soon introduced to the best intellectual circles of the capital. In part to escape marriage, she entered the strict Carmelite order but later switched to the more liberal Hieronymite convent of Santa Paula.

This portrait shows Sor Juana, who took her vows in 1669, wearing the Hieronymite habit. Around her neck, she wears an *escudo de monja,* or nun's shield. These depicted religious scenes of significance to the wearer. On the bookshelves are selections from her own library.

22 *Presbytero Pedro Rosillo de Rivera y Moncada*

Ignacio Berbén (Mexican?, active second half of eighteenth century)

Oil on canvas, 105 × 85 cm (41⅝ × 33⅞ in.), 1778
Private collection (C.N.), Guadalajara, Mexico

Little is known about the artist of this richly painted portrait, although he was clearly someone highly trained in formal portraiture. This painting depicts a young priest, Pedro Rosillo de Rivera y Moncada (1752–1778), who died while serving the church in Nochistlán, Oaxaca, an important colonial center in the Sierra Mixteca, originally administered by the Dominicans. He is shown dressed in sumptuously embroidered liturgical vestments and holds a chalice veiled by a richly decorated cover.

23　*Dom Luíz de Vasconcellos e Sousa*

Leandro Joaquim (Brazilian, 1738–1798)

Oil on canvas, 88.2 × 65.7 cm (34¹¹⁄₁₆ × 25⅞ in.), 1780
Museu Histórico Nacional/IPHAN, Rio de Janeiro, Brazil

Rio de Janeiro's prime coastal location was ideal for shipping Brazil's vast mineral wealth to Portugal, and the city became the colony's capital in 1763. Rio's new status led to many artistic projects. Leandro Joaquim—a locally trained *mestiço* painter, theater designer, and architect—received numerous commissions. He is probably best known for six panels originally painted for a pavilion in the Passeio Publico, a park created when a seawall was built and the lagoon of Boqueirão drained. This massive engineering project was initiated by Dom Luíz de Vasconcellos e Sousa (1740–1807), the Brazilian viceroy from 1778 to 1790 who was born in Lisbon. Vasconcellos also established Brazil's first literary society, encouraged the documentation of local flora and fauna, and opposed the harsh treatment of slaves. His opulent lifestyle is evident in the artist's depiction of this assured and self-satisfied ruler.

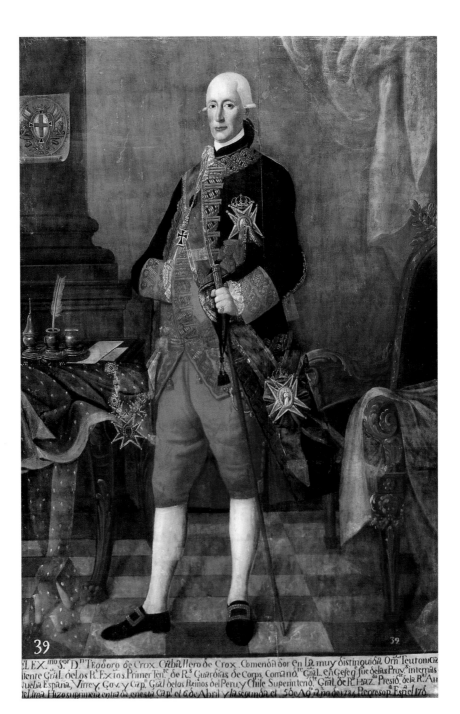

39

ELEX.^{mo} S^{or} Dⁿ Teodoro de Crox. Cabal^{llero} de Crox. Comendador en la muy distinguida Orn Teutonica tiente Gral. delos R.^s Ex.^{tos} Primer Ten.^{te} de R.^s Guardias de Corps. Coma.^{ndo.te} Gral. enGefeg fue delas Prov.^s internas *uebla* España, Virrey, Gov. y Cap.ⁿ Gral delos Reinos delPeru y Chile Superinteno.^{te} Gral. de R.^l Haz.^{da} Presió. dela R.^l Au *te* Lima. Hizo suprimieron entrada en esta Cap.^l el 6 de Abril y la segunda el 5 de Ag.^o 2.^{do} de 1784 Regresop España 1786

24 *Teodoro de Croix*

Unidentified artist (Peruvian school, late eighteenth century)

Oil on canvas, 235 × 161 cm (92½ × 63⅜ in.), 1785
Museo Nacional de Arquelogía, Antropología, e Historia del Perú, Instituto Nacional de Cultura, Lima

Teodoro de Croix (1730–1792), like his contemporary Bernardo de Gálvez (pl. 25), played a major role in the colonial history of several countries. He was one of a handful of Crown officials who seemed to be almost everywhere.

Born near Lille, France, he entered the Spanish army at age seventeen. When his uncle was appointed viceroy of New Spain in 1766, de Croix traveled in his entourage as a guard. Shortly afterward, de Croix was made governor of Acapulco and later became inspector of troops for New Spain. In 1777 he was named commandant general of the Provincias Internas (Interior Provinces), which included much of the southwestern United States. He served as viceroy of Peru (1784–90) and died in Madrid. The escutcheon recapitulates his career.

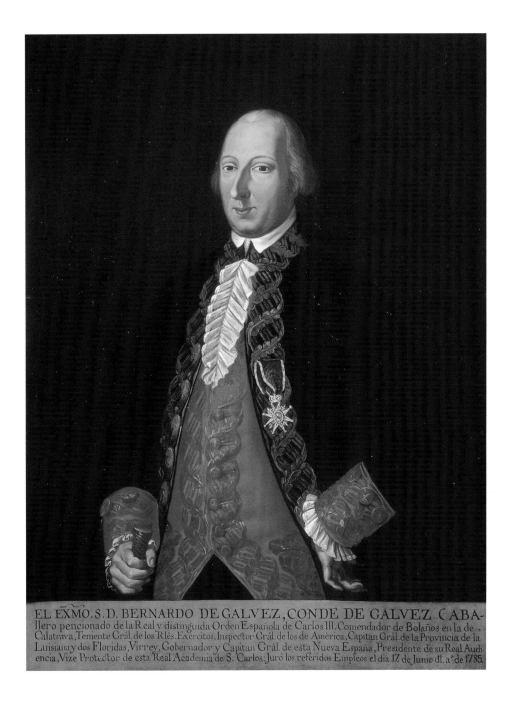

EL EXMO. S. D. BERNARDO DE GALVEZ, CONDE DE GALVEZ CABA-
llero pencionado de la Real y distinguida Orden Española de Carlos III. Comendador de Bolaños en la de
Calatrava, Teniente Grāl. de los Rles. Exercitos, Inspector Grāl. de los de América, Capitan Grāl. de la Provincia de la
Luisiana y dos Floridas, Virrey, Gobernador y Capitan Grāl. de esta Nueva España, Presidente de su Real Audi-
encia, Vize Protector de esta Real Academia de S. Carlos: Juró los referidos Empleos el dia 17 de Junio dl. aº de 1785.

25 *Bernardo de Gálvez*

Unidentified artist (Mexican school)

Oil on canvas, 112 × 84 cm (44⅛ × 33⅟₁₆ in.), c. 1785
Museo Nacional de Historia, CONACULTA-INAH, Mexico, D.F.

Bernardo de Gálvez (1746–1786), a key figure in late-eighteenth-century Spanish colonial history, was born in Macharaviaya, a mountain village outside of Málaga. After a brief but distinguished military career in Spain, he became commandant of military forces in Nueva Viscaya and Sonora.

He was governor of Louisiana when the American Revolution broke out. After the Spanish formally declared war against George III in 1779, Gálvez fought the British along the Mississippi River. He won the Battle of Mobile Bay and led the fight to capture Fort George in Pensacola in 1781. His diversion of British forces in the war's southern theater was a factor in the success of the French and Americans at Yorktown. Rewarded with the title of count, in 1785 he was also named viceroy of New Spain. He died in Mexico the following year. This portrait was made to commemorate his assumption of the viceregal office.

26 *Doña María Mercedes de Salas y Corvalán*

Unidentified artist (Chilean school)

Oil on canvas, 54 × 43 cm (21¼ × 16¹⁵⁄₁₆ in.), c. 1780
Museo Histórico Nacional, Santiago, Chile

This haunting portrait depicts a socially prominent and obviously beautiful Chilean woman who was the daughter of a colonial administrator. Her brother, Manuel de Salas y Corvalán, played an important role in Chilean independence.

 This portrait by an unidentified artist presents Doña María Mercedes in an arresting, if essentially popular, costume. Her attire is striking in its originality, certainly compared to the dress of her contemporary, the Mexican marchioness of Jaral de Berrio (pl. 15). A comparison of both portraits, in fact, suggests important differences in lifestyles between members of the elite in a wealthy viceroyalty such as Mexico and a considerably more modest outpost such as Chile.

Dama a Caballo

27 *Lady on Horseback*

José Campeche y Jordán (Puerto Rican, 1751–1809)

Oil on wood, 39.8 × 30.5 cm (15¹¹⁄₁₆ × 12 in.), 1785
Museo de Arte de Ponce, Puerto Rico, The Luis A. Ferré Foundation, Inc.

José Campeche was Puerto Rico's finest colonial painter. His production of religious paintings was impressive; however, his greatest legacy lay in the realm of portraiture. This portrait of an unidentified woman on horseback is an excellent example of his equestrian portraiture, and it demonstrates his talent for capturing the physical aspects of both sitter and mount. The elegantly attired subject sits sidesaddle on a fine horse. The horse's mane has been meticulously braided and beribboned. Campeche successfully conveys the confidence of the rider, who holds the reins in one hand while lightly touching the front leg of her horse with a riding crop. This is one of several equestrian portraits attributed to Campeche (see p. 108).

Un Alférez del Regimiento de Infantería Fijo de Puerto Rico

28 *An Ensign in a Regiment of the Permanent Infantry of Puerto Rico*

José Campeche y Jordán (Puerto Rican, 1751–1809)

Oil on canvas, 41.2 × 31.5 cm (16¼ × 12⅜ in.), c. 1789
Miriam Ramos de Ward, New Mexico

José Campeche, considered by many to be the father of Puerto Rican painting, learned art from his father, a gilder and painter. He also studied under the visiting Spanish painter Luis Paret y Alcázar. Campeche worked mainly in San Juan but also spent time working in Venezuela. In the late eighteenth century, he designed coinage bearing the royal effigy for the Mexico City mint.

Campeche excelled at portraiture. This painting shows a young army ensign standing against a background of vegetation and architectural elements that frames the walled city of San Juan. He wears the uniform of his unit, the famed *Regimiento de Infantería Fijo de Puerto Rico*, established in 1764. His gaze is fixed firmly on the viewer. As with other Campeche portraits (pl. 27), this one is rather small in size.

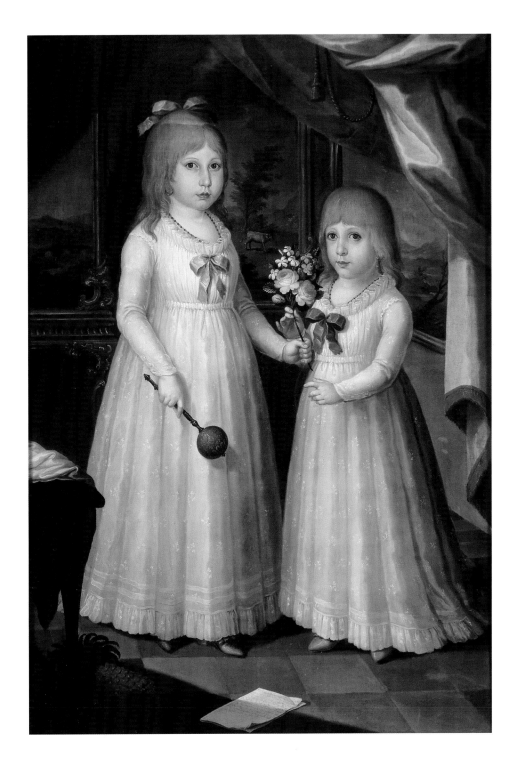

Las Hijas del Gobernador Don Ramón de Castro

29 *The Daughters of Governor Don Ramón de Castro*

José Campeche y Jordán (Puerto Rican, 1751–1809)

Oil on canvas, 114 × 81 cm (44⅞ × 31⅞ in.), 1797
Museo de Arte de Puerto Rico, San Juan

This is one of Campeche's most famous portraits. Governor Ramón de Castro's daughters are shown dressed in almost identical white muslin dresses, standing in the corner of a formal room against a backdrop of painted screens. They hold a bouquet of flowers. The older daughter, María Guadalupe Josefa, holds a beautifully carved maraca, or rattle, in her right hand, placing the painting in the context of the Antilles Islands. In addition, the pineapple resting on the floor reminds the viewer that the scene is a tropical one.

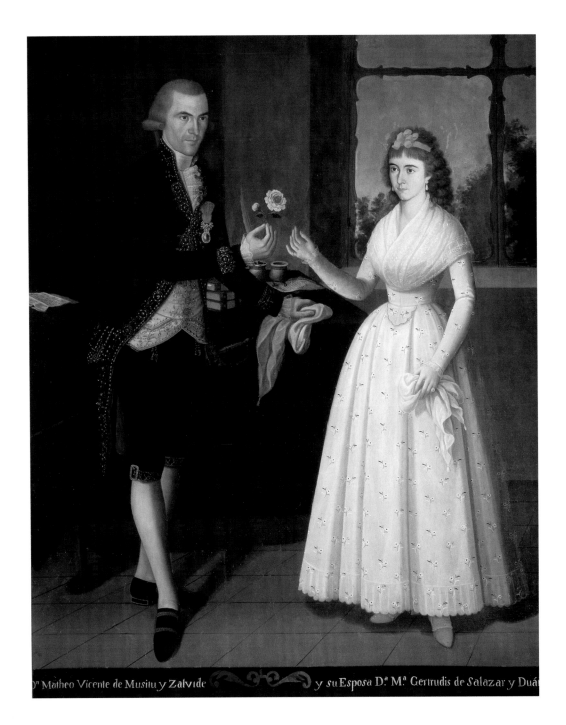

Dⁿ Matheo Vicente de Musitu y Zalvide · y su Esposa Dª Mª Gertrudis de Salazar y Duá···

30 *Matheo Vicente de Musitu y Zalvide y su Esposa Doña María Gertrudis de Salazar*

Joseph Mariano Lara (Mexican, active mid- to late eighteenth century)

Oil on canvas, 206 × 165 cm (81⅛ × 65 in.), c. 1791
Banco Nacional de México, Mexico, D.F.

Little is known about Joseph Mariano Lara except that he was from the city of Puebla and started painting during the second half of the eighteenth century. In this classically composed painting, we see Don Matheo presenting a delicate rose to his new bride, Doña María. Although their hands do not meet, the energy between the two is apparent. Probably made as a wedding gift, this elegant portrait is beautifully balanced. The dark, richly appointed masculine costume of Don Matheo stands in contrast to the delicate white dress of his new bride. The red of the ribbon over his heart is repeated in the diadem, shoes, and flowers of her dress. Finally, the white handkerchiefs in their left hands complement each other and bring the couple closer together compositionally. The couple married on July 8, 1791, at the Sagrario Metropolitano in Puebla.

31 *Don Tomás Mateo Cervantes*

Vicente Escobar y Flórez (Cuban, 1762–1834)

Oil on canvas, 40 × 31 cm (15¾ × 12³⁄₁₆ in.), 1800
The Cuban Foundation Collection of the Museum of Arts and Sciences, Inc., Daytona Beach, Florida

Vicente Escobar was one of Cuba's preeminent colonial painters. A free man of color, he specialized in secular themes, producing numerous portraits of the entrepreneurial Havana *criollo* (colonial-born white) oligarchy. Escobar lived when Cuba was beginning to emerge as the world's new sugar bowl, a time of unprecedented growth for the island.

 The sitter, Tomás Mateo Cervantes, operated at the core of the powerful *criollo* ruling class. His influence was felt on the island's finances, governance, and social life. This is made evident by his position as manager of *Temporalidades,* the agency created to administer the assets of the Jesuit order, which was dissolved by the Crown in 1764. His patronage of two of Havana's most prestigious charities, the Foundlings' Home and the vast convent of Saint Clare of Assisi, further underlines his status, somewhat belied by the sober attire more befitting a merchant than an aristocrat.

32 *Doña María Guadalupe Sanvía y Aguilar*

Emanuel López (Mexican, lifedates unknown)

Oil on canvas, 58 × 48 cm (22¹³⁄₁₆ × 18⅞ in.), late eighteenth century
The Vázquez Noris Family, Mexico

Very little is known about the artist who painted this portrait. However, his handling of facial features and drapery indicates that he had probably received considerable formal training. The sitter, Doña María Guadalupe Sanvía y Aguilar, is from Puebla, possibly the Tehuacan region. She wears a richly woven dress with an elegant but simple shawl over her shoulders. Her diamond, jet, and gold earrings and the multiple rings adorning her fingers suggest that she is from a well-to-do family. The beauty spot on her left temple is typical of eighteenth-century fashion.

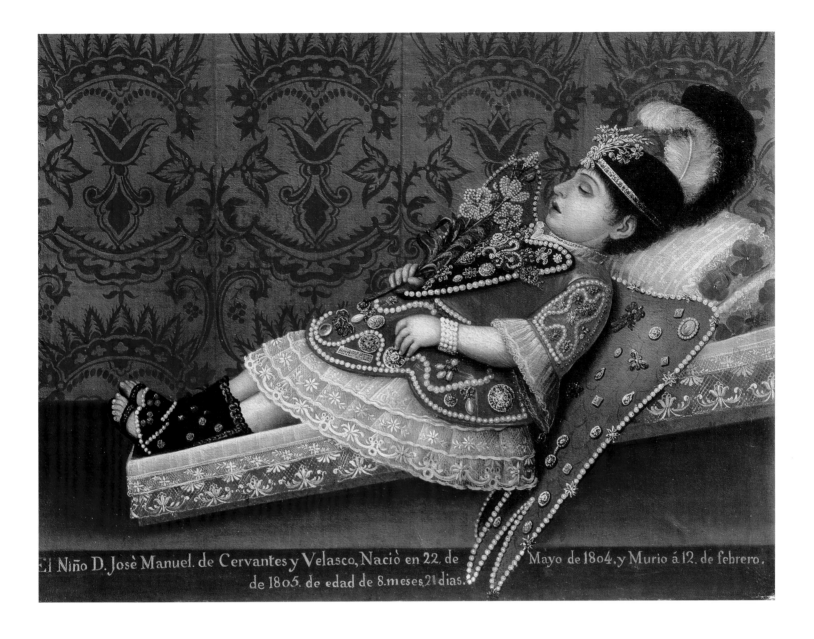

El Niño D. Josè Manuel. de Cervantes y Velasco, Naciò en 22. de Mayo de 1804, y Murio á 12. de febrero. de 1805. de edad de 8. meses 21 dias.

33 *El Niño José Manuel de Cervantes y Velasco*

Unidentified artist (Mexican school)

Oil on canvas, 57.5 × 91.5 cm (22⅝ × 36 in.), 1805
Private collection, Mexico, D.F.

In late colonial Mexico, it became customary to commission portraits of deceased children in order to preserve their memory for the living. Artists would rapidly capture specific facial features of the deceased and add them to a stock of generic bodies and backgrounds. In the Catholic tradition, deceased baptized children are assumed to go directly to paradise and are consequently called *angelitos,* or "little angels." Artists dressed them accordingly—girls as the Virgin and boys usually as Saint Joseph.

In this death portrait, the artist has dressed José Manuel de Cervantes y Velasco (1804–1805) as the archangel Saint Michael, complete with the jeweled wings and boots, as if for service in the heavenly host. He holds flowers and palm fronds. Although painted in the early nineteenth century, this work harks back to Mexico's baroque tradition. The practice of preserving the memory of deceased children lived on in photography well into the twentieth century.

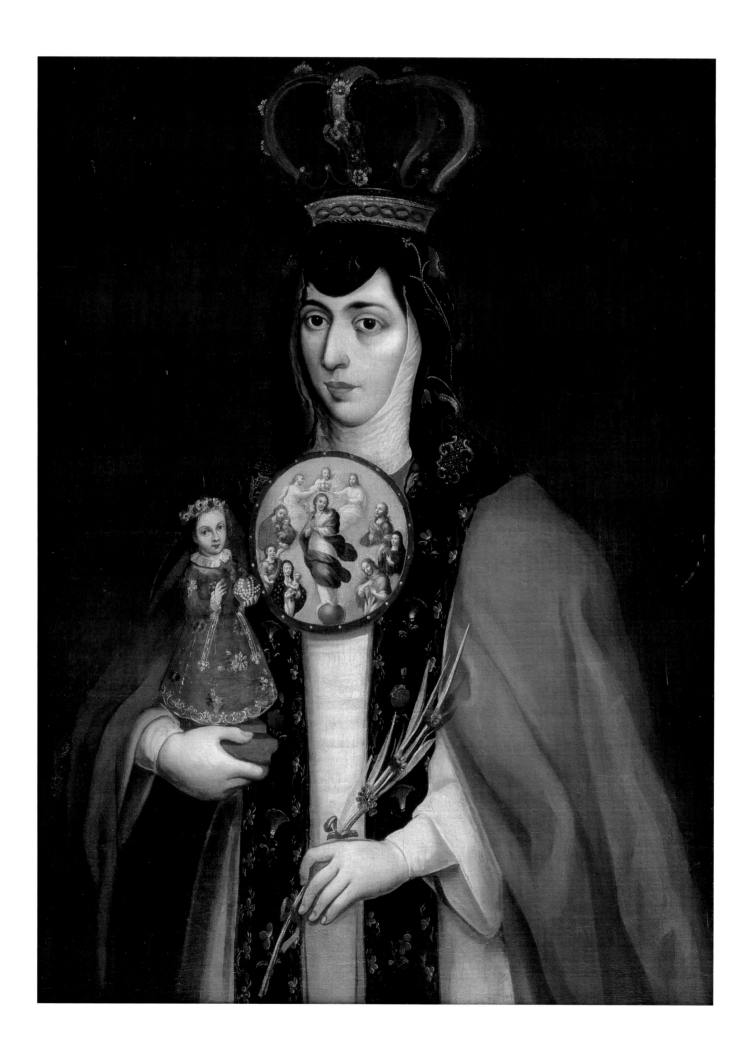

34 *Crowned Nun*

Unidentified artist (Mexican school)

Oil on canvas, 120 × 96 cm (47¼ × 37¾ in.), late eighteenth century
Margara Garza Sada, Mexico

Crowned nuns, or *monjas coronadas,* are a portrait genre that originated in Mexico. This tradition first appeared in the eighteenth century and persisted well into the nineteenth. The majority of these images celebrate the moment a young woman enters a convent, takes her final vows, and symbolically marries Christ, who is here represented by the doll in her right hand. This novitiate wears a white habit and blue cape, which signifies that she belongs to the Conceptionist order. She also wears an *escudo de monja,* or nun's shield, a kind of reliquary that contains an image of the Virgin of the Immaculate Conception, after whom the order was named. The palm frond she carries was a liturgical symbol used in the profession ceremony. The Conceptionist order was the first founded in New Spain and grew to be the largest in the viceroyalty. Only those of Spanish descent were allowed to profess.

Retrato de Matrimonio de Caciques como Donantes

35 *Wedding Portrait of Indigenous Couple as Donantes*

Unidentified artist (Mexican school)

Polychromed wood, 19 cm (7½ in.) height, mid- to late eighteenth century
Daniel Liebsohn, Mexico

This set of donor portraits is rare because of its relatively small size and because it represents an in-digenous couple, dressed in costumes typical of rural Mexico near the end of the viceregal period. No doubt they originally flanked a religious image, probably a local figure of the Virgin Mary. Donor portraits such as these were commissioned to show continuing devotion to a particular saint or virgin, and this tradition continued well into the nineteenth century.

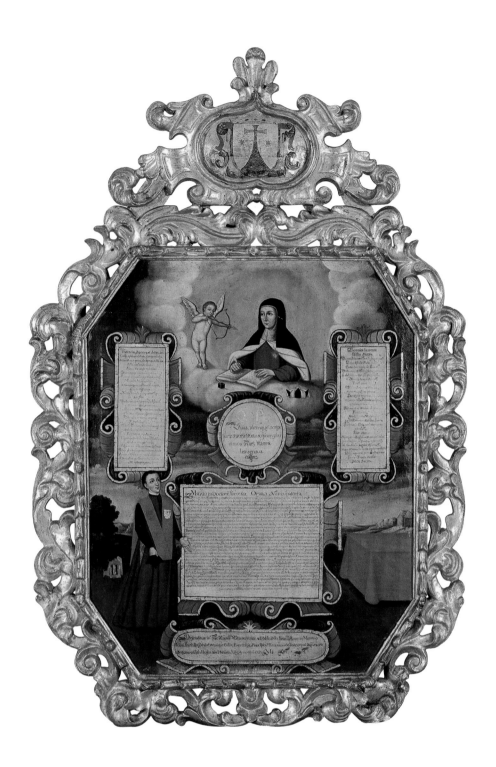

Defensa de la Tesis de Grado de Francisco Antonio Moreno

36 *Defense of Doctoral Thesis by Don Francisco Antonio Moreno*

Joaquín Gutiérrez (New Granadan, 1715–1805)

Oil on canvas, 86 × 69 cm (33⅞ × 27³⁄₁₆ in.), 1752
Museo de Arte Colonial, Bogota, Colombia

A variant of colonial Spanish American *donante* portraits developed in New Granada when candidates for advanced degrees commissioned mementos of the successful defenses of their theses. A handful of these prolix pictorial testimonials exist.

This one, by Joaquín Gutiérrez, features a portrait of the doctoral candidate, Francisco Antonio Moreno, in his academic robes, a summary of the thesis sustained by him, and the effigies of the saint under whose patronage and protection his program of studies was placed. The opulent frame emphasizes the significance attached by their patrons to these simultaneously learned and naive trophies, which are apparently unique to New Granada.

IV

THE NINETEENTH CENTURY: INDEPENDENCE
AND NATIONAL IDENTITY (1810–1910)

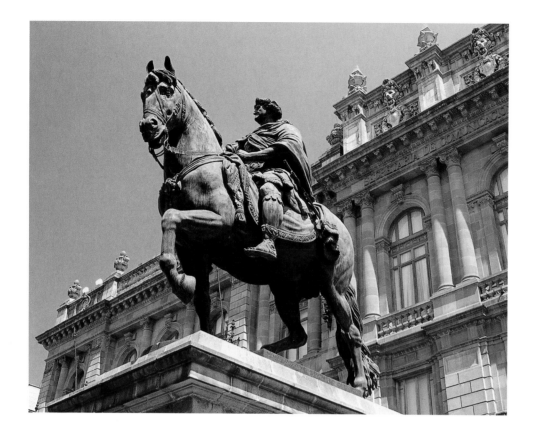

Fig. 1 Charles IV *(El Caballito)* by Manuel Tolsá. Bronze, 1803. Museo Nacional de Arte, CONACULTA-INBA, Mexico, D.F.

Unlike the Portuguese Braganças, who had the option of opening, as it were, an offshore branch, the Spanish dynasty had to share its home with a dangerous visitor. To make things worse, the French presence in Spain precipitated a series of maneuvers and intrigues within the court and royal family. Godoy proposed endorsing Spain over to Napoleon in exchange for a little kingdom for himself in the Algarve. In the wake of a revolt at Aranjuez in 1808, Charles IV fled to Seville and abdicated in favor of his son, then rescinded his abdication. Ferdinand meanwhile proclaimed himself King Ferdinand VII and asked the French emperor for the hand of a Bonaparte princess in marriage.

Perplexed, Napoleon summoned the Spanish royals to the French Basque city of Bayonne. There, Queen María Luisa confided personally to him, as only she could, that Ferdinand was not really Charles IV's son. Appalled, and judging the Spanish people by their rulers, the emperor concluded that taking over Spain would not be difficult. He therefore interned the entire Spanish royal family in France and installed his own brother, Joseph, as king of Spain.

It was a bad career move, but that would not be evident for a few more years. As the first round of this high-stakes game of musical chairs ended, Charles IV had been left standing up. The hapless king found himself without a throne while a reviled foreigner sat on a spurious one in Madrid.

Charles was still in the saddle in at least one place: his magnificent Mexican equestrian bronze statue (fig. 1) by Manuel Tolsá (1757–1816). Cast in one piece in Mexico—a great technical achievement—it had been installed in Mexico City's main square, the Zócalo, in December of 1803. Charles is dressed like a Caesar in good classical fashion—no stirrups—and looks a bit like Louis XIV. (Tolsá's statue, in fact, was a superb though fairly slavish version of Girardon's statue of the Sun King.) For all that rotund majesty on horseback,

the statue has been known as *El Caballito*—never mind the rider—since the middle of the nineteenth century.[5]

Spain was in chaos as 1809 began. British and French armies operated throughout the land, delivering death and destruction to each other and to the civilians caught in between. It was the war of Goya's *Disasters*. Joseph I was promptly dubbed "Pepe Botella" by his Spanish subjects—i.e., "Joe the Boozer"—while the exiled Ferdinand became *El Deseado*— "the Desired One"—the symbol of national resistance to invasion and usurpation. At one fell swoop, the delicate constitutional and dynastic arrangement that held the vast empire together came tumbling down.

One cannot understand this depressing period in Spanish history without contemplating the extraordinary portraits it produced. Thousands of words might be spent on Charles IV's bland ineptitude, María Luisa's crass vulgarity, Godoy's cynical opportunism, or Ferdinand VII's treacherous duplicity, but it was Goya who captured those traits definitively in his penetrating court portraits.[6] Goya's imaging of the age's events and dramatis personae carry an unusual weight in the dialectical relationship of visual, mnemonic, and textual discourse that produces historical understanding. Seldom has an artist so definitively captured the essence of a period—or perhaps so decisively influenced posterity's perceptions of an historical age—as Goya did for the turbulent, unhinged Spain of his day. One wonders whether the dense Spanish royals he served were aware that their court painter was not so much portraying as caricaturing them. Indeed, one wonders why they sat for him at all.

The Colonies Rebel

The debacle of the Spanish monarchy had immediate repercussions. During 1810, juntas of notables assumed power in Ferdinand VII's name in Caracas, Santa Fé de Bogotá, Santiago de Chile, and Buenos Aires. In September of 1810, Miguel Hidalgo y Costilla, the parish priest at the town of Dolores in the mining region of Guanajuato, declared Mexico's independence and marched to the capital at the head of a native army.[7] Hidalgo's army— a mob, really—was defeated and its leader executed, but another priest, José María Morelos y Pavón, curate of Carácuaro, took up the struggle. Morelos shared Hidalgo's fate in 1815.[8] Mexico would not become independent until 1821, when a conservative general, Agustín de Iturbide (pl. 42), declared himself emperor Agustín I (reigned 1821–23).

The struggle for Latin American independence was long and complicated.[9] A few early bids for national freedom succeeded where others failed. Argentina, independent since 1810, and Paraguay, independent since 1811, were never brought back under Spanish obedience. Venezuela's "First Republic" of 1810 was liquidated a year later by Tomás Boves, an Asturian warlord fighting in the name of the king. Chile's independence, proclaimed in 1810, was rolled back in 1814 by loyalist Spanish forces. Colombia's was ended by a "reconquest" launched from Spain itself in 1816. (By then Ferdinand VII had been securely installed on the throne.) A reign of terror followed, and scores of patriots were ruthlessly executed.

Where Spain managed to retain or regain control, independence had to be won at great cost in blood and treasure. That is what the epic marches and campaigns of Simón Bolívar, Antonio José de Sucre, José de San Martín, Bernardo O'Higgins, and Central America's Francisco Morazán were all about. The last battle of the wars was fought at Ayacucho, in the highlands of Peru, on December 9, 1824. Ayacucho was Latin America's Yorktown.[10] Not far from there, at Cajamarca, a Spanish adventurer named Francisco Pizarro had captured a perplexed Atahualpa in the light of a bright November afternoon in 1532.

Fig. 2 *Pedro I* by Marc Ferrez. Bronze, 1826. The Catholic University of America, Oliveira Lima Library, Washington, D.C.

Portraits for a New Order

The weight of history shifted throughout Spain's former domain like a rumbling earthquake. With king and viceroy gone, a new pantheon of heroes and heroines had to be acknowledged and promoted by the new sovereign states, and portraiture was enlisted to do the honors. The new high and mighty, like Venezuela's "Liberator," Simón Bolívar, and his Argentine counterpart, José de San Martín, claimed their place in the emerging national heroic galleries. So did, though in lesser measure, humble folks like Colombia's Policarpa Salavarrieta and Peru's José Olaya, about both of whom more shall be said.

Some traditions fell out of favor while others remained. Independence had a major impact on the church. For years, vacant bishoprics went unfilled, meaning that fewer new priests could be ordained. The close partnership between church and state under the Spanish monarchy simply ceased to exist except in attenuated fashion. Formal portraits of high ecclesiastics, once common, became rare as the church's role as a patron diminished.

Change, dramatically evident in some areas was imperceptible in others. Victorino García Romero (1791–1870) was a Bogota painter who specialized in the locally much appreciated head-and-shoulder portraits of crowned nuns on their biers. He went on painting as if nothing had happened. There is virtually no difference between the nuns he painted early on in his career and those he painted many years later.[11]

The brief Mexican empire of Agustín de Iturbide produced a handful of imperial portraits done in a derivative Napoleonic style. The longer-lasting Brazilian reign of Pedro I would recycle the tradition of European court portraiture to fill the propaganda needs of a New World monarchy. The mercurial Pedro was often portrayed in full uniform, as in the handsome bronze bust by Marc Ferrez (fig. 2).[12]

Some of this was art on the march, produced while the dust of battles had not yet settled. When Simón Bolívar entered Santa Fé de Bogotá shortly after his resounding victory at the Bridge of Boyacá (August 7, 1819), he sat for the established local portrait artist Pedro José Figueroa (1770–1736). Figueroa came from a family of artists and was in every respect a provincial colonial painter working well within the parameters of eighteenth-century New Granadan art. His Bolívar, flat and lifeless, could be a colonial *oidor,* a petty aristocrat, or a traditional *donante* calling attention to a sculpture of a saint (fig. 3).[13]

But the figure *is* Bolívar—aren't those the initials "SB" on the buckle? The figure he is embracing is no saint but a representation of "American Freedom" dressed as an Indian maiden. She carries bow and arrows, wears a plumed crown, and is completely out of scale with the Liberator. Figueroa's Bolívar is clearly short, dark-complexioned, woolly haired, mustachioed, and wears a three days' growth on his face. This is not only the model for many later copies made by Figueroa himself but also the virtual prototype for the "dark" Bolívar of the iconographic debate.

An additional, extraordinary feature of this painting makes it uniquely compelling. Apparently, canvas and frames were not abundant in 1819 Bogota. So the artist helped himself to a canvas bearing a portrait of Pablo Morillo, the commandant of the "reconquering" Spanish expedition of 1816—in effect the last viceregal ruler of New Granada—and painted it over. Turn the portrait on its side and Morillo's face appears dimly under the top pictorial layers: a true historical palimpsest.

Bolívar was portrayed often throughout his career. He sat for, among others, Venezuela's Juan Lovera (1778–1841) (fig. 4) and Chile's José Gil de Castro (pl. 51). One of the best-known faces in all of Latin American history, Bolívar sat for portraits from literally early adolescence until the last, melancholy few weeks of his life. It was none other than José María Espinosa who somehow caught the stress and despair of his last days when, facing

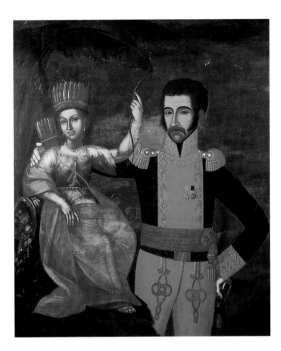

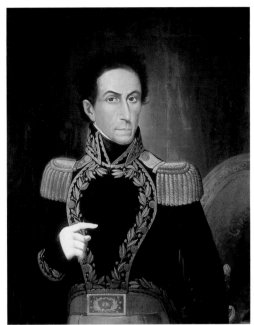

Fig. 3 *Bolívar con la alegoría de America* by Pedro José Figueroa. Oil on canvas, 1819. Casa Museo Quinta de Bolívar, Bogota, Colombia

Fig. 4 *Simón Bolívar* by Juan Lovera. Oil on canvas, c. 1835. The Historical Society of Pennsylvania Collection, Atwater Kent Museum of Philadelphia

political defeat, the Liberator headed for a self-imposed exile. He died at Santa Marta, Colombia, on December 17, 1830, waiting for passage to Europe. In all probability he never complained of having plowed on the ocean, as legend would have it. His last proclamation, however, reveals a deep disenchantment with the outcome of events. "Unite, unite," he pleaded with his countrymen, "or anarchy will devour you."

For all this iconographic abundance, Bolívar's physiognomy is elusive. All those who painted his portrait coincide in that he had dark black hair (definitely receding when Espinosa portrayed him in Santa Marta at age forty-seven). He was short, had bony, delicate features, and deeply set black eyes. Curiously, virtually all of his portraits show his favorite silver buckle with his initials, "SB."[14]

As the nations of Latin America turned a page on the independence movement, new genres and perspectives came into vogue. The miniature, light and portable, moved to center stage as a favored mode of representation with practitioners of excellence such as José María Espinosa (pls. 49 and 50, and p. 158) in New Granada (Colombia).[15] New national oligarchies, which more often than not included the military and political leadership of the independence wars, produced a host of new, worthy subjects of portrayal. In Brazil, the planters, landowners, intellectuals, politicians, and their families that acceded to nonhereditary titles often echoing the nation's lovely Tupi-Guarani place-names had their portraits done. In Venezuela, Lovera portrayed the members of the freshly minted postcolonial bourgeoisie: doctors, lawyers, and *licenciados*.[16] European academicism crept in while a magnificent tradition of popular portraiture rooted in colonial precedents struggled to be born.

An image that wonderfully captures the spirit of the age is the iconic circa 1812 portrait of the rebel priest Morelos by an unknown artist. Kept in the collections of Mexico's national historical museum at Chapultepec, this is the Morelos effigy that appears on banknotes (fig. 5).[17] Unlike Hidalgo, who was white, Morelos was a *mestizo*. The subject is represented within a classical oval cartouche surmounted by Mexico's eagle. The swarthy commander wears a flashy, gold-embroidered uniform as "generalissimo of the armies of America." A bandana is wrapped, turbanlike, around his head. The fierce, intense gaze and

Fig. 5 *José María Morelos y Pavón* by an unidentified artist. Oil on canvas, c. 1812. Museo Nacional de la Historia, CONACULTA-INAH, Mexico, D.F.

the hand resting on his baton's handle proclaim his determination. A chain with a cross made of gold and amethysts rests on his breast. Though thousands of miles removed, the Mexican Morelos portrait has remarkable affinities with the work being done by its contemporary, José Gil de Castro, in the shadow of the faraway Andes.

Painter of the Liberators

Bolívar, San Martín, and O'Higgins may be the great figures of the independence movement in Spanish South America but its great artist was a Peruvian-born mulatto who lived part of his life in Chile. Unlike the great liberators whose portraits he painted, José Gil de Castro y Morales (1785–1841)—*El Mulato Gil*—is far from a household name.[18] He should be better known. Castro was the contemporary of a group of racially mixed, mostly mulatto painters who made a remarkable contribution to Latin American art during the early 1800s. They include José Campeche (1751–1809) in Puerto Rico, Nicolás de la Escalera and Vicente Escobar (1762–1834) in Cuba, Fermín Gayoso in Buenos Aires,[19] and Juan Lovera in Venezuela. Campeche, a key figure in the history of Spanish American portraiture, is the subject of an essay by Teodoro Vidal in this volume.

Free colored people occupied a unique niche in late colonial society. Largely urban dwellers and victimized by both law and prejudice, it was not uncommon for them to gravitate toward those areas of the economy and the social network where opportunities existed. Thus they served in the militia and practiced traditional trades, such as carpentry and joinery, woodcarving, shoemaking, tailoring, and leatherwork. In the colonial Hispanic world, the dividing line between the artist and the artisan was often unclear, so music, sculpture, and painting—which were then considered trades—became favored occupations of the free colored community.

José Gil de Castro was born in the City of Kings—Lima's viceregal name—in September of 1785. He was the son of José Mariano Carvajal y Castro, a mulatto from Trujillo, and María Leocadia Morales, a freed black slave from Lima. His surname should have been "Carvajal" but his father gave him his own maternal surname, "Castro." In any case, "Gil" is a given name—as in "José Gil"—not a surname.

We know that Castro grew up in Trujillo and served in the regular militia—his father was a captain—but very little about his training as an artist. He may have studied under José del Pozo, one of the artists of Alejandro Malapina's expedition that visited Lima in 1796. (Malapina's team circumnavigated the globe on behalf of the Spanish Crown, collecting data and specimens for study.) Around 1807, give or take a year, he arrived in Santiago de Chile and set himself up as a *retratista*. His first commissions came from the Izquierdo family, some of whose members he portrayed before he became the "in" painter with the late colonial Chilean elite.

Castro did some religious scenes, but it is as a portrait painter that he has a claim to posterity. His oeuvre has a remarkable coherence; some might say a predictable sameness. His figures are for the most part stiffly posed according to a formula. He loved profiles and seemed to have a standard nose for everybody, regardless of gender. A wit once remarked that judging from Castro's work, all Chileans in 1810 must have looked like Bernardo O'Higgins's mother, Isabel Riquelme.[20] His portraits from time to time carry heavy drapes and prolix texts in cartouches in the colonial tradition. Couples painted in matching portraits are balanced, like mirror images.

José Manuel de Lecaros y Alcalde and his wife, Mercedes Alcalde y Bascuñán de Lecaros Alcalde (private collection, Santiago, Chile) lean their elbows on different corners of the same inlaid table while a print of the Virgin of Mercy hangs on the wall (curiously,

rendered in positive and mirror image versions for the sake of symmetry). Like a colonial *donante* portrait, the devotion to the Queen of Heaven is clearly signified but beware: the Virgin's presence is no longer at the center with the faithful devoutly kneeling around her. She is now just a print on the wall. The sitter, not the saint, moves resolutely to the foreground.[21]

A remarkable item now at the Museo Nacional de Bellas Artes in Santiago depicts Ramón Martínez de Luco y Caldera and his son José Fabián Martínez de Luco y de Andia y Varela. The elder Martínez de Luco is dressed in an elegant brown suit as befits a devotee of the Virgin of Carmel—he faithfully displays her scapular on his lapel—and wears a watch chain. Ramón married a daughter of Ignacio de Andia y Varela, a well-known Chilean sculptor, and had several children by her. He sits on an upholstered chair or settee (we only see the armrest), his left arm protectively resting on young José Fabián's shoulder. (The son, not more than four or five years old, is dressed in a cadet's tunic and white pants and holds a ball.)[22]

With his right hand, Martínez de Luco points to a text on the wall, visible behind a heavy mourning drape. *"Hijos míos queridos,"* reads the inscription, *"esta memoria, espera de buestro cariño, los sufrajios, p[o]r q[u]e tanto suspira, un P[adr]e que vien supo amaros"* (Do not forget me though I am gone, dear children: the father who loved you well expects your prayers for his soul). A form of prepaid soul insurance, no doubt, but any macabre association is dispelled by the portrait's lifelike quality. Young José Fabián seems ready to go play with his friends as soon as the paternal hand is lifted and the solemn, if contrived, tableau dissolves. Martínez de Luco is rather nattily dressed for a man engaged in so somber a charge.

Castro's portrait of José Raymundo Juan Nepomuceno de Figueroa y Araoz (pl. 43) is especially touching.[23] The sitter, a child, stands in the middle of a room. He is dressed in a military tunic with epaulettes and braids. (He was entitled to wear a cadet's military uniform on account of his father's status.) Children were often dressed like clerics in the colonial period; military gear seems a better fit for a martial age.

Behind José Raymundo, an extensive legend inscribed on a pilaster tells us, among other things, that the child was depicted holding a book and a ball at his own request. A table holds a purse, marbles, a document, and an inkwell. This serene tableau gives no clue—how could it?—to the tragic fate that awaited this child, so fond of his book and his toys.

In 1816, shortly after this portrait was made, little José Raymundo traveled to Spain with his father, a prominent royalist. The elder Figueroa contracted yellow fever and died in Panama. The child, then five years and five months old, was sent on to Spain alone. Without any family to turn to, he soon passed away also. The mother, Dolores Araoz, had stayed behind in Chile. She was pregnant with a second child, Francisco de Paula, when her husband and eldest son embarked for Spain. She was left with the portrait likeness of her lost child, a moving reminder of his fleeting encounter with life.

Castro's great breakthrough came when Chile's independence was secured following the Battle of Maipú (April 5, 1818). As the guns fell silent and the patriots settled into Santiago, he was on hand to record the likenesses of the heroes of the day, among them the Argentine liberator, José de San Martín, and Chile's own supreme director, Bernardo O'Higgins.

O'Higgins developed a friendship with the painter, who did several extraordinary portraits of him. In fact, Castro portrayed quite a few of the military and political figures of the day, including O'Higgins's finance minister, Hipólito Villegas, the minister of state, Custodio Amenábar, and Dr. Benjamín Vera y Pintado, composer of Chile's first national anthem. In 1829, O'Higgins appointed Castro "second cosmographer" to the supreme director, a title he would henceforth incorporate to his signature.

In 1820 the main theater of the independence wars shifted from the Southern Cone to the Peruvian viceroyalty itself. That same year Castro moved with his family to Lima, where he would spend virtually the rest of his life. It was there that he painted his first portrait of Bolívar from life, a landmark in the Venezuelan liberator's iconography. Castro's Bolívar (pl. 51) is based on earlier sittings and was conceived in a reverential mood. Like a saint of yore, Bolívar is offered up to the "veneration" on the people. "Peru remembers [its] heroic deeds venerating its Liberator," reads the bright red banner across the top of the portrait.

Bolívar was not the only one of the three great South American liberators that Castro captured on canvas. He enjoys the distinction of having painted state portraits of South America's "great three" from life: Bolívar, San Martín, and O'Higgins. This unique achievement has earned him renown as "the painter of the liberators."[24]

Transitional Portraits

Castro's stay in Peru was the occasion for his portrait of the "martyr," José Olaya, now in the Museo Nacional de Historia in Lima. Unlike the liberators, who were exalted personages, José Silverio Olaya Balandra was Everyman.[25] A fisherman from the Lima suburban town of Chorrillos, he supported the patriot cause during Lima's revolt against the Spanish on July 28, 1821, and served as a patriot spy. Captured by the royalists, he was tortured and executed in Lima's main square on June 29, 1822.

What makes this work especially remarkable is that for the first time in the history of South American art, a man of the people had been made the subject of such a painting. The work was ordered by the municipality of Chorrillos specifically to honor a local hero. It is virtually lifesize. Olaya is represented in an almost glorified fashion: he is dressed in his Sunday best, with fine shoes and a fancy hat. To ensure that no one missed the canonizing intent of the canvas, inscribed on a red banner is the text, *"El patriota D. José Olaya sirvió con Gloria a la Patria y honró el lugar de su nacimiento"* (The patriot Don Jose Olaya served the Fatherland with glory and honored his birthplace). The use of the honorific "don" denotes a recognition of Olaya's status.

The Olaya portrait is remarkable for its transitional quality. In that sense, it bears comparison with two other capital items of independence-era portraiture: the 1825 depiction of Policarpa Salavarrieta's execution in Bogota in 1817 and the 1812 Morelos portrait at Chapultepec.

Salavarrieta, Colombia's national heroine (she is honored on Colombian banknotes), was, like Olaya, of humble extraction.[26] A patriot spy, she was caught by the Spanish and summarily executed by firing squad. She was depicted, possibly from memory, conceivably from descriptions, by an anonymous artist around 1825 (fig. 6). The picture is rather small, almost like an ex-voto. A soldier pulls Salavarrieta along by a rope around her neck—the badge of those condemned to the capital penalty in the Spanish world. A friar seeks to minister to her. Her gaze is modestly turned downward in resignation while the chair in which she will be shot appears in the background. As art historian Beatriz Gonzalez has argued, it is ironic that a painting that was once considered either marginal or primitive in the worst sense, has been reevaluated as one of the key works in the history of Colombian art and a clear antecedent to the work of twentieth-century artist Fernando Botero.[27]

All three works share a colonial palette and compositional scheme. But their intent is completely new and, in a sense, profoundly revolutionary. Morelos is no bishop, and certainly no viceregal official, although he is inserted in a setting befitting either: he is a guerrilla priest. Salavarrieta is no Christian saint of yore being taken to her place of martyrdom although it might seem that way. She is a national heroine; a martyr indeed, but for her native

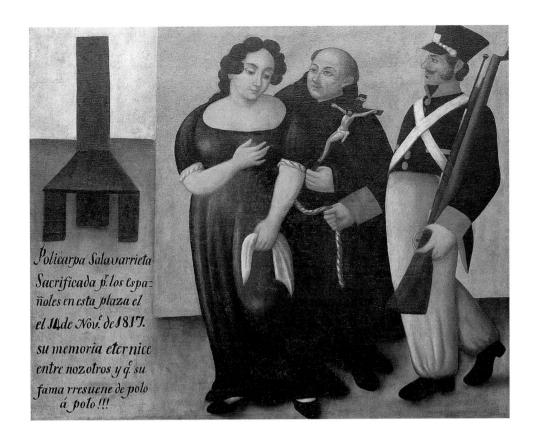

Fig. 6 *Policarpa Salavarrieta marcha al suplicio (Policarpa Salavarrieta Goes to Her Execution)* by an unidentified artist. Oil on canvas, c. 1825. Museo Nacional de Colombia, Bogota

land, not for her God. Olaya was an Indian who gave his life for his country and is represented in a setting that is saintly in all but name. He is offered up for veneration in a way that is completely unprecedented; not as a saint, of course, but as a *prócer,* a patriot, and a father of his country. No Indian, save for Inca royalty, was ever so portrayed in colonial Peru.

O'Higgins's Self-Portrait

Chile's supreme director was a remarkable man by all accounts, and an improbable liberator. O'Higgins was the illegitimate son of a viceroy. His father was an Irish-born soldier of fortune, Ambrosio O'Higgins, who had done well in Spain's service and risen to the highest office of colonial Peru. His mother was Isabel Riquelme, a member of colonial Chile's social elite. Castro painted her, a venerable and matronly lady fashionably dressed with a neoclassic gown. Her son Bernardo painted her also.

There was a great deal more to Bernardo O'Higgins y Riquelme than his red hair, military prowess, political genius, and tangled pedigree. He was an accomplished visual artist from whose hand several small-scale portraits are known, including the one mentioned above of his own mother. He learned to draw in London, during his early years as a cadet there. His head-and-shoulders self-portrait (fig. 7) bears comparison with his imposing state portrait by Castro (both in the Museo Histórico Nacional, Santiago). The former is intimate and introspective; the latter is monumental in concept, with O'Higgins standing like a colossus against a rugged Andean background.[28]

Independence in Miniature

Miniature portraits, an invention of sixteenth-century France, entered the viceregal Latin American art repertoire in the latter part of the eighteenth century. Early miniatures were done in watercolor or gouache on vellum. In the eighteenth century, the Venetian painter Rosalba Carriera revolutionized the genre by substituting a thin ivory plaque as the base for miniatures.[29] José Celestino Mutis, the leader of the Royal Botanical Expedition to the

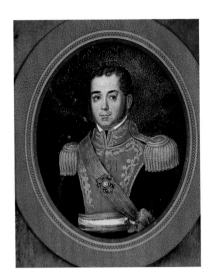

Fig. 7 *Bernardo O'Higgins* self-portrait. Oil on ivory, 1818. Museo del Carmen, Maipú, Chile

Fig. 8 *José María Espinosa* self-portrait. Watercolor on ivory, 1834. Museo Nacional de Colombia, Bogota

New Kingdom of Granada, pioneered the introduction of miniature techniques in Spanish South America. He had a practical end in mind: they were especially appropriate to the production of precise botanical illustrations. It worked. In 1808 the New Granadan savant Jorge Tadeo Lozano reported that Mutis had on file some six thousand illustrations of plants done in such techniques.

Miniature portraits became popular throughout Latin America until the advent of daguerrotypes. Small, vivid, sentimental, and relatively affordable, they were especially appropriate at a time of intense social mobilization matched by poor communications. As cameos, brooches, and forget-me-nots, they would prove especially appealing to a romantic age. Many portraits of the age of independence, in fact, were recorded as miniatures. The Museo Histórico Nacional in Buenos Aires has a remarkable series of miniatures of liberator José de San Martín's family.

The case of New Granada (the name was officially changed to Colombia in 1861) is particularly instructive. In all likelihood, no Latin American country cultivated the art of the miniature so assiduously, partially owing to the influence of Mutis and the Royal Botanical Expedition.[30] Colombia, moreover, was fortunate in having a remarkable self-taught miniature artist José Maria Espinosa (1796–1883) whom Beatriz Gonzalez calls "the central figure of Colombia's 19th century art" (fig. 8).

Espinosa was born in Bogota. As a young man he joined the insurgent forces of the Colombian "precursor of independence," Antonio de Nariño. Because of his youth, he was made *abanderado,* or standard bearer, of Nariño's small army, a title of which Espinosa was immensely proud. Essentially self-taught, he missed a promised opportunity to travel to Europe—Bolívar himself had promised him a subsidy to study art—as a consequence of the September 1828 attempt on Bolívar's life.

This exhibition features two extraordinary miniatures by Espinosa. One of them depicts General Francisco de Paula Santander (pl. 50), *el hombre de las leyes* (the man of the laws), vice president of the Republic of Colombia and later president of the Republic of New Granada (1832–37). A liberal icon, Bolívar's most distinguished rival, and Colombia's national hero, Santander is depicted in full military uniform, his head turned slightly to the right. His hair is fashionably combed, Brutus-style, forward over the forehead. The strength of the general's personality is palpable, and the likeness more than holds its own against the opulent frame in which the work is set.

The second miniature depicts a personage at the opposite end of Santander, both politically and ideologically. He was a conservative clerical rabble-rouser, Father Francisco Margallo y Duquesne (pl. 49). A charismatic preacher, Margallo was a sworn enemy of governmental secularism, especially the utilitarian ideas of the English philosopher Jeremy Bentham, which were then popular in liberal circles throughout Latin America. Espinosa has faithfully captured the wild expression; the zealot's intensity that impressed—and often scared—many who knew Father Margallo.

Imaging and Imagining

From vast canvases conceived in the ages-old tradition of the state portrait, to charming explorations of individual personality and domestic space, to remarkable miniatures, the age of Latin American independence left a rich legacy of effigies. The transitional nature of the period is evident in its portrait repertoire: colonial and often popular in form, revolutionary in intent.

Independence implied nationhood, but nationhood was more often than not inchoate or ill-defined. Discovering the new nations' identities, therefore, and constructing imaginaries capable of sustaining their aspirations became urgent. Images were clearly needed. *Costumbrismo*, a mixture of romantic landscape studies and anthropological illustration, flourished for a generation, roughly between 1830 and 1850. Ironically, many of the *costumbristas* were foreigners such as Jean Baptiste Debret, John Searle, and Johann Moritz Rugendas, who became enraptured by the continent's irresistibly picturesque appeal. *Costumbrismo* yielded classical landscapes and the generic, foundational icons of the emerging nationalities but few individual portraits. The Mexican *charro*, the Chilean *huaso*, and the River Plate *gaucho*—major keystones for the building of a national ethos—are all there.

The struggle for independence itself was a quarry from which national identity and national pride could be mined: the great epic of Latin America's birth and its dramatis personae. The national pantheon had been initially established by contemporary artists such as Espinosa in Colombia and Castro in Chile and Peru. It would be reworked again and again as the nineteenth century unfolded.

Seeking their inspiration in the independence wars, artists such as Arturo Michelena (1863–1898) and Martín Tovar y Tovar (1827–1907) in Venezuela, Alberto Urdaneta (1845–1887) in Colombia, Prilidiano Pueyrredón (1823–1870) in Argentina, Pedro Américo (1843–1904) in Brazil, Juan Manuel Blanes (1830–1901) in Uruguay, and others set out to illustrate their national books of Genesis. When no portrait existed of Uruguay's José Gervasio Artigas, for example, Juan Manuel Blanes created one. Artigas by Blanes, dressed like a *gaucho*, his legs spread and his arms folded, stands at the gate of Montevideo's Citadel, a hero for the ages. This is the Artigas of the Uruguayan imagination (and, with variations, the subject of his bronze statue at Eighteenth Street and Constitution Avenue in Washington, D.C., next to the Organization of American States building).

Mexico is a unique case. There, the independence epic was not as important a theme of nationalist nineteenth-century historical paintings as it was elsewhere in Latin America. Maybe nineteenth-century Mexican image-makers and nation-builders had a history too complex and problematic to deal with. Nineteenth-century Mexico did not exalt the independence epic because there was no independence epic that everyone could agree on.

Colombia had a liberator, and so did Ecuador, Peru, Venezuela, Argentina, and Chile, but who was Mexico's? Choose Hidalgo or Morelos, the clerical renegade and Indian rabble-rouser, and you lost the conservatives. (Lucas Alamán, the dean of Mexico's nineteenth-century conservative ideologues, witnessed Hidalgo's sack and burning of Guanajuato while hiding in a corner as a child. What he saw marked him for life.)[31] Choose the emperor Iturbide and you lost the liberals. It would not be until the time of the nominally liberal Porfirio Díaz (1886–1911), and especially the nominally revolutionary twentieth century, that these things would be sorted out—in Hidalgo and Morelos's favor, to be sure.

Where it was practiced, the visual re-creation and exaltation of the independence epic enjoyed significant official support. The Argentine dictator and nation-builder Juan Manuel de Rosas was Pueyrredón's patron. Tovar y Tovar was essentially the "court painter" of Antonio Guzmán Blanco, the "civilizing autocrat," long-serving dictator, and self-styled "Illustrious American, Pacifier and Regenerator" of Venezuela. The re-creation of independence within an emerging nationalist discourse, both in a literary and visual sense, was well enough done and well enough accomplished by the time of the centennial of independence in 1910. That, however, is another story.

Los Hermanos Servantes y Michaus

38 *The Servantes y Michaus Siblings*

José María Uriarte (Mexican, active 1800–1835)

Oil on canvas, 97.5 × 136 cm (38⅜ × 53⁹⁄₁₆ in.), 1814
Daniel Liebsohn, Mexico

The inscription on the left side of this painting tells us that this double portrait was commissioned by Martín Angel de Michaus, a lieutenant colonel and sergeant-major for the regiment of commerce, as well as the children's grandfather. When this image was created, José Juan was four-and-one-half years old, and his sister Guadalupe was nearly three-and-one-half. The artist, José Maria Uriarte, made full use of the neoclassical style, which is quite fitting, given the family's French background. In all likelihood Uriarte trained at the Academia de San Carlos in Mexico City, which was established in 1783. He subsequently served as director of the art academy at Guadalajara, where his most promising student was José María Estrada (see pl. 52). Uriarte is also known for his altarpieces, two of which are in California—one at the Mission San Diego (1809) and the other at San Gabriel (1810).

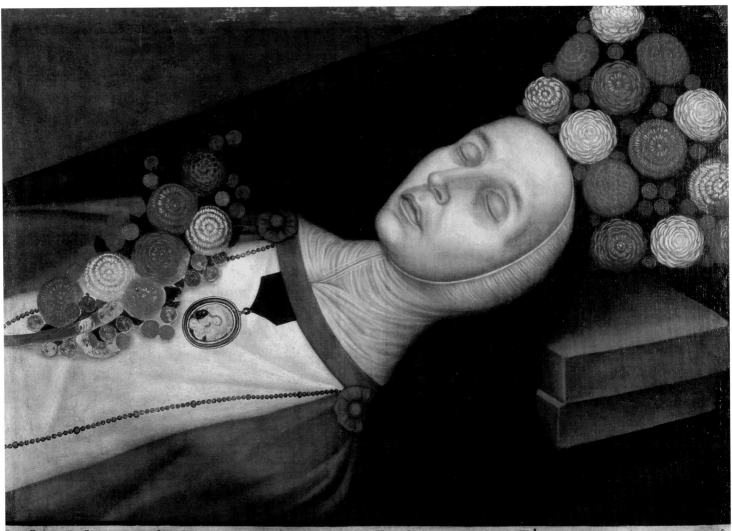

LA M.R.Mᴱ CATHARÍNA THEREZA DE Sᵀᵒ DOMÏNGO, RELIGIOSA EN ESTE Rᴸ MONASTERIO DE LA PURÍS SIMA CONCEPCION. MURIO SIENDO ABADESA DIA 2 DE AGOSTO DEL AÑO DE 1786, SIENDO DE EDAD DE .. AÑOS, Y 23 DIAS, Y 44 DE RELIGION. DIGNA DE PERPETUA MEMORIA POR SUS EXCLARESIDAS VIRTUDES

39 *María Catharína Theresa de Santo Domingo*

Attributed to Victorino García (Colombian, 1791–1870)

Oil on canvas, 54 × 68 cm (21¼ × 26¾ in.), 1809
Banco de la República, Bogota, Colombia

There were two occasions for which nuns' portraits were painted; both marked rites of passage. The first was on the occasion of her profession—when she assumed the veil and became the "bride of Christ." The second occurred after she died, thereby leaving this earthly world to enter paradise. Here, we see Madre María Catharína Theresa de Santo Domingo (d. 1786) laid out on her funerary bier. She wears the habit of a member of the Conceptionist order, and a medallion around her neck professing her devotion to the Virgin of the Immaculate Conception. A corsage of flowers rests on her chest, and she wears a floral crown—both symbolic of her rebirth through death.

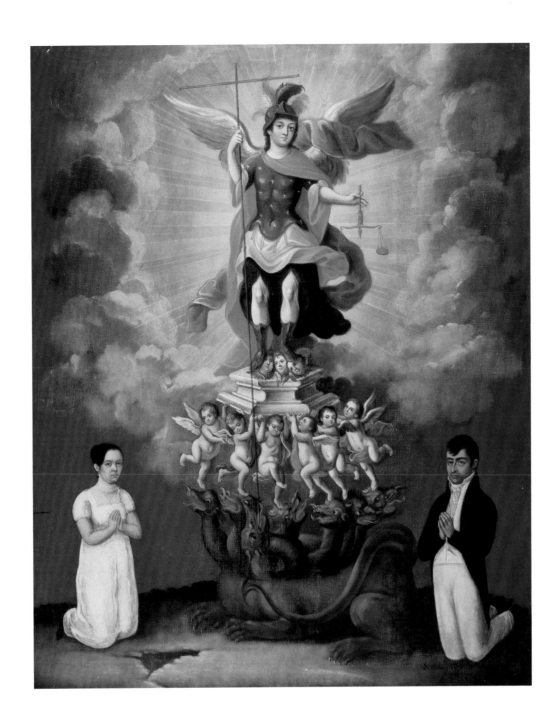

Matrimonio Hernández a Devoción de San Miguel Arcángel

40 *The Hernándezes Honoring Their Devotion to the Archangel Saint Michael*

Unidentified artist (Mexican school)

Oil on canvas, 91 × 73.5 cm (35¹³⁄₁₆ × 28¹⁵⁄₁₆ in.), 1818
Museo Soumaya, Mexico, D.F.

"Donor paintings," showing a religious figure flanked by portraits of devotees, or *donantes,* have been popular in Latin America from the beginning of the viceregal period. They were commissioned to show continuing devotion to a particular saint or to give thanks for a miracle or favor received. This painting, by an unknown artist, shows the recently married Hernández couple. Attired in typical *criollo* dress of the early nineteenth century, the couple kneel in devotion beneath a heavenly image of the archangel Saint Michael, who is supported aloft by a team of cupids. The motivation behind this painting is unknown. Perhaps it was in thanks for a successful courtship and marriage or for being safely guided through crises of health or war.

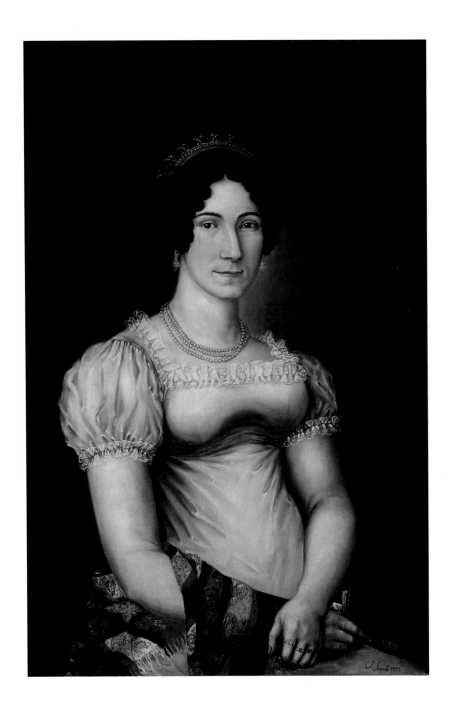

4I *Lucía Petrona Riera de López*

Jean Philippe Goulú (Argentine, 1786–1855)

Oil on canvas, 94.3 × 63.2 cm (37⅛ × 24⅞ in.), 1827
Museo Histórico Nacional, Buenos Aires, Argentina

Jean Philippe Goulú was born in Geneva, but probably studied in France. Like numerous French artists, he immigrated to Brazil in the second decade of the nineteenth century to become part of King João VI's court. While in Brazil, Goulú painted portraits of the monarch and taught his young daughters drawing. By the early 1820s, he had relocated to Buenos Aires, where he quickly came to know the city's important families. He is also credited with being the teacher of noted Argentinian artists Carlos Morel and Fernando García del Molino (pl. 62).

In 1822 Goulú painted the portrait of ardent patriot Vicente Lopez y Planes, who wrote the Argentinian national anthem in 1814. This portrait of his wife, Lucía Petrona Riera de López, done five years later, shows her wearing a neoclassically inspired Empire-style dress. Named after Napoleon Bonaparte's first reign (1804–15), this type of garment was itself a symbol of independence.

Agustín de Iturbide y Esposa Ana María de Huarte

42 *Agustín de Iturbide and His Wife Ana María de Huarte*

Bonpierre (nationality and lifedates unknown)

Gouache on ivory, approx. 6 × 7 cm (2⅜ × 2¾ in.), c. 1805
Private collection, Mexico, D.F.

Little is known about the presumably French artist who painted this miniature of Mexico's ephemeral imperial couple.

Agustín de Iturbide (1783–1824) was born in Valladolid (present-day Morelia), Michoacán. A *criollo,* he became a lieutenant in the Spanish colonial army in 1797, and married another *criolla,* Ana María Josepha de Huarte y Nuñiz (1786–1861), in 1805. By 1813 he had been promoted to colonel of the Spanish colonial regiment in Celaya. The following year he helped defeat José María Morelos's insurgent army.

Seven years later, in 1821, Iturbide led Mexico's proclamation of independence and had himself declared emperor. He was crowned in 1822 but abdicated less than a year later with Mexico in a state of crisis. He went into exile in Europe, but encouraged by supporters in Mexico, he returned in 1824, was arrested, and was executed.

Iturbide presented this double portrait to his new bride on their wedding day.

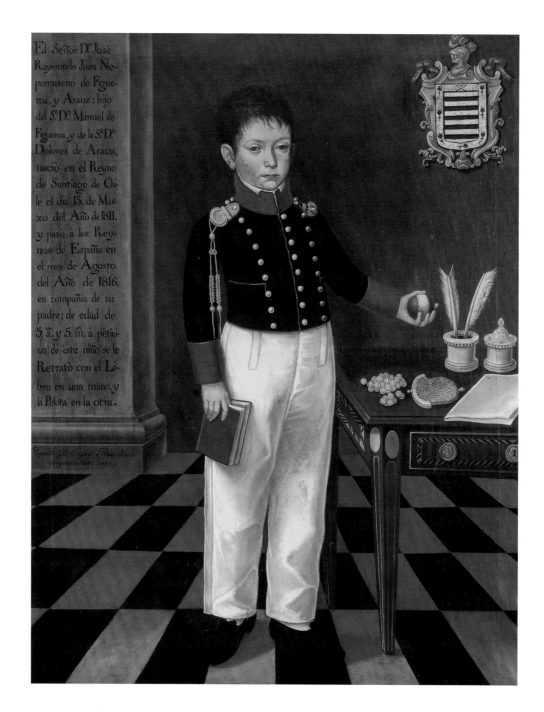

43 *José Raymundo Juan Nepomuceno de Figueroa y Araoz*

José Gil de Castro (Peruvian, 1785–1841)

Oil on canvas, 135 × 99 cm (53⅛ × 39 in.), 1816
Roberto Palumbo Ossa, courtesy of Galería Jorge Carroza, Santiago, Chile

José Raymundo Juan Nepomuceno de Figueroa y Araoz's brief life (1811–1816) had a tragic ending. In 1816, he and his father, Don Manuel, left Chile for Spain. The elder Figueroa died of a fever in Panama, and his little son, rather than being returned to his mother in Chile, was sent on to Spain alone, where he died shortly thereafter.

José Raymundo was all of five years and five months old when he posed. He already had a mind of his own; we learn from the painter's extensive inscription on the pilaster that he is portrayed with a ball in one hand and a book in the other because that is the way he wanted it. The painting itself was undoubtedly originally commissioned as a memento for his pregnant mother.

Peruvian-born José Gil de Castro made his reputation in Chile, painting its independence heroes and members of its socially well-connected families.

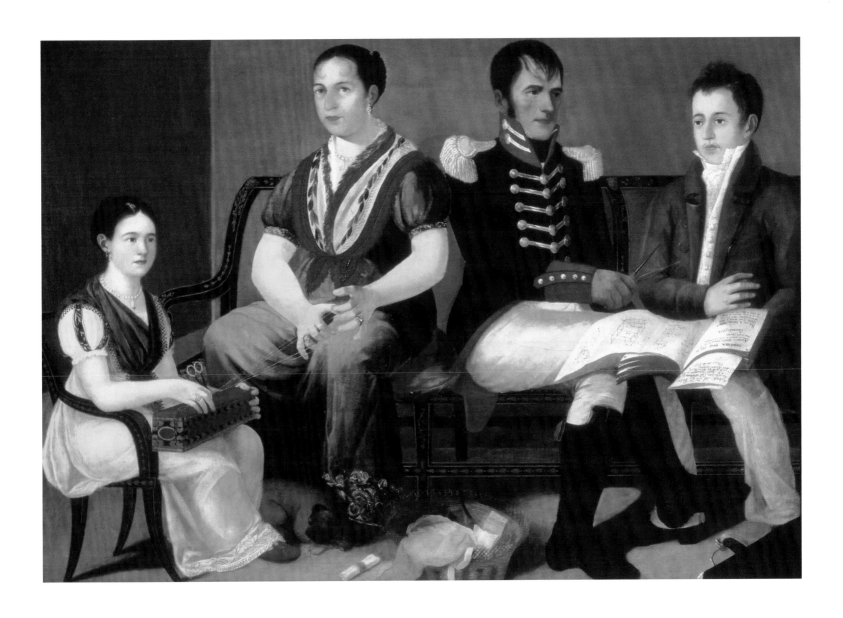

Capitán Pedro Márquez Gutiérrez y Su Familia

44 *Captain Pedro Márquez Gutiérrez and His Family*

Unidentified artist (Mexican school)

Oil on canvas, 144.5 × 202 cm (56⅞ × 79½ in.), 1815
Museo Soumaya, Mexico, D.F.

We do not know the identity of the artist of this painting; however, his or her vernacular style suggests someone informally trained. Among other things, this portrait of a *criollo* family is an interesting study in the sexual division of labor at the beginning of the viceregal period. The left side of the painting shows mother and daughter carefully making lace, while the family dog sleeps at their feet. On the right side, the father and son review lessons related to the mathematical sciences, perhaps geometry. Curiously, the husband and wife are turned away from each other in a manner that bifurcates the painting, creating two vignettes of family life instead of one.

49 *Francisco Margallo y Duquesne*

José María Espinosa Prieto (Colombian, 1796–1883)
Watercolor on ivory, 6.5 × 5.5 cm (2⁹⁄₁₆ × 2³⁄₁₆ in.), 1837
Museo Nacional de Colombia, Bogota

This miniature represents a controversial figure of Colombia's early national history: Francisco Margallo y Duquesne (1765–1837). A firebrand preacher and tireless polemicist, Father Margallo was especially critical of utilitarian thought as the basis for the nation's educational system and proposed a brand of fundamentalist Catholicism as the alternative. He was also a bitter enemy of New Granadan President Francisco de Paula Santander (pl. 50).

José María Espinosa portrayed Father Margallo in a strange pose. He has captured something of the zealot's intensity in the jaundiced complexion, the limp mane of white hair, and the half-shut eyes, perhaps to indicate that Margallo was already dead when the portrait was made. Margallo died in Bogota on May 23, 1837. One of his pallbearers was none other than Santander himself.

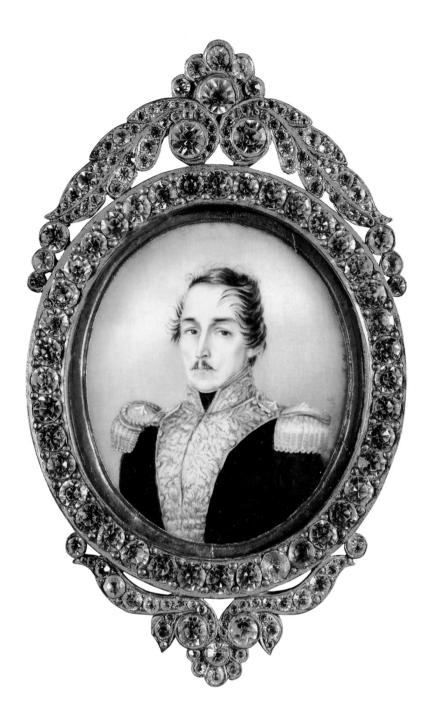

50 *Francisco de Paula Santander*

José María Espinosa Prieto (Colombian, 1796–1883)
Oil on ivory, 14.7 × 8.9 cm (5¹³⁄₁₆ × 3½ in.), 1840
Museo Nacional de Colombia, Bogota

General Francisco de Paula Santander (1792–1840) was a key figure in the Latin American independence movement. He is said to represent Colombia's liberal and democratic tradition, in contrast to Simón Bolívar's militarism and authoritarianism. The debate about their contrasting personalities and legacies has been an enduring one in Colombia.

Santander served as the vice president of the Republic of Gran Colombia (which included what is today Venezuela, Colombia, Ecuador, and Panama) between 1821 and 1827. While originally supportive of Bolívar's policies, he eventually became the Liberator's adversary. Following the failed attempt on Bolívar's life in September 1828, Santander went into exile, but in 1832 he became independent New Granada's (present-day Colombia) first president.

This miniature is iconic and is essentially the Santander effigy that appears on Colombia's banknotes.

5I *Simón Bolívar*

José Gil de Castro (Peruvian, 1785–1841)
Oil on canvas, 237 × 167 cm (93⅝ × 65¾ in.), 1830
Museo Nacional de Arqueología, Antropología, e Historia del Perú, Instituto Nacional de Cultura, Lima

Like his politics and religion, Simón Bolívar's (1783–1830) aspect has led to much debate. Contemporary portraits, for example—let alone posthumous ones—show a nuanced range of physiognomy, from dark- to light-skinned. José Gil de Castro first caught him at the onset of an ascendant phase leading to the battles of Junín and Ayacucho in 1824 and the creation of Bolivia in 1825. From there, Bolívar went essentially downhill, beset by crises and poor health, until his death in 1830.

Castro's portraits are a landmark in the Liberator's iconography. This posthumous one shows Bolívar in a formal state setting, and points to the kind of hero worship he would receive from posterity. The banner text reads: "Peru remembers the heroic deeds honoring its Liberator," and, further down, "he was admirable for his courage, integrity and citizenship, worthy of emulation by Americans."

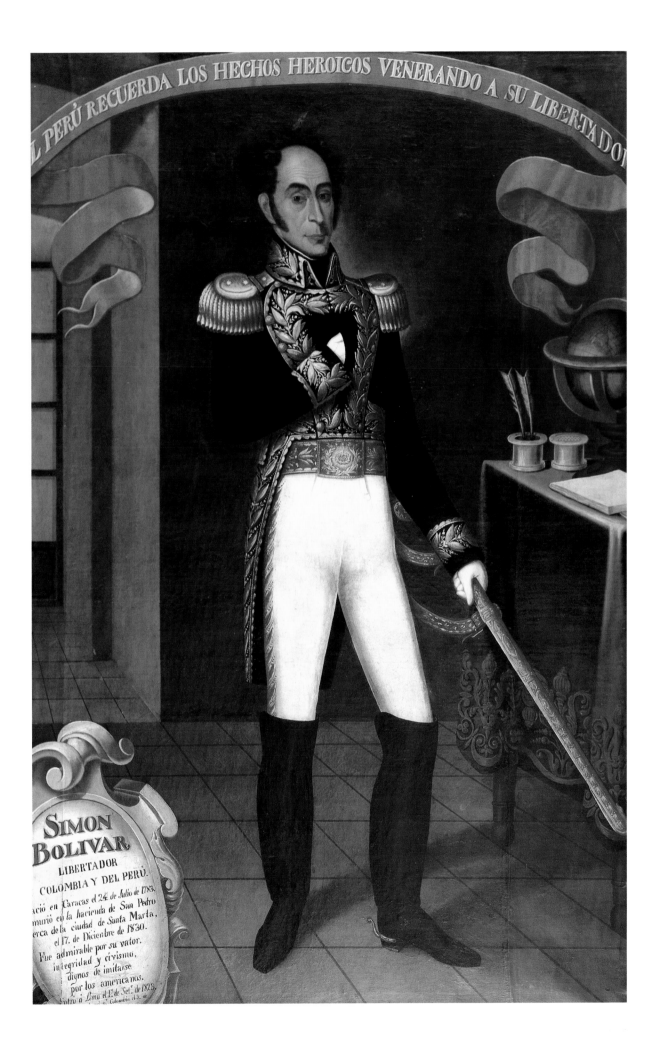

EL PERÚ RECUERDA LOS HECHOS HEROICOS VENERANDO A SU LIBERTADOR

SIMON
BOLIVAR
LIBERTADOR
COLOMBIA Y DEL PERÚ.
...ació en Caracas el 24 de Julio de 1783.
...murió en la hacienda de San Pedro
...erca de la ciudad de Santa Marta,
el 17 de Diciembre de 1830.
Fue admirable por su valor,
integridad y civismo,
dignos de imitarse
por los americanos.
...ntro á Lima el 1.° de Set.° de 1823.
...Colombia el 3. ...

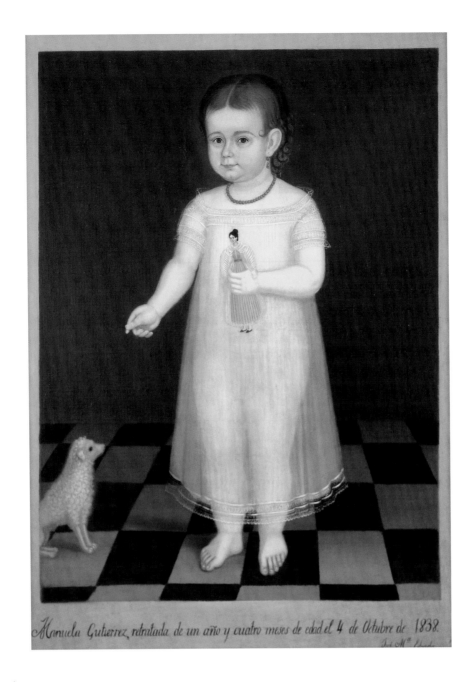

Manuela Gutiérrez retratada de un año y cuatro meses de edad el 4 de Octubre de 1838.
Jose Mª Estrada

Manuela Gutiérrez (La Niña de la Muñeca)

52 *Manuela Gutiérrez (Girl with a Doll)*

José María Estrada (Mexican, c. 1810–c. 1862)

Oil on canvas, 97 × 71 cm (38³⁄₁₆ × 27¹⁵⁄₁₆ in.), 1838
Museo Nacional de Arte, CONACULTA-INBA, Mexico, D.F.

Guadalajara-born José María Estrada studied art under José María Uriarte (see pl. 38), a miniature
painter and director of painting at the Academy of Fine Arts in Jalisco. Estrada is best known as a
prolific portrait painter in the Guadalajara area, but he painted religious themes and historical scenes
as well.

Estrada's portrait of Manuela Gutiérrez (b. 1837) is typical of his provincial style and closely
aligns his work to popular portraiture of the first half of the nineteenth century in other parts of
Mexico, the United States, and elsewhere. But for the culturally specific details of dress and accoutre-
ment, one would mistake this painting as being by a nineteenth-century limner painter from Con-
necticut or New York State. The sitter's frontal gaze and interaction with toys and pets are typical of
Estrada's work and are very effective at bringing the viewer into the scene.

Poblana con Ramito de Rosas

53 *Woman from Puebla with Small Bouquet of Roses*

Unidentified artist (Mexican school)

Oil on canvas, 87 × 65.5 cm (34¼ × 25¹³⁄₁₆ in.), mid-nineteenth century
Museo Nacional de Arte, CONACULTA-INBA, Mexico, D.F.

The number of locally trained or self-taught artists in Mexico increased exponentially in the mid-nineteenth century. This phenomenon attests to the growth of art schools throughout the country, as well as the diminution of the presence of European-trained artists following the severing of close political ties with Spain and France.

This anonymous painting, with its strong calligraphic quality, bold colors, forms that lack traditional modeling, and shallow space that eschews traditional perspective, has much in common with the work of José María Estrada (see pl. 52)—perhaps the best known of the mid-nineteenth-century artists who did not train in Europe or seek to emulate Continental style. When early-twentieth-century Mexican painters sought to create an art that would express their country's indigenous traditions, among the precedents they admired were the works of the "primitives," such as this artist.

LA R. M.ᵉ MARIA TERESA DE LA SMA. TRINIDAD
Carmelita descalza del Conv.ᵗᵒ de Guatemala. Fueron sus Padres el Sor. Marques D.ⁿ Juan
Fermin de Aycinena, y la Sra. Marquesa D.ᵃ Maria Micaela Piñol.
Nació el 15 de Abril de 1784. Tomó el habito el 21 de Noviembre de 1807. Profesó en 24 de
Noviembre de 1808, y murió en 29. de Noviembre de 1841.

54 *Sor María Teresa de la Santísima Trinidad*

Unidentified artist (Guatemalan school)

Oil on canvas, 83 × 63.8 cm (32¹¹⁄₁₆ × 25⅛ in.), early nineteenth century
Museo Soumaya, Mexico, D.F.

This portrait could have been painted on the occasion of Sor María's (1784–1841) profession as a member of the Carmelite order at the age of twenty-four, but judging from the text, it was probably done about the time of her death. She is shown here in the Carmelite habit, holding a richly embroidered scapular. Both of her hands bear marks of the stigmata of Christ, symbolizing her identification with his suffering. She also wears a rosary around her neck.

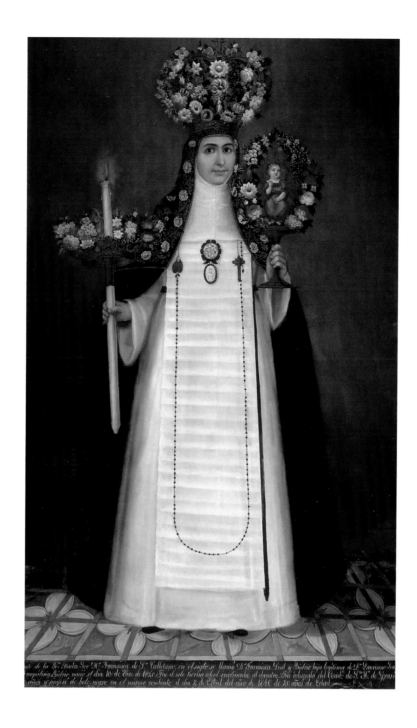

55 *Sor María Francisca de San Calletano*

Félix Zárate (Mexican, active 1788–1847)
Oil on canvas, 197 × 121 cm (77⁹⁄₁₆ × 47⁵⁄₈ in.), c. 1840
San Antonio Museum of Art, Texas

Félix Zárate was a well-respected painter from Jalisco in the first half of the nineteenth century, but we know little else about him. The Museo Regional de Guadalajara owns several of his works, and the San Antonio Museum of Art holds his 1822 portrait of Emperor Agustín de Iturbide.

Born Francisca Leal y Bidrio, Sor María (b. 1820) came from a well-known Jalisco family. A full-length portrait of her mother (1852) by Guadalajara artist José María Mares is known. Sor María is shown as a "crowned nun" wearing the Dominican habit and a rosary. A disc with the Dominican emblem and a depiction of Saint Dominic of Guzman hangs from her habit. She carries a lit candle, a symbol of fidelity, and an image of the Christ child. Her crown represents victory over sin and contains images of the Immaculate Conception, her patron saint, Saint Cajetan, and an unidentified figure.

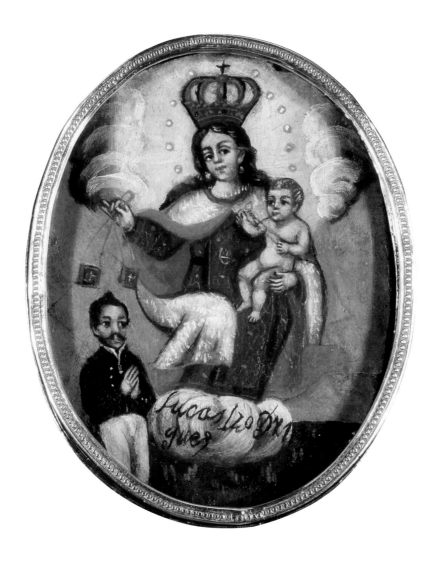

Nuestra Señora del Carmen con Lucas Rodríguez

56 *Our Lady of Carmel with Lucas Rodríguez*

Unidentified artist (Peruvian school)

Oil on metal, silver frame, 10 × 9 cm (3¹⁵⁄₁₆ × 3⁹⁄₁₆ in.), 1830–50
Brooklyn Museum of Art, New York; Frank L. Babbott Fund, Frank Sherman Benson Fund, Carll H. de Silver Fund,
A. Augustus Healy Fund, Carolyn A. L. Pratt Fund, Charles Stewart Smith Memorial Fund, and the Ella C. Woodward
Memorial Fund, 48.206.37

In the Christian world, the veneration of relics gave rise to reliquaries—receptacles in which items associated with religious figures could be housed, carried, and honored. In the Iberian colonial world, the word *relicario* referred to a wide range of devotional images, for the most part small and meant to be worn. Many of these images carry portraits of the devotees as well as the holy person in question. Some religious orders incorporated such items in their habits.

A miniature representation from Peru of the Virgin of Carmel (pl. 56) shows a man identified as Lucas Rodríguez kneeling next to the Virgin. Another, from present-day Bolivia (pl. 57), shows the crucified Christ receiving the devotion of a young woman.

Closely related to *relicarios* are *ex-voto* images, or votive offerings. Some are painted depictions of miraculous events. Others are sculpted and represent ailing body parts cured by supernatural intervention. These latter votive objects, referred to as *milagros,* are usually attached to the image of the holy person being acknowledged. Most of these diminutive offerings are generic and mass-produced. This small silver sculpture (pl. 58), however, is signed with the initials "FX" on the back and may have been made to order as a portrait of the donor.

Relicario de la Crucifixión con Donate

57 *Reliquary of the Crucifixion with Donor*

Unidentified artist (Bolivian school)

Oil on tin, 11 × 7.5 cm (4�5⁄₁₆ × 2¹⁵⁄₁₆ in.), mid-nineteenth century
San Antonio Museum of Art, Texas

58 Hombre Orando Ex-voto

Praying Man Ex-Voto

Unidentified artist (Bolivian school)

Silver, 6.5 cm (2⅝ in.) height, mid-nineteenth century
San Antonio Museum of Art, Texas

Mulher de Bahía

59 *Woman from Bahía*

Unidentified artist (Brazilian school)

Oil on canvas, 98 × 79 cm (38⅞ × 31⅛ in.), mid–nineteenth century
Museu Paulista da Universidade de São Paulo, Brazil

This image of a regal Afro-Brazilian woman from the Bahía region of northeastern Brazil is a rare example of nineteenth-century South American portraiture. The sitter's elegant bearing and the richness of her attire suggest that she may have been a slave in a wealthy household or the free daughter of slaves. Her sumptuous jewelry was probably made from gold extracted from one of Brazil's great gold mining centers such as Minas Gerais and fashioned using techniques traced back to the gold-smithing regions of West Africa.

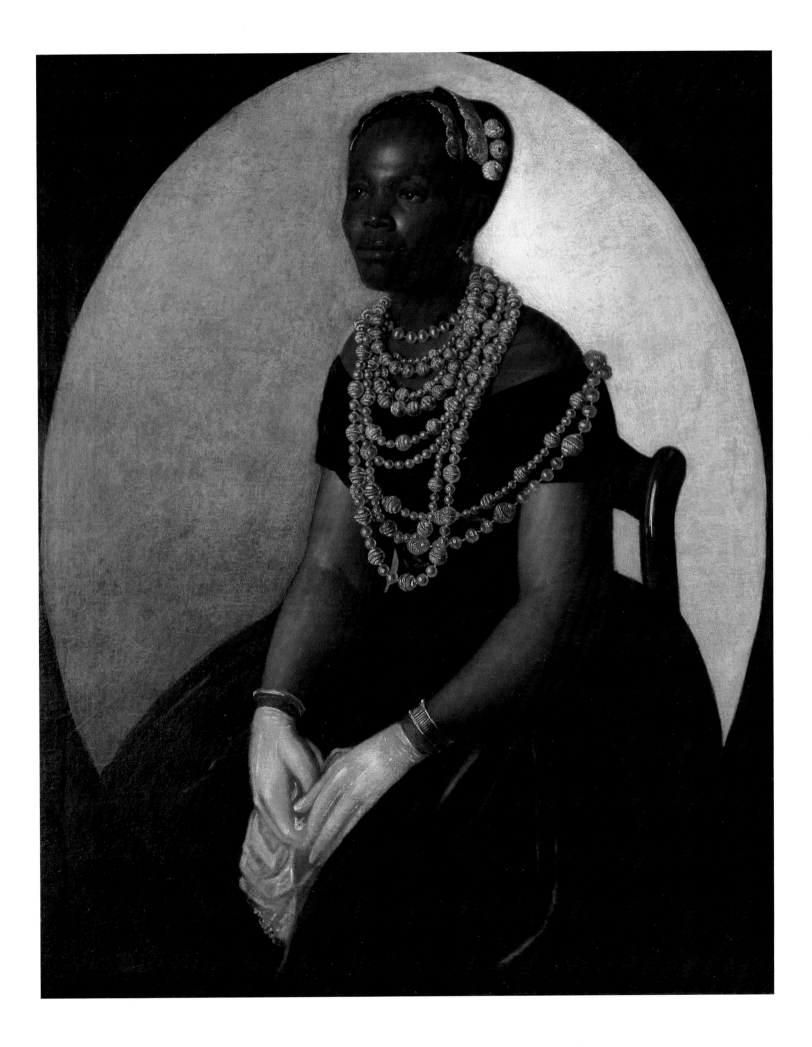

Intrépido Marinheiro Simão, Carvoeiro do Vapor *Pernambucana*

60 *The Brave Sailor Simão, Coalman of the Steamship* Pernambucana

José Correia de Lima (Brazilian, 1814–1857)

Oil on canvas, 93 × 72.6 cm (36⅝ × 28⁹⁄₁₀ in.), c. 1857
Museu Nacional de Belas Artes/IPHAN/MinC, Rio de Janeiro, Brazil

José Correia de Lima, a student of Jean Baptiste Debret (1768–1848), was one of the first Brazilian pupils to enter the Academy of Fine Arts when it was launched in 1826. The precocious student followed his master into the chair of history painting at the academy when Debret returned to France. Correia de Lima's career bears witness to the extraordinary impact the French mission of 1816 had in the development of Brazilian art during the nineteenth century. Correia de Lima excelled as a painter of historical themes, a skill much in demand in the context of emerging Brazilian nationalism.

The sitter is an Afro-Brazilian sailor, Simão, who served aboard the steamship *Pernambucana*. The vessel foundered off the coast of Santa Catarina, and Simão saved numerous lives. His right hand holds a rope, a reference to his trade.

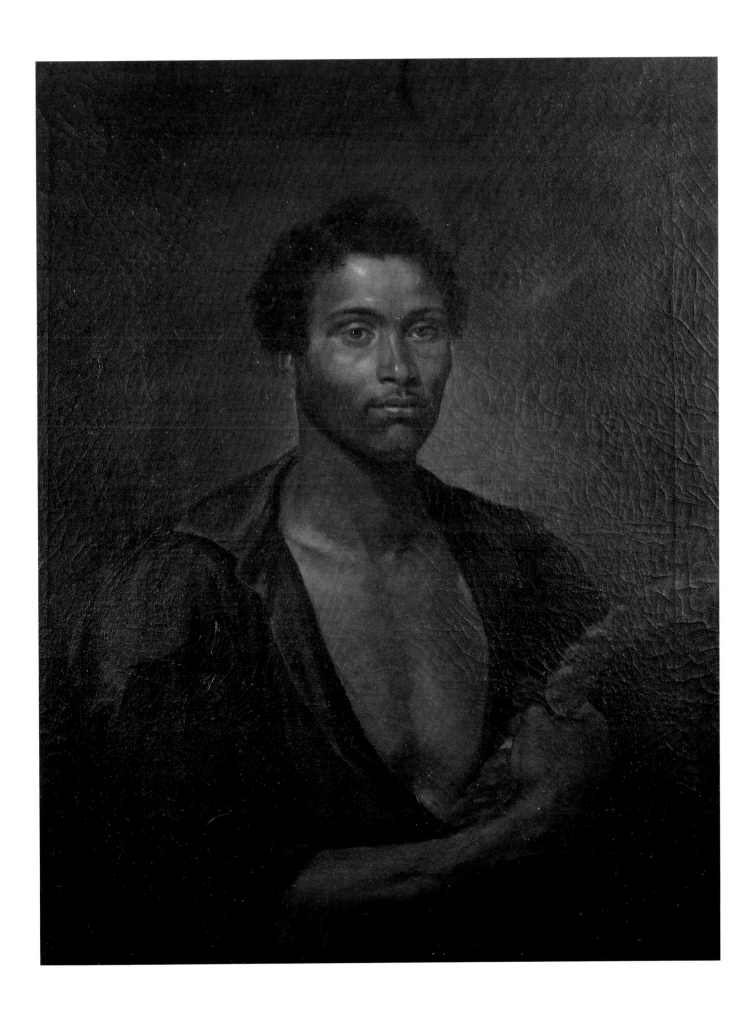

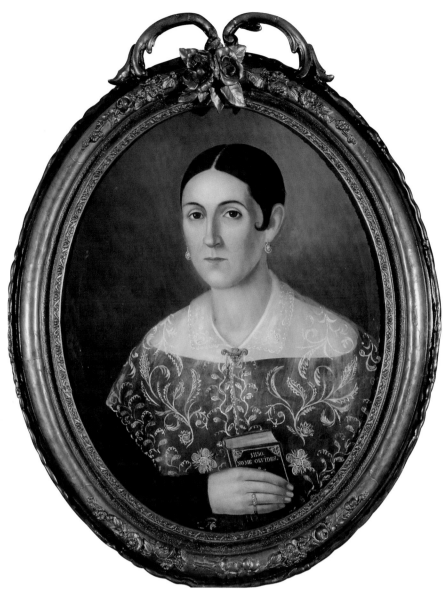

61 *Cirila Suárez y Lacasa de Roballos*

Isaac Fernández Blanco y Rodrigo (Argentinian, 1818–1867)
Watercolor on ivory, 16 × 8 cm (6⁵⁄₁₆ × 3⅛ in.), 1847
Museo de Arte Hispanoamericano Isaac Fernández Blanco, Buenos Aires, Argentina

62 *Cirila Suárez y Lacasa de Roballos*

Fernando García del Molino (Argentinian, 1813–1899)
Oil on canvas, 84 × 70 cm (33¹⁄₁₆ × 27⁹⁄₁₆ in.), 1850
Museo de Arte Hispanoamericano Isaac Fernández Blanco, Buenos Aires, Argentina

Fernando García del Molino was among the first generation of Argentinian artists who received their artistic training in Buenos Aires. Born in Santiago, Chile, Molino moved with his family to Argentina in 1819. The inscription on Molino's 1850 self-portrait states that he had not studied with any master. In truth, beginning in 1828, he had taken drawing lessons at the University of Buenos Aires, at the art school taught by disciples of Joseph Guth, a Swiss artist.

By midcentury, Molino, like his contemporary Prilidiano Pueyrredón (1823–1870), had ingratiated himself with dictator Juan Manuel de Rosas. In addition to de Rosas's family, his commissions came from the military and the well-connected in Buenos Aires. The inscription on the small gilt-edged book that the sitter holds reads "*No me olvides,* 1850" ("Do not forget me"), which suggests that this modest canvas could be a memorial portrait. It may well have been based on the 1847 miniature (pl. 61) also in the museum's collection.

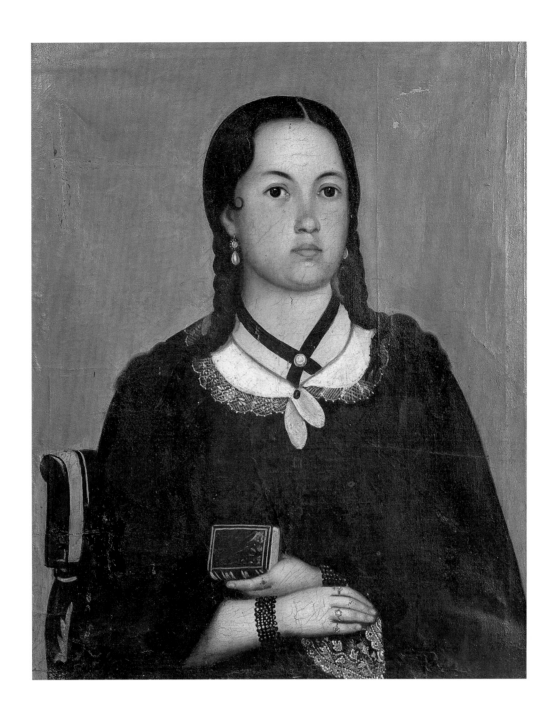

Esposa de Francisco Cevallos

63 *Wife of Francisco Cevallos*

Unidentified artist (Quito school)

Oil on canvas, 39 × 32 cm (15⅜ × 12⅝ in.), mid-nineteenth century
Casa de la Cultura Ecuatoriana, Quito

In this serene, haunting portrait, a serious but lovely young woman sits calmly in what is known in the United States as a Hitchcock chair. We know very little about her beyond the fact that she was the wife of Francisco Cevallos. She holds a prayer book in her left hand; on her right hand she wears a wedding ring. In fact, she displays quite an array of jewelry, including several rings, a set of pearl earrings, a ribbon, and two bracelets. Her hair is modestly parted in the middle and braided, but a curl next to her ear introduces a coquettish note. A lace collar and an exquisite little handkerchief complete her ensemble. Her conservative black dress suggests the almost convent-like sobriety of nineteenth-century Quito fashion, which contemporary travelers such as Friedrich Hassaurek often commented upon.

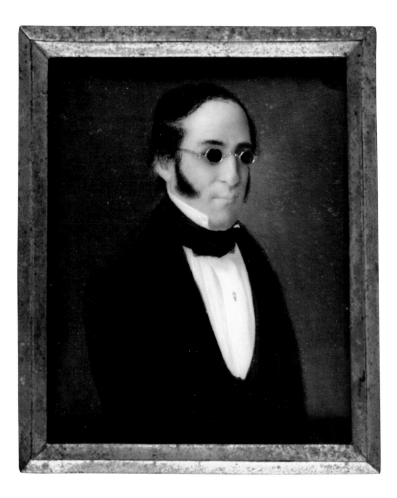 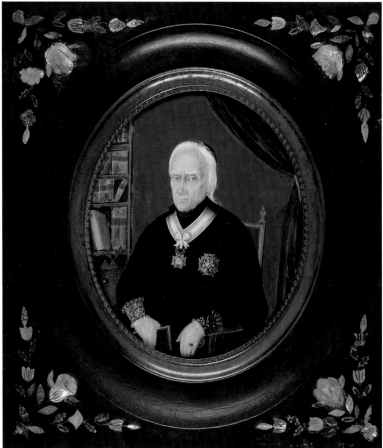

Caballero con Lentes de la Familia Canals

64 *A Gentleman of the Canals Family Wearing Spectacles*

Unidentified artist (Puerto Rican school)

Watercolor on ivory, 7.3 × 5.8 cm (2⅞ × 2⁵⁄₁₆ in.), 1840–55
Smithsonian American Art Museum, Washington, D.C.; Teodoro Vidal Collection

65 *Don José Gutiérrez del Arroyo y Delgado*

Unidentified artist (Puerto Rican school)

Watercolor on ivory, 9.2 × 7.3 cm (3⅝ × 2⅞ in.), 1843
Smithsonian American Art Museum, Washington, D.C.; Teodoro Vidal Collection

While the vast majority of miniatures, like that representing a member of the Canals family, are personal reminders of a loved one, the portrait of Puerto Rican Don José Gutiérrez del Arroyo y Delagdo (1757–1851) has the appearance of an official portrait created to memorialize the subject's position and professional success. Gutiérrez, shown seated in a book-lined study, was dean of San Juan Cathedral as well as Knight Commander of the American Royal Order of Queen Isabella I of Spain, whose medal he wears. Regrettably, nothing is known about the artists of these two images, although they both attest to the vitality of miniature painting in Puerto Rico in the mid-nineteenth century.

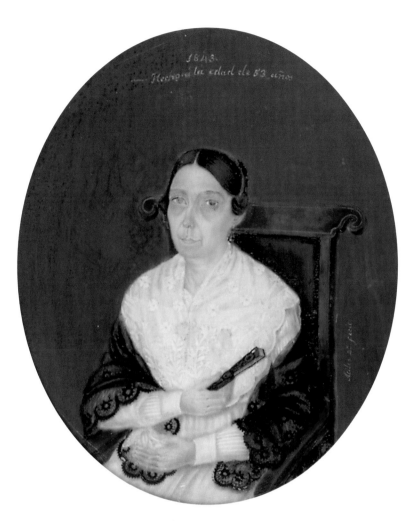

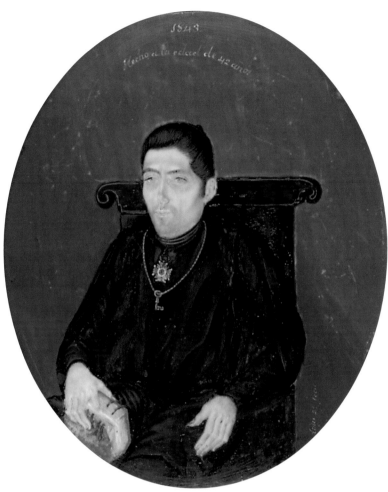

Dama Desconocida

66 *Unknown Lady*

Ramón Atiles y Pérez (Puerto Rican, 1804–1875)

Watercolor on ivory, 9.2 × 7.3 cm (3⅝ × 2⅞ in.), 1843
Smithsonian American Art Museum, Washington, D.C.; Teodoro Vidal Collection

Clérigo Desconocido

67 *Unknown Cleric*

Ramón Atiles y Pérez (Puerto Rican, 1804–1875)

Watercolor on ivory, 9.2 × 7.3 cm (3⅝ × 2⅞ in.), 1843
Smithsonian American Art Museum, Washington, D.C.; Teodoro Vidal Collection

Ramón Atiles y Pérez, who signed these miniatures, was born in Ponce, Puerto Rico, and died there as well. An 1841 San Juan newspaper advertisement suggests that he also worked there. The cleric in this portrait has yet to be identified, although he is wearing the cross of the American Royal Order of Queen Isabella I of Spain, awarded for distinguished service to the Spanish Crown. The portrait of the woman was presumably painted as a pendant to that of the priest. She was possibly his sister, and perhaps a major donor to the church with which the priest was affiliated.

68 Dama con Peineta Vestida de Rojo
Lady in Red with a Head Comb

Unidentified artist (Peruvian school)

Oil on ivory, 8 × 5 cm (3⅛ × 1¹⁵⁄₁₆ in.), early to mid-nineteenth century
Colección Lambarri-Orihuela, Cuzco, Peru

69 *Joven Criolla*

Unidentified artist (Puerto Rican school)

Watercolor on ivory, 7.3 × 5.8 cm (2⅞ × 2⁵⁄₁₆ in.), c. 1860
Smithsonian American Art Museum, Washington, D.C.;
Teodoro Vidal Collection

Little is known about these four miniatures, although their diverse geographic origins testify to the widespread fascination with miniatures throughout Latin America, Mexico, and the Caribbean during the nineteenth century. The miniatures of the woman in the red dress from Peru, that of the Mexican woman with the elegant shawl, as well as that of the woman with the fashionable hairstyle from Puerto Rico, were probably commissioned by the husbands of these young women to remind them of their loved ones when they were on an extended journey. The Mexican miniature of the deceased young woman clearly commemorates the tragedy of her early death. She is shown wearing a scapular, probably containing the image of Our Lady of Carmel. According to legend, the Virgin of Carmel promised her intercession to those who wore her pendant loyally and died wearing it.

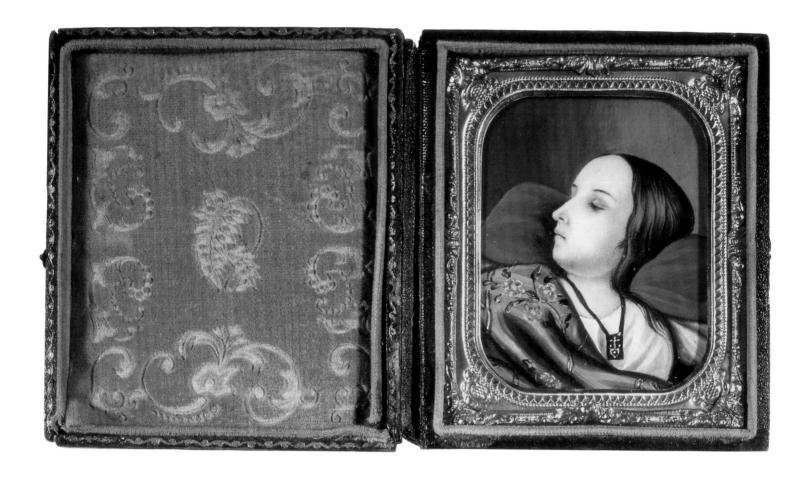

Retrato de Dama Muerta

70 *Death Portrait of a Lady*

Unidentified artist (Mexican school)

Gouache on bone, 7.6 × 6.4 cm (3 × 2½ in.), 1850
Museo Soumaya, Mexico, D.F.

Retrato de Dama

71 *Portrait of a Lady*

Attributed to Francisco Morales van den Eynden
(Mexican, 1811–1884)

Oil on bronze, 8.3 × 6.8 cm (3¼ × 2¹¹⁄₁₆ in.), c. 1860–70
Museo Soumaya, Mexico, D.F.

72 *Fray Francisco Rodríguez, Padre de Cocula*

Abundio Rincón (Mexican, active 1823–1885)

Oil on canvas, 245 × 120 cm (96⅞₆ × 47¼ in.), 1853
Museo Regional de Guadalajara, CONACULTA-INAH, Mexico

In this painting of a bespectacled village priest from Cocula, a village southwest of Guadalajara, artist Abundio Rincón (see also pl. 76) captures the distinctive physical appearance of Fray Francisco. He has also painted him in an environment filled with information about the sitter. Fray Francisco was a member of the Franciscan order, as noted by his name, his blue habit with corded sash, and the tabletop crucifix. The regional Franciscan church and the related buildings where he served appear in a delightful painting hanging on the wall in the background. Finally, the book in his hand and those resting on the table indicate that much of his life was spent as a teacher and scholar.

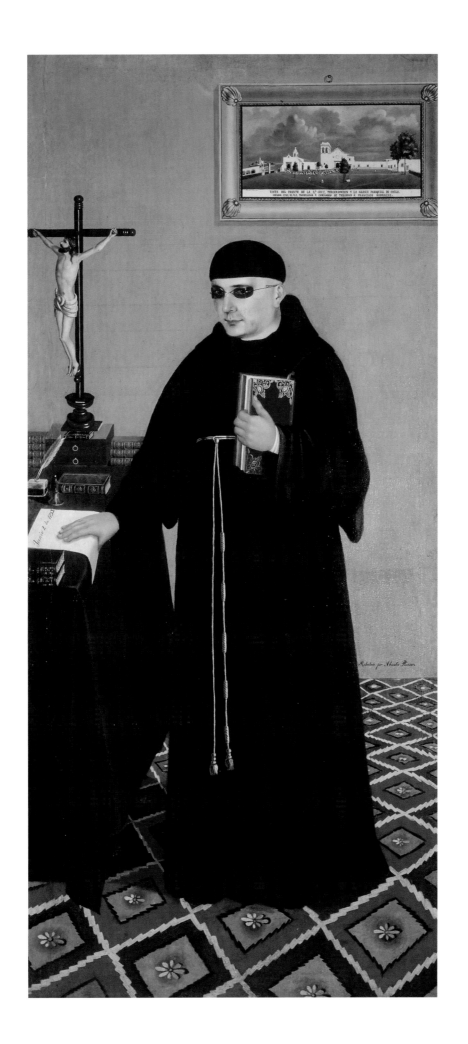

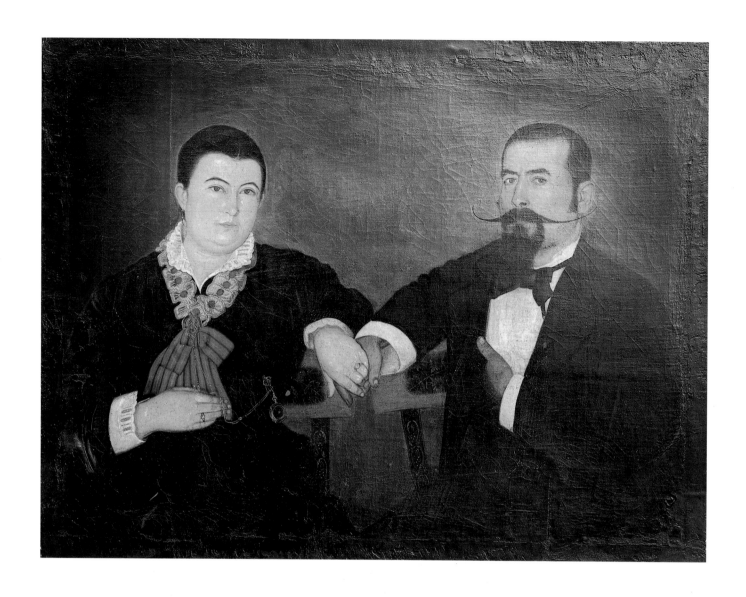

Retrato de un Matrimonio

75 *Portrait of a Married Couple*

Hermenegildo Bustos (Mexican, 1832–1907)

Oil on canvas, 55.5 × 72.5 cm (21⅞ × 28⁹⁄₁₆ in.), 1883
Museo Regional de Guanajuato: Alhóndiga de Granaditas, CONACULTA-INAH-INBA, Mexico

Born in Guanajuato and a self-proclaimed *aficionado* ("amateur") Hermenegildo Bustos (see also pl. 74) greatly influenced later artists, such as Frida Kahlo. Today he is included among Mexico's finest artists, and his works are highly valued for their charm, originality, and provincial honesty.

Although most of Bustos's portraits represent individual sitters, he also painted couples and families. This portrait of a married couple is vintage Bustos: perspective and background are subordinate to a straightforward depiction full of small but captivating details of expression, mood, and dress. This couple is a study of contrasts. The husband is overbearing, with his cool stare and eccentric moustache. The wife is gentle and kind. Her serenity is underlined by the richness of her scarf and collar. Their joined hands, the focal point of the painting, suggest that they are devoted to each other despite their differences.

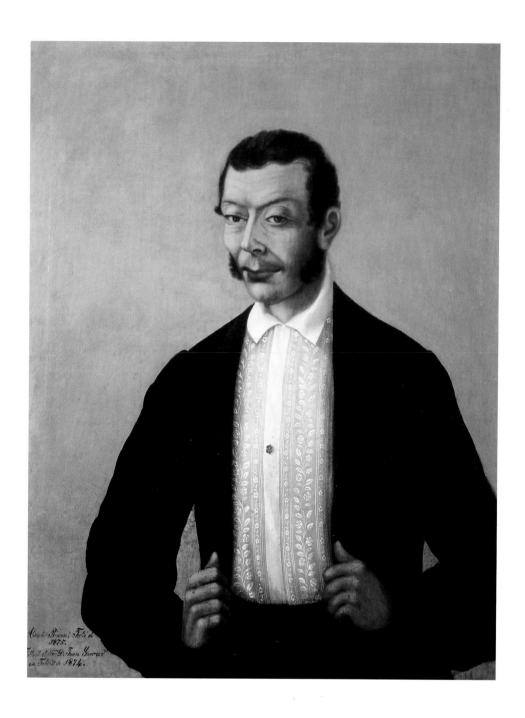

76 *Don Juan Guerrero*

Abundio Rincón (Mexican, active 1823–1885)

Oil on canvas, 94 × 74 cm (37 × 29⅛ in.), 1875
Private collection (C.N.), Guadalajara, Mexico

We do not know when Abundio Rincón (see also pl. 72) was born or died, but he was active by 1823, based on his dated portrait of Agustín de Iturbide. Other dated portraits establish that he continued painting until at least 1885.

　　Rincón studied at the Instituto de Ciencias in the state of Jalisco and may have been a disciple of the Spanish academic painter José María Uriarte (see pl. 38). Rincón worked mainly in the small town of Cocula, Jalisco, but he must have spent considerable time in Guadalajara, where he did several paintings of the city's town council. He painted many religious and secular portraits, and had a gift for capturing sitters' unusual, often eccentric, qualities. This posthumous portrait of Don Juan Guerrero (d. 1874), with his muttonchop sideburns, heavy eyelids, and aloof bearing, is a good example of Rincón's provincial but penetrating style.

Dama con Mantón

77 *Lady with Shawl*

Unidentified artist (Peruvian school)

Oil on canvas, 97 × 75 cm (38³⁄₁₆ × 29½ in.), mid- to late nineteenth century
Colección Lambarri-Orihuela, Peru

Neither the artist nor the sitter of this portrait is known, but the articulation of the hands and face and the detail of the drapery suggest that the painter had received professional training. His career may have been similar to that of Peru's noted mid-nineteenth-century painter Francisco Laso (1823–1869), who received his initial training at the Academia Nacional de Dibujo y Pintura (National Academy of Drawing and Painting) in Lima, before being given a scholarship to study in Paris. Interestingly, when in Peru, Laso spent time in the Cuzco region, the area in which this portrait currently resides.

Portraits derive their significance in part from the role they play in creating an enduring image of the sitter. The small miniature held by this strong, self-possessed, and wealthy *mestizo* woman— probably a picture of her husband—underscores this role.

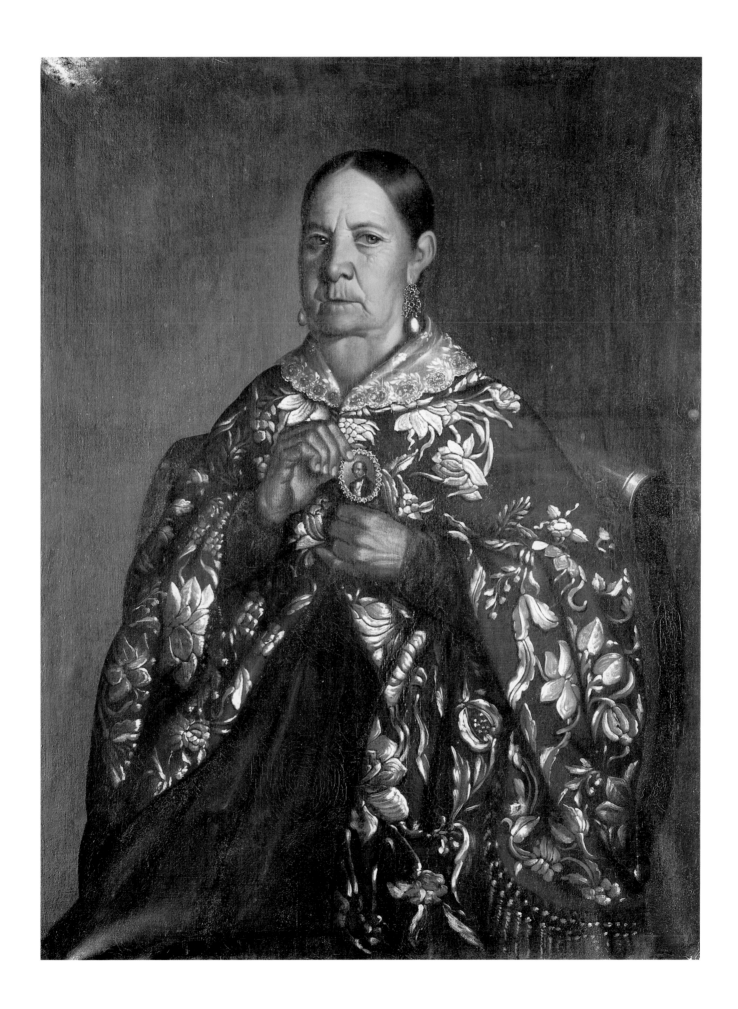

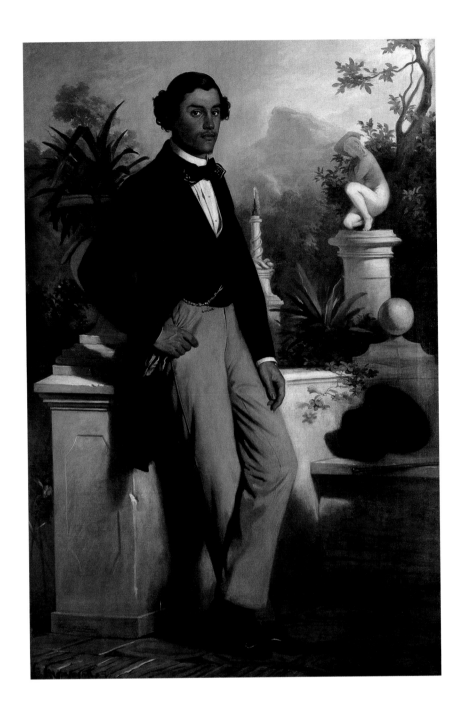

78 *Carlos Gomes*

Victor Meirelles de Lima (1832–1903)

Oil on canvas, 193 × 130 cm (76 × 51 3⁄16 in.), c. 1862
Hecilda and Sérgio Fadel, Brazil

Brazil's most noted nineteenth-century composer, Carlos Gomes (1836–1896), is portrayed here by its most famous painter of the time, Victor Meirelles. Meirelles, who gained his reputation as a history painter, first studied at Academia Imperial das Belas Artes in Rio de Janeiro (founded 1818), before leaving in 1853 for additional training in Rome. Returning to Rio in 1861, he became a professor at the Academia, and later its director (1863–90). This portrait is characteristic of his style, which blends romantic theatricality with neoclassical precision.

Gomes initially trained at Rio's conservatory of music, but the success of his first two operas led the emperor to pay for his additional study in Europe. Gomes gained an international reputation with the success at La Scala of *Ó Guarani* (1870), a tragic opera set in sixteenth-century Rio about the love between a man from the largest tribe in South America and a Portuguese woman.

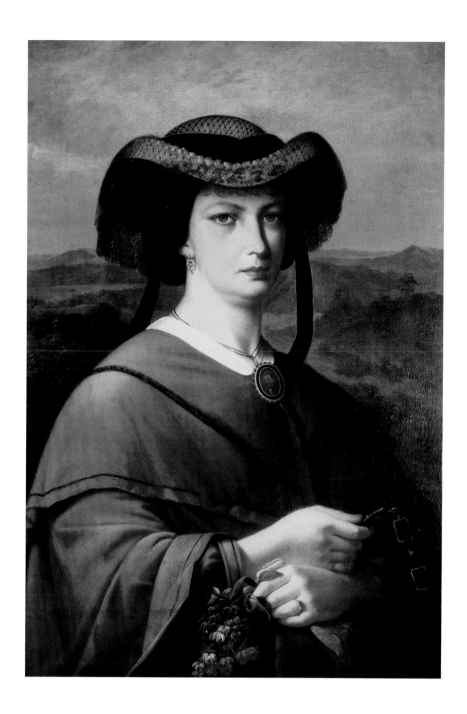

Dama con Sombrero, Doña Isabel Vivanco Patiño

79 *Lady with Hat, Isabel Vivanco Patiño*

José Justo Montiel (Mexican, 1824–1899)

Oil on canvas, 77.5 × 52.5 cm (30½ × 20¹¹⁄₁₆ in.), 1864
Universidad Veracruzana, Jalapa, Mexico

José Justo Montiel may have begun his artistic career as a student of Gabriel Barranco (1796–1886), a professor of drawing at the preparatory school in Orizaba, Veracruz. Montiel's first known painting dates to October 1844. In 1857 he was admitted to the Academia de San Carlos in Mexico City under the sponsorship of Pelegrín Clavé. Montiel's works lie in the fascinating intersection of the traditional and the academic that has been so fertile in Mexican art.

Isabel Vivanco, a local beauty and a member of Orizaba society, was among those who welcomed Emperor Maximilian and Empress Carlota to the town in June 1864. Impressed by Vivanco's charm and bearing, Carlota suggested that Montiel portray her wearing the empress's traveling outfit.

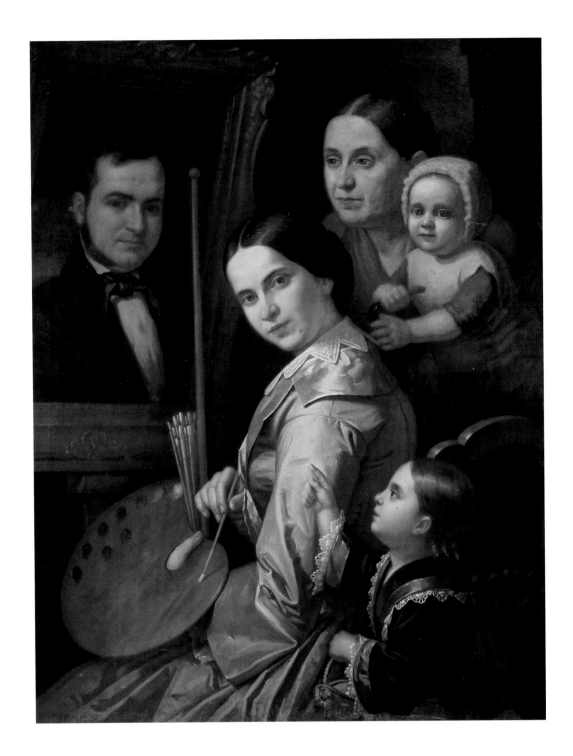

Autorretrato de Guadalupe Carpio con Su Familia

80 *Self-Portrait of Guadalupe Carpio with Her Family*

Guadalupe Carpio (Mexican, lifedates unknown)

Oil on canvas, 119.5 × 84 cm (47⅟₁₆ × 33⅟₁₆ in.), 1865
José Mayora Souza, courtesy of Museo Nacional de Arte, Mexico, D.F.

Little is known about Guadalupe Carpio except that she was a fine artist trained in the academic style of the mid-nineteenth century.

We know from a descendant that Carpio is the woman seated before the canvas, holding paintbrushes and palette. Her father, the poet Manuel Carpio, is represented on the easel. Standing behind the artist is her mother, holding the artist's son, Martín Mayora. He later married Guadalupe Sierra, the daughter of Justo Sierra, a well-known intellectual of late-nineteenth-century Mexico. The other child is Carpio's daughter.

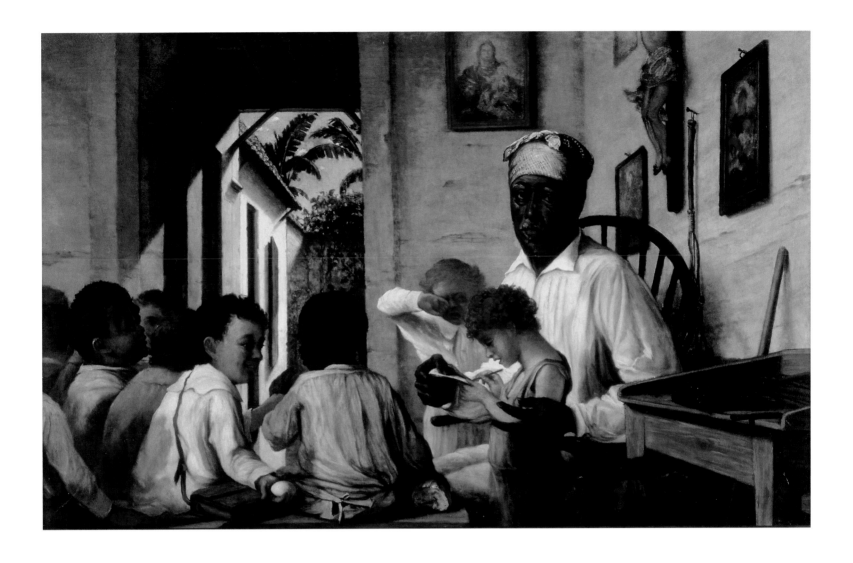

La Escuela del Maestro Rafael Cordero

81 *The School of the Teacher Rafael Cordero*

Francisco Oller y Cestero (Puerto Rican, 1833–1917)

Oil on canvas, 99 × 159 cm (39 × 62⅝ in.), 1891
Ateneo Puertorriqueño, San Juan, Puerto Rico

Francisco Oller started painting at age eleven, and as a teenager he studied at the Real Academia de Bellas Artes de San Fernando in Madrid. Oller was later deeply influenced by Gustave Courbet's realism and the French avant-garde, and his own painting alternated between realism and impressionism. In 1868, he helped found the Puerto Rican Free Academy of Drawing and Painting.

The painting lets the viewer into the world of legendary teacher Rafael Cordero Molina (1790–1868). Because Cordero was black, he was not allowed to attend school; instead, his parents educated him. As an adult, Cordero dedicated much of his time to teaching elementary subjects and religion. He ran a school for black and mulatto boys from his home and later established a free school for poor children of all races and social classes in San Juan. To support himself financially, Cordero worked as a cigarmaker and a shoemaker.

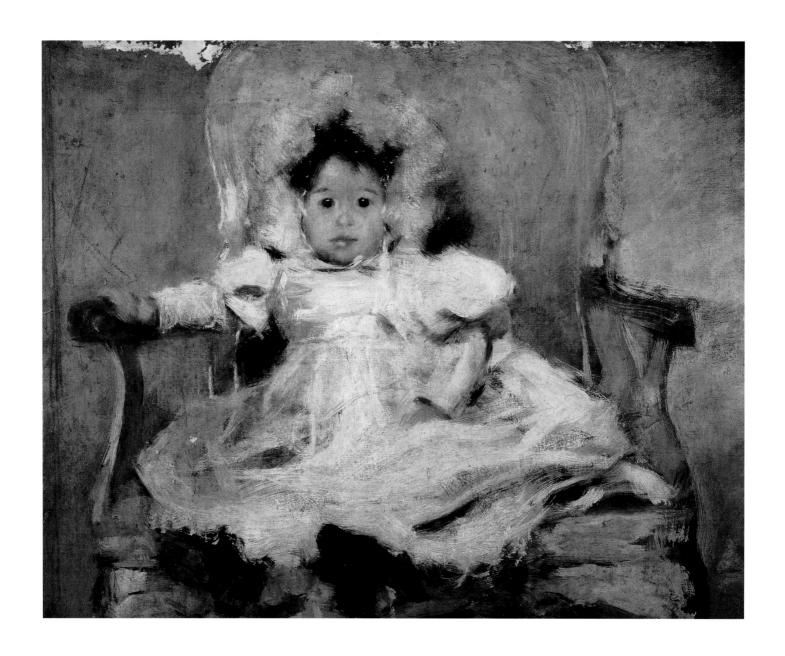

Niña en Blanco

82 *Girl in White*

Carlos Baca Flor (Peruvian, 1867–1941)

Oil on canvas, 67.5 × 84 cm (26⅝ × 33⅛ in.), 1902
Museo de Arte de Lima, Peru

Peruvian-born Carlos Baca Flor's family moved to Chile when he was four. In 1882, he entered the School of Fine Arts in Santiago, but five years later he returned to Peru, having rejected an offer of Chilean citizenship. A beneficiary of the government's policy of sending talented artists abroad to study, Baca Flor left for Europe in 1890. As clever with people as he was with paint, Baca Flor soon received commissions to portray socially and politically well-connected individuals. In 1908, American banker and collector J. Pierpont Morgan asked him to come to New York. Baca Flor remained there for the next twenty years, painting more than one hundred portraits, including one of Morgan. He spent the last decade of his life in France. This sketchy, freely painted portrait of an unidentified child is characteristic of the impressionistic style that Baca Flor employed at the turn of the century.

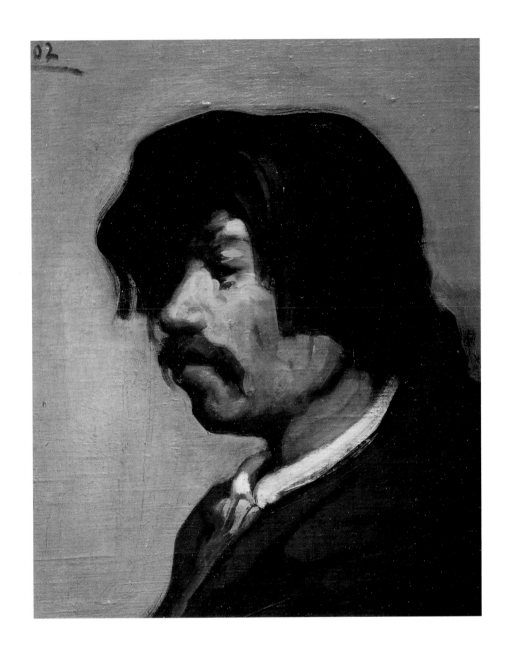

Autorretrato

83 *Self-portrait*

Xavier Tizoc Martínez (Mexican American, 1869–1943)

Oil on canvas, 40.6 × 33 cm (16 × 13 in.), 1902
The Oakland Museum of California

Born in Guadalajara, Mexico, Xavier Martínez moved to San Francisco, California, at age twenty-four. He studied at the California School of Design, participated in many exhibitions, and frequented the San Francisco bohemian scene. Between 1897 and 1901, he spent much time in Paris, at the École des Beaux-Arts, the Académie Carrière, and in the atelier of Jean-Léon Gérôme, where he was influenced by Whistler, Manet, and Goya and met Diego Rivera and other Mexican expatriates.

The artist combined impressionist techniques with the realism of his own early art education along with a handling of light derived from the American luminists. This powerful self-portrait demonstrates his sophisticated yet subtle use of soft light, and his limited palette of mainly ochers, greens, grays, and browns. Tizoc Martínez was a founder of the California modernist movement and became a key shaper of twentieth-century art on the West Coast.

84 *Don Guillermo Puelma Tupper*

Pedro Lira (Chilean, 1845–1912)

Oil on canvas, 119 × 90 cm (46⅞ × 35⁷⁄₁₆ in.), 1908
Museo Nacional de Bellas Artes, Santiago, Chile

Initially a lawyer, Chilean painter Pedro Lira received his art training from Alejandro Ciccarelli, the founder of the University of Santiago's painting academy. Lira left to study in Europe in 1873 and, as this portrait indicates, was influenced by French naturalism. Back in Santiago in 1884, Lira organized exhibitions, wrote about art, translated aesthetic texts, coestablished the Chilean Artists Union, and served as the director of the School of Fine Arts (1892–1908).

A doctor, poet, activist, and businessman, Santiago native Guillermo Puelma Tupper (1851–1895) won renown for assisting the stricken during the 1872 smallpox epidemic. In 1878, he established an asylum for casualties from the War of the Pacific. Puelma founded the Sociedad de Fomento Fabril, which still exists; published and wrote for newspapers; won election to Congress in 1885 and opposed the Balmaceda regime; and managed the construction of the Trans-Andean Railroad between Chile and Argentina. His *Fragmentos de un Poema* was published the year of his death.

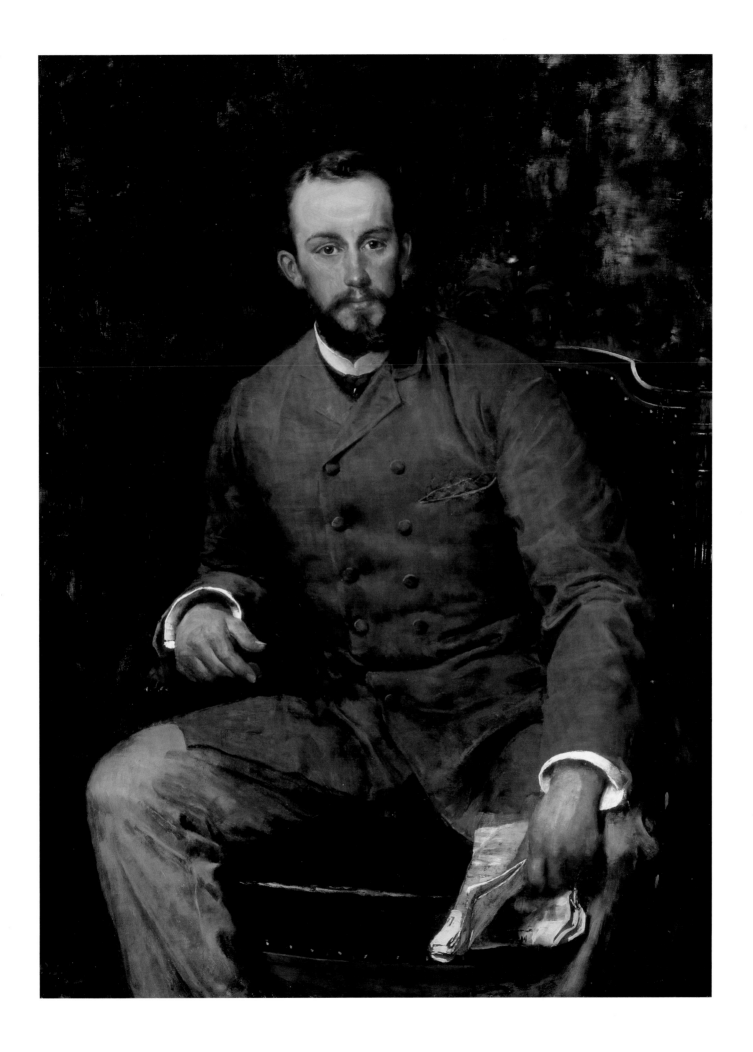

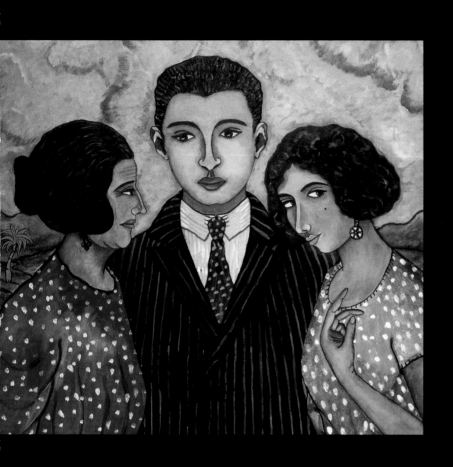

PORTRAITS IN THE MODERN PERIOD:
POINT AND COUNTERPOINT (1910–1980)

LUIS-MARTÍN LOZANO V *Tradition and Avant-garde:*
 The Portrait in Modern Latin American Painting

Historical studies of twentieth-century Latin American art have mainly emphasized each country's stylistic peculiarities, with particular attention paid to artists' efforts to consolidate a language of their own and a cultural identity opposite to that of Europe or the West. It is often forgotten that Latin America also forms part of Western culture and has contributed in many ways to the contemporary view of the world. Specialists have concentrated more on the differences than on the similarities, often as a result of extreme nationalism that claims false historical positions of pretended modernity while overlooking the artistic origins and parallels occurring in the countries comprising modern-day Latin America. In other words, while we do indeed have our own identities, we also share undeniable cultural links and historical processes.

The process by which a modern artistic identity took root in the first years of the twentieth century mainly took the form in Latin America of establishing distances from academicism, both local and foreign, and of restraining passive imitation of European art. The intellectuals, artists, and writers, the incipient critics, and even the cultural policies of some countries, such as Mexico, tended toward the development of aesthetic positions that recuperated the Latin American cultural reality. Nevertheless, while the observation of landscapes, customs, and even historical events was a process of introspection—of encounter or reencounter with their countries of origin—Latin American artists did not remain on the margin of the European avant-garde. Many of their proposals of visual modernity in the arts initiated a fruitful dialogue between the Latin American reality and the artists' position in the face of, and as part of, the remainder of the West.

The climate of the early twentieth-century avant-garde was widely felt in countries such as Mexico and Brazil. The appearance of discourses and production of manifestos exalting Latin American essences, with a view to breaking with Europe, were postures intended to emphasize the consciousness of the artists' own values, rather than a renunciation of the languages of formal experimentation with which the international avant-garde was promising revolutionary changes in society, politics, and the arts. For example, Latin American artists and writers in the 1920s were aware of cubism, futurism, and German Expressionism. Both in Mexico City and in São Paulo, a need for independence and renewal—but also open visual modernity—was discussed, questioned, and promoted. Almost at the same time, the Brazilian critic Menotti del Picchia exulted, in *Correio Paulistano* (under the pseudonym of Helios), "futurism, that apocalyptic war-cry against routine, is not as bad as it is portrayed. Sometimes, as in its original conception, it is the rebel battering of the avant-garde hordes against the stale systematisation of the aged, and as such, the sudden drive of Huns and Sicambri of the ultra-Modernist aesthetic." Meanwhile, from Barcelona, the Mexican artist David Alfaro Siqueiros demanded in the magazine *Vida Americana,* "Let us live our

marvellous dynamic epoch! Let us love modern mechanisms that put us in contact with unexpected artistic emotions." So for all of them, here and there, the seed of the avant-garde was successfully planted in American soil.

Although the process of the Latin American avant-garde became established in the twentieth century, especially in the dual aspect of dialogue and investigation, its origins may be traced back to the aesthetics of late-nineteenth-century *modernismo,* nourished by knowledge of the post-impressionists who had revolutionized the way of understanding modern art. The late impressionists were in the forefront of formal languages in the art schools during the early twentieth century, whether in the Academia de San Alejandro in Cuba or in the Escuela Nacional de Bellas Artes in Mexico City. For this reason, painters as dissimilar as Manuel Cabré in Venezuela and Andrés de Santamaría in Colombia followed this path around the turn of the century. A particular case in the history of Mexican art involves Xavier Martínez, also known as Xavier Tizoc Martínez, who is represented in the exhibition by a self-portrait of 1902 (pl. 83). Born in 1869, he immigrated to the United States and enrolled at the Mark Hopkins Institute of Art in San Francisco even before taking part in his native Guadalajara's artistic bohemia. He was probably in the circle of Félix Bernardelli (1866–1905), a painter of Brazilian origin who arrived in Mexico to establish an art academy around 1897, and around whom various Mexican artists such as Roberto Montenegro (1887–1968) and Gerardo Murillo (1875–1964), the celebrated Dr. Atl, obtained their early training.[1] In any case, his self-portrait evokes the artistic language prevalent at the turn of the century, displaying traces of naturalism being renewed in its formal qualities and evoking both a move away from impressionism and a focus on the viewer's moods. The results were often charged with an atmosphere of decadence, by means of which the artist appealed to the questioning of modernities brought about by development and science. The vision left by Xavier Martínez is that of a man who, at the age of thirty-three, still sees himself as nonconformist (to judge from the carelessness of his rebellious hair) yet reflexive, absorbed in his thoughts. The face is no longer juvenile, being marked by the experience of someone who has lived in the Parisian bohemia and perhaps now looks to settle down; for, on returning from Europe, where he had studied with Jean-León Gérôme and Eugène Carrière, he decided to settle permanently in California. He later obtained United States citizenship.

The experience of Latin American painters as travelers in search of replies to the art of the old continent was a symptom of the need for renewal and exploration demanded by the new generations of artists who rejected local academicism. That very motive took Diego Rivera to Europe, first to Spain and then to France, for a stay that extended to fourteen years. From 1907 to 1921, he gravitated from the ideas of the impressionists and post-impressionists to those of avant-garde neoclassicism, going on to become one of the most polemical cubists in Paris.[2] Having passed through Paris in 1909, on his way to Bruges, Rivera perceived the aesthetic innovations of Paul Cézanne, Toulouse-Lautrec, and Paul Gauguin, among others (fig. 1). From 1911 onward, he gradually came to understand and practice cubism, largely due to his analysis of El Greco's work, particularly his study of landscape.[3] Rivera's 1913 work, *The Painter Zinoviev* (pl. 85), present in this exhibition, bears witness to his understanding of cubist principles. Along with his portrait of the sculptor Oscar Miestchaninoff (1913, Gobierno del Estado de Veracruz, Mexico), it is possibly the first of Rivera's cubist portraits. Both paintings show the degree of compositional complexity that Rivera achieved, with the Russian painter Zinoviev being observed from a multiplicity of angles, from the front and in profile, in one continuous movement, taking Rivera close to the simultaneism of Robert Delaunay. Notwithstanding Rivera's accomplishments

Fig. 1 *Still Life* by Diego
Rivera. Oil on canvas, 1908.
Private collection

as an avant-garde artist in Paris, when he returned home to become part of the post-revolutionary Mexican Renaissance, he opted to minimize his cubist experience and address himself entirely to Mexican mural art.

In the opposite direction, the Brazilian painter Anita Malfatti (1889–1964) returned to her country to become integrated into the local artistic community, as an artist fully committed to the avant-garde. Malfatti had studied in Germany and the United States in a climate of frank acceptance and development of a new visual modernity. The painter Fritz Burger had been her mentor in Berlin, and she also joined the Lewin Funcke Academy. Oriented towards fauvism, Malfatti took part in the Berlin Secession, and after a brief return to Brazil, in 1915 she enrolled at the Art Students League in New York City. Her experience with the avant-garde art of cubism, futurism, and German expressionism led her toward a modern, critical line of painting inclined to question the individual's condition in modern society. When she presented her work in São Paulo in 1916 and 1917, Malfatti lit the torch of artistic modernity in Brazil, soon to be reinforced by the "Week of Modern Art" held in February 1922 at the city's Municipal Theatre. Supported by writers and artists such as Mário and Oswald de Andrade, Malfatti is considered a fundamental element of rising artistic modernism in Brazil. Her work reveals her commitment to the free association of the gesturalism of color with the treatment of innovative compositional spaces as an inheritance of cubism. Although her proposals were rejected by some radical academics, Malfatti continued to promote modern art in Brazil until her death in 1964.[4] Malfatti's arrival coincided with changing artistic ideas in Brazilian literature and visual arts, to which she gradually adapted her European avant-garde language.

Fig. 2 *Abraham Ángel* by Manuel Rodríguez Lozano. Oil on cardboard, 1924. Museo de Arte Moderno, CONACULTA-INBA Collection, Mexico, D.F.

Not all of the formal innovations in Latin American modernism came from artists who worked or studied in Europe, however. Some, such as Abraham Ángel (1905–1924), were never in direct contact with the overseas avant-garde, although they did participate in an intellectual climate of renewal (fig. 2). Ángel belongs to the generation of Mexican painters who emerged after the Mexican Revolution of 1910. Once political stability had been attained, General Álvaro Obregón installed a new ministry of education, which had the difficult task of teaching the rural population of Mexico to read and write. Between 1921 and 1924, as part of an active cultural policy, a method of drawing was established for use in primary schools, technical training schools, and some secondary schools. Designed by the painter Adolfo Best Maugard, the program was based on a system of seven simple graphic elements that picked up the juxtaposition of the line on the plane. When used in a decorative way, these elements would allow pupils to become acquainted with the forms of Mexican popular art. Ángel was trained in this method, and under the influence of Manuel Rodríguez Lozano (1897–1971), his art evolved until attaining an autonomous artistic expression for which there is no equivalent in the history of modern Mexican painting. Ángel's work is perhaps the best example of a style attempting to delve into the cultural reality of Mexico, while proposing new visual languages as a product of the artistic environment following the revolution. Ángel died at age nineteen, but he lived vigorously at a time of great upheaval in the visual arts in Mexico. Only five years earlier, in the period of constitutionalist concord, his talent would never have flourished. His is the most sincere thematic proposal of Mexican painting in the 1920s. His subject matter centers around the transition toward modernity: an urban Mexico being transformed with incipient telegraph wires and electricity posts, under the nostalgia of a rural world disappearing in the interest of modernization. *La Familia* (1924), an oil painting in the collection of the Museo de Arte Moderno of Mexico (pl. 89), expresses the best qualities of his work: an unequivocal palette of colors, as though under the influence of fauvism, with compositions containing an air of primitivism that, nevertheless, uses solutions derived from classical painting. Those portrayed in the portrait are not entirely anonymous, and they presuppose a new prototype of the Mexican family where the father is missing, perhaps due to the armed struggle.[5] His place has been occupied by the young son, who must look to the future of his mother and sister, although his expression reveals that his soul is still juvenile. Ángel, who was often called the boy-painter because of his eloquent sincerity, produced a faithful portrait of the artistic endeavors and aesthetic intentions characteristic of his generation.

Mexico's cultural reality imposed itself even on painters with great experience with the avant-garde, such as Diego Rivera (1886–1957) and David Alfaro Siqueiros (1896–1974). Siqueiros arrived from Europe in 1922 and soon joined in the climate of cultural effervescence that characterized post-revolutionary Mexico. In 1913 he had attended Alfredo Ramos Martínez's school of open-air painting in the town of Santa Anita. The young artist abandoned his studies to take part in the Mexican Revolution, attaining the rank of captain. After the armed struggle he returned to his art and traveled to Europe, after a brief stay in New York. In Europe he was soon in touch with Diego Rivera and the avant-garde circles of Paris, Rome, and Barcelona, assimilating cubism, futurism, and the movement of metaphysical painting. Siqueros returned to Mexico at the urging of the education secretary, José Vasconcelos, to join the program of mural decorations for the building of the Escuela Nacional Preparatoria (National Preparatory School), which proved to be the cradle of the Mexican muralist movement. Siqueiros (fig. 3) subsequently considered most of the works he produced in Europe to be of little importance. Among those he kept is his 1920 portrait of Amado de la Cueva (pl. 87), now held by the Museo Regional de

Fig. 3 *David Alfaro Siqueiros* by an unidentified artist. Photograph, 1920. Museo de Arte Moderno Archive, Mexico, D.F.

Guadalajara. As the late Mexican historian Xavier Moyssén pointed out, Siqueiros's composition reflects his assimilation of the formal innovations of the avant-garde, particularly the expressive strength of the color and the volumetric projection of the foreshortening of the hands.[6] In the following decade, portraiture would prove to be one of the most fascinating fields of experimentation for Siqueiros, perhaps on a par with his murals. In a lecture he delivered in 1932 at the Casino Español in Mexico City, Siqueiros declared that the portrait "places the painter or the sculptor face to face with all the problems involved in painting or sculpture, and situates them in a condition to produce an integral work of art. . . . Furthermore, the portrait is an artistic gymnastic of the first order, for in the first place it situates the painter or the sculptor in an objective terrain."[7]

Several artists, upon their arrival in Latin America, were unable to elude the cultural strength they encountered. If this occurred for those returning to their own country, it was even more so for new immigrants. Lasar Segall (1891–1957) is a case in point. Born into the Jewish community of Russian Lithuania, Segall was a completely European artist until 1923, when he moved to Brazil. He had been trained at the academies of Dresden and Berlin, participating in the Dresden Secession of 1919 with Otto Dix and Conrad Felixmüller, among others. He exhibited works in Hanover concurrently with Kurt Schwitters and Wassily Kandinsky. An active member of the German expressionists, Segall was influenced by the work of Ernst Ludwig Kirchner and Lyonel Feininger. The war, his position as a Jew, and the fact of having brothers living in Brazil, convinced him to move to South America, a

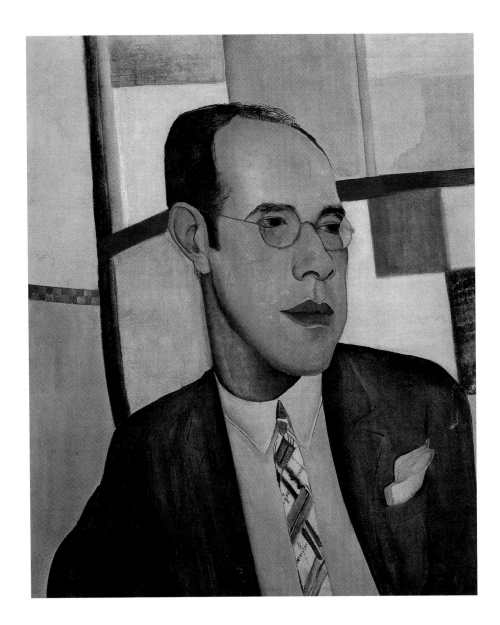

Fig. 4 *Mário de Andrade* by Lasar Segall.
Oil on canvas, 1927. Coleção Artes Visuais,
Instituto de Estudios Brasileiros–USP,
São Paulo

continent that he had visited briefly in 1913. Segall's work was well received by the writers
and intellectuals there who had been influenced by the "Week of Modern Art" held the
year before, in 1922. His works painted from 1924 onward (fig. 4) reflect the color of the
tropics and the presence of the mulatto. Segall left a testimony to this process of adaptation
and his new artistic condition in one of his many self-portraits, dated 1927 (pl. 90). Here
he appears no longer as the foreigner impressed by American exoticism, for he had recently
obtained Brazilian citizenship. He now presents himself with a less-white skin, faced by the
challenge of painting on an empty canvas, as though beginning a new, unknown path. His
expression is inquisitive, as though challenging the spectator and reflecting the aesthetic
principles of "new objectivity," a trend in German figurative painting that flourished in
the late twenties and early thirties. Segall seems, therefore, to be preparing himself for the
definitive artistic itinerary in his career as a Brazilian artist.

No less eloquent a spokesman for the history of Latin American art is the Venezuelan
painter Armando Reverón (1889–1954). After receiving artistic training in Europe between
1911 and 1915, he decided to isolate himself in *El castillete de las quince letras* at Macuto,
in an area remote from the Venezuelan coast, thus becoming a virtual immigrant in his
own land. Like Rivera, Reverón had moved in the academic circles of Madrid and Paris,
assimilating a late impressionism that was, nevertheless, a stylistic novelty for the academic

style predominant in his native country. From 1920 onward, after his return to Venezuela, he produced a series of landscapes and portraits marked by the intense luminosity of the Caribbean sun, which tends to distort the perception of color and produces optical phenomena. These are precisely the qualities of *Rostro Blanco* (pl. 92). The sitter might be Juanita Ríos, Reverón's model and companion for many years, to whom he dedicated many portraits "in the white manner" during the 1930s. Although Reverón's works could not have been conceived in any geographical context other than the landscape and coastal light of Venezuela, his contact with and knowledge of impressionism enabled him to carry his aesthetic proposals to the limit of form on the boundaries of lyrical abstraction.

In the 1920s, several Latin American countries underwent a stylistic renewal of pictorial expression. This decade marked a watershed for countries such as Brazil, but particularly for Mexico: its recent revolution had in ten years substantially modified the politics, social structure, and, above all, the mentality of Mexico City's inhabitants. Notably, women played a greater role in artistic life, not only in the visual arts but also in dance and literature. The Mexican Revolution of 1910 introduced for women, among other things, the possibility of attaining a new position in a modern society. In the visual arts, the painters María Izquierdo (1902–1955) and Isabel Villaseñor (1909–1953) stand out, as do photographers Tina Modotti (1896–1942) and Lola Álvarez Bravo (1907–1993), and undoubtedly Frida Kahlo (1907–1954). They all struggled to succeed as women creators, despite having shared a period of their existence with men who were equally outstanding in art.

María Izquierdo was born into humble conditions in a remote province of Mexico. She escaped from an early marriage with her small children and found refuge in the anonymity of Mexico City (fig. 5). Enrolling at the Academy of Fine Arts, she was obliged to leave because of the attacks of a student faction known as group ¡30-30! She was the companion of the artist Rufino Tamayo (1899–1991), the first person to give her solid support, but he left her to marry someone else. Despite these vicissitudes, Izquierdo began to achieve prominence, and by 1929 she held an important individual exhibition that received the critical praise of Diego Rivera. During the next two decades she achieved innumerable successes, recognized by those who were able to understand the search for universal qualities in her painting. By 1940, Izquierdo's work had been presented at the Metropolitan Museum of Art and the Museum of Modern Art, and in the city of Paris.[8] At the summit of her career she painted one of her most ambitious works, the multiple portrait *Mis Sobrinas* (*My Nieces*, pl. 97), which she created to form part of the collections of the Museo de Arte Moderno in Mexico City. The composition of this oil painting is based on photographs from her family album, which Izquierdo reinterpreted. *Mis sobrinas* possesses a matchless expressive strength in the use of color, which is the most distinctive feature of Izquierdo's personal artistic style.

Today, however, Frida Kahlo is the most widely recognized woman painter from Mexico. Although she did win the approval of some early collectors in the 1930s and 1940s (such as Eduardo Morillo Safa, Edward G. Robinson, and Natasha Gelman), her work was for the most part rediscovered only after her death. During her lifetime, Kahlo was probably only really understood as an artist by the father of surrealism, André Breton. Despite having been married twice to Diego Rivera, Kahlo succeeded in creating work with a singular autobiographical personality, perhaps like no other painter in the universal history of art. Her various self-portraits painted between 1925 and 1954 retell her autobiography—not a banal biography in the strict sense, but the intellectual and aesthetic construction of her own history, told in the first person, by the artist. Mainly self-taught, Kahlo nevertheless had an advanced artistic and intellectual formation, first as the daughter of a man who was

Fig. 5 *María Izquierdo with daughter and son* by Iris Studio. Photograph, 1924. María Izquierdo Archive, Mexico, D.F.

a photographer and an amateur painter, and later as wife of Diego Rivera, a mentor who exposed her to innumerable experiences and to outstanding personalities in the international art world. Kahlo had a firm desire to progress in her technique, despite long periods in which she was unable to take up her brush. Other years, however, were fruitful in output. Intelligent and conscious of the fascination she could arouse as an artistic personality, Kahlo knew how to assess the cultural ambience in which she moved. She took an active part in the aesthetic discussions of her time, on subjects such as what value to place on folk art and painting with a social content, although always through the dimension of her own work. She was never satisfied with her painting being merely descriptive, instead elevating it to a symbolic and iconographic complexity that made it simultaneously cultured and disquieting, full of mysteries and meanings to be resolved. We might say that her self-portraits present her image but at the same time a riddle.[9] The 1940 *Autorretrato con collar de espinas y Colibrí* (*Self-Portrait with Thorn Necklace and Hummingbird,* pl. 95), is one of her most complex works. Kahlo presents herself to the viewer with an absent gaze, impassive before the events about to occur around her. On her neck she wears a necklace of thorns, evoking a religious promise wherein the believer exteriorizes a bodily sacrifice. Also hanging from her neck is a hummingbird, which in its desperate efforts to escape has hurt her with its beak and has

caused the thorns to penetrate into her skin. Kahlo remains immobile in the face of incipient pain, remote from the unfolding drama, for the exhausted hummingbird has stopped beating its wings and will soon succumb to the jaws of a black cat approaching cautiously over Kahlo's left shoulder. The cat is preparing to leap, its attention fixed and its ears laid back. Its action will cause the spider monkey resting behind Kahlo to become agitated. As the frenzy of forces is unleashed, the monkey will try to flee, tugging at the thorn necklace it is holding with one of its paws and causing Kahlo terrible pain. Painted for her lover, the photographer Nickolas Muray, this work presents a metaphor of pain, of Kahlo's own anguish, caused by the amorous relationship that could not continue in the shadows.[10] In this way we understand that Frida Kahlo transforms the strength of her amorous desires into the innate condition of nature's laws of survival, where the cat and the monkey, traditional symbols of infidelity and lust, are now the carriers of the artist's conflicting emotions and sentiments.

The manner in which Latin American artists have questioned the social and political structures of their country of origin has not always taken the form of denunciation, demands, or rhetoric. Painter Fernando Botero (b. 1932), for example, has used irony. The inclusion in the exhibition of a portrait by Botero (pl. 102) is well considered, due to the eloquence of the work. The 1960s in particular were a marvelous decade in his output, because his art was already fully mature and showed a powerful capacity to reflect bourgeois social conventions. Like Rivera, Botero has devoted special attention to studying the great masters of Western art. Both expressed great admiration for Jean-Auguste-Dominique Ingres and the masters of the Italian Renaissance. Botero, like Rivera, also displays enthusiasm for the capacities of figuration as an artistic language to transmit messages. His painting is made up not only of technical virtues, although Botero is without doubt a magnificent painter and draftsman, but of contents, of symbolic associations, and of grandiloquence. With his rotund figures, Botero ennobles and minimizes the human condition through his painting, just as he elevates virtues and condemns vices; on occasion, he makes the invisible evident, and on others he makes the plausible risible.

This exhibition draws attention to one of the artistic genres with the most extensive tradition in Latin American art. It will display the plurality and expressive strength of portraits painted by various twentieth-century artists, some of them totally unknown to the United States public. It also underlines the complexity and richness of Latin American art, made up of constant quests and continuities, of reflection based on the cultural situation of each one of the countries, but also in the intense dialogue with existential preoccupations belonging to the dominion of universal culture.

Diego Rivera's work, often regarded as the epitome of Mexican painting in the twentieth century, was deemed transparent, superficial, and pedagogical for years during the artist's life and after his death. Within a framework that opposed social realist art against modernist, abstract art, Rivera's painting was usually thought of as politically committed, while at the same time intellectually and aesthetically shallow. Since the 1984 exhibition "Diego Rivera, the Cubist Years," held at the Phoenix Art Museum, the scholarly trend has been to see Rivera's painting as far more complex and contradictory than previously acknowledged.[1] Ramón Favela's pathbreaking essay for that exhibition catalogue stressed the complexity of Rivera's identity, education, influences, and style, a viewpoint anticipated by Oliver Debroise's 1979 *Diego de Montparnasse*.[2] Both Favela and Debroise focused on Rivera's sojourn in Paris, stressing the depth of his commitment to the avant-garde, the quality of his cubist works, and the importance of the debates he held within such contexts. Despite its importance, this historiographical renewal was little known beyond a few specialists. The Detroit Institute of Arts's 1986 retrospective inaugurated a renewed and broader interest in both the language of Rivera's painting and in his thorough commitment to the Russian avant-garde of the 1930s.[3] This enlightened research overcame Rivera's image as an opportunistic muralist comrade, as opposed to the pure, avant-gardish, early cubist painter. A flood of Rivera scholarship published since has seriously improved our knowledge of the pictorial, intellectual, and political traits of an oeuvre too often impoverished by reductive criticism. This article tries to benefit from this renewed scholarship, avoiding the condemnations and all-too-easy tributes of Rivera's contemporaries.

In the context of this scholarship, Rivera's portraits have received mainly a rhetorical attention. Rivera's presence in many of his murals is seen as a symbol of his flamboyant individual personality. Indeed, Rivera himself inaugurated this myth. Recalling his mural production up to 1926, he praised his frescoes at the secretariat of education in Mexico City, and at the National School of Agriculture in Chapingo, claiming that he had "expanded his personality" through those panels.[4] This mythmaking fits within the context of the 1951 national tribute to Rivera, in which the poet Salvador Novo said, "our history fits in his unbelievable sixty years."[5] And Rubén Salazar Mallén went as far as claiming, "it is not unlikely that Diego Rivera, the painter, will disappear," melted into his own paintings.

So to understand Rivera, one needs a knowledge of the very self-image embedded, either explicitly or implicitly, in his paintings. In this respect, it is telling that Rivera did not write an autobiography (as did fellow painter José Clemente Orozco). Instead, Rivera let his memoirs be told by three different writers who dwelled extensively on his personal reminiscences: Bertram D. Wolfe, Gladys March, and Loló de la Torriente.[6] However, since Rivera was a professed liar, his recollections are not trusted by most scholars. Quoting

from Jacques Chaumié, translator of the noted Galician writer Ramón del Valle-Inclán, Rivera claimed his own inspiration in Valle-Inclán's construction of his life as an artwork. He would thus warn every new acquaintance with a purportedly pompous speech on the reasons for his deliberate untrustworthiness:

> What moles call "lies" are really a pure projection of the artist genius' life. Since the artwork is the only thing to survive a man's life, and the only means to know something about such life, in the becoming of time and space, what the artist tells of his own life is always an artwork in itself—if he is really an artist—and, as such, the truest and most valuable asset for a science of history.[7]

With the notable exception of Ramón Favela, Rivera scholars have missed the point regarding the artist's so-called "mythomania," using it as a pretext to dismiss whatever testimony he gave on his life and works. This propensity to uncritically eliminate the painter's memory as a source contrasts sharply with other aspects of the scholarship: the need to compile a bibliography obsessively centered on the reconstruction of his life, while at the same time being frequently oblivious of his paintings. Even if his recollections usually need confirmation by some independent source, their patent dismissal deprives us of the very best source for understanding Rivera's imagination and intentions, which are much more coherent, aesthetically and ethically, than usually acknowledged.

Loló de la Torriente's book is by far the richest in both unbelievable anecdotes and bombastic inventions. For precisely this reason, her book—though unevenly written—is the most useful of the three. It is de la Torriente who delivers the following diagnosis about the diseases that sickened Rivera after his arrival in Europe:

> But, since he had some potentially active drive—besides the inferiority complex —and, by some weird biological paradox, a notable resistance and vitality within his hypothyroidism—which made of him "a gentleman that seems a frog walking on his two feet"—he had his wants materialized after overcoming difficulties such as typhus, malaria, pneumonia, and other such small specimens of the pathological arsenal.[8]

This extreme hypochondria was narrowly associated with Rivera's self-image as an artist. He had a problematic notion of the painterly style as analogous to his bodily delusions:

> He went to Spain, wherein the conflict between the Mexican tradition, the examples of antique painting, and the Spanish environment and modern production, had a disorienting effect on his shyness, brought to respect Europe. That made him paint detestable paintings, quite inferior to the ones he had done in Mexico, prior to his departure to Europe.[9]

He thus, through his biographers, recalled the trends in Spanish painting, using a narrative almost identical to the one he deployed for the definition of his various health problems, as if styles were but infectious germs. Rivera did have a commitment to style—strong because it involved his welfare and his physical integrity, both of which were seriously menaced by foreign influences.

This type of hysteria can be traced back to Rivera's biography, but it can also be found in his intellectual development. When Rivera was young, positivist philosophy was a full-fledged hegemonic ideology in Mexico, taught in schools and promoted by the dictatorship of Porfirio Díaz. Such a sophisticated system of thought and social research provided the artist with the rhetoric necessary to formulate an aesthetic placebo, allowing him to

use medical and biological categories to describe both his aesthetic beliefs and his relationship to his models. Paradoxically, Rivera would use the terms and categories of positivist discourse to conceal an irrational ideology that tended toward spiritual ecstasies, while at the same time evincing a fear of so-called monsters such as women, infections, and stylistic change.

In 1916, Rivera wrote a letter to Marius de Zayas, a fellow artist and promoter of New York's Modern Gallery. De Zayas was interested in presenting Rivera as a member of the French school (i.e., as a cubist), and Rivera manages to portray himself as an ultra-cubist:

> Form exists per se in everything, everlastingly, immutably, independently from the perceptive accident, and without being under the influence of the surrounding space, and being only in relation with the Primary Form. Form exists as a quantity that participates in both the preceding dualities, that is to say, as belonging to one independent case of the physical space; in a portrait, for instance, the *head* exists as a generality common to all men; as a head it will have qualities of accidental form, its position in space, total roundness of the cranium, but in a portrait, after painting a head one must particularize it and make of that head *one head,* and this individualization that will come over it will not depend upon the plastic accident but will be a particular ensemble of traits that would make a unique and personal facial cipher.[10]

This almost Aristotelian discourse sought definition through genus and specific difference, but it ultimately appealed to a higher dimension for the understanding of pure form. At the time, Rivera was attracted to every fashionable concept about the fourth dimension, topology, and perception, and he played with the idea of establishing a painterly theory akin to Poincaré's ideas on space.[11] As Ramón Favela has demonstrated, Rivera's approach to cubism followed an unusual path, taking him from the appreciation of El Greco's painting, through a commitment to Albert Gleizes and Jean Metzinger's theoretical book *Du cubisme,* to a late discovery of Paul Cézanne.[12] His 1913 portrait of Adolfo Best Maugard stands in the middle of such stylistic transformation, showing an almost supernatural apparition of Rivera's dandyish Mexican colleague (fig. 1). A walking stick hangs from Best's sleeve, while his finger points to the axis of the wheel in the background. The train and the building in the bottom, behind Best's legs, appear as if they were a part of a rotating device that includes the machine's fumes and Best's bending trunk. A centripetal movement precipitates every figure toward Best's gloved finger, while the model himself seems to turn outward, as if both man and wheel represented opposite forces moving a machine.

This painting is reminiscent of Paul Signac's 1890 portrait of art critic and theorist Félix Fénéon (fig. 2). When he painted Best's portrait, Rivera was doubtless aware of Fénéon's interest in the formal method of divisionist painting.[13] In the previously mentioned letter to Marius de Zayas, written three years later, Rivera stated that color was a force independent of any particular painting or form. But color, he said, "exists also as a result produced by the reactions that are the consequence of the action of the color and local form, the pure color and form and substance, like in the work of Grünewald, Seurat, and the Impressionists."[14] So he conceived of color as both an exterior force driving all things within every painting, and as well as a force resulting from interaction, acting from the painting outward: "color-impelling force" and "color-derived-force."[15] Having received an important geometric education as a landscape painter,[16] Rivera liked to see paintings as the entanglement of opposing forces. This is why Gino Severini quoted him as saying that "a being who lived in a milieu of different refractions and not homogeneous refractions would be obliged to

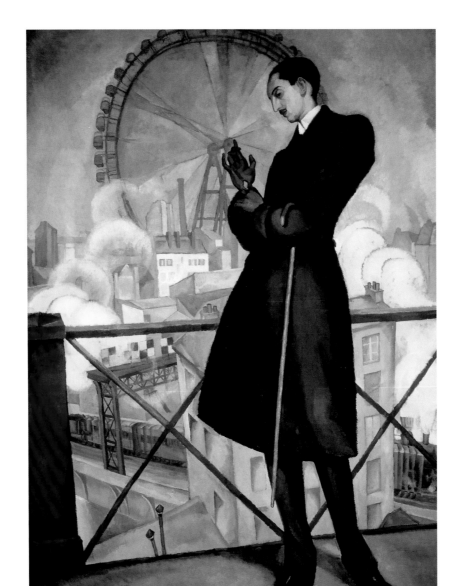

Fig. 1 *Adolfo Best Maugard* by Diego Rivera. Oil on canvas, 1913. Museo Nacional de Arte, CONACULTA-INBA, Mexico, D.F.

conceive a 4th dimension."[17] Severini, who thought of the work of art as a "machine," was convinced that painting was an art of construction and, as such, heavily grounded in geometry. However, Italian perspective was not the only means to centralize the forces within the canvas. "So the apparent discontinuity of our paintings is, above all, the result of the lack of optical education in those who look at them."[18] Every painting was a field of contradictory forces, color included; and it was this tension that would replace linear perspective in the organizing of the pictorial space.

In this respect, it is significant that Best's finger points to the wheel's mechanical axis (as opposed to Fénéon's Newtonian color wheel). And it is also quite telling that his body's curved silhouette appears in opposition to the movement in the painting. Best's elongated silhouette makes him an odd fit with the linear industrial landscape of early-twentieth-century capitalism. And no doubt Rivera would think of the spiritual qualities in his peer, who was well known in Mexico for his interest in theosophy and occultism. "In plastic space, things have a super-physical dimension which grows or diminishes in direct ratio to the importance that its existence has in the spirit of the painter," he said. And so, he continued, in the work of the "primitives," Saint Francis would appear "as tall as the church

it supports."[19] Inasmuch as Best appears as tall as the wheel he points to, there is little doubt that Rivera would think of him as a higher spiritual creature—like a fellow in some spiritual knightly order. Even if Severini thought of Rivera as influenced by Poincaré (in contrast to his own interest in French philosopher Henri Bergson), suggesting that his Mexican colleague was something of a positivist, Rivera had a much broader intellectual horizon. To begin with, his own words show that he had not fully abandoned the symbolist framework that fascinated him shortly after arriving in Europe. One would think that symbolism was like a concoction that would enable Rivera to make a successful—and difficult—transition from conservative academic painting, to post-impressionist eclecticism (shortly after arriving in Europe), to a doctrinaire cubism, and finally, back to Mexico, to social realism. This conversion would make him travel to the Netherlands in search of foggy landscapes to share with his Russian partner, painter Angeline Beloff.[20]

The background for this symbolist core of his painterly thought is not from some bookish relationship. Despite his far-ranging intellectual interests, Rivera's philosophical and scientific education was rather feeble. Instead, his letter to de Zayas shows that the Mexican National School of Arts taught the development of manual skills in a very

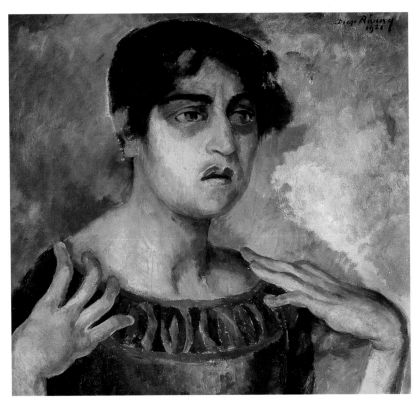

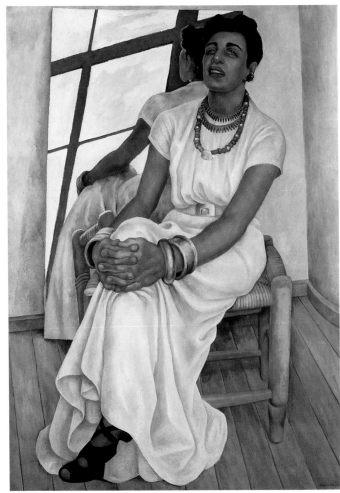

Fig. 3 *Guadalupe Marín* by Diego Rivera.
Oil on canvas, 1924. Colección del Gobierno
del Estado de Veracruz, Mexico

Fig. 4 *Guadalupe Marín* by Diego Rivera.
Oil on canvas, 1938. Museo de Arte Moderno,
CONACULTA-INBA, Mexico, D.F.

old-fashioned way. Rivera was trained as a painter through the copying of classic casts, start-ing with fragments of hands, feet, and heads. This systematic pedagogy aimed at developing specific abilities, both physical and intellectual, that resulted, after years of strenuous exer-cises, in the depiction of a lively model: the so-called *dibujo del natural*.[21] Rivera saved some drawings of that sort, which proves how important he considered such conservative educa-tion. Years later, in 1929, when Rivera was appointed director of the academy (the Escuela Central de Artes Plásticas), he would restore the compulsory drawing lessons.[22] So when Rivera says, "the *head* exists as a generality" and that "one must particularize and make of that head *one head*,"[23] one has to understand that it is a declaration intrinsic to an artistic training that still conceived of itself as standing on the classic academic tradition. And one has to acknowledge as well in such a statement the symbolist mentality embedded within the cubist theories akin to Rivera—a framework that would lead Rivera to look beyond the accidental to the general ideas. In this respect, it is significant, as Favela has pointed out, that Rivera's Paris studio was near that of Piet Mondrian, a painter entangled within an analogous set of contradictions, although directed toward a painting style that was not at all realist.[24]

This underlying symbolism is visible in his portraits painted back in Mexico of Guada-lupe Marín. An early portrait shows her as a fin-de-siècle femme fatale (fig. 3). Her hands invade the viewer's space slightly and fold back onto her shoulders, as if expressing deep trouble. In his 1947 remembrances to Loló de la Torriente, Rivera described her using the turn-of-the-century's misogynist discourse:

A tall, firmly standing woman who kept both hands forward as kangaroos do, or maybe as a mule standing on her two back legs. They were strong, magnificent hands, probably closer to a raptorial bird's claws than to a sanguinary feline. Her nerved arms ended in a trunk that was little, if compared to the large forelegs, alike to those of a jumping animal, and which ended down in a tremendous pair of legs, magnificent, like those of the finest blooded mare. And then, after a pure-race ankle, hoof-like feet of a strange and extra-human beauty, which provoked a sensation close to horror. . . . And, on top of all of these, under a loose tuft of marvelous black manes, two green eyes with a pupil so bright that it blended with the cornea, giving the impression of blindness.[25]

Rivera termed her a "woman-monster," with jaws "made for the ripping of live flesh or the crushing of bones."[26] Soon after meeting her, Rivera married Marín.

The animalization of women was a trope common to a number of literary and aesthetic avant-garde philosophies, from symbolism to expressionism.[27] Accordingly, Marín's turning hands close her figure and make her self-sufficient—as if concealing herself from the observer's well-documented desirous sight. Rivera described the model as so bright-eyed that she would give "the impression of blindness." Blindness is a metaphor for self-containment: the surface to the right of the vampirish Marín is a short-stroked, blurred background that encloses her figure within the limits of a greenish silhouette.

However, the portrait goes farther than these universal ideas about the dangerous woman-vampire. In his 1916 letter to de Zayas, Rivera had expressed his admiration of sixteenth-century painter Matthias Grünewald.[28] Looking at Marín's portrait, one cannot help but remember the distorting hands of Christ in the Isenheim altarpiece (1515). As odd as it might seem, this reference to medieval mysticism was filtered through a vocabulary taken from evolution theories: the vicinity of the female to nature and the dangerous nature of desire to the civilized man.

On the other hand, even though Marín posed in person for Rivera, his point of view was probably affected by her strong social image, and particularly to Edward Weston's contemporary series of portraits of her. Reproduced in Bertram D. Wolfe's biography of Rivera, the Weston images do not show Marín's eyes, but concentrate on her undulating hair and her jaw. This resemblance between photographs and portrait is interesting, since Rivera later used his own photograph by Weston as a model for a self-portrait.

Rivera and Marín parted ways in the late 1920s, as she began a relationship with the young poet Jorge Cuesta. In 1938, she documented her relationship with him in a novel entitled *La única,* depicting herself, under the name of "Marcela," as a victim of both an authoritarian husband (Cuesta) and a serious psychotic episode. Although badly written, *La única* features an interesting series of strange speeches that Marcela writes to be delivered by herself or her friends in places such as public marketplaces. They are about politics, corrupted doctors, and healthy food. So, for example, after rejecting French cheese and foie gras, Marcela urges the working classes to consume vegetables:

Comrades! The one who addressees you herein does not aim to be a leader, because she knows that vitamin E is to be found in a one-cent lettuce; and vitamin C in a two-cent tomato. And she knows such vegetables to be good even when symptoms of sterility or scurvy are lacking.[29]

Rivera's late portrait of Marín (1938) deals with the complexity of the character (fig. 4). Her hands still have an eminent place in the foreground. Rivera has added a mirror in the background to show her multiple dimensions. Guadalupe Marín had a flamboyant personality,

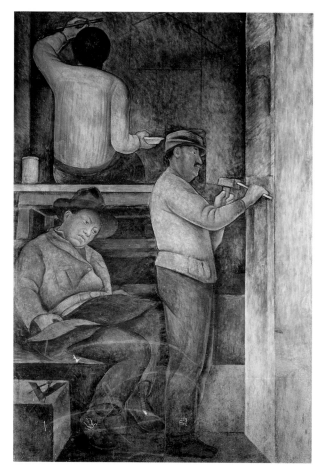

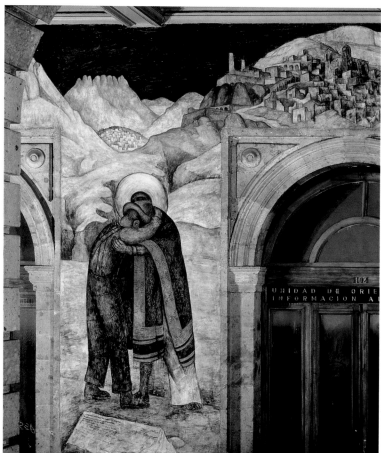

Fig. 5 *Diego Rivera* self-portrait, from
El pintor, el escultor y el arquitecto. Fresco,
1923–24. Secretaría de Educación Pública,
Mexico, D.F.

Fig. 6 *El abrazo* by Diego Rivera. Fresco,
1923–24. Secretaría de Educación Pública,
Mexico, D.F.

and the mirror makes a baroque pun on her spirit. It also indicts Lupe's follies as a merely
external reflex that has a complex relationship to whatever her inner troubles might be.
Her face is nearly a mask, yet her opened mouth remains expressive. Rivera would deem
Marín's face "the most extraordinarily beautiful Olmec-Zapotec mask ever produced in art,
neither born, naturally formed nor created by men in the whole of the Anáhuac.[30]

The mirror is an archetypical symbol of vanity. Cuesta, who became Guadalupe Marín's
second husband, wrote *Canto a un dios mineral* (Song to a Mineral God) from the late 1930s
until he killed himself in 1942. He deemed mirrors unfit for an individual's own understand-
ing. Appropriate for the reconstruction of the image, mirrors could not, however, interpret
an image that would go back and forth from her model to her devious reflection.

> Nada perdura, ¡oh, nubes!, ni descansa.
> Cuando en un agua adormecida y mansa
> un rostro se aventura,
> igual retorna a sí del hondo viaje
> y del lúcido abismo del paisaje
> recobra su figura.
>
> Íntegra la devuelve al limpio espejo,
> ni otra, ni descompuesta en el reflejo
> cuyas diáfanas redes
> suspenden a la imagen submarina,
> dentro del vidrio inmersa, que la ruina
> detiene en sus paredes.[31]

An explanation of this portraiture might be found in the esoteric tradition. During Rivera's early engagement in the 1910s Parisian avant-garde, and well throughout his involvement with the Mexican revolutionary state afterward, he was involved with a number of esoteric ideas. He shared with cubism a long-lasting fascination with the theosophical speculation on a fourth dimension of space. Back in Mexico in the early 1920s, his murals conscientiously used the symbols of the Masons and late-nineteenth-century Rosicrucians as he became an initiate in a Rosicrucian lodge called Quetzalcóatl.[32] This is why, as a part of his program of iconographic frescoes for the secretariat of education, he depicted himself lying on a square stone—a quintessential Masonic symbol—his head bent downward and his eyes lost in the contemplation of a blueprint (fig. 5). The latter was an emblem of the architect and the master, as were the compass and the square ruler. Following a photographic portrait by Edward Weston, he pictured himself as nearly a dead man. Mason and Rosicrucian lodges have a strictly codified initiation rite in which the neophyte has to endure symbolic death in order to be reborn as a newly purified man. This passage is supposed to be joyous, the neophyte killing his previous, vain, preposterous self so that he can be born again to a higher life.

The access to such an improved spiritual existence was achieved through the help of a partner. An official or a master Mason would welcome the neophyte to the lodge, help him learn of the order's doctrine, and urge him to find his own personal interpretation of the symbols and allegories. This kind of symbolic brotherhood appears insistently in the more than one hundred panels in the secretariat of education, celebrating a form of social commitment peculiar to the Mexican political elites of the time (fig. 6).

The reversal of Rivera's all-too-kind self-portrayal of the political elites is to be found in an illustration that appeared in the October 1938 issue of the American magazine *Fortune* (fig. 7). It shows a two-sided political activist. On the left side, a drawing in white lines on black ground shows a corrupt Mexican politician with an official party badge on his lapel receiving a large sum of money from a group of military and bourgeois characters. On the right half, the black lines on red ground show the same man wearing a hammer and sickle badge while addressing a multitude of ferocious peasants. This Janus-like figure has big hands, expressive for both the opposing tasks of grabbing a bribe or inciting the masses. As Rita Eder had already noticed, Rivera "made a very special use of the subject's hands as a means of defining their characters."[33] The face of the devious leader is a mixture of famous politicians of the time, including the anarchist martyr Ricardo Flores Magón and

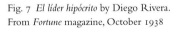
Fig. 7 *El líder hipócrito* by Diego Rivera. From *Fortune* magazine, October 1938

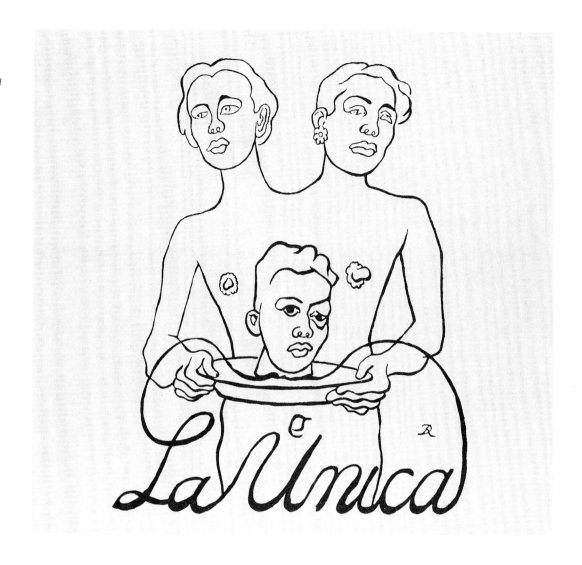

the former official party leader Carlos Riva Palacio. The hand is crucial for the identity of this two-sided character, as his mustache is significantly shorter in the left half. Since the appearance of Gleizes and Metzinger's *Du cubisme,* cubist theory had claimed that pictorial space was a field of refractions. In the words of Gino Severini, "a multiplicity of pyramids replaces the single cone of Italian perspective."[34] The *Fortune* illustration was quite a different "refraction," showing the ethical duplicity of political figures at the time, or for that matter, the complexity of any given character and the refractive quality of politics. In the same year that Rivera drew this illustration (and painted Guadalupe Marín's second portrait), he also made an illustration for the cover of *La única* (fig. 8). Again the femme fatale, Marín is depicted as a double-headed Salomé, with Jorge Cuesta's head on a plate. It seems that Rivera intended to include his own head in the bottom, with a pair of "long horns that would turn around, circling us all."[35] This biographical information should not conceal the tremendous irony that opposes this double-headed "monster" to the title of her book: "la única." This same drawing seems related to a two-inked, wooden engraving that Rivera did as an homage to André Breton (Museo Dolores Olmedo Patiño). An allegorical whim, it shows a brain and a circulatory system mocking the form of a tree trunk with an embedded face. A pair of hands grows from both sides of the trunk, holding a pair of glasses filled with blood either dripped by or intended for the feeding of the figure's veins. On top of the glasses are a pair of eyes, one with its lid closed, while the other stares at the viewer in

earnest. Although obviously illustrating Breton's aesthetics, the engraving refers to theories of symbolist precedent in a number of ways, but especially by the two-sided metaphor that opposes a closed, blind eye to an opened, alert one. It is the opposition of an outer, short-sighted materialism, and an inner, spiritual—and higher—understanding of the world.[36]

It is hardly a surprise that Rivera thought of stylistic transition in the form of infectious disease. His whole intellectual framework led him to consider the opposing forces of purity and impurity; the resistance of the individual was the only way to deter both the contamination and/or the division of the self. It is significant that almost every doctrine embraced by Rivera (symbolism, cubism, marxism, Masonry) would talk of a world driven by, and an individual entangled in, the opposition of overwhelming forces, namely, material versus spiritual, three-dimensional versus four-dimensional space, representation versus illusion, bourgeoisie versus proletariat, purification versus corrupted, material existence; historical forces versus the individual's impotence.

In 1921, one of Rivera's partners in the Parisian avant-garde (and later to be a Stalinist bureaucrat), Iliá Ehrenburg, wrote a novel in which Rivera was the protagonist. *The Extraordinary Adventures of Julio Jurenito and His Disciples*[37] made Rivera the bombastic master of an unlikely farcical lodge. Written to conceal Ehrenburg's doubts in the aftermath of the Soviet revolution, the novel alternates between the European contradictory political theories of its time. Foreseeing the authoritarian traits in both Soviet communism and German political theories, Ehrenburg has Rivera decreeing the abolishing of art in a weird, neoplatonic Siberian soviet.[38] Evoking, no doubt, Rivera's excessive lies, Julio Jurenito declares: "after the liquidation of art, we still have, at least, the adventures of Baron Munchausen."[39]

However, together with this ludicrous aesthetical characterization, it is possible to find in Rivera's work and thought a drive toward communion with the self. So it happens with Guadalupe Marín's portraits, wherein a sheer mystic reflection is distinguishable amid the whirling compositional devices. And such is the case as well with Adolfo Best Maugard's portrait, a painting full of scientific and aesthetic rhetoric, yet still aimed at demonstrating the spiritual superiority of the character. Style, in every one of these cases, is as intrinsic to the coherence of personality as disease, infection, and delusion. It would be fair to call this thought "paranoia," had the pictures not successfully conflated the opposing forces of the world to mere representation and discourse.

El Pintor Zinoviev

85 *The Painter Zinoviev*

Diego Rivera (Mexican, 1886–1957)

Oil on canvas, 127 × 106 cm (50 × 41¾ in.), 1913
Museo Regional de Guadalajara, CONACULTA-INAH, Mexico

Diego Rivera, one of the twentieth century's most important artists, studied at Mexico City's Academia de San Carlos under such classical painters as Santiago Rebull and José María Velasco. He lived in France for a decade, participating in the impressionist and cubist movements. Back in Mexico in 1921, he was one of the founders of the muralist movement and left his mark on dozens of important buildings all over Mexico. In 1931 he became the second artist to be honored with a one-man exhibition at New York's Museum of Modern Art.

Rivera was enormously productive in Paris; he painted more than two hundred works. This portrait of the Bolshevik painter Zinoviev dates from the beginning of that important, primarily cubist, phase. Rivera would remain involved with the Communist movement off and on for the rest of his life.

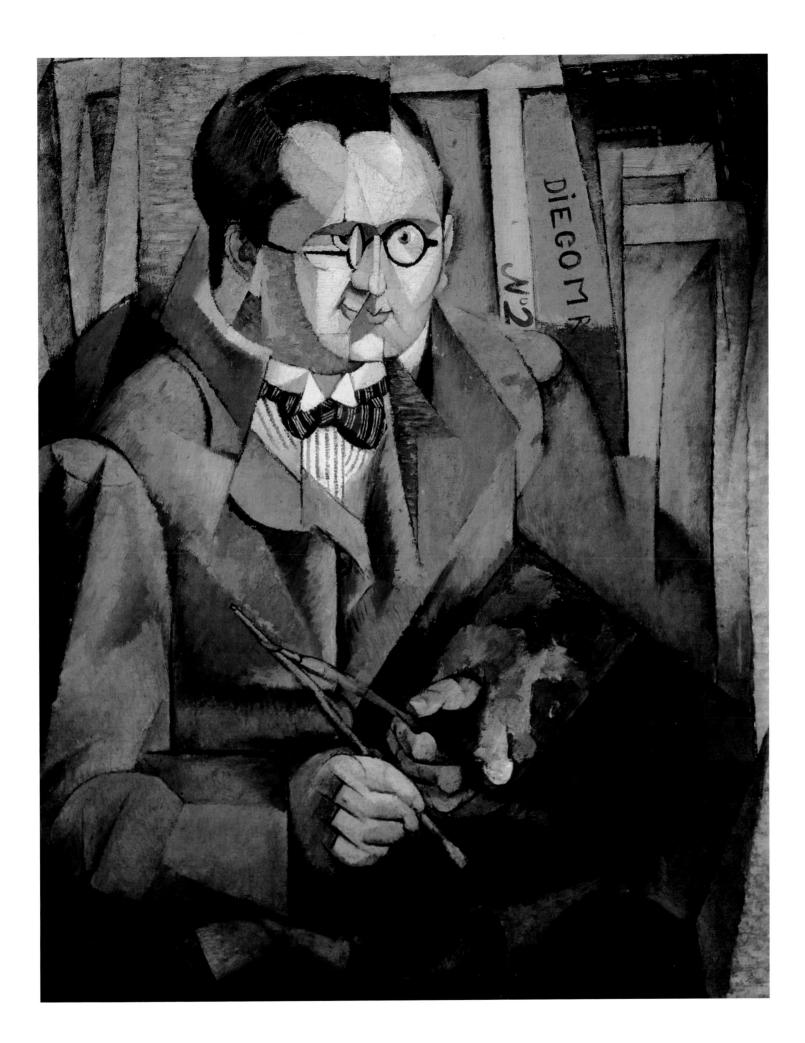

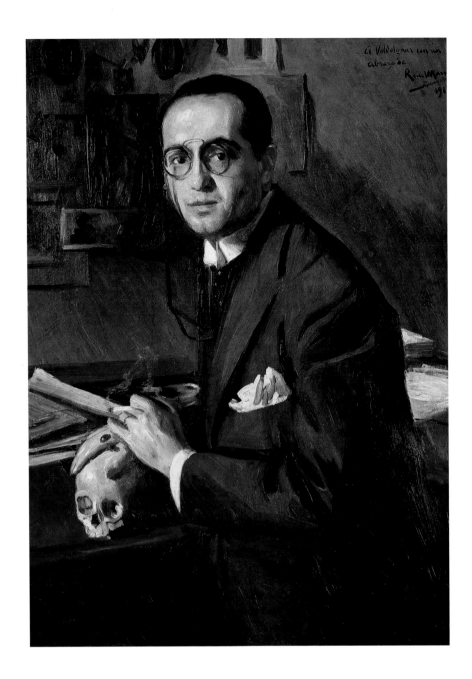

86 *Abraham Valdelomar*

Raúl María Pereira (Pereyra) (Peruvian, 1877–1933)
Oil on canvas, 92 × 67.5 cm (36¼ × 26⁹⁄₁₆ in.), 1917
Museo de Arte de Lima, Peru; gift of Luis Alberto Sánchez

Abraham Valdelomar (1888–1919) is one of Peru's major literary figures. In 1905 he enrolled at the University of San Marcos, the oldest university in South America, and gained notoriety as a revolutionary. When millionaire populist Guillermo Billinghurst became president in 1912, he named Valdelomar director of the state newspaper and entrusted him with numerous diplomatic missions to Europe. When Billinghurst was ousted by a coup in 1914, Valdelomar returned to Lima, writing poetry and establishing the literary magazine *Colónida* before he died in an automobile accident.

Valdelomar was portrayed in a realistic style popular in Europe in the late nineteenth century. It shows him in his *Colónida* office holding a skull—presumably a reference to his interest in anthropology—and surrounded by art and manuscripts. The artist, Raúl María Pereira (Pereyra), was born in Portugal and studied at Lisbon's art academy before immigrating first to Ecuador and then to Peru. He quickly gained important patrons, including the eminent historian and public figure Senator Javier Prado y Ugarteche.

87 Amado de la Cueva

David Alfaro Siqueiros (Mexican, 1896–1974)

Oil on canvas, 137 × 99 cm (53¹⁵⁄₁₆ × 39 in.), 1920
Museo Regional de Guadalajara, CONACULTA-INAH, Mexico

Like his contemporaries, Diego Rivera and José Clemente Orozco, David Alfaro Siqueiros is one of
Mexico's great mural painters. And also like them, Siqueiros was a political activist. He promoted
art that was monumental in scale, public in scope, nationalist, preferably indigenous in content, and
socially and politically committed. Siqueiros's first major protest was the 1911 strike in Mexico City
against the traditional teaching methods of the Academia de San Carlos; his last was the organization
of student riots in 1960, for which he served time in prison.

In 1917 Siqueiros settled in Guadalajara, where he met Amado de la Cueva (1891–1926).
During 1920, with support from the new government, the two traveled in Europe, where this por-
trait was painted. Back in Mexico, they worked on murals for the Escuela Nacional Preparatoria
(1923) and the Ibero-American Library at the University of Guadalajara (1925). De la Cueva died
in a motorcycle accident.

88 *Mário de Andrade*

Anita Malfatti (Brazilian, 1889–1964)

Oil on canvas, 51 × 44 cm (20⅛ × 17⁵⁄₁₆ in.), c. 1921/23
Hecilda and Sérgio Fadel, Brazil

São Paulo native Anita Malfatti, a key figure in Brazilian art, was exposed to modern art as a student in Berlin (1910–13). In 1915 she traveled to New York. Her portrait of Mário de Andrade suggests that there she was influenced by synchromism, a style of painting that employs abstract shapes and stresses the rhythmic nature of color.

Malfatti met fellow *paulista* Mário de Andrade (1893–1945) in 1916. Andrade, a music historian, launched his literary career in 1917. The publication of *Paulicéla Desvairada* (1922), and, later, *Macunaíma* (1928), cemented his reputation as a leading writer. In 1922, he organized the vastly influential "Week of Modern Art," where Malfatti exhibited twenty works. Andrade, Malfatti, poets Oswald de Andrade and Paulo Menotti del Picchia, and artist Tarsila do Amaral subsequently formed the "Group of Five," which became synonymous with avant-garde art and literature in Brazil.

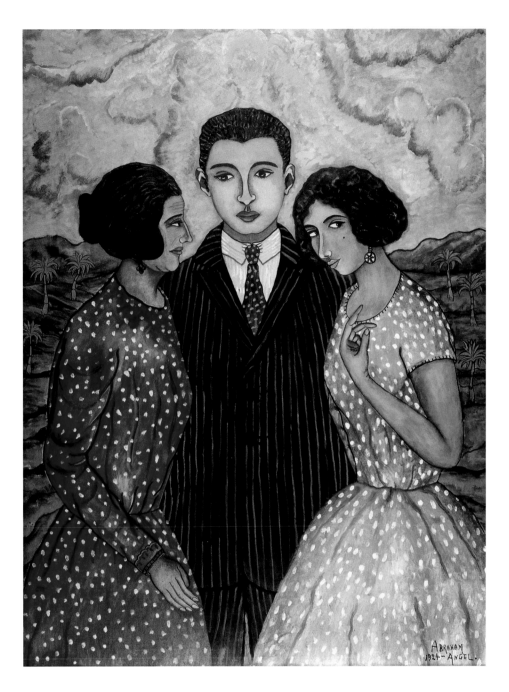

La Familia

89 *The Family*

Abraham Ángel (Mexican, 1905–1924)

Oil on cardboard, 160 × 122 cm (63 × 48 in.), 1924
Museo de Arte Moderno, CONACULTA-INBA, Mexico, D.F.

Abraham Ángel Card Valdés was one of five children born to a Scottish father and a Mexican mother. He spent his early childhood in Puebla, but moved to Mexico City in 1916, where he lived with his mother and sister, who are featured with him in this painting.

Ángel's art is characterized by the use of brilliant and intense colors and a deliberately primitive style in which the figures are drawn without traditional modeling, and their flat forms are surrounded by heavy, dark lines. Landscape elements are also simplified, and there is no sense of spatial perspective. Ángel was profoundly affected by the work of Manuel Rodríguez Lozano (1897–1971), who taught him drawing and painting, and by the theories of Adolfo Best Maugard (1891–1964). Ángel's meteoric rise in the Mexican art world was cut short by his death from either an unintentional cocaine overdose or suicide.

Rostro Blanco

92 *White Face*

Armando Reverón (Venezuelan, 1889–1954)

Oil, acrylic, and charcoal on canvas, 47.6 × 37.8 cm (18¾ × 14⅞ in.), c. 1932
Colección Cisneros, Venezuela

Armando Reverón, a major Venezuelan modernist, studied at the Academia de Bellas Artes in Cara-
cas and the Escuela de Artes y Oficios y Bellas Artes in Barcelona, where he was first exposed to
impressionism. His early work was influenced by the Romanian landscape painter Samys Mützner
and the Venezuelan impressionist Emilio Boggio. Around 1916, during his "white period," Reverón
began to paint landscapes and portraits of his wife and friends with a monochromatic palette. This
painting is an example of work from that period.

93 *Augusto César Sandino*

Roberto de la Selva (Nicaraguan, 1895–1957)

Wood, 48.3 cm (19 1/16 in.), c. 1934
Ron and Stephanie Burkard, Oklahoma

General Augusto Sandino was a charismatic leader of the Nicaraguan nationalistic and anticolonist struggles of the 1920s and 1930s. He was particularly known for his fight to expel U.S. Marines from Nicaraguan soil.

Sculptor Roberto de la Selva grew up in León, Nicaragua, and moved to Mexico in 1921. He studied art at the Academia de San Carlos and became deeply involved in the art of the Mexican renaissance of the 1920s and 1930s. Although rooted in the artistic tastes of his native Nicaragua, de la Selva easily moved in and out of changing Mexican styles. He was greatly influenced by Diego Rivera and other leading modernist artists of the period. Throughout his career, de la Selva, the "sculptor of the people," was concerned with problems of equality and human justice.

94 *Rockwell Kent*

Cândido Portinari (Brazilian, 1903–1962)

Oil on canvas, 55 × 46 cm (21⅝ × 18⅛ in.), 1937
Museu de Arte Brasileira, FAAP, São Paulo

Cândido Portinari, among Brazil's best-known modernists, met American artist, author, and political activist Rockwell Kent (1882–1971) in 1937, when Kent traveled to Brazil to examine the status of political prisoners under the regime of President Getulio Vargas. Portinari and Kent shared a common social and political viewpoint, and the two became close friends. They corresponded frequently, and in 1940 Kent wrote the introduction to one of the early books about the artist's work, *Portinari: His Life and Art* (1940). Many Americans became familiar with Portinari's strong and dramatic images because of the murals he made for the Brazilian Pavilion at the 1939 New York World's Fair and for those he made in 1942 for the Hispanic Reading Room at the Library of Congress.

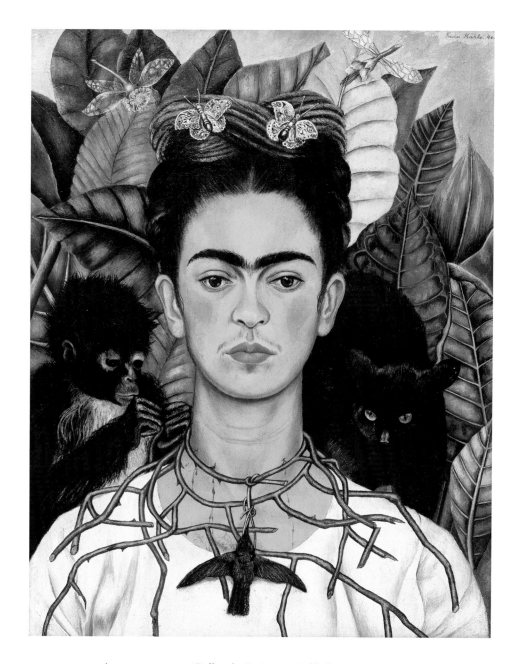

Autorretrato con Collar de Espinas y Colibrí

95 *Self-Portrait with Thorn Necklace and Hummingbird*

Frida Kahlo (Mexican, 1907–1954)

Oil on canvas mounted to board, 62.5 × 48 cm (24⅝ × 18⅞ in.), 1940
Art Collection, Harry Ransom Humanities Research Center, The University of Texas at Austin

Frida Kahlo was born in Coyoacán, near Mexico City. Injured in a traffic accident as a teenager, her wounds plagued her for the rest of her life. She was twice married to Diego Rivera (see pls. 85, 99), and both their turbulent relationship and his work influenced her profoundly.

Her paintings, intimate and intensely autobiographical, are at once naive and surrealistic. Because of her poor health, her production comprises only about two hundred paintings. Kahlo became the subject of international attention in the 1980s and 1990s and is today recognized as one of Mexico's best-known artists.

In this self-portrait painted for her lover, Nicholas Muray, Kahlo's spider monkey, Caimito del Guayabal, and a menacing black cat (the two traditional symbols of lust and infidelity) frame her face. The monkey toys with her thorn necklace, which pierces her neck. Dangling from her necklace is a dead hummingbird, a bird with which she often identified and which, in Mexico, is sometimes used as a love charm.

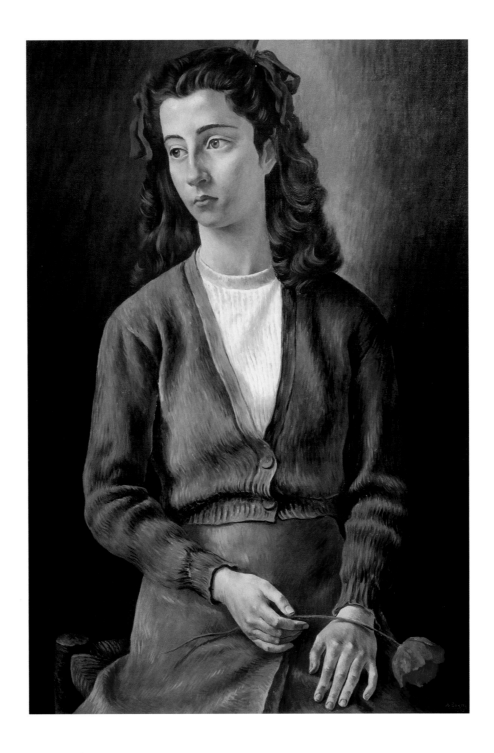

96 *Lily*

Antonio Berni (Argentinian, 1905–1981)

Oil on canvas, 100 × 70 cm (39⅜ × 27⁹⁄₁₆ in.), 1943
Museo Nacional de Bellas Artes, Buenos Aires, Argentina

In 1925 Antonio Berni, the son of Italian immigrants, won a scholarship from the Jockey Club in his hometown of Rosary to study in Europe. For the next five years, this young and immensely talented Argentinian settled in Paris, immersing himself in its art world and taking frequent trips to other countries to study the great masters of the past. When Berni returned to Buenos Aires with his French wife, Paolo Cazenave, and their newborn daughter Hélène (Lily), he quickly became one of the leading artists in Argentina. As with so many artists in the 1930s, the reality of everyday life became his subject matter. This concern for the mundane found an outlet in simple and emotionally somber portraits, many of which were of his wife and daughter.

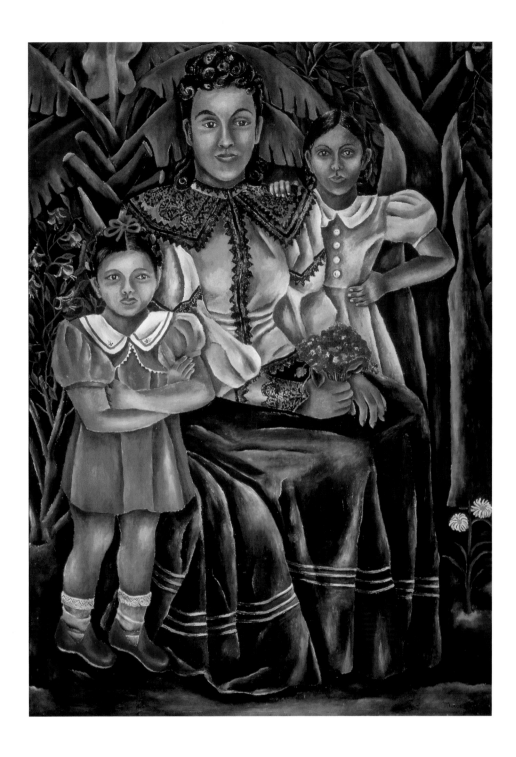

Mis Sobrinas

97 *My Nieces*

María Izquierdo (Mexican, 1902–1955)

Oil on plywood, 139 × 99.8 cm (54¾ × 39⁵⁄₁₆ in.), 1940
Museo Nacional de Arte, CONACULTA-INBA, Mexico, D.F.

Although she received traditional training at the Escuela Nacional de Bellas Artes in Mexico City, María Izquierdo quickly affiliated herself with more radical modern art trends, particularly those exemplified in the work of Diego Rivera (see pls. 85, 99) and Rufino Tamayo (see pl. 101). She was also a great admirer of the nineteenth-century regional painter José María Estrada (see pl. 52). These influences are evident in this work in the overall patterning of the lush vegetation, the brilliant color, the flat, angular forms, and the shallow, compressed space that the figures occupy.

In 2002, on the one-hundredth anniversary of her birth, Izquierdo was made a national treasure.

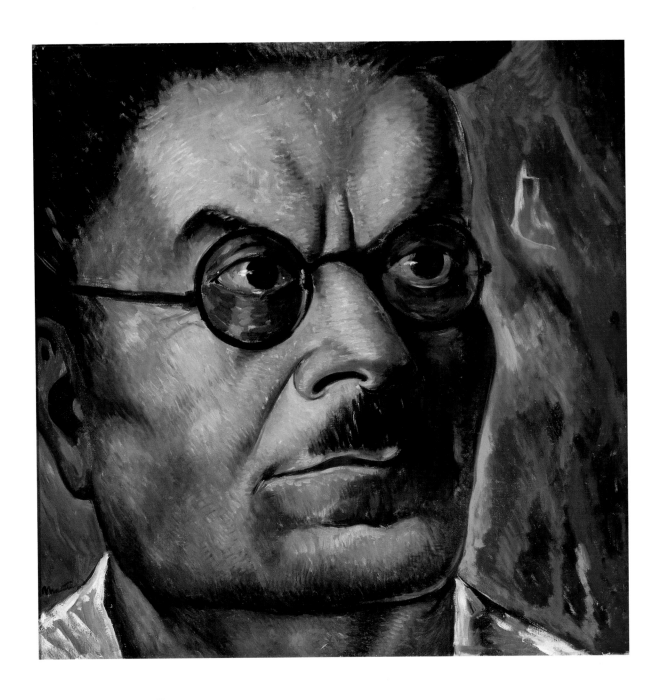

98 *José Clemente Orozco*

Roberto Montenegro (Mexican, 1887–1968)

Oil on canvas, 100 × 100 cm (39⅜ × 39⅜ in.), c. 1945
Instituto Cultural Cabañas, Guadalajara, Mexico

Roberto Montenegro was born to an affluent family in Guadalajara and studied art at the Academia de San Carlos in Mexico City and the École des Beaux-Arts in Paris during the first decade of the twentieth century. He was a founder of the muralist movement in Mexico and an unflagging supporter of the preservation of the popular arts. In particular, he was a major champion of the work of the nineteenth-century painter José María Estrada (see pl. 52). Montenegro also illustrated books, painted set designs for the ballet and theater, and became an accomplished easel painter. His portraits and self-portraits are among his most lasting contributions.

In this portrait of the great Mexican muralist José Clemente Orozco (1883–1949), Montenegro captures some of the intensity that was characteristic of Orozco's life and work.

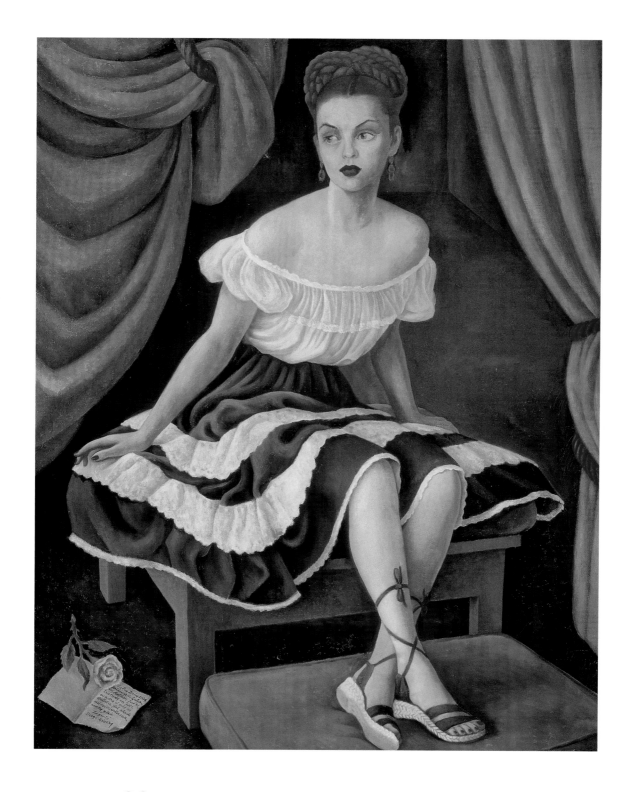

99 *Elisa Saldívar de Gutiérrez Roldán*

Diego Rivera (Mexican, 1886–1957)

Oil on canvas, 150 × 125 cm (59⅟₁₆ × 49³⁄₁₆ in.), 1946
Pascual Gutiérrez Roldán, Mexico

During the 1940s and early 1950s, Diego Rivera painted many portraits of artists, movie stars, and international socialites. This portrait of Elisa Saldívar de Gutiérrez Roldán (1911–1997; see also pl. 101) is an excellent example of Rivera's work from this period. The bold, strongly modeled forms characteristic of Rivera's socially and politically conscious murals are evident in this portrait, completed when the sitter was in her early thirties. The desire—probably on the part of the artist as well as the subject—to assert the sitter's Mexican identity is suggested by her costume and hairstyle.

Autorretrato

100 *Self-Portrait*

Oswaldo Guayasamín (Ecuadorian, 1919–1999)

Oil on canvas, 93 × 66 cm (36⅝ × 26 in.), 1950
Fundación Guayasamín, Quito, Ecuador

Oswaldo Guayasamín was born in Quito, Ecuador, and studied art at the Escuela Nacional de Bellas
Artes. From the time of his first one-man exhibition in 1941, he was very popular in his native coun-
try and enormously productive during his lifetime. The late Nelson Rockefeller purchased several of
his early paintings and sponsored his successful tour of the United States in 1943. He briefly studied
the fresco technique under the Mexican muralist José Clemente Orozco. Guayasamín is best known
as a portrait painter, but he produced landscapes and still lifes as well. His earlier works are painted
in a representational style, but his later works, like this self-portrait, are more expressionistic, with
overlays of cubist forms.

IOI *Elisa Saldívar de Gutiérrez Roldán*

Rufino Tamayo (Mexican, 1899–1991)
Oil on canvas, 130 × 95.5 cm (51¾₆ × 37⅝ in.), 1969
Pascual Gutiérrez Roldán, Mexico

A major focus of the art collection that Pascual Gutiérrez Roldán, a Mexico City–based engineer who made his fortune in the petrochemical industry, assembled over a fifty-five-year period was portraits of his wife. Over her lifetime, she sat for such notable Mexican artists as Jesús Guerrero Galván, Carlos Orozco Romero, Roberto Montenegro, Diego Rivera (see pl. 99), and David Alfaro Siqueiros.

 Artist Rufino Tamayo, a Zapotec Indian born in the state of Oaxaca, studied and later taught at the Escuela Nacional de Bellas Artes in Mexico City. This portrait, like his more abstract work, makes use of flat shapes, interlocking geometric forms, and softly modulated areas of sensuous color to connote a sense of reverie and suggest the sitter's calm reserve.

Joachim Jean Aberbach y Su Familia

102 *Joachim Jean Aberbach and His Family*

Fernando Botero (Colombian, b. 1932)

Oil on canvas, 234 × 196 cm (92⅛ × 77³⁄₁₆ in.), 1970
Susan Aberbach, New York

Fernando Botero has been a major figure in Latin American art for more than thirty years. Born in Medellín, Colombia, he started as an illustrator and writer for a Sunday newspaper. He studied art at the Real Academia de Bellas Artes de San Fernando in Madrid and the Accademia San Marco in Florence, Italy. Botero moved to New York City in 1960, after being awarded a Guggenheim Fellowship. He was given a one-man show at the Museum of Modern Art in 1969, which established him as a major painter. Botero's signature style of large, rounded, voluptuous men, women, children, and animals drawn from classical art are painted within the context of Latin America.

Although most of Botero's works represent generic types, this painting is an actual portrait of the Aberbach family. Note how the artist has extended his distinctive rounded style to animals, toys, the family house, and other items.

CONTEMPORARY PORTRAITURE (1980–present)

I.

Seneca reports (*Controversies,* X, 5) the following scene: that Parrasius the painter had purchased an elderly slave from among the prisoners of war of Philip the Great. He had bought him in order to produce a portrait of Prometheus, in the scene of his being rent asunder and dying, which the city of Athens had commissioned him to paint. For this purpose, with the help of his assistants, slaves, and helpers, after erecting the scaffold in the artist's studio and assembling the artist's easels, they subjected the old man to torture. He was contorted by pain and cried out, but the artist could still not see the subject of intolerable suffering. Then they tortured him more, while those present in the studio could hardly bear to look at the scene and implored him to have pity on the old man. "I've bought him. He's mine," replied Parrasius dryly. They nailed his hands to a block of wood while Parrasius painted, absorbed by the fever of his art. The assistants cursed in terror at the sufferings of the man. "He's mine," murmured the artist, "he's my slave. I am supported in this by the laws of war." Parrasius prepared his colors, his pigments, his measures, while one of the executioners prepared the torches, chains, whips, the rack of torture. "Tie him up," ordered the artist, "I want the suffering to be in his face." The old man uttered heartrending screams. The helpers, in desperation, called out to Parrasius, "Are you an executioner or a painter?" Parrasius, without giving them a reply, commanded, "Torture him more, more, more. . . . Keep him like that: there is the ideal face of Prometheus rent asunder, dying." The elderly man, overwhelmed, wept feebly. Parrasius warned him, "Your moans are not yet those of one pursued by the hounds of death." The man, fainting, muttered with an inaudible voice, "I'm dying, Parrasius." And the painter said, "Stay like that. Stay like that."

Pascal Quignard has written that all painting is in that scene.[1]

Every portrait is in that supplication.

The cries of the elderly slave will never be a subject for the art of painting because painting is an office of silences, mute poetry. Neither were the shouts of Laocoön heard in sculpture, dying in marble, like Prometheus, but restrained by serpents. At a certain moment in his celebrated dissertation on the Laocoön sculpture group, Lessing argued against Winckelmann, who had claimed it was impossible for the Trojan's cries to be heard in the sculpture due to the moderate size of his mouth, which was hardly open. According to Lessing, the representation of a cry lies beyond the dominion of sculpture because marble can only imitate the bodily exertions of Laocoön, but not his voice: a mute Laocoön with "an open mouth that in painting is a stain; in sculpture, a hole."[2]

Events taking place in time are not proportional to the visual representation, the German theoretician argued, not suspecting that one day the moving image would come to exist. In reality, what painting and sculpture can do is detain time, freeze actions; detain

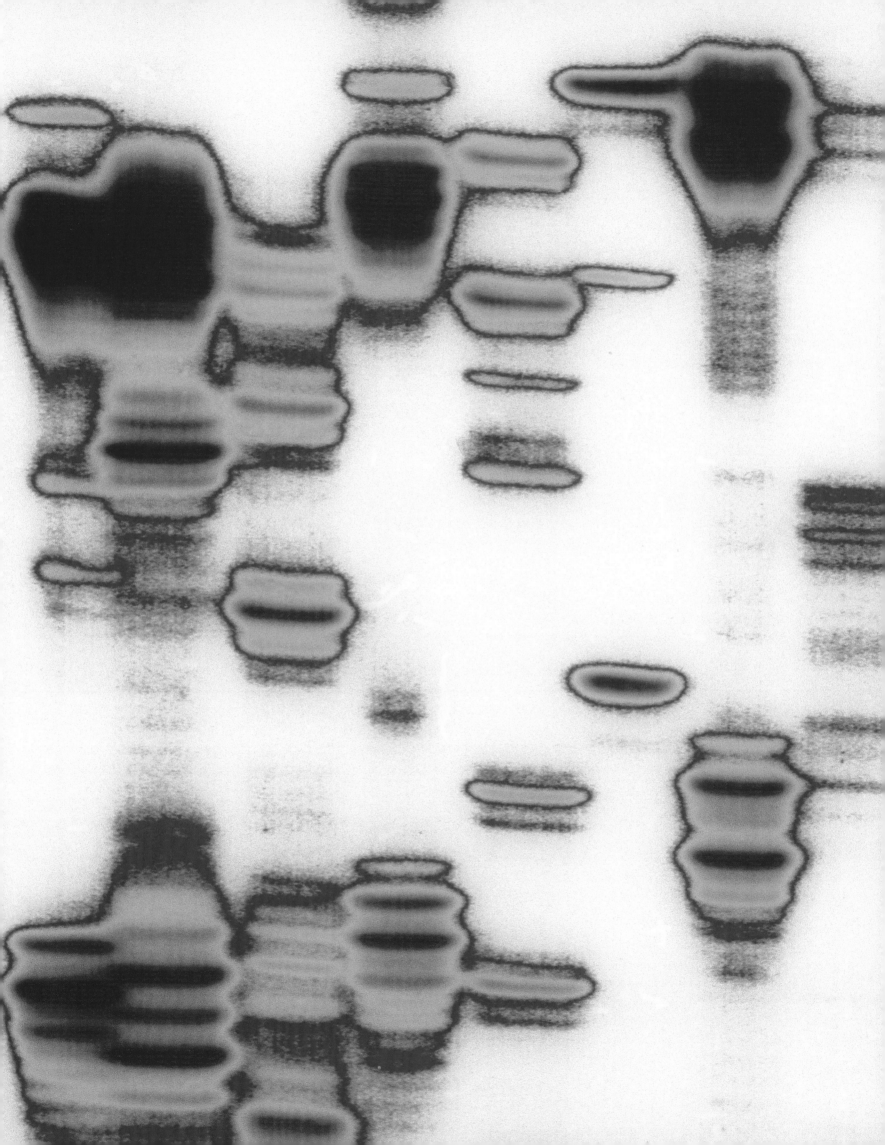

the growth of death in bodies; suspend the circumstances that incubate it. And yet, Laocoön still lives in the sculpture, and Prometheus has not yet died, even the one we can imagine in the work of Parrasius, in whose studio the corpse of his elderly model may yet lie buried. The scene reported by Seneca is no less than the very operation involved in each portrait: as it were, an "execution" by means of which the face of someone, which in life is only variation and movement, is immobilized forever in pigments as dry as stones and is eternalized in the form of an effigy.

Then what is a portrait?

Every portrait is like a sentence without a verb, with no mode, timeless, without circumstance; the visual equivalent of a name or a nominal phrase: this woman, that man, an old man, a young man, Caesar (or the Sun King), the spouses (Arnolfini), or the Princess (Margarita and her parents in the mirror), the bullfighter (Pedro Romero), the Virgin of the Annunciation, or the viewer's own face as it would appear in a mirror.

These are my examples: any imperial profile; a portrait by Hyacinthe Rigaud where Louis XIV appears embodied in a timeless figure, sustained by delicate legs, protected by monumental columns (Musée du Louvre, Paris); the double portrait by Jan van Eyck of a bourgeois couple swearing marital fidelity through a mirror where the image of the painter representing them is frozen in time (National Gallery, London); the luminous effigy of the future empress of Austria with her ladies in the enormous belly of the Alcázar of Madrid, in the lower rooms of Prince Baltasar Carlos with Philip IV and Mariana of Habsburg looking on while Velázquez paints (Museo Nacional del Prado, Madrid); the portrait of the bullfighter that Goya always longed to be (private collection, Madrid); the eternally surprised face of Mary regarding us from a little panel by Antonello da Messina (Galleria Nazionale della Sicilia, Palermo), situating us in the impossible place of the archangels; Nicolas Poussin amid his canvases (Musée du Louvre); every self-portrait.

These are the repertoires of portraiture in the West: a suspension of action, an introduction into the eternity of the visage, now freed from the movement of life. The portrait, any portrait—writes Louis Marin—is nothing "but the representation of a false countenance, that is to say, a mask: the fixing and immobilization of the face in an atemporal state: [in which] far from registering the marks of the passage of time, the gradual death laboring under the face of every son of Adam is necessarily dissimulated."[3]

At some moment all human societies have had an ideal of image, an ideal image, even those that have conceived it in its impossibility or absolute prohibition, imagining negatively, like an absence of image or a minute object. Two examples come to mind. The first is the *xoana:* a crudely scraped piece of wood, lacking any recognizable form, which in archaic Greece signified the "incommensurability between sacred power and everything that manifests it, always in an inadequate and incomplete manner, to the eyes of human beings."[4] Closer to us is the Mandylion, the image on the sheet of Christ, the *Vera Icona,* the apparition of which, as in the archaic *xoana,* is attributed to a miraculous effect in which the hand of man played no part: an *aqueiropoetic* image, "non humana manu factum, sed de caelo lapsam."[5]

Since then, the *aqueiropoetic* image, the Veronica, is the central image of every utopia of the image in the West. There are two versions of this prodigious image: one is specifically Christian, on the legendary origin of which ancient scripts abound. Among these, possibly the best-known one claims that on the way to his martyrdom Jesus dried his sweat on a cloth handed to him by Saint Veronica, thus imprinting his features on it. In this, as in the scene from Seneca, the portrait immortalizes the face of someone in the imminence of death. However, prodigious images stating the absolute of the portrait as something

beyond human faculties and crafts also abounded in antiquity. Among the most fecund pagan versions of the *Vera Icona* is the one related by Ovid in his *Metamorphoses:* that of the youth who paused, *full of himself, besieged in his epidermis,*[6] to rest after the exertions of the hunt, to discover the countenance of someone in the mirror of water where he was slaking his thirst: Narcissus. Like the Veronica, the image of Narcissus is a face, a scarcely recognizable *index*. Like the Veronica, it is an ideal face, in a state of disappearance. Like the Veronica, like the portrait of Prometheus by Parrasius, the image of Narcissus frozen in the inconstant water of his gaze is a funeral mask, the anticipation of his face immobilized by death. Like the Veronica, the image of Narcissus is ideal, that is to say, a matrix: a matrix of image—a model generating other images, a machine producing iconography. Not surprisingly, in the age when pagan antiquity was reborn from the oblivion of the Christian era, in the Florence of the Renaissance, to imagine the origin of painting, Leon Battista Alberti decided that "the inventor of painting, according to the formula of the poets, must have been that Narcissus . . . because, what else is painting than the art of embracing the surface of a spring?"[7]

So it is that at the dawn of modern thought on the sign—under the Jansenist shadows where the Logic of Port Royal was written—when it was necessary to think of the ideal model of a sign, the French moralists Antoine Arnaud and Pierre Nicole recalled another version of the ideal portrait, in the form of a performative phrase, a "speech act" uttered by Christ on the eve of his death, one day before his face was imprinted on Veronica's cloth or on the winding sheet of his open tomb: "Hoc est corpus meum"; "ceci est mon corps"; "this is my body." This piece of bread, this sip of wine, a portrait emancipated from any resemblance by Christ's phrase instituting the eucharistic sacrament, is the equivalent of an absolute sign, under the resonance and regulation of which the other signs should function, moving further from or approaching closer to its efficacy, according to the logical minds of Port Royal: "the same thing, capable of being at once thing and sign, can conceal as a thing what it reveals as a sign."[8]

What every portrait reveals as a thing is a mask. What every portrait conceals as a thing, and reveals as a sign, is death.

II

Among nineteenth-century Latin American paintings there is a scene in which this whole tragic ontology of the portrait is summarized. There must be few pictures in Latin America like the portrait of Charlotte Corday by Arturo Michelena (fig. 1) in which painting, with its mute eloquence of the brush, tips the portrait toward its theory. Michelena was an excellent portrait painter, a genre artist, an eloquent conceiver of grand scenes in the manner of later French academic painting. An outstanding disciple of Jean-Paul Laurens, this young Venezuelan, at the surprising age of twenty-four, won the gold medal of the Paris Salon, reaching the envied distinction *hors concours* and attaining the heights of the great masters of his time. At the Universal International Exhibition of 1889, where the centenary of the French Revolution was celebrated and the Eiffel Tower was inaugurated, Michelena exhibited *Charlotte Corday on the Way to the Scaffold*. Once again, the work was awarded the maximum prize by a committee with Jean-Louis Ernest Meissonier as chairman. The scene portrayed by Michelena can be interpreted as one in which the impassioned assassin of Marat, embodied in a kind of Lukacsien tragic "type character" of the ancien régime, goes toward her execution and death. In other words, it is the tragic triumph of the republic, the triumph of history. But the scene of Charlotte Corday does not only represent a typical moment of history painting "in the French manner," which had such an influence

Fig. 1 *Carlota Corday camino al patíbulo*
(Charlotte Corday on the Way to the Scaffold)
by Arturo Michelena. Oil on canvas, 1889.
Galería de Arte Nacional de Venezuela,
Caracas

on Latin America in the nineteenth century. An anachronistic scene, Michelena's work also represents the very scenario of the act of producing a portrait: the theoretical (and tragic) scene of every portrait.

Thus, Charlotte Corday on the way to the scaffold is a version of the scene described by Seneca: in the dungeon during the last moments of Corday's life, the painter Jean-Jacques Hauer was painting the prisoner's portrait. In Michelena's work, the engrossed painter ("absorbed," as Michael Fried would say)[9] gazes at her at the moment the young woman steps through the doorway to walk to the scaffold. There are two main sources of light: one comes from the courtyard where the scaffold has been erected, bathing Charlotte Corday's body with its pale premonition of death; the other enters through the window of the dungeon and falls onto the canvas which, tied to a chair acting as an easel for the occasion, presumably contains the effigy, the portrait—pigments still fresh—of the woman going to encounter death. In this way these two lights, these two sources of visibility, are equivalent: the lethal clarity that extracts us from life and that other clarity which gives life to the portrait and brings the painting into the light.

Michelena's picture is highly complex, and it cannot be described exhaustively here, but that light originating in the fields of death illuminates the painter's signature, projecting an oblique rectangle. The utensils of the person occupying his place in the picture, Jean-Jacques Hauer, lie there like instruments of torture, blood-colored stains standing out among them, the livid pigments. The shading stump, like the lance that blinded Longinus, like a cloth soaked in vinegar that cannot slake the thirst of the moribund man on the cross, reposes on a broken chair. The painting instruments—the book and the box of colors—rest on the floor, vanquished. One last detail: an ellipse of blue stains appears on the paving stones, as though the prisoner, walking from her portrait and treading on the blue pigments, had left the trail of her footprint between the chair on which her portrait is lying and the

doorway in which, detained an instant before her death, dressed in blue, she contemplates the blind destiny awaiting her.

In this way Michelena, in a pure logarithm of painting, seems to have established the definition of every portrait: a movement from life toward the immobility of death, from the palpitation of the living body to the sluggish effigy; as though every portrait's condition of visibility were to imitate its object at the moment in which it stops breathing, at the moment in which it accedes to the frozen eternity of death. A theory of profiles: the most surprising aspect of Michelena's portrait of Corday is that the central figure turns her back on us, refuses herself to our eyes, exactly as does the canvas containing her effigy, of which we see only indistinct features against the light. A theory of profiles: between the pallid, cadaverous profile of Charlotte Corday and the vivid red profile of the painter, the painting is no more than a canvas wounded by the light, a rigid body, a sheet on which it is possible to glimpse the features of someone who has been, who has gone, who has already ceased to be. And between the two, it seems, the painting is embodied, not on a canvas but in a lighted fire, in the slight innocence of a flame held like a funeral torch by an executioner whose keys are, in reality, those of Charon, those of Hades.[10]

III

The first portrait of all, if we are to believe the ancient books, was the profile of someone absent drawn on a wall by his lover. A theory of profiles: according to Pliny in his *Natural History*,[11] the daughter of the potter Butades drew the profile of her lover on the eve of his departure, with the help of a lamp, on the shadow projected onto stones to conserve a trace of similitude during his absence. Pliny's often-underestimated text is full of infinite suggestions: does it not claim that the portrait, or rather the scene functioning as its situation of enunciation, the scene in which it is traced out, the act of its visible apparition, is one of the eve of absence, one of an imminence of leave-taking? According to this theory, a portrait is only produced of someone who is about to go away, to disappear, to change inexorably, or to perish. Pliny does not explain whether the lover of Butades' daughter was going away to war or in search of adventure, but this journey, this farewell, precedes his portrait. And its explicit mention, at the moment when the ancient author announces the end of his history of painting with a satisfied affirmation—"This is sufficient and indeed more than enough to be said about painting"—precedes the explicit mention in the *Natural History* of the first portrait: the cast of a face, a mask. One could suppose that the leave-taking is a metaphor of death, and that the commerce of death—as the absolute image of disappearance—has always governed every act of portraiture.

The pages in which Pliny mentions this portrait tell of nothing less than the absolute beginning of the arts of mimetic representation. Pliny says there is no doubt about it: the first painting was that outline of a shadow drawn with the help of a lamp, and with the first portrait was born a form of resemblance opposed to ideal beauty. A theory of profiles: insofar as the only one of these paintings mentioned by Pliny in his text is the one made by Butades' daughter—just as the author is about to enter into a discussion of other arts, specifically that of modeling—one may infer that the first painting was this portrait of an absent lover. The interesting thing is that the first portrait, and the first painting, in Pliny's fable, were these profiles drawn on the shadow projected by a body against the light. As though also shown in the first portrait was the impulse present in every *index:* the dynamic connection, the "blind compulsion," connecting the real presence of something or someone to the material traces of its state.[12] Thus, the first portrait was also a tracing and a work of physical contact: an imprint.

For centuries Western thinking has tried to escape from this submission to contact. To make it possible for visual art to acquire the social status of the liberal arts, it was necessary to construct an ideal genealogy for it, to conceal the material nature of its origins, to dissimulate the craft elements of its operations. This practice has been repeated incessantly. Ortega y Gasset recognized it as the intellectualization of the painting process: it is Velázquez in *Las Meninas* painting in a cerebral manner, without touching the canvas with his brush, suspending it in the air of a purely conceptual gaze. And it must be repeated: what Velázquez was painting was a portrait of portraits, the *summa theologica* of the portrait or the "theology of painting," as it was described by Luca Giordano.[13]

On this taboo of contact, on this humanistic repression toward similitude by contact, much has been written.[14] Velázquez's attitude in *Las Meninas* denotes a distance from the manual aspects of his work, from the practice of art conceived as a friction between materials and as tactile contacts. Velázquez had already adopted the idea of a purely intellectual visual art, which, since the publication of Vasari's *Lives,* had been in the process of being (re)formulated in the West: an art of individual geniuses who—like the portraits of prudent men in antiquity, like the very name of Pericles in Aristotle's *Ethics*[15]—embodied the virtue of prudence, would exemplify the knowledge and prudence of art, and therefore, individually, the totality of its idea. So it is that, as Georges Didi-Huberman has pointed out repeatedly, Vasari would dissimulate the craft sources and the low original material of the humanistic art of the portrait. Not in vain, in his celebrated and capital essay on the art of portraiture and the Florentine bourgeoisie, has Aby Warburg created the necessary memorial to remind us of these truths camouflaged by humanistic idealism: namely, that the Florentine painters of the Renaissance trained in the goldsmiths' workshops, and that, therefore, a monumental (craft) commerce of funerary items determined the humanistic invention of the portrait as the ideal effigy.[16]

Warburg recalled the case of Santa María Annunziata, where the family of craftsmen by the name of Bennintendi, trained by Verrocchio, arranged bourgeois commissions of wax portraits, some of them equivalent to the body weight of the models, under the ritual form and material of ex-votos. Thus the fact that the portrait was born in Renaissance Florence from a funerary practice, directly extracted from a tradition of manufacturing funerary portraits and masks, was disguised by Vasari in his biographical tale of the artists. Everything happens as though, in the eyes of a humanist, that contact between the material and the lifeless body dismantled the possible dignity of an art that should guarantee the cold distance of the idea in order to enjoy its liberal privileges. Everything happens as though it was necessary to annihilate the memory of that base cadaverous contact, to replace the effects of the modeling by a prodigious ideal of memory, by hand-drawing a face without first touching it or modeling a mass of clay as though its skill did not really depend on the corporality of the model, as though it could be emancipated from the body, as though the pure force of visual ideas could rise above—transcend—that vulgar history of corpses and rigid bodies hanging from the ceiling of Santa María Annunziata.

The history of Western art, in its desire to create an ideal image, would thus have progressed from that shadow projected by a lover, drawn with the certainty of absence and of a cooling of passion, caressing the profile of the loved one on a cold stone as though caressing his body for the last time, to this humanistic dissimulation of the craft and funerary sources of the art of portraiture. And not in vain—Pliny's ancient text seems to suggest incessantly that the portrait began as a death mask: it is Lysistratus making the cast of a face and pouring wax in, which as Pliny adds, instituted "the practice of likeness," for previously only ideally beautiful faces were made.[17]

Everything has happened as though, on the one hand, the miracle of a divine portrait were to shine forth in which no hand ever played a part—*Vera Icona*—and, on the other, as though incessantly to conceal the memory of the funerary hand burying and pressing the features of a corpse into the wax of the mask, pretending in this way to invent an art of portraiture in which only a trained and distant eye memorizes and reproduces the ideal features of the subject portrayed. As though the matter of the likeness were opposed to the reflexive, idealizing, and purely conceptual distance. As though in order to make the ideal image of the world it were necessary to isolate oneself from all contact with the world.

IV

The climax of this story was to come one day in 1962, when Robert Rauschenberg sent a laconic telegram from Sweden to the Parisian gallery owner Iris Clert, with the following text: "This is a portrait of Iris Clert if I say so."

"Hoc est corpus meum."

Thus, in the brevity of a telegram was instituted the survival of the portrait in a time of immaterialities. Then, immersed in a world that would gradually see the loss of the material basis of the notion of economic value, which would become purely speculative, semiotic, and immaterial, the visual arts would forge a proportional mode of existence, conceive themselves in a conceptual mode. Beyond the ambiguities of this process of dissimulation of the matter of art, it is worth pointing out that Robert Rauschenberg then produced a portrait under the form of a performative phrase, repeating Christ's gesture—though without the power of instituting a sacrament—by means of which the equivalence between the thing and its sign is affirmed, while at the same time freeing the sign from all dependence on the similitude of the thing.

Thus emancipated from similitude, the portrait ceases to be a mask yet does not cease to mask the possibility of being a portrait, in the illusory performativity of the phrase illustrating it. Nobody recognizes the face of Iris Clert in Rauschenberg's phrase. But we all recognize that in this last conceptual survival of the portrait, what survives is the model of an invisible face rising up like a prodigy, by a purely intellectual power, without any bodily contact, "non humana manu factum, sed de caelo lapsam."

However, every recognizable portrait involves its mortal condition, its power of funerary anticipation. Every recognizable portrait involves an illusory suspension of time, detaining the growth of death in the material of the body, the features of which are petrified in the portrait. In this way, two forces in portraiture confront each other in every modern portrait: the portrait as a prodigious apparition—the *Vera Icona*—even under the semiotic form of a pure phrase; or the portrait as visible remains, as a sum of traces in the material that receives it, supports it, and displays it—the cloth, the very notion of the *subjectile*.[18] Thus, on the one hand, the portrait is the power of representation as the exercise of an intellect dissimulating its corporal destiny; on the other, it is a body, even if only a body of artistic material, shapeless and malleable.

To conclude this short journey around the theory of portraiture, I should like to comment briefly on three moments in the practice of portraiture during the twentieth century in Latin America.

Armando Reverón did not cease to paint portraits during his artistic career.[19] And he did this from a conception of painting as a Veronica. Reverón's work reveals the purely material conditions of painting—his material leitmotiv of painting is as a remainder of light, but even so, an objectualizing impulse led him even in his most retinous moments. Facing the need to safeguard painting against a light that was annihilating it, Reverón conceived

a pictorial grammar of eclipses, of shadows, of bodies against the light. Thus, in his work the visible aspects of the world represented appear like a blurring interposed between us and a terrifying, moving, and blinding light. *Rostro Blanco (White Face,* pl. 92) might thus be said to show us the features of the artist himself, in the manner of a *Vera Icona.* What resists and what remains here is the canvas on which the face is a shadow, the blurred material of painting, the pure dispersion of pigments: the body of art as the result of a visible body— a face—that fades away.

It happens as though at that moment and through its office of masks, art had a power to unmask: the Mandylion is a piece of wood, as shapeless as a *xoana,* on which the face of Christ appears. This face is, therefore, a pure sign of the art incessantly added as a supplement to a body, to a work in another material. In its taboo on contact, Western thinking has insisted on minimizing the fact that art resides truly, basically, and potentially in its materiality. If the soul is immaterial, it is no less true that in its etymological and conceptual root it appears described as an exhalation, a warm vapor breathed into bodies. When Oscar Muñoz presents his narcissistic portraits in mirrors onto which we must breathe in order to be able to see them appear and disappear (pl. 109), he confronts us with the materialization of this idea of the soul: inseparable from the body of the observer, Muñoz's works return portraiture to its state of tactile appearance, as in the ancient funerary masks. The ungraspable permanence of these faces blown onto the mirror, which are confused with our own reflection but really are like striations or blind clouds floating in our eyes in front of what we see, is opposed to the image of faces portrayed by the artist in a series of works made from evaporating water.

In these Narcissi, Muñoz seems to be making a visual commentary on a phrase of Ovid in his retelling of the myth of Narcissus. It occurs that in the climax of amorous desperation, Narcissus recognizes what separates him from his (illusory) lover: a negligible thickness of water, he says, like an infinite distance. In reality, according to Ovid, the face toward which Narcissus so amorously strives is no more than a shadow.[20] Oscar Muñoz has made this negligible thickness of water imprint itself on the basis of its recipients, drying out, and leaving there the face of Narcissus evaporated, like a print and like a shadow. It is not a sheet, not a revelation of the material nature of painting as a support: strictly speaking, it is the exact time of death written down, the precise time it has taken death to freeze the features: "Stay like that, stay like that."

In 1997, the Argentine conceptual artist Eduardo Costa produced one of the most significant portraits in contemporary Latin American art, significant because it is precisely an unmasking. It is one of his "volumetric paintings," a series begun by Costa around 1994, as sculptural forms produced entirely from sedimentations of pigments and accumulated acrylic paint. The "ironic" connotations of these works is evident, Costa being an artist who was directly linked to the beginning of conceptual art: if the painting after Clement Greenberg should be converted into its own materiality in order to attain the Parnassus of modernity, Costa produces it now without any resemblance to paint, literally converted into pigmentary material, and therefore into sculpture. A powerful sincerity underlies these works: they are "materialistic tautologies" in which "paint is paint" and the visual arts are literally identified with their own "plasticity." When in 1997 Costa came to model the face of Lygia Pape to make her portrait like a mask of paint (fig. 2), he was producing a particularly acute version of the truth of portraiture: a mask, as all portraits have always been, funerary or anticipatory of a funeral in the form of a portrait. There is no space in these lines to enunciate the complexity of this work. Suffice it to state that it is the significant portrait of an emblematic artist of the Brazilian neoconcrete aesthetic, in the framework

Fig. 2 *Lygia durmiendo y soñando (retrato de Lygia Pape) (Lygia Sleeping and Dreaming: Portrait of Lygia Pape)* by Eduardo Costa. Acrylic, 1997–98. Eduardo Costa

of which the body as subjectivity has erupted into the ideal forms of abstraction. In this work the body erupts as the mortal destination of the idea—in the conceptual ideology—of portraiture, unmasking both the idea and the portrait precisely like a mask. And the underlying portrait in it is a molding: once again, a body touched by a body. The portrait, then, is no more but no less than an instance of passage: from life to petrification, from movement to rigidity, from the idea to a body that lies, from breath to touch, from variation to cessation.

"Hoc est corpus meum."

What remains in every portrait is the body that configures it, and this figure is a metaphor of death. Not in vain does Pliny describe the legend of the origins of painting, and of the portrait, in the story of Butades' daughter to close the first history of pictorial art, to announce the *parusia* of another art. The hands of the potter Butades are going to bring onto that first shadow, in the form of clay and modeling, a voluminous shape, a tumulus, a tomb. As an instance of the passage ceaselessly constituting us, the portrait has always spoken of a territory separating our body from the body that will contain its remains, already separated forever from all similitude.

103 *Augusto Roa Bastos*

Carlos Colombino (Paraguayan, b. 1937)
Carved and painted wood (*xilo*), 135 × 160 cm (53¾₆ × 63 in.), 1989
Nicolás Darío Latourrette Bo, Paraguay

Augusto Roa Bastos (b. 1917) is Paraguay's foremost novelist and one of Latin America's twentieth-century literary giants. As a young man, he served in the bloody Chaco War with Bolivia (1932–35), which marked him for life. As a writer, his main theme has been the noxious legacy of dictatorship, especially in his own country. What is possibly his best-known work, *Yo, el Supremo,* appeared in 1974.

　　Carlos Colombino is one of Paraguay's top artists. He is also a major literary figure in his own right under the pseudonym Esteban Cabanas, and is a dedicated promoter of Paraguayan culture. Colombino has captured the strength of Roa Bastos's personality, representing him as the craggy face of a boulder inserted in a fantastic landscape.

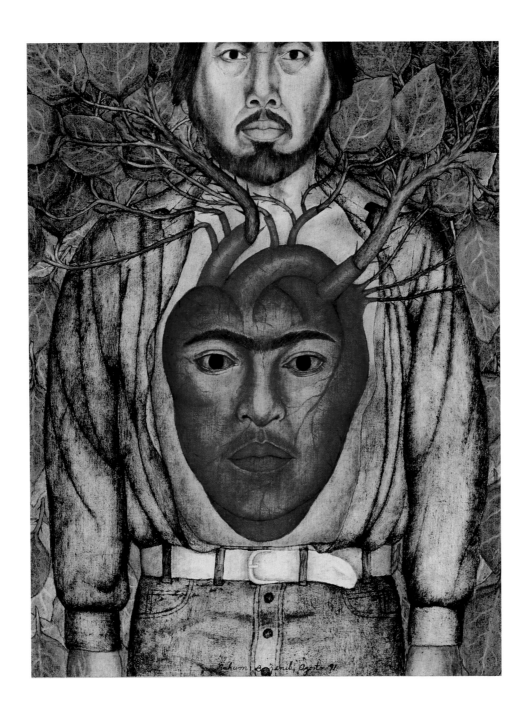

Frida de Mi Corazón

104 *Frida of My Heart*

Nahum Zenil (Mexican, b. 1947)

Oil on wood, 52 × 40 cm (20½ × 15¾ in.), 1991
Private collection, courtesy of Galería de Arte Mexicano, Mexico, D.F.

Nahum Zenil was born in Chicontepec, Veracruz, and graduated from the National Teachers School. He taught for several years and then enrolled at the Escuela Nacional de Pintura y Escultura la Esmeralda of the Instituto de Bellas Artes in Mexico City. His first major exhibition was at the Galería de Arte Mexicano in 1985. In 1991, a major retrospective of Zenil's work was held at the Museo de Arte Contemporáneo in Monterrey.

Zenil's work is very autobiographical, and he often uses his own body to analyze the society in which he lives. Many of his paintings are references to his relations with his own family and messages related to gay rights and gay sensibilities. This self-portrait, *Frida de Mi Corazón,* illustrates the important role that Frida Kahlo has played in Zenil's own life and work.

Autorretrato

10 5 *Self-Portrait*

Francisco Toledo (Mexican, b. 1940)

Mixed media on gold leaf on wood, 35 × 27 cm (13¾ × 10⅝ in.), 1991
Private collection, courtesy of Galería Arvil, Mexico, D.F.

Francisco Toledo first studied graphic art under Arturo García Bustos and later at the Taller Libre de Grabado in Mexico City and the Stanley William Hayter graphic workshop in Paris. Although primarily known as one of Mexico's best graphic artists, Toledo also works in other media, including drawing, assemblage, sculpture, and painting. He draws heavily from his Zapotec Indian background and often works in a form of magical realism. Enormously productive, Toledo has also been instrumental in creating a renaissance in the arts of his native Oaxaca and was the founder of the Instituto de Artes Gráficas in Oaxaca City. He has done dozens of self-portraits; this example is typical of his palette and style.

106 Tentaciones
Temptations

Arnaldo Roche-Rabell (Puerto Rican, b. 1955)

Oil on canvas, 120 × 90 cm (47¼ × 35⁷⁄₁₆ in.), 1992
María Teresa and Shane McClellan, Texas

Arnaldo Roche-Rabell attended architecture school at the University of Puerto Rico and later received degrees from the Art Institute of Chicago. In 1991 he was given an important retrospective exhibition at Monterrey's Museo de Arte Contemporáneo. An art critic has said that from the beginning, Roche-Rabell's work "demonstrated his intense search for an appropriate form in which to express dream-like states of being. His paintings are like exorcisms in which his own image is seen as protagonist, either a victim of himself or of his models or victimizing them. Self-portraiture is the central theme of the art of Roche, which has undergone countless changes of appearance and scale."

La Máscara

107 *The Mask*

Angel Rodríguez-Diaz (Puerto Rican, b. 1955)
Oil on paper on canvas, 76 × 61 cm (29¹⁵⁄₁₆ × 24 in.), 1993
Private collection, San Antonio, Texas

Angel Rodríguez-Diaz studied art at the University of Puerto Rico and now lives and works in San Antonio, Texas. Since the 1980s, he has pursued the social and political boundaries of portraiture, celebrating the diversity of individuals through the use of dynamic colors and masterful brushstrokes. This self-portrait is an excellent example of the power of combining bold coloration with rich texture and provocative subject matter.

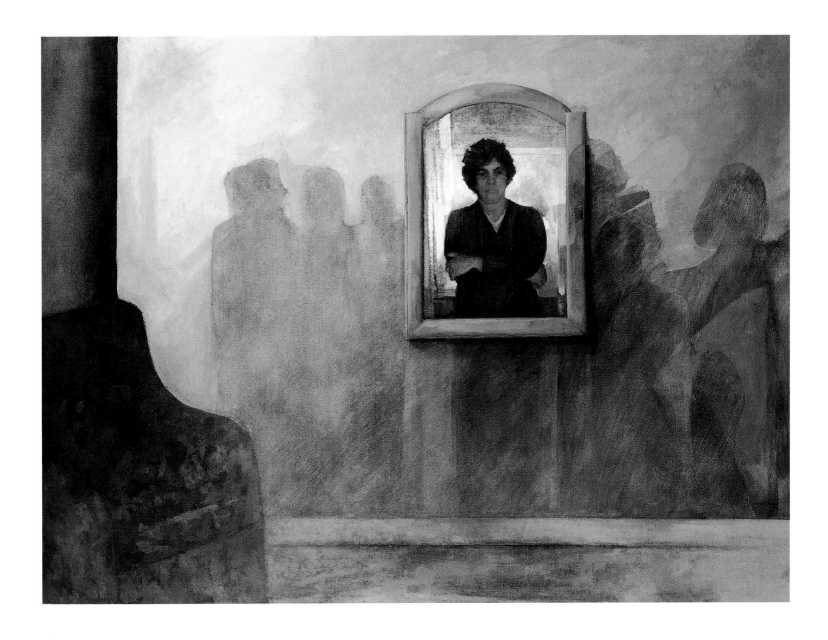

Espectadores

108 *Spectators*

Myrna Baez (Puerto Rican, b. 1931)

Acrylic and oil on linen, 114.3 × 157.5 cm (45 × 62 in.), 1994
Mr. and Mrs. David Morrow, Puerto Rico

Myrna Baez, a painter and a printmaker and one of the few Puerto Rican women of her generation to make a career as a professional artist, has been a major force in the artistic life of her country for more than four decades. In her softly painted, luminous canvases, which often reference the island's political and social circumstances, she seeks to capture ambiguous psychological states, giving, as one critic noted "corporeal sensation to invisible strata." Baez clearly delights in creating pictures within pictures and confounding the viewer's notions of space and reality. Is, for instance, the central image a painted self-portrait or the image of the artist painted as if it was a reflection in a mirror? And who are the "spectators," the shadowy forms that surround the artist? And where are they located? These unanswerable questions, like a calm but disorienting dream made manifest, create the magic in Baez's painting.

Aliento

109 *Breath*

Oscar Muñoz (Colombian, b. 1951)

Photoserigraph on steel disk with grease, edition of three, each 20 cm (7⅞ in.) diameter, 1996–97
Oscar Muñoz, Colombia

Oscar Muñoz chooses and manipulates materials to express his interest in the transitory nature of life and the relation of people to each other. In *Aliento,* the steel discs appear as small mirrors until the viewer, in an intuitive but ultimately narcissistic gesture, moves closer to see himself or herself. The viewer's breath on the disc's greased surface blurs his or her image and releases a photoserigraphed image of another, in each case a portrait of a deceased man, woman, or child whose photograph the artist found in the obituary pages of Colombian newspapers. Many of these individuals were victims of Colombia's civil and political unrest. As the viewer moves away from the object, the image of the stranger disappears until his or her image is encountered by the actions of another museum visitor.

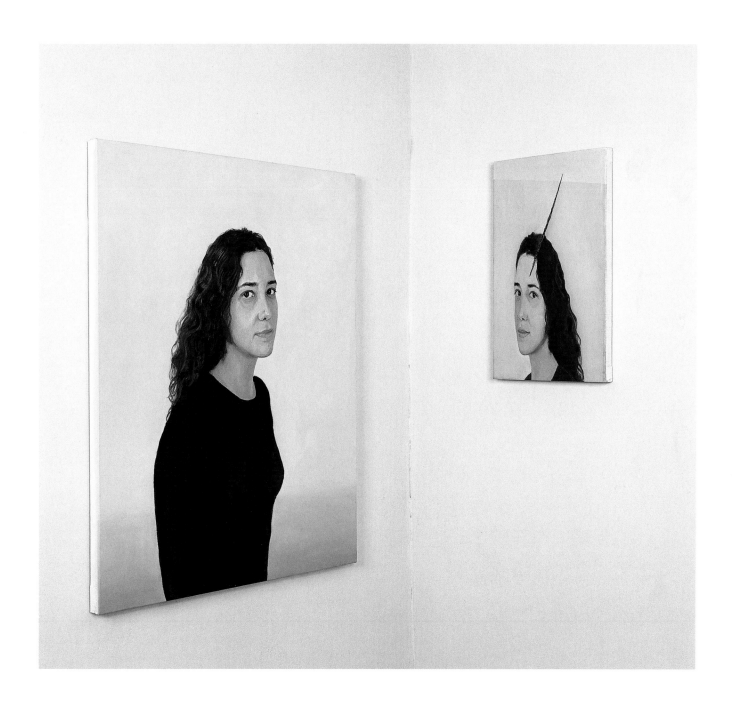

Duplo Reflexo do Outro

I I O *Double Reflection of the Other*

Adriana Varejão (Brazilian, b. 1964)

Oil on canvas, 80 × 63.5 cm (31½ × 25 in.) diptych, 1999
Nassau County Museum of Art, Roslyn Harbor, New York; Permanent Collection

The contemplative gaze, the sober demeanor, and the placid blue of the background of this self-portrait belie the fact that this Brazilian artist is best known for her visceral subject matter that recalls the psychological turmoil and physical trauma that was part of colonialism. For her, it is often a part of the creative process as well. Only the slash in the smaller canvas provides a hint of the emotional reality that lies beyond the self-contained image that Varejão projects in the larger of the two canvases.

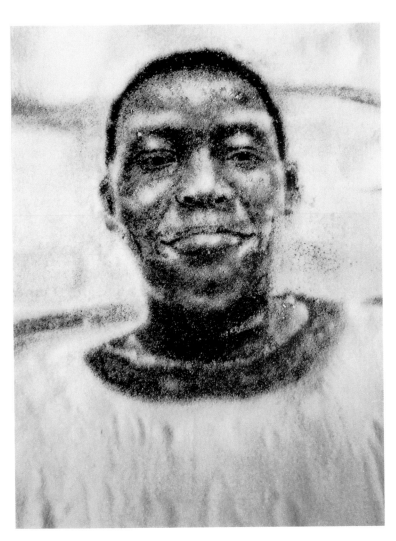 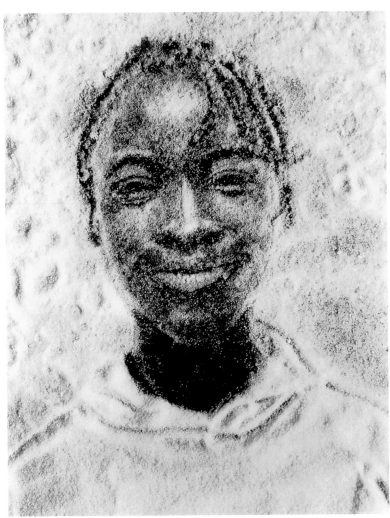

III *Sugar Children Series—Big James Sweats Buckets and Valicia Bathes in Sunday Clothes*

Vik Muniz (Brazilian, b. 1961)

Gelatin silver prints, 35.6 × 27.9 cm (14 × 11 in.), 1997
Smithsonian American Art Museum, Washington, D.C.

Vik Muniz was born in São Paulo and now lives and works in New York City. He has been the subject of dozens of one-man exhibitions in the United States, Latin America, and Europe, and his photographs are now in the permanent collections of the Metropolitan Museum of Art, the Art Institute of Chicago, the Museu de Arte Moderna in Rio de Janeiro, and other major institutions.

In the *Sugar Children* series, Muniz creates unusually compelling images of children of sugar-cane workers from the island of Saint Kitts by drawing them with granulated sugar on black paper. "After each image was 'drawn' he photographed it and then wiped the background paper clean . . . in preparation for the next. Blended with these faces is a socially critical message, for each print represents the island sugar trade in both subject and medium."

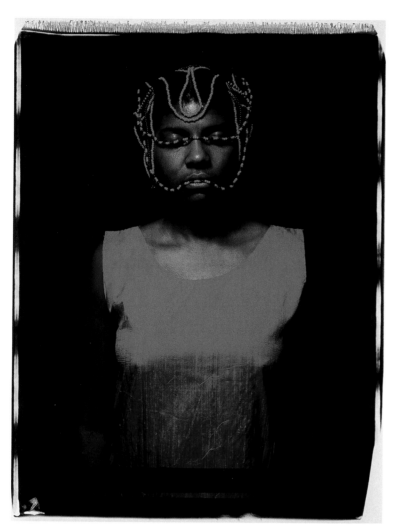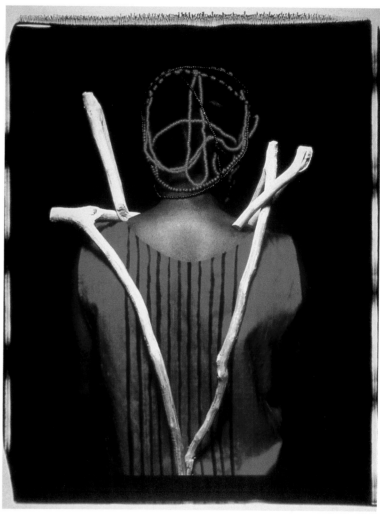

Abridor de Caminos

I I 2 *Pathfinder*

María Magdalena Campos-Pons (Cuban, b. 1959)

Polaroid photographs, 71.1 × 55.2 cm (28 × 21¾ in.) left; 55.9 × 73.7 cm (22 × 29 in.) right; both 1997
Lehigh University Art Galleries Museum Operation, Bethlehem, Pennsylvania (left)
Gutiérrez-Bermudez Collection, Santurce, Puerto Rico (right)

María Magdalena Campos-Pons, who now lives outside of Boston, was born in Matanzas, Cuba, to
descendants of a family brought from Nigeria in the late nineteenth century to work as slaves on a
sugar plantation. They carried with them and kept numerous African traditions and beliefs. Campos-
Pons incorporates many of these into her work as she explores issues of identity, race, heritage,
gender, exile, and assimilation.

In these two Polaroid photographs from *Abridor de Caminos,* normally a larger, multipanel in-
stallation, Campos-Pons's Yoruba-derived Santería heritage shapes the iconography. Red and black
are the colors of Elegguá, the deity that opens one's path. The *garabado,* or hooked branch, is one of
his attributes. In Campos-Pons's portrait, the status of the individual is connoted through elaborately
coiffed and beaded hair.

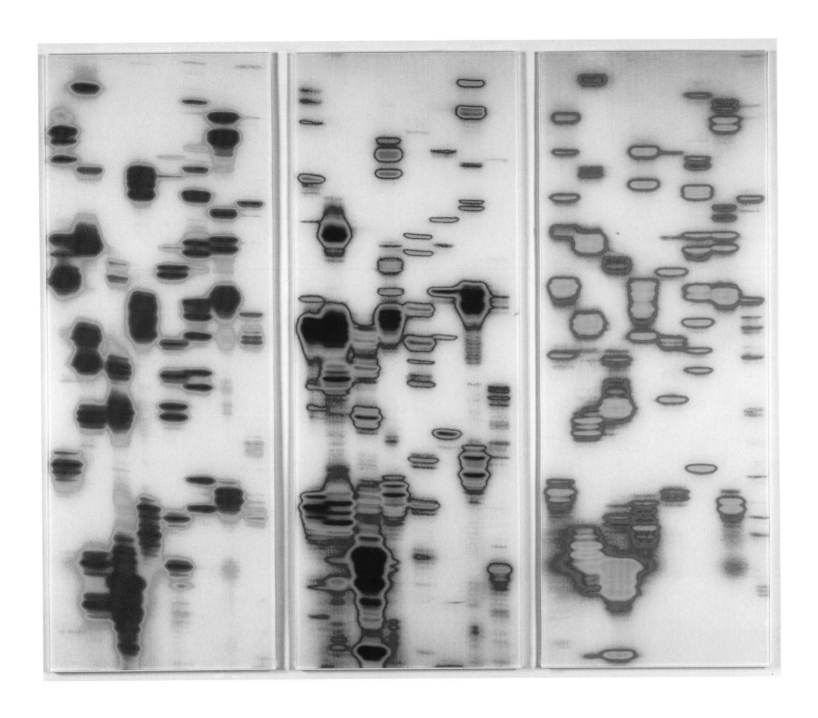

Carter, Anna, y Daryl (*de* El Jardín de las Delicias)

I I 3 *Carter, Anna, and Daryl* (from *The Garden of Delights*)

Iñigo Manglano-Ovalle (Spanish, b. 1961)

C-print of DNA analysis, 152 × 187.5 cm (59⅞ × 73¹³⁄₁₆ in.) overall, 1998
Iñigo Manglano-Ovalle, courtesy of the Max Protetch Gallery, New York City

Iñigo Manglano-Ovalle was born in Spain, spent part of his youth in South America, and now lives in Chicago. He received his formal education at Williams College and the Art Institute of Chicago and has exhibited widely throughout the United States, Europe, and Latin America. In 2001 Manglano-Ovalle was the recipient of a John D. and Catherine T. MacArthur Foundation fellowship.

In *The Garden of Delights* series, the artist uses "a series of triptychs composed of digitized images of DNA samples to reveal striking similarities and differences among the biological blueprints of acquaintances and family members." The series is part of his larger focus on "universal issues of identity, class, and the role of the individual in a multiethnic, technologically changing society."

Figura sin Título

I I 4 *Untitled Figure*

Salomón Huerta (Mexican, b. 1965)

Oil on canvas on panel, 172.7 × 121.9 cm (68 × 48 in.), 2000
Museum of Contemporary Art San Diego, California; Museum purchase,
International and Contemporary Collectors Fund

Born in Tijuana, Mexico, and raised in East Los Angeles, Salomón Huerta's initial exposure to art was the publicly funded, politically charged murals of the Ramona Gardens housing project where he lived. In his own work, Huerta, who studied first at the Art Center College of Design in Pasadena and later at UCLA, seeks to explore issues of identity by giving the viewer only a limited number of clues about the sitter. He places his subjects with their backs to the viewer to further underscore a sense of mystery and ambiguity. Huerta calls these portraits "mirror images," because they allow the viewer a relatively undefined surface on which to project and consider his or her own prejudices. Huerta's portraits further engage the visitor by juxtaposing the delicacy of the surface with the intensity of the bold colors and strident centrality of the figure.

NOTES

From Prehispanic to Post-Romantic
by Miguel A. Bretos

1. Alfonso Méndez Plancarte, *Obras completas de sor Juana Inés de la Cruz,* 4 vols. (Mexico, D.F.: Fondo de Cultura Económica, 1951–57). See also the excellent Dartmouth College site on Sor Juana, http://www.Dartmouth.edu/~sorjuana. For a superb biography, see Octavio Paz, *Sor Juana, o las trampas de la fé* (Barcelona: Seix Barral, 1982).

The Spanish text of the full sonnet is:

> *Este, que ves, engaño colorido,*
> *que del arte ostentando los primores,*
> *con falsos silogismos de colores,*
> *es cauteloso engaño del sentido.*
>
> *Este, en que la lisonja ha pretendido*
> *excusar de los años los horrores,*
> *y venciendo del tiempo los rigores,*
> *triunfar de la vejez y del olvido,*
>
> *es un vano artificio del cuidado,*
> *es una flor al viento delicada,*
> *es un resguardo inútil para el hado,*
>
> *es una necia diligencia errada,*
> *es un afán caduco, y bien mirado,*
> *es cadáver, es polvo, es sombra, es nada.*

2. Esther Pasztory, *Aztec Art* (New York: Harry N. Abrams, 1983), 127–28, pl. 69.

3. José Vasconcelos (1882–1959) was Mexico's minister of education between 1921 and 1924. It was he who gave its first major boost to the Mexican muralist movement, commissioning vast historical murals in official spaces. His book is called *La raza cósmica: Misión de la raza iberoamericana, notas de viajes a la América del sur* (Paris: Agencia Mundial de Publicaciones, 1925).

While portraiture in Latin America has not received the sustained and systematic attention it has been accorded elsewhere, important contributions to the subject nevertheless exist. Adolfo Luis Ribera's pioneering *El retrato en Buenos Aires, 1580–1870* (Buenos Aires: Universidad de Buenos Aires, 1982) and María Ester Ciancas and Bárbara Meyer's *La pintura de retrato colonial, siglos XVI–XVIII* (Mexico, D.F.: INAH/Museo Nacional de Historia, 1994) are fine introductions to the subject for Argentina and colonial New Spain, respectively. Colonial and nineteenth-century Mexican portraiture has been explored in at least three important exhibitions and their accompanying catalogues: *Lazos de sangre: Retrato mexicano de familia, siglos XVIII y XIX* (Mexico, D.F.: Museo de la Ciudad de México, 2000); Marita Martínez del Río de Redo, *El retrato civil en la Nueva España* (Mexico, D.F.: Museo de San Carlos, 1991); and *El retrato novohispano en el siglo XVIII* (Puebla: Museo Poblano de Arte Virreinal, 1999). Monographic studies and exhibition catalogues have approached portraiture from national, regional, chronological, and thematic perspectives. *Frente al espejo: 300 años del retrato en Antioquia* (Medellín: Museo de Antioquia, 1993) and Cecilia Cavanagh's *Autorretratos y retratos* (Buenos Aires: Pontificia Universidad Católica Argentina/Pabellón de las Bellas Artes, 2004) document important exhibitions dealing with Colombia's Antioquia department and the Argentine Republic, respectively. Children's and women's portraits have received both museum and scholarly attention, to wit: *El niño mexicano en la pintura* (Mexico, D.F.: Fondo Cultural Banamex, n.d. [1979?]); Vera Pacheco Jordão, *A imagem da criança na pintura brasileira* (Rio de Janeiro: Salamandra, 1979); and Teodoro Vidal, *Cuatro puertorriqueñas por Campeche* (San Juan de Puerto Rico: Ediciones Alba, 2000). Honduran writers and Brazilian elites have been approached from the perspective of portraiture. See Mario Castillo (Castillo Cárcamo), *Retratos de escritores hondureños* (Tegucigalpa: Fondo Editorial UPNFM, 2002) and Sergio Miceli, *Imagens negociadas: Retratos da elite brasileira, 1920–1940* (São Paulo: Companhia das Letras, 1996). Significant coverage of the subject exists in the academic journals and mass media. Hopefully this exhibition will stimulate

much-needed research in the rich but hitherto neglected field of Latin American portraiture.

4. Duncan T. Kinkead, "Artistic Trade Between Seville and the New World in the Mid-Seventeenth Century," *Boletín del Centro de Investigaciones Históricas y Estéticas* (Universidad Central de Venezuela, Caracas) 25 (November 1983): 73–101. On the Luzón shipment, see pages 88–89.

5. See Vicente Bécares Botas, *Arias Montano y Plantino: El libro flamenco de la España de Felipe II* (León: Secretariado de Publicaciones de la Universidad de León, 1999).

6. Among those European-trained artists who made a mark in New Spain were Sebastián de Arteaga, Martín de Vos, Simón Pereyns (the latter two Flemish), and the Basque Baltasar de Echave Orio, the progenitor of a veritable dynasty of painters. The Italians Angelino Medoro, Mateo de Lecce (known as Mateo Pérez de Alessio), and Bernardo Bitti worked in Peru. Medoro worked for a while in New Granada's highland city of Tunja.

It is likely that all of them may have done portraits, although few have survived. (A head-and-shoulders portrait of the future Saint Rose of Lima by Medoro is known.) Baltasar de Echave Orio's son, Baltasar de Echave Ibía, did a remarkable head-and-shoulders portrait of an aristocratic lady in prayer that is without a doubt one of the finest portraits produced in viceregal Mexico. Unfortunately, the identity of the lady, gorgeously attired in a black dress with a ruffle and a lovely veil, is a mystery.

For a general overview of sixteenth-century painting, see Damián Bayón, *History of South American Colonial Art and Architecture: Spanish South America and Brazil* (New York: Rizzoli, 1992). Manuel Toussaint, *Colonial Art in Mexico,* trans. Elizabeth Wilder Weismann (Austin: University of Texas Press, 1967) is still useful for Mexico despite its age, especially 129–52. For an image of the Echave Ibía painting of the lady, see Toussaint, 144, pl. 13.

7. One whose name we do know is Juan Gerson. His Apocalypse scenes appear on the underchoir of the Franciscan church at Tecamachalco, Puebla, Mexico. Long assumed to be Flemish, Gerson was shown by Constantino Reyes Valerio and his colleagues to have been a full-blooded Aztec. Gerson's "murals," originally thought to be dry fresco, were actually painted on *amate* (bark) paper and glued to the vault—an unusual technique incorpor-

ing both European and native ideas. See Constantino Reyes Valerio et al., *Arte indocristiana: Escultura del s. XVI en México* (Mexico, D.F.: INAH/CONACULTA, 2000). On Gerson, see Reyes Valerio, *Juan Gerson, tlacuilo de Tecamachalco* (Mexico, D.F.: INAH, 1964).

8. Santiago Londoño Vélez, *Arte colombiano: 3.500 años de historia* (Bogota: Villegas Editores, 2001), 94–95.

9. On the general background of this remarkable painting, see John L. Phelan, *The Kingdom of Quito in the Seventeenth Century: Bureaucratic Politics in the Spanish Empire* (Madison: University of Wisconsin Press, 1967). See also Thomas B. F. Cummings and William B. Taylor, "The Mulatto Gentlemen of Esmeraldas, Ecuador," in Kenneth Mills and William B. Taylor, eds., *Colonial Spanish America: A Documentary History* (Wilmington, Del.: Scholarly Resources, 1998), and María Concepción García Sáiz's discussion in this book.

What accounts for this extraordinary tableau, the painstaking detail, the careful labeling? Earlier in the sixteenth century, a boatload of African slaves was shipwrecked on the Esmeraldas coast. Over time, the Africans mixed with the local natives, and a community emerged. (In 1606 the community was said to consist of 450 Christian natives and thirty-five "mulattoes," who essentially ran the place.)

In 1597 Juan del Barrio Sepúlveda, an *oidor* (judge) in Quito's Audiencia (High Court), sent a mission to Esmeraldas led by a Mercedarian friar, Diego de Torres. The mission successfully converted the Esmeraldas community to Christianity—never mind how thoroughly or sincerely; the conversion was good enough. Don Francisco had ruled over his people de facto as a native "natural lord." Spanish law recognized the rights of "natural lords" and their status as natural nobility, but only Christians were entitled to social honors. When Don Francisco and his companions went to Quito for the proclamation of the new king, Philip III, the judge commissioned the portrait and sent it to Spain—a shrewd political move.

10. Héctor H. Schenone, *Iconografía del arte colonial: Los santos,* 2 vols. (Buenos Aires: Fundación Tarea, 1992–98), 1:31–33.

11. Elisa Vargas Lugo, "El retrato de donantes y el autorretrato en la pintura novohispana," *Anales del Instituto de Investigaciones Estética* 51 (1983).

12. For a sampling of viceregal episcopal portraits, see *Pintura novohispana: Museo Nacional del Virreinato, Tepotzotlán,* vol. 1: *Siglos XVI, XVII y principios del XVIII* (Tepotzotlán: Asociación de Amigos del Museo Nacional del Virreinato, 1992), 159–83.

13. Ibid., 175.

14. Salazar is recognized as the first known artist to work in Louisiana. He was born in Mérida, Yucatán, migrated to Louisiana in 1782, and died in 1802. He may have belonged to the group of Yucatec artists trained under the influence of Bishop Antonio Caballero y Góngora (bishop of Yucatan and subsequently archbishop of Santa Fé de Bogotá).

15. Robert M. Laughlin, *La Gran Serpiente Cornuda: ¡Indios de Chiapas, no escuchen a Napoleón!* (Mexico, D.F.: UNAM, 2001), 27.

16. On colonial female religious life, see Josefina Muriel's pioneering book, *Conventos de monjas de la Nueva España* (Mexico, D.F.: Editorial Santiago, 1946). There is a growing and excellent corpus of scholarship on colonial women in religious orders. See Electa Arenal and Stacey Schlau, eds., *Untold Sisters: Hispanic Nuns in Their Own Words* (Albuquerque: University of New Mexico Press, 1989); Asunción Lavrín and Rosalva Loreto, eds., *Monjas y beatas: La escritura femenina en la espiritualidad barroca latinoamericana, siglos XVII y XVIII* (Mexico, D.F.: Universidad de las Américas/Archivo General de la Nación, 2002); and Constanza Toquica C., "La economía espiritual del convento de Santa Clara de Santafé de Bogotá, siglos XVII y XVIII," *Fronteras de la historia* (ICCH) 3, no. 3 (1998). On convent life seen through the eyes of a nun, Sor María de San José, see Kathryn Myers and Amanda Powell, *A Wild Flower Out in the Garden: The Spiritual Journals of a Colonial Mexican Nun* (Bloomington: Indiana University Press, 1999).

For a recent treatment of the crowned nuns' genre, see Alma Montero Alarcón, *Monjas coronadas* (Mexico, D.F.: CONACULTA, 1999).

17. For the former, see Pilar Jaramillo de Zuleta, ed., *En olor de santidad: Aspectos del convento colonial, 1680–1830* (Bogota: Iglesia Museo Santa Clara, 1992); on the latter, see Colección Banco de la República, *Serie monjas muertas* (Bogota: Biblioteca Luis-Angel Arango, Casa de Exposiciones, 2000).

18. *Francisco Oller: Un realista del impresionismo/ Francisco Oller: A Realist of Impressionism* (Ponce, P.R.: Museo de Arte de Ponce, 1983), pl. 10.

19. On royal portraiture, see F. J. Sánchez Cantón, *Los retratos de los reyes de España* (Barcelona: Omega Editores, 1948). See also Elisa Vargas Lugo, "Retratos de Carlos III en la Nueva España," in Graciela Braccio and Gustavo Tudisco, *Ser y parecer: Identidad y representación en el mundo colonial* (Buenos Aires: Museo de Arte Hispanoamericano Isaac Fernández Blanco, 2001), esp. 9–14.

20. Braccio and Tudisco, *Ser y parecer,* 12–13.

21. See *El retrato novohispano en el siglo XVIII* and Marita Martínez del Rió de Redo, *El retrato civil en la Nueva España* (Mexico, D.F.: Museo de San Carlo, n.d.)

22. Elisa Vargas Lugo, *La iglesia de Santa Prisca de Taxco* (Mexico, D.F.: UNAM, 1982), 17.

23. C. Willett Cunnington and Phillis Cunnington, *Handbook of English Costume in the Eighteenth Century* (Boston: Plays, Inc., 1972), 178–79.

24. See Elena Estrada de Guerlero, "Las pinturas de castas: Imágenes de una sociedad variopinta," *Mexico en el mundo de las colecciones de arte: Nueva España* (Mexico, D.F.: UNAM, n.d.), 2:79–113.

25. See Lygia da Fonseca et al., *Riscos illuminados de figurinhos de brancos e negros dos uzos do Río de Janeiro e Serro do Frío* (Rio de Janeiro: Livraría São Jose, 1960).

26. See Rolena Adorno, *Guamán Poma and His Illustrated Chronicle from Colonial Peru: From a Century of Scholarship to a New Era of Reading/Guamán Poma y su crónica ilustrada del Perú: Un siglo de investigación hacia una nueva era de lectura* (Copenhagen: Museum Tusculanum Press, University of Copenhagen, and the Royal Library, 2001), published on the occasion of the launching of the online version of Guamán Poma de Ayala's work; see http://www.kb.dk/elib/mss/poma/.

27. Jorge Juan and Antonio de Ulloa, *Relación Histórica del Viage a la América Meridional hecho de orden de Su Mag. para medir algunos grados de meridiano terrestre, y venir por ellos en conocimiento de la verdadera figura y magnitud de la tierra, con otras observaciones astronómicas y físicas* (Madrid: Impressa de Orden del Rey Nuestro Señor por Antonio Marín, 1748), pl. opp. 604 and appendix.

28. On the Royal Academy of San Carlos, see Jean Charlot, *Mexican Art and the Academy of San Carlos, 1785–1945* (Austin: University of Texas Press, 1962). On the academy's decline, see Justino Fernández, *El arte del siglo XIX en México* (Mexico, D.F.: UNAM, 1983), esp. 16–22.

29. Eugenio Pereira Salas, *Estudios sobre la historia del arte en Chile republicano* (Santiago: Ediciones de la Universidad de Chile, 1992), 63–73.

30. On Guzmán, see George S. Wise, *Caudillo: A Portrait of Guzmán Blanco* (New York: Columbia University Press, 1951).

31. See Félix Luna et al., *Prilidiano Pueyrredón: Proyecto Cultural Artistas del Mercosur* (Buenos Aires: Banco Velox, 1999).

32. See Fernández, *El arte del siglo XIX,* 65–75.

33. See Eduardo Salteráin y Heredia, *Blanes: El hombre, su obra y su época* (Montevideo: Impresora Uruguay, 1950), and Octavio Assumpção et al., *El arte de Juan Manuel Blanes* (New York: Americas Society, 1994).

34. Donato Mello Júnior, *Pedro Américo de Figueiredo e Melo, 1843–1905: Algumas singularidades de sua vida e de sua obra* (Rio de Janeiro: Edições Pinakotheke, 1983).

35. Cándido López has a significant bibliography. A good starting point for his study is Marcelo Eduardo Pacheco, with an introduction by Augusto Roa Bastos, *Cándido López: Proyecto cultura: Artistas del Mercosur* (Buenos Aires: Banco Velox, 1998).

36. See Fernández, *El arte del siglo XIX,* 104–15, and Ana Ortiz Angulo, *La pintura mexicana independiente de la academia en el siglo XIX* (Mexico, D.F.: INAH, 1995).

37. On Bustos, see Raquel Tibol's excellent *Hermenegildo Bustos: Pintor del pueblo* (Mexico, D.F.: Ediciones la Rana, 1999).

38. Juan Luis Mejía Arango, *Manuel D. Carvajal Marulanda: La pintura como autobiografía* (Bogota: Fondo Cultural Cafetero, 2001).

39. See P. M. Bardi, *Miguel Dutra, o poliédrico artista paulista* (São Paulo: Museo de Arte Francisco de Assis Chateaubriand, 1981).

40. Ventura Reyes y Zavala, *Las bellas artes en Jalisco* (Guadalajara: Tip. de Valeriano C. Olague, 1882), quoted by Fernández in *El arte del siglo XIX,* 106. Fernández's informative discussion of Estrada is on pages 104–13.

41. For a thorough study of Bustos, see Tibol, *Hermenegildo Bustos.*

42. For a general overview, see Leopoldo Zea, ed., *Pensamiento positivista latinoamericano* (Caracas: Biblioteca Ayacucho, 1980).

43. On Oller, see *Francisco Oller: Un realista del impresionismo.*

Varieties of Precolumbian Portraiture
by Elizabeth P. Benson

1. Beatriz de la Fuente, *Los hombres de piedra,* 2d ed. (Mexico, D.F.: UNAM, 1984), pl. 15; Rebecca B. González Lauck, "La antigua ciudad olmeca en La Venta, Tabasco," in *Los olmecas in Mesoamérica,* ed. John E. Clark (Mexico, D.F.: Citibank, 1994), fig. 6.2.

2. Clark, *Los olmecas in Mesoamérica,* especially Ann Cyphers Guillén's chapter, "San Lorenzo Tenochtitlan"; Michael D. Coe and Richard A. Diehl, *In the Land of the Olmec* (Austin: University of Texas Press, 1980), 1:299–309; de la Fuente, *Los hombres de piedra;* de la Fuente, *Cabezas colosales olmecas* (Mexico, D.F.: El Colegio Nacional, 1992); Esther Pasztory, "The Portrait and the Mask: Invention and Translation," in *Olmec Art and Archaeology in Mesoamerica,* ed. John E. Clark and Mary E. Pye (Washington, D.C.: National Gallery of Art, 2000).

3. De la Fuente, *Los hombres de piedra,* 334–35.

4. Elizabeth Benson and Beatriz de la Fuente, eds., *Olmec Art of Ancient Mexico* (Washington, D.C.: National Gallery of Art, 1996), no. 66; Michael D. Coe et al., *The Olmec World: Ritual and Rulership* (Princeton, N.J.: Princeton University Press, 1995), cover, no. 42.

5. Elizabeth P. Benson, "Some Olmec Objects in the Robert Woods Bliss Collection at Dumbarton Oaks," in *The Olmec and Their Neighbors: Essays in Memory of Matthew W. Stirling,* ed. Michael D. Coe, David Grove, and Elizabeth P. Benson (Washington, D.C.: Dumbarton Oaks Research Library and Collections, 1981), 99–100; Benson and de la Fuente, *Olmec Art of Ancient Mexico,* no. 58.

6. Benson and de la Fuente, *Olmec Art of Ancient Mexico,* 16, no. 51

7. Elizabeth P. Benson, "An Olmec Figure at Dumbarton Oaks," *Studies in Pre-Columbian Art and Archaeology* 8 (1971); Benson, "Some Olmec Objects in the Bliss Collection," 103–4; Benson and de la Fuente, *Olmec Art of Ancient Mexico,* no. 52.

8. Nicolai Grube, ed., *Maya: Divine Kings of the Rain Forest* (Cologne: Könemann, 2001), 8–9, 112–13, 282–83.

9. Gillett G. Griffin, "Portraiture in Palenque," in *The Art, Iconography and Dynastic History of Palenque,* Proceedings of the Segunda Mesa Redonda de Palenque, part 3, ed. Merle Greene Robertson (Pebble Beach, Calif.: Pre-Columbian Art

Research, Robert Louis Stevenson School, 1976), 137–47; see also Linda Schele and Mary Ellen Miller, *The Blood of Kings* (Fort Worth: Kimball Art Museum, 1986), fig. 1.1.

10. Merle Greene Robertson, Marjorie S. Rosenbaum Scandizzo, and John H. Scandizzo, "Physical Deformities in the Ruling Lineage of Palenque, and the Dynastic Implications," in Robertson, *Art . . . of Palenque.*

11. Alfonso Arellano Hernández et al., *The Mayas of the Classical Period* (Milan: Editoriale Jaca, 1999), pl. 104; Simon Martin and Nicolai Grube, *Chronicle of the Maya Kings and Queens* (London: Thames and Hudson, 2000), 168; Schele and Miller, *Blood of Kings*, 64–66; Peter Schmidt, Mercedes de la Garza, and Enrique Nalda, eds., *Maya* (Milan: RCS Libri CNCA and Mexico, D.F.: INAH, 1998), nos. 76, 467, 468, 471–73.

12. Griffin, "Portraiture in Palenque," 141, figs. 10, 11.

13. Benson, "An Olmec Figure at Dumbarton Oaks"; Peter David Joralemon, "Human Mask with Incised Design," in Benson and de la Fuente, *Olmec Art of Ancient Mexico*, nos. 31, 186–88, 192.

14. Joralemon, "Human Mask," in Benson and de la Fuente, *Olmec Art of Ancient Mexico*, 237.

15. Benson and de la Fuente, *Olmec Art of Ancient Mexico*, no. 94; Eduardo Matos Moctezuma, *The Great Temple of the Aztecs: Treasures of Tenochtitlan*, trans. Doris Heyden (London: Thames and Hudson, 1988), 113, pl. 16.

16. Arellano et al., *Mayas of the Classical Period*, pl. 105; Beatriz de la Fuente, *Peldaños en la conciencia: Rostros en la plástica prehispánica*, 2d ed. (Mexico, D.F.: UNAM, 1989), fig. 58; Elizabeth Kennedy Easby and John F. Scott, *Before Cortés: Sculpture of Middle America* (New York: Metropolitan Museum of Art, 1970), no. 189; Linda Schele and Peter Mathews, *The Code of Kings* (New York: Scribner, 1998), 126; Schmidt, de la Garza, and Nalda, *Maya*, 332, no. 142.

17. Elisabeth Wagner, "Jade: The Green Gold of the Maya," in Grube, *Maya*, 66, illus. 89; Martin and Grube, *Chronicle of the Maya Kings and Queens*, 113; Schmidt, de la Garza, and Nalda, *Maya*, no. 146.

18. Kathleen Berrin and Esther Pasztory, eds., *Teotihuacan: Art from the City of the Gods* (San Francisco: Fine Arts Museums of San Francisco; New York: Thames and Hudson, 1993).

19. Esther Pasztory, "The Natural World as Civic Metaphor at Teotihuacan," in *The Ancient Americas: Art from Sacred Landscapes*, ed. Richard Townsend (Chicago: Art Institute of Chicago, 1992), 145.

20. Benson and de la Fuente, *Olmec Art of Ancient Mexico*, nos. 60–64; Coe et al., *Olmec World*, nos. 111–18.

21. Jaime Errázuriz, *Tumaco—La Tolita: Una cultura precolombina desconocida* (An unknown Precolumbian culture) (Bogota: Carlos Valencia Editores, 1980), 195–204.

22. Peter David Joralemon, "The Old Woman and the Child: Themes in the Iconography of Preclassic Mesoamerica," in Coe, Grove, and Benson, *The Olmec and Their Neighbors*; see also Coe et al., *Olmec World*, nos. 4–6; Easby and Scott, *Before Cortés*, no. 14; Gillett G. Griffin, "Olmec Forms and Materials Found in Central Mexico," in Coe, Grove, and Benson, *The Olmec and Their Neighbors*, figs. 8 and 9.

23. Richard L. Burger, *Chavín and the Origins of Andean Civilization* (London: Thames and Hudson, 1992), fig. 72.

24. Alan Kolata and Carlos Ponce Sangines, "Tiwanaku: The City at the Center," in Townsend, *Ancient Americas*, 332, fig. 17.

25. Benson and de la Fuente, *Olmec Art of Ancient Mexico*, 50, 132, no. 9; Clark, *Los olmecas en Mesoamérica*, cover; Coe and Diehl, *In the Land of the Olmec*, vol. 2; Coe et al., *Olmec World*, nos. 1–10, 33–35; de la Fuente, *Los hombres de piedra*, pl. 63, color pl. 21; González Lauck, "La antigua ciudad," figs. 6.27–.28; Griffin, "Olmec Forms and Materials," fig. 11.

26. Michael D. Coe and Justin Kerr, *The Art of the Maya Scribe* (New York: Harry N. Abrams, 1997), pl. 9; Schmidt, de la Garza, and Nalda, *Maya*, no. 86 bis.

27. Coe and Kerr, *Art of the Maya Scribe.*

28. José Antonio de Lavalle, *Arte y tesoros del Perú: Nazca* (Lima: Banco de Crédito del Perú, 1986), 124, 125; *Trésors du Nouveau Monde* (Brussels: Museaux Royaux d'Art et d'Histoire, 1992), figs. 441–43.

29. Arellano et al., *Mayas of the Classical Period*; Coe and Kerr, *Art of the Maya Scribe*; Easby and Scott, *Before Cortés*, no. 187; Grube, *Maya*; Martin and Grube, *Chronicle of the Maya Kings and Queens*; Schele and Mathews, *Code of Kings.*

30. De la Fuente, *Peldaños en la conciencia*, pl. 43; Schmidt, de la Garza, and Nalda, *Maya*, 97, no. 70.

31. Grube, *Maya*, frontispiece, illus. 93, 149; Martin and Grube, *Chronicle of the Maya Kings and Queens*, 139; Mary Ellen Miller, "The Image of People and Nature in Classic Maya Art and Architecture," in Townsend, *Ancient Americas*, 165; Schele and Miller, *Blood of Kings*, pl. 21; Schmidt, de la Garza, and Nalda, *Maya*, 356, 368, nos. 143, 287.

32. Merle Greene Robertson, "57 Varieties: The Palenque Beauty Salon," in *Fourth Palenque Round Table*, ed. Merle Greene Robertson and Elizabeth P. Benson (San Francisco: Pre-Columbian Art Research Institute, 1985); Griffin, "Portraiture in Palenque"; Grube, *Maya*, 309; Joralemon, "Old Woman and the Child"; Martin and Grube, *Chronicle of the Maya Kings and Queens*, frontispiece; Schele and Miller, *Blood of Kings*; Schmidt, de la Garza, and Nalda, *Maya*, 386–91.

33. Griffin, "Portraiture in Palenque," fig. 7.

34. De la Fuente, *Peldaños en la conciencia*, figs. 26–30, 39, pl. 7.

35. Berrin and Pasztory, *Teotihuacan*; Pasztory, "Natural World."

36. Berrin and Pasztory, *Teotihuacan*, 222, fig. 1.

37. Jorge Angulo V., "Teotihuacán: Aspectos de la cultura a través de su expresión pictórica," in *La pintura mural prehispánica en México: Teotihuacán*, vol. 2, ed. Beatriz de la Fuente (Mexico, D.F.: UNAM/Instituto de Investigaciones Estéticas, 1996); Pasztory, "Natural World," fig. 8a; María Teresa Uriarte, "Tepantitla, el juego de pelota," in de la Fuente, *La pintura mural prehispánica*, vol. 2.

38. Easby and Scott, *Before Cortés*, no. 127; Joyce Marcus and Kent V. Flannery, *Zapotec Civilization* (London: Thames and Hudson, 1996), fig. 237; see also Griffin, "Portraiture in Palenque."

39. Easby and Scott, *Before Cortés*, no. 155; Marcus and Flannery, *Zapotec Civilization*, fig. 11.

40. Esther Pasztory, *Aztec Art* (New York: Harry N. Abrams, 1983), pls. 86–98.

41. Ibid., frontispiece, color pl. 61, pls. 268, 292.

42. Fray Diego Durán, *The History of the Indies of New Spain*, trans. Doris Heyden (Norman: University of Oklahoma Press, 1994), pl. 19,

Plate 16: *Miguel de Berrio y Saldívar*
Doris M. Ladd, *The Mexican Nobility at Independence, 1780–1826* (Austin: Institute of Latin American Studies/University of Texas, 1976).

Plate 21: *Sor Juana Inés de la Cruz*
Mexico: Splendors of Thirty Centuries (New York: Metropolitan Museum of Art and Little, Brown, 1990), 351–55.

Plate 23: *Dom Luíz de Vasconcellos e Sousa*
Pedro Doria to Carolyn K. Carr, Jan. 3, 2004. I wish to thank Mr. Doria and his father, Professor Francisco Antonio Doria, for sharing their research on Luíz Vasconcellos with me.

Nancy Priscilla S. Naro, "Imperial Palms over Colonial Gardens," *Revista/Review Interamericana* 29, http://www.sg.inter.edu/revista-ciscla/volume29/naro.html.

Enciclopédia artes visuais, "Leandro Joaquim," http://www.itaucultural.org.br/AplicExternas/Enciclopedia/artesvisuais2003/index.cfm.

Plate 24: *Teodoro de Croix*
Robert S. Weddle, *The Handbook of Texas Online,* Texas State Historical Association, 2003, http://www.tsha.utexas.edu/handbook/online/articles/view/CC/fcr26.html.

Plate 25: *Bernardo de Gálvez*
Robert H. Thonhoff, *The Handbook of Texas Online,* Texas State Historical Association, 2002, http://www.tsha.utexas.edu/handbook.

Plate 26: *Doña María Mercedes de Salas y Corvalán*
Isabel Cruz de Amenábar, *El traje: transformaciones de una segunda piel* (Santiago: Universidad Católica de Chile, 2002).

Plate 28: *Un Alférez del Regimiento de Infantería Fijo de Puerto Rico*
Susan Theran, *Leonard's Price Index of Latin American Art at Auction* (Newton, Mass.: Auction Index, 1999), 43.

Teodoro Vidal, *Cuatro puertorriqueñas por Campeche* (San Juan de Puerto Rico: Ediciones Alba, 2000), 62.

Plate 33: *El Niño José Manuel de Cervantes y Velasco*
Gutierre Aceves Piña, "El Arte Ritual de la Muerte Niña," *Artes de México* 15 (spring 1992): 18–19.

Section IV, Nineteenth Century
Plate 38: *Los Hermanos Servantes y Michaus*
Norman Neuerberg, "The Changing Face of Mission San Diego," *Journal of San Diego History* 32, no. 1 (winter 1986): 4.

Plate 41: *Lucía Petrona Riera de López*
Enciclopedia del arte en América: Biografías 2 (Buenos Aires: Bibliográfica OMEBA, 1968–69).

Plate 42: *Agustín de Iturbide y Eposa Ana María de Huarte*
Christopher Buyers, "México: The Iturbide Dynasty," 2002, http://www.4dw.net/royalark/Mexico/mexico3.htm.

Plate 43: *José Raymundo Juan Nepomuceno de Figueroa y Araoz*
Ricardo Mariátegui Oliva, *José Gil de Castro (El "Mulato Gil")* (Lima: Imprenta "La Confianza," 1981), 124–25.

Plate 46: *Retrato de Caballero Muerto*
Guillermo Tovar de Teresa, *Repertorio de artistas en México: Artes plásticas y decorativas* (Mexico, D.F.: Grupo Financiero Bancomer, 1996), 3:178.

Plate 49: *Francisco Margallo y Duquesne*
Historia contemporánea de Colombia (desde la disolución de la antigua república de ese nombre hasta la época presente), 6 vols. (Bogota and Cali: Arboleda & Valencia, 1918), vol. 1.

Plate 50: *Francisco de Paula Santander*
Pilar Moreno de Angel and Horacio Rodriguez Plata, *Santander: Su iconografía* (Bogota: Arco, 1984).

Miguel A. Bretos, "From Banishment to Sainthood: A Study of the Image of Bolívar in Colombia, 1830–1886" (Ph.D. diss., Vanderbilt University, 1976).

Plate 52: *Manuela Gutiérrez (La Niña de la Muñeca)*
Dawn Ades, *Art in Latin America: The Modern Era, 1820–1980* (New Haven, Conn.: Yale University Press, 1989), 344.

Plate 60: *Intrépido Marinheiro Simão*
Dicionário brasileiro de artistas plásticos, 4 vols. (Brasília: Ministerio de Educacao e Cultura, 1974), 2:478.

Plate 63: *Esposa de Francisco Cevallos*
Friedrich Hassaurek, *Four Years Among the Ecuadorians,* ed. C. Harvey Gardiner (Carbondale: Southern Illinois University Press, 1967).

Plate 65: *Don José Gutiérrez del Arroyo y Delgado*
Teodoro Vidal et al., *Essence and Presence: Our Traditional Arts* (San Juan: Banco Popular, 1993), n.p.

Plate 81: *La Escuela del Maestro Rafael Cordero*
Susan Theran, *Leonard's Price Index of Latin American Art at Auction* (Newton, Mass.: Auction Index, 1999), 85.

Luis R. Negrón Hernández, "Rafael Cordero Molina: Teacher of Great Men, Servant of God," 2003, http://www.preb.com/biog/cordero.htm.

Plate 82: *Niña en Blanco*
Arteperúgallery website, "Carlos Baca-Flor Soberón," http://www.arteperustore.com/.

Plate 83: *Autorretrato*
George W. Neubert, *Xavier Martínez (1869–1943)* (Oakland: Oakland Museum of California, 1974), 9–10.

Plate 84: *Don Guillermo Puelma Tupper*
Antonio R. Romera, *Historia de la pintura Chilena* (Santiago: Editorial Andrés Bello, 1976), 67–76.

Mario Céspedes, ed., *Gran diccionario de Chile,* 2d ed., 2 vols. (Santiago: Importadora Alfa, 1988).

Section V, Modern
Plate 85: *El Pintor Zinoviev*
Laurance P. Hurlburt, "Diego Rivera (1886–1957): Chronology of His Art, Life, and Times," in *Diego Rivera: A Retrospective* (New York: W. W. Norton, 1986), 34.

Plate 86: *Abraham Valdelomar*
Universidad Nacional Mayor de San Marcos, http://www.unmsm.edu.pe.

"Raúl María Pereira," in *Pinturas y pintores del Peru,* ed. Guillermo Tello Garust (Lima: C&C Servicios Especializados, 1997). Thanks to Carlos J. Olave, senior reference librarian, Hispanic Division, Library of Congress, for this information.

Research, Robert Louis Stevenson School, 1976), 137–47; see also Linda Schele and Mary Ellen Miller, *The Blood of Kings* (Fort Worth: Kimball Art Museum, 1986), fig. 1.1.

10. Merle Greene Robertson, Marjorie S. Rosenbaum Scandizzo, and John H. Scandizzo, "Physical Deformities in the Ruling Lineage of Palenque, and the Dynastic Implications," in Robertson, *Art . . . of Palenque.*

11. Alfonso Arellano Hernández et al., *The Mayas of the Classical Period* (Milan: Editoriale Jaca, 1999), pl. 104; Simon Martin and Nicolai Grube, *Chronicle of the Maya Kings and Queens* (London: Thames and Hudson, 2000), 168; Schele and Miller, *Blood of Kings,* 64–66; Peter Schmidt, Mercedes de la Garza, and Enrique Nalda, eds., *Maya* (Milan: RCS Libri CNCA and Mexico, D.F.: INAH, 1998), nos. 76, 467, 468, 471–73.

12. Griffin, "Portraiture in Palenque," 141, figs. 10, 11.

13. Benson, "An Olmec Figure at Dumbarton Oaks"; Peter David Joralemon, "Human Mask with Incised Design," in Benson and de la Fuente, *Olmec Art of Ancient Mexico,* nos. 31, 186–88, 192.

14. Joralemon, "Human Mask," in Benson and de la Fuente, *Olmec Art of Ancient Mexico,* 237.

15. Benson and de la Fuente, *Olmec Art of Ancient Mexico,* no. 94; Eduardo Matos Moctezuma, *The Great Temple of the Aztecs: Treasures of Tenochtitlan,* trans. Doris Heyden (London: Thames and Hudson, 1988), 113, pl. 16.

16. Arellano et al., *Mayas of the Classical Period,* pl. 105; Beatriz de la Fuente, *Peldaños en la conciencia: Rostros en la plástica prehispánica,* 2d ed. (Mexico, D.F.: UNAM, 1989), fig. 58; Elizabeth Kennedy Easby and John F. Scott, *Before Cortés: Sculpture of Middle America* (New York: Metropolitan Museum of Art, 1970), no. 189; Linda Schele and Peter Mathews, *The Code of Kings* (New York: Scribner, 1998), 126; Schmidt, de la Garza, and Nalda, *Maya,* 332, no. 142.

17. Elisabeth Wagner, "Jade: The Green Gold of the Maya," in Grube, *Maya,* 66, illus. 89; Martin and Grube, *Chronicle of the Maya Kings and Queens,* 113; Schmidt, de la Garza, and Nalda, *Maya,* no. 146.

18. Kathleen Berrin and Esther Pasztory, eds., *Teotihuacan: Art from the City of the Gods* (San Francicso: Fine Arts Museums of San Francisco; New York: Thames and Hudson, 1993).

19. Esther Pasztory, "The Natural World as Civic Metaphor at Teotihuacan," in *The Ancient Americas: Art from Sacred Landscapes,* ed. Richard Townsend (Chicago: Art Institute of Chicago, 1992), 145.

20. Benson and de la Fuente, *Olmec Art of Ancient Mexico,* nos. 60–64; Coe et al., *Olmec World,* nos. 111–18.

21. Jaime Errázuriz, *Tumaco—La Tolita: Una cultura precolombina desconocida* (An unknown Precolumbian culture) (Bogota: Carlos Valencia Editores, 1980), 195–204.

22. Peter David Joralemon, "The Old Woman and the Child: Themes in the Iconography of Preclassic Mesoamerica," in Coe, Grove, and Benson, *The Olmec and Their Neighbors;* see also Coe et al., *Olmec World,* nos. 4–6; Easby and Scott, *Before Cortés,* no. 14; Gillett G. Griffin, "Olmec Forms and Materials Found in Central Mexico," in Coe, Grove, and Benson, *The Olmec and Their Neighbors,* figs. 8 and 9.

23. Richard L. Burger, *Chavín and the Origins of Andean Civilization* (London: Thames and Hudson, 1992), fig. 72.

24. Alan Kolata and Carlos Ponce Sangines, "Tiwanaku: The City at the Center," in Townsend, *Ancient Americas,* 332, fig. 17.

25. Benson and de la Fuente, *Olmec Art of Ancient Mexico,* 50, 132, no. 9; Clark, *Los olmecas in Mesoamérica,* cover; Coe and Diehl, *In the Land of the Olmec,* vol. 2; Coe et al., *Olmec World,* nos. 1–10, 33–35; de la Fuente, *Los hombres de piedra,* pl. 63, color pl. 21; González Lauck, "La antigua ciudad," figs. 6.27–.28; Griffin, "Olmec Forms and Materials," fig. 11.

26. Michael D. Coe and Justin Kerr, *The Art of the Maya Scribe* (New York: Harry N. Abrams, 1997), pl. 9; Schmidt, de la Garza, and Nalda, *Maya,* no. 86 bis.

27. Coe and Kerr, *Art of the Maya Scribe.*

28. José Antonio de Lavalle, *Arte y tesoros del Perú: Nazca* (Lima: Banco de Crédito del Perú, 1986), 124, 125; *Trésors du Nouveau Monde* (Brussels: Museaux Royaux d'Art et d'Histoire, 1992), figs. 441–43.

29. Arellano et al., *Mayas of the Classical Period;* Coe and Kerr, *Art of the Maya Scribe;* Easby and Scott, *Before Cortés,* no. 187; Grube, *Maya;* Martin and Grube, *Chronicle of the Maya Kings and Queens;* Schele and Mathews, *Code of Kings.*

30. De la Fuente, *Peldaños en la conciencia,* pl. 43; Schmidt, de la Garza, and Nalda, *Maya,* 97, no. 70.

31. Grube, *Maya,* frontispiece, illus. 93, 149; Martin and Grube, *Chronicle of the Maya Kings and Queens,* 139; Mary Ellen Miller, "The Image of People and Nature in Classic Maya Art and Architecture," in Townsend, *Ancient Americas,* 165; Schele and Miller, *Blood of Kings,* pl. 21; Schmidt, de la Garza, and Nalda, *Maya,* 356, 368, nos. 143, 287.

32. Merle Greene Robertson, "57 Varieties: The Palenque Beauty Salon," in *Fourth Palenque Round Table,* ed. Merle Greene Robertson and Elizabeth P. Benson (San Francisco: Pre-Columbian Art Research Institute, 1985); Griffin, "Portraiture in Palenque"; Grube, *Maya,* 309; Joralemon, "Old Woman and the Child"; Martin and Grube, *Chronicle of the Maya Kings and Queens,* frontispiece; Schele and Miller, *Blood of Kings;* Schmidt, de la Garza, and Nalda, *Maya,* 386–91.

33. Griffin, "Portraiture in Palenque," fig. 7.

34. De la Fuente, *Peldaños en la conciencia,* figs. 26–30, 39, pl. 7.

35. Berrin and Pasztory, *Teotihuacan;* Pasztory, "Natural World."

36. Berrin and Pasztory, *Teotihuacan,* 222, fig. 1.

37. Jorge Angulo V., "Teotihuacán: Aspectos de la cultura a través de su expresión pictórica," in *La pintura mural prehispánica en México: Teotihuacán,* vol. 2, ed. Beatriz de la Fuente (Mexico, D.F.: UNAM/Instituto de Investigaciones Estéticas, 1996); Pasztory, "Natural World," fig. 8a; María Teresa Uriarte, "Tepantitla, el juego de pelota," in de la Fuente, *La pintura mural prehispánica,* vol. 2.

38. Easby and Scott, *Before Cortés,* no. 127; Joyce Marcus and Kent V. Flannery, *Zapotec Civilization* (London: Thames and Hudson, 1996), fig. 237; see also Griffin, "Portraiture in Palenque."

39. Easby and Scott, *Before Cortés,* no. 155; Marcus and Flannery, *Zapotec Civilization,* fig. 11.

40. Esther Pasztory, *Aztec Art* (New York: Harry N. Abrams, 1983), pls. 86–98.

41. Ibid., frontispiece, color pl. 61, pls. 268, 292.

42. Fray Diego Durán, *The History of the Indies of New Spain,* trans. Doris Heyden (Norman: University of Oklahoma Press, 1994), pl. 19,

242–43, 290; see also Schele and Miller, *Blood of Kings,* 66.

43. Suzanne Abel-Vidor et al., *Between Continents, Between Seas: Precolumbian Art of Costa Rica* (Detroit: Detroit Institute of Arts; New York: Harry N. Abrams, 1981).

44. *Trésors du Nouveau Monde,* fig. 357; see also Errázuriz, *Tumaco—La Tolita.*

45. *Arte Precolombino de Ecuador* (Quito: Salvat Editores Ecuatoriana, 1985), 111.

46. Ibid., 27; Townsend, *Ancient Americas,* 243, cat. no. 104.

47. Lavalle, *Arte y tesoros del Perú.*

48. Martin and Grube, *Chronicle of the Maya Kings and Queens;* Schele and Mathews, *Code of Kings;* Pasztory, "Natural World."

49. Arellano et al., *Mayas of the Classical Period,* pl. 55; Schele and Mathews, *Code of Kings;* Schmidt, de la Garza, and Narda, *Maya.*

50. Pasztory, "Natural World," 137.

51. De la Fuente, *Los hombres de piedra,* 332–33.

52. Marcus and Flannery, *Zapotec Civilization,* 210.

53. De la Fuente, *Peldaños en la conciencia,* 9.

Moche Portraits
by Christopher B. Donnan

1. Anne Marie Hocquenghem identified a vessel depicting the head of a female, but it lacks the realistic, lifelike features that characterize Moche portraits. Thus it seems to be a generic depiction rather than a portrait of a specific individual. See Hocquenghem, "Un 'Vase Portrait' de femme Mochica," *Ñawpa Pacha* (Institute of Andean Studies, Berkeley) 15 (1977).

2. Slips were mixtures of clay, mineral pigments (generally iron oxide), and water.

3. The variety of headdresses and ornaments reflected in the multiple portraits of some individuals is consistent with what is often found in the graves of elite Moche males—as many as eighteen distinct headdresses, and multiple sets of ear ornaments, nose ornaments, and necklaces in a single tomb.

4. Christopher B. Donnan and Donna McClelland, *Moche Fineline Painting: Its Evolution and*

Its Artists (Los Angeles: Fowler Museum of Cultural History, UCLA, 1999), 69–72, 130–35.

5. Rafael Larco Hoyle and Alan Sawyer mentioned that Moche portraits depicted individuals at different ages, but they did not provide any examples. See Larco Hoyle, *Mochicas* (Lima: Empresa Editorial "Rímac" S.A., 1939), 2:136, and Sawyer, *Ancient Peruvian Ceramics: The Nathan Cummings Collection* (New York: Metropolitan Museum of Art, 1966), 37–38. E. Michael Whittington identified an individual that he thought was portrayed at different ages, but the portraits appear to be of several different individuals. See Whittington, "Moche Ceramic Portraiture: Theme and Variation in Ancient Peruvian Art" (Master's thesis, University of Florida, Gainesville, 1990).

6. Donnan and McClelland, *Moche Fineline Painting,* 292.

7. Larco Hoyle, *Mochicas,* 138, figs. 192–94.

8. Izumi Shimada et al., "Cultural Impacts of Severe Droughts in the Prehistoric Andes: Application of a 1500-Year Ice-Core Precipitation Record," *World Archaeology* 22 (1991): 247–70, and Shimada, *Pampa Grande and the Mochica Culture* (Austin: University of Texas Press, 1994), 122–31.

Portraiture in Viceregal America
by María Concepción García Sáiz

1. The importance of the portrait in the output of civil pictures in western art has been maintained over time. Peter Burke recalls that 67 percent of lay paintings signed in Italy between 1420 and 1539 were portraits. See *El Renacimiento italiano: Cultura y sociedad en Italia,* 2d rev. ed. (Madrid: Alianza Editorial, 2001), 176. Nigel Glendenning tells how, in the second half of the eighteenth century, the portrait had become the preferred genre in the official salons of Paris and London, displacing genres traditionally considered more noble, such as history painting. See *Goya: La década de los Caprichos, retratos, 1792–1804* (Madrid: Real Academia de Bellas Artes de San Fernando, 1992), 86–87.

2. The different ways in which portraits have been evaluated over time have been studied with great erudition by Édouard Pommier in *Théories du portrait: De la Renaissance aux Lumières* (Paris: Éditions Gallimard, 1998).

3. Jusepe Martínez, *Discursos practicables del nobilísimo arte de la pintura,* ed. Julián Gállego (Madrid: Ediciones AKAL, 1988), 207. Martinez noted, "But so as not to fall short and to show a desire to assist you and forewarn you, I want to tell you that this profession of making portraits is a very painful matter, and sometimes poorly rewarded, because the censors who have to make judgement of them are mostly ignorant, and to have to pay attention to the judgement of each one is a very great fatigue for one who practices this activity."

4. Manuel Toussaint, "Proceso y denuncias contra Simón Pereyns en la Inquisición de México," in *Anales del Instituto de Investigaciones Estéticas,* supplement to no. 2 (1938).

5. The concept of the dignity of the image that the portrait should offer was a clear obstacle to the realistic representation of the effigies. See Juan Miguel Serrera, "Alonso Sánchez Coello y la mecánica del retrato de corte," in *Alonso Sánchez Coello y el retrato en la corte de Felipe II* (Madrid: Museo del Prado, 1990), 38–63.

6. Quoted by Yannick Vu, "Nins," in *Nins: Retratos de niños de los siglos XVI–XIX,* collection of the Fundación Yannick y Ben Jakober (Valencia: Museo de Bellas Artes de Valencia, 2000), 25.

7. Carmen Sotos Serrano, "La imagen de Felipe II en México," in *Felipe II y las Artes* (Madrid: Actas del Congreso Internacional/Universidad Complutense de Madrid, 1998), 553–67.

8. Javier Portús, "Orden y concierto: Escenas familiares en la pintura española, del Renacimiento a Goya," in *Ternura y Melodrama: Pintura de escenas familiares en tiempos de Sorolla* (Valencia: Museo del siglo XIX, 2002), 24.

9. Juan Miguel Serrera, *Alonso Vázquez en México* (Mexico, D.F.: INBA/CNCA, 1991) and Jaime Cuadriello, "El origen del Reino y la configuración de su empresa: Episodios y alegorías de triunfo y fundación," in *Los pinceles de la historia: El origen del Reino de la Nueva España* (Mexico, D.F.: Museo Nacional de Arte, 1999), 95–97.

10. Testimonies to the importance of clothing as a sign of identity in the pre-Hispanic world are very numerous. A sufficient reference is the recollection of Guaman Poma de Ayala of the rules that he calls "ordinances of the Incas": "we order that no Indian in this kingdom shall

change his dress and costume of each district and ayllo, under penalty of one hundred lashes." See Felipe Guaman Poma de Ayala [Waman Puma], *El primer nueva corónica y buen gobierno,* ed. John V. Murra and Rolena Adorno (Mexico, D.F.: Siglo XXI, 1980), 192 [194].

11. José de Mesa and Teresa Gisbert, *Historia de la pintura cuzqueña,* 2d ed. (Lima: Fundación A. N. Wiese/Banco Wiese, 1982), 212.

12. Pablo Escalante, "El patrocinio del arte indocristiano en el siglo XVI: La iniciativa de las autoridades indígenas de Tlaxcala and Cuauhtinchán," in *Patrocinio, colección y circulación en las artes,* XX Coloquio Internacional de Historia del Arte (Mexico, D.F.: UNAM, 1997).

13. Serrera refers to the ambivalence of the term used in documents of the period to refer to the representation not only of persons but also of animals, buildings, and even cities ("Alonso Sánchez Coello," 38–39).

14. See the catalogues of the exhibitions *Alonso Sánchez Coello y el retrato en la corte de Felipe II* and *El linaje del Emperador* (Cáceres: SEACEX, 2000).

15. No one could fail to appreciate the importance of the discovery of this document, the consultation and use of which in this article I acknowledge most particularly to the generosity of the aforementioned researchers, who include it in the paper "Disposiciones Eclesiásticas," which forms part of the *Antología de textos y documentos para la historia de la pintura virreinal* (forthcoming).

16. Elisa Vargas Lugo, "El retrato de donantes y el autorretrato en la pintura novohispana," *Anales del Instituto de Investigaciones Estéticas* 51 (1983): 75–79.

17. All the Mexican bibliographies referring to this subject have traditionally accepted the exclusive identification of this figure with the donor; nevertheless, Rogelio Ruiz Gomar has recently pointed out her identification with the elderly woman forming part of the narrative of the miracle. See *Arte y Mística del Barroco* (Mexico, D.F.: Colegio de San Ildefonso, 1994), cat. no. 72, 264–65.

18. Rosa López Torrijos, "Teatro y pintura en la época de Calderón," *Revista Goya* 287 (2002): 88–91.

19. M. Remedios Portes Ruiz, "El control del aspecto femenino: Las perfectas invisibles de Juan Luis Vives y Fray Luis de León," in *Moda y sociedad: La indumentaria: estética y poder* (Granada: Universidad de Granada, 2002), 249–58.

20. Cited by Carmen Bernis, "La moda en los retratos de Velásquez," in *El retrato en el Museo del Prado* (Madrid: Museo del Prado, 1994), 271–301.

21. Antonio de León Pinelo, *Velos Antiguos i modernos en los rostros de las mugeres sus conveniencias i daños: Ilustracion De la Real Premática de las Tapadas* (Madrid, 1641), 69v.

22. *Monjas coronadas,* secretaría personal de la Presidencia, Mexico, D.F., 1978.

23. René Taylor et al., *José Campeche y su Tiempo* (Ponce, P.R.: Museo de Arte de Ponce, 1988), 168–69.

24. Ibid., 140–43.

25. Reproduced in *El retrato novohispano en el siglo XVIII* (Puebla: Museo Poblano de Arte Virreinal, 1999), 81.

26. Ricardo Estabridis, "El retrato en Perú en el siglo XVIII: Cristóbal Lozano," in *Tradición, estilo o escuela en la pintura iberoamericana, siglos XVI–XVIII,* ed. M. Concepción García Sáiz and Juana Gutiérrez Haces (Mexico, D.F.: UNAM, 2003).

27. Cuadriello, "El origen del Reino," 80–91.

28. Teresa Gisbert, *Iconografía y mitos indígenas en el arte,* 2d ed. (La Paz: Apartado 195, 1994), 149–53.

29. Tom B. F. Cummins, *Toast with the Inca: Andean Abstraction and Colonial Images on Quero Vessels* (Ann Arbor: University of Michigan Press, 2002), 270–96.

30. Cuadriello, "El origen del Reino," 102.

31. Tom Cummins stresses the discrepancies between the treatment of the face and the clothing, which he considers flat and lacking in coherence with the overall composition—especially the lace sleeves—and he suggests a still-undefined intention (*Los siglos de oro en los virreinatos de América, 1550–1700* [Madrid: Museo de América, 1999], cat. no. 20, 188–89). Nevertheless, here again it is likely that the artist only worked with the live model when painting the face, adding the clothing later without a great deal of skill.

32. M. A. Galindo Carrillo, *Los tratados sobre la educación de príncipes (siglos XVI y XVII)* (Madrid: CSIC, 1948).

33. Cummins discusses the significance of the difference between the images of the Incas, invented and interpreted through the eyes of European representation, and those of the Spanish monarchs corresponding to a known reality: "Portraiture represents Inca imperial symbols based on European iconographic elements to establish what is represented in a Western historical, not an Andean sociopolitical, sense. The colonial figure of Inca makes manifest the dynasty that had been supplanted by the Spaniards." Nevertheless, in many cases the images of the Spanish kings did not correspond to reality either, as they were used as generic models of the Spanish monarch, without any intention of verisimilitude. See Cummins, *Toast with the Inca,* 282–86.

34. Gisbert, *Iconografía,* 117–46.

35. Bernal Díaz del Castillo, *Historia verdadera de la conquista de la Nueva España,* ed. Carmelo Sáenz de Santa María (Madrid: CSIC, 1982), chap. 204, 621–22.

36. Miguel León Portilla, ed., *Visión de los vencidos,* Historia 16, *Crónicas de América 6* (Madrid, 1985), 72.

37. Cuadriello, "El origen del Reino," 59–61.

38. Adam Szaszdi, "El trasfondo de un cuadro: 'Los mulatos de Esmeraldas' de Andrés Sánchez Galque," *Cuadernos Prehispánicos* 12 (1986–87): 93–142.

Monjas Coronadas
by Kirsten Hammer

1. Josefina Muriel, *Retratos de monjas* (Mexico, D.F.: Editorial Jus, 1952), 37

2. Ibid., 29.

3. Ibid., 38.

4. Ibid.

5. Christiane Klapisch-Zuber, "Holy Dolls: Play and Piety in Florence in the Quattrocento," in *Women, Family, and Ritual in Renaissance Italy,* trans. Lydia Cochrane (Chicago: University of Chicago Press, 1985), 311.

6. Klapisch-Zuber maintains that ritual *bambini* were exported by Italy throughout the world: "The objects that served as property for these rituals, the *bambini,* were made in the convents of Lucca, and after 1600 they were exported to the four corners of the world, accompanied by the maternal rites so characteristic of this new form of devotion" (ibid., 324).

7. Muriel, *Retratos de monjas*, 41.

8. Ibid., 39.

9. Eugenio Noriega Robles, "Retratos de monjas muertas," in *Arte funerario: Coloquio internacional de historia del arte,* ed. Beatriz de la Fuente (Mexico, D.F.: UNAM, 1987), 155–63, 156.

José Campeche
by Teodoro Vidal

1. René Taylor, "José Campeche y la Ilustración," *Reales Sitios* (Madrid) 26, no. 99 (1989): 21.

2. Juan Antonio Gaya Nuño, "Precisiones en torno a José Campeche," *La Torre* (San Juan) 20, nos. 77–78 (July–December 1972): 37.

3. Ibid., 32.

4. The biographical data offered here on Campeche, together with part of the information on his work, appears in my book *Cuatro puertorriqueñas por Campeche* (San Juan de Puerto Rico: Ediciones Alba, 2000).

5. Alejandro Tapia y Rivera, *Vida del pintor puertorriqueño José Campeche y noticia histórica de Ramón Power,* 2d ed. (San Juan: Imprenta Venezuela, 1946), 8.

6. Luisa Géigel de Gandía, *La genealogía y el apellido de Campeche* (San Juan: Instituto de Cultura Puertorriqueña, 1972), 19–20.

7. "Solicitud de pensión de las hermanas de Campeche," Archivo Histórico Nacional, Madrid, Sección Ultramar, leg. 2004/15, doc. 4, p. 3v sn.

8. Ibid., doc. 3, p. 3 sn.

9. María Concepción García Sáiz, "Dos obras religiosas de Campeche, en Madrid," *Revista de Indias* (Madrid) 145–46 (July–December 1976): 303 (offprint).

10. Alfredo Boulton, *Historia de la pintura en Venezuela* (Caracas: Editorial Arce, 1968), 2:13.

11. The rank of second captain, held by Don Ramón Carvajal y Cid, husband of Doña María de los Dolores, did not exist in the army units in the peninsula, being exclusive to the companies of fusiliers of the Fixed Infantry Regiment of Puerto Rico, according to Spanish historians M. Gómez Ruiz and V. Alonso Juanola in their work, *El Ejército de los Borbones* (Madrid: Ministerio de Defensa, 2002), 66. They add that outside of Spain there was only one similar military rank, and it was in the contemporary Swiss regiments. This rank existed in the Puerto Rican organization probably because of the many soldiers assigned to the companies of fusiliers belonging to this regiment.

12. Gaya Nuño, "Precisiones en torno a José Campeche," 33.

13. The Goyena miniature painters, sons of Doña Ysabel O'Daly, were Francisco Estanislao de los Dolores Goyena (1805–1857), José Félix de los Dolores Goyena (1811–1853), and Joaquín Antonio de los Dolores Goyena (1813–1843). See Vidal, *Cuatro puertorriqueñas por Campeche,* 171–75, nn. 9, 10, 11.

14. René Taylor, "Catálogo," in *José Campeche y su tiempo* (Ponce, P.R.: Museo de Arte de Ponce, 1988), 195.

15. Isabel Gutiérrez del Arroyo, "El Dr. Don Juan Alejo de Arizmendi, primer obispo puertorriqueño," conference, San Juan, Fundación Puertorriqueña de las Humanidades, May 1, 1956, 13.

16. "Solicitud de pensión de las hermanas de Campeche," doc. 4, p. 1 sn.

17. Ibid., doc. 4, p. 2 sn.

18. Ibid., doc. 3, p. 8v–9 sn.

19. Tapia, *Vida del pintor puertorriqueño José Campeche,* 18, n. 12.

20. José G. Rigau Pérez, Francisco Figueroa, and Henry Hutchinson, "José Campeche, ¿compositor?," *El Nuevo Día* (San Juan), Revista Domingo, June 26, 1994, 16–18.

Portraiture and the Age of Independence
by Miguel A. Bretos

1. For a general discussion of events in Spain, see Gabriel Lovett, *Napoleon and the Birth of Modern Spain,* 2 vols. (New York: NYU Press, 1965), and Timothy Anna, *Spain and the Loss of America* (Lincoln: University of Nebraska Press, 1983). See also Robert M. Laughlin, *La Gran Serpiente Cornuda: ¡Indios de Chiapas, no escuchen a Napoleon!* (Mexico, D.F.: UNAM, 2001). There is an extensive bibliography on Godoy. See especially Douglas Hilt, *The Double Trinity: Godoy and the Spanish Monarchs* (Tuscaloosa: University of Alabama Press, 1987), and Emilio La Parra López, *Manuel Godoy: La aventura del poder* (Barcelona: Tusquets, 2002).

2. On Dom João VI's Brazilian regency and reign, see Manoel de Oliveira Lima's still-useful *Dom João VI no Brasil,* 3 vols. (1908; reprint, Rio de Janeiro/São Paulo: José Olympo Editora, 1945).

3. See Claudine Lebrun Jouve's excellent recent biographical study of Taunay, *Nicolas-Antoine Taunay (1755–1830)* (Paris: Arthena, 2003), especially her discussion of the 1816 Brazilian mission on pages 87–99. See also Gean Maria Bittencourt, *A missao artística francesa de 1816* (Petrópolis: Museu de Armas Ferreira da Cunha, 1967), and Afonso de E. Taunay, *A missao artistica de 1816* (Rio de Janeiro: Ministerio de Educacao e Cultura, 1956).

4. Debret is the author of the iconic *Viagem pitoresca e histórica ao Brazil* (Belo Horizonte: Editora Itatiaia/São Paulo: Editora da Universidade de São Paulo, 1989).

5. Manuel Tolsá was the great figure of the Mexican neoclassic style. Born in Valencia in 1757, he arrived in Mexico in 1791 with an appointment to the Royal Academy of San Carlos as director of sculpture. An architect of note as well, he made extraordinary contributions in both disciplines. He died in 1816. The Charles IV statue was an initiative of the viceroy, the marquis of Branciforte. Cast in Mexico in August of 1803, it was inaugurated on December 9 of that year. It has been installed at different places at different times, including a *glorieta,* or traffic circle, on the great nineteenth-century boulevard, the Paseo de la Reforma, and the little square in front of the School of Mines, where it is now and where it was originally intended to be installed. There is an extraordinary portrait of Tolsá by his Mexican contemporary Rafael Jimeno y Planes. See Manuel Toussaint, *Colonial Art in Mexico,* trans. Elizabeth Wilder Weismann (Austin: University of Texas Press, 1967), 432–35.

6. Elizabeth du Gué-Trapier, *Goya and His Sitters: A Study of His Style as a Portraitist* (New York: Hispanic Society of America, 1964). See also Alfonso E. Perez-Sánchez and Eleanor A. Sayre, *Goya and the Spirit of Enlightenment* (Boston: Museum of Fine Arts, 1989).

7. For a superb scholarly overview of the Mexican independence struggle, see Eric Van Young, *The Other Rebellion: Popular Violence, Ideology, and the Mexican Struggle for Independence, 1810–1821* (Stanford, Calif.: Stanford University Press, 2001). See also Hugh Hamill, *The Hidalgo Revolt: Prelude to Mexican Independence* (Gainesville: University of Florida Press, 1966).

8. Morelos's classic biography is by Alfonso Teja Zabre, *Vida de Morelos* (Mexico, D.F.: Comisión Nacional para la celebración del 174 aniversario de la independencia y el 75 de la Revolución Mexicana, 1985). See also Rafael Heliodoro Valle, *Seis imágenes de Morelos* (Mexico, D.F.: Imprenta de la Honorable Cámara de Diputados, 1950).

9. The best starting point for understanding the process and dynamics of the age is John Lynch's massive study, *The Spanish American Revolutions, 1808–1826* (New York: W. W. Norton, 1986). See also Anna, *Spain and the Loss of America.* For the Brazilian side of the story, see Neill Macaulay, *Dom Pedro: The Struggle for Liberty in Brazil and Portugal, 1798–1834* (Durham, N.C.: Duke University Press, 1986).

10. For details of the battle and aftermath, see Angel Grisanti, *La batalla, la capitulación y las actas de Ayacucho* (Caracas: Ministerio de Defensa de la República de Venezuela, 1974).

11. Santiago Londoño Vélez, *Arte colombiano: 3.500 años de historia* (Bogota: Villegas Editores, 2001).

12. On the iconography of Pedro I, see the exhaustive and massive work by Stanislaw Herstal, *Dom Pedro,* 3 vols. (São Paulo: n.p., 1972).

13. Fernando Restrepo Uribe et al., *Los Figueroa, aproximación a su época y a su pintura* (Bogota: Museo de Arte Moderno de Bogotá, Villegas Editores, 1986).

14. Bolívar's iconographic repertoire is especially rich and lends itself to fascinating comparisons. It has been the subject of numerous studies, including exhaustive *iconografías* by the eminent Venezuelan scholar Alfredo Boulton and his Colombian counterpart, Enrique Uribe White. For a thorough discussion of Bolívar's posthumous image, see Miguel A. Bretos, "From Banishment to Sainthood: A Study of the Image of Bolívar in Colombia" (Ph.D. diss., Vanderbilt University, 1976).

15. Beatriz González, *José María Espinosa: Abanderado del arte y de la Patria* (Bogota: Museo Nacional de Colombia, n.d.).

16. On Lovera, see the catalogue for the exhibition *Juan Lovera y su tiempo* (Caracas: Petróleos de Venezuela, 1981). See also Carlos F. Duarte's excellent study, *Juan Lovera, el pintor de los próceres* (Caracas: Fundación Pampero, 1985).

17. See Justino Fernández, *El arte del siglo XIX en México* (Mexico, D.F.: UNAM, 1983), 24.

18. On José Gil de Castro, see the excellent and exhaustive, if rather humbly published, catalogue raisonée by Ricardo Mariátegui Oliva, *José Gil de Castro (El "Mulato Gil")* (Lima: Imprenta "La Confianza," 1981). See also *José Gil de Castro en Chile: Exposición retrospectiva (junio–julio 1994)* (Santiago: Museo Nacional de Bellas Artes, 1994), and the exhibition's excellent website, http://www.puc.cl/faba/ARTE/ARTORES/GildeCastro.html.

19. Romualdo Brughetti, *Nueva historia de la pintura y la escultura en la Argentina desde sus orígenes hasta nuestros días,* 3d ed. (Buenos Aires: Ediciones de Arte Gaglione, 2000), 29.

20. *Eugenio Pereira Salas: Estudios sobre la historia del arte en Chile republicano* (Santiago: Ediciones de la Universidad de Chile, 1992), 22.

21. Mariátegui, *José Gil de Castro,* 107–9.

22. Ibid., 127–28.

23. Ibid., 123–24.

24. Jaime Eyzaguirre, *O'Higgins* (Santiago de Chile: Zig-Zag, 1965).

25. Patricia Mondoñedo Murillo, *El retrato de José Olaya: La obra disímil de José Gil de Castro* (Lima: Seminario de Historia Rural Andina, Universidad Nacional Mayor de San Marcos, 2002).

26. *Policarpa 200: Exposición conmemorativa del bicentenario del nacimiento de Policarpa Salavarrieta,* Serie Cuadernos iconográficos del Museo Nacional de Colombia, no. 1 (Bogota: Museo Nacional de Colombia, 1996), 7–13.

27. Ibid., 9.

28. Eyzaguirre, *O'Higgins.*

29. For a concise, well-informed overview of the history of miniatures, see Karen P. Schaffers-Bodenhausen, "Portrait Miniatures and Miniature Portraits," in *The Portrait Miniatures in the Collections of the House of Orange-Nassau* (The Hague: House of Orange-Nassau Historical Collections Trust, 1992), 11–45.

30. See Gabriel Giraldo Jaramillo, *La miniatura, la pintura y el grabado en Colombia* (Bogota: Instituto Colombiano de Cultura, 1980), and Museo Nacional de Colombia, *Catálogo de miniaturas,* Serie Colecciones del Museo Nacional, vol. 1 (Bogota: Instituto Colombiao de Cultura; El Museo, 1993).

31. Lucas Alamán, *Episodios históricos de la guerra de independencia* (Mexico, D.F.: Impr. de "El Tiempo," de V. Agüeros, 1910).

Tradition and Avant-garde
by Luis-Martín Lozano

1. Biographical information about Xavier Martínez, an artist who is largely unknown in Mexico, was given by the painter and cultural promoter Ixca Farías in *Biografía de pintores jaliscienses, 1882–1940* (reprint, Guadalajara: Gobierno de Jalisco, 1989). On artistic life in Guadalajara and the circle of Félix Bernardelli, see Laura González Matute and Luis-Martín Lozano, *Félix Bernardelli y su taller* (Guadalajara: Instituto Cultural Cabañas, 1996).

2. See *Diego Rivera: Arte & revolución* (Mexico, D.F.: Consejo Nacional para la Cultura y las Artes, 1999), a catalogue of the exhibition organized by the Instituto Nacional de Bellas Artes, Mexico, in collaboration with the Cleveland Museum of Art. Both the exhibition and the catalogue stressed Rivera's contribution as an international avant-garde artist, beyond his career as a mural painter.

3. This has been demonstrated by Dr. Ramón Favela, the most enthusiastic expert on Rivera's cubist work. See Favela, *Diego Rivera: The Cubist Years* (Phoenix, Ariz.: Phoenix Art Museum, 1984).

4. For further details of the adverse criticism of Anita Malfatti's work, see the writings of Oswald de Andrade. Some are collected in the documentary and anthological volume *Una semana en São Paulo,* trans. Alberto Paredes (Mexico, D.F.: Breve Fondo Editorial, 2001).

5. The work probably contains autobiographical references: Ángel's father died during his childhood, and he grew up with his mother and siblings. The most complete study on this artist is Luis Mario Schneider's *Abraham Ángel* (Mexico, D.F.: Gobierno del Estado de México/UNAM, 1995).

6. See Xavier Moyssén, *David Alfaro Siqueiros: Pintura de caballete* (Mexico, D.F.: Fondo editorial de la plástica mexicana, 1994). For more details on the period Siqueiros spent in Europe, see Jean Charlot, *The Mexican Mural Renaissance, 1920–1925* (New Haven, Conn.: Yale University Press, 1963).

7. See David Alfaro Siqueiros, "Rectificaciones sobre las artes plásticas en México," lecture delivered at the closing ceremony of his first one-man exhibition, held at the gallery of the Casino Español, Mexico D.F., February 18, 1932, in *Palabras de Siqueiros,* ed. Raquel Tibol (Mexico, D.F.: Fondo de Cultura Económica, 1996).

8. See Luis-Martín Lozano, *María Izquiedo: Una verdadera pasión por el color* (Mexico, D.F.: Consejo Nacional para la Cultura y las Artes, 2002).

9. On Kahlo, her training, the interpretation of some of her works, her aesthetic influences, and her artistic references, see my earlier writings: Luis-Martín Lozano, "Frida Kahlo or the Will to Paint," in *Diego Rivera, Frida Kahlo* (Martigny, Switzerland: Fondation Pierre Gianadda, 1998) and *Frida Kahlo* (Mexico, D.F.: BITAL/Landucci Editores, 2000).

10. The best source for the details of Kahlo's relationship with Nickolas Muray is Hayden Herrera, *Frida: A Biography of Frida Kahlo* (New York: Harper & Row, 1983).

Diego Rivera's Portraits
by Renato González Mello

1. Ramón Favela, *Diego Rivera: Los años cubistas* (Mexico, D.F.: INBA/Museo Nacional de Arte, 1985).

2. Olivier Debroise, *Diego de Montparnasse* (Mexico, D.F.: Fondo de Cultura Económica, 1979). However, Debroise notes that his book was not widely read until the 1986 retrospective.

3. *Diego Rivera: A Retrospective* (New York: W. W. Norton, 1986).

4. Xavier Moyssén, *Diego Rivera, textos de arte,* 1st ed. (Mexico, D.F.: UNAM/Instituto de Investigaciones Estéticas, 1986), 100.

5. Elisa García Barragán y Luis Mario Schneider, *Diego Rivera y los escritores mexicanos, antología tributaria* (Mexico, D.F.: UNAM/Instituto de Investigaciones Bibliográficas, 1986), 145.

6. Gladys March, *Diego Rivera, mi arte, mi vida, una autobiografía hecha con la colaboración de . . .* (Mexico, D.F.: Librería Herrero, 1963), 238; Loló de la Torriente, *Memoria y razón de Diego Rivera,* 1st ed., 2 vols. (Mexico, D.F.: Renacimiento, 1959); Bertram D. Wolfe, *La fabulosa vida de Diego Rivera,* 3d ed. (Mexico, D.F.: Secretaría de Educación Pública/Editorial Diana, 1986).

7. De la Torriente, *Memoria y razón de Diego Rivera,* 1:266–77: "lo que los topos llaman "mentiras" son, en realidad, la proyección pura de la vida del genio del artista y ya que la obra de arte es lo único que sobrevive a la vida del hombre y lo único por medio de lo cual podemos saber algo de esa vida, en el desarrollo del tiempo y del espacio lo que cuenta el artista sobre su propia vida es siempre una obra de arte si, realmente, es un artista y como tal lo más cierto, real y de mayor valor para nuestra ciencia de la historia."

8. Ibid., 263: "Pero, como además del complejo de inferioridad, tenía una cierta potencialidad de empuje activo y, por un raro hecho biológicamente paradójico, una resistencia y una vitalidad considerable dentro de su hipotiroidismo que hizo de él 'un señor que parece una rana andando en dos pies', materializó sus aspiraciones después de haber sobrepasado dificultades como el tifo exantemático, un ataque de paludismo agudo, una neumonía y otras pequeñas muestras del arsenal patológico."

9. Moyssén, *Diego Rivera, textos de arte,* 99: "Marchó a España donde el choque entre la tradición mexicana, los ejemplos de pintura antigua, y el ambiente y producción moderna española, obrando sobre su timidez educada en el respeto a Europa lo desorientaron, haciéndole producir cuadros detestables muy inferiores a los hechos por él en México antes de marchar a Europa."

10. Quoted in Marius de Zayas, *How, When and Why Modern Art Came to New York,* ed. Francis M. Naumann (Cambridge, Mass.: MIT Press, 1996), 103–4. On Rivera's relationship to de Zayas, see Alejandro Ugalde, "The Presence of Mexican Art in New York Between the World Wars: Cultural Exchange and Transnational Propaganda" (Ph.D. diss., Columbia University, 2003), 115–19: ". . . En un retrato, pongamos por caso la *cabeza* existe como una generalidad común a todos los hombres. Como cabeza poseerá las cualidades de la forma accidental—su posición en el espacio, la redondez total del cráneo—pero en un retrato, después de pintar la cabeza es preciso particularizarla y hacer de esa cabeza *una* cabeza. Ahora bien, ésta individualización que le sobreviene no dependerá del accidente plástico sino que será un determinado conjunto de rasgos que han de constituir una cifra facial personal y única."

11. Linda Dalrymple Henderson, *The Fourth Dimension and Non-Euclidean Geometry in Modern Art* (Princeton, N.J.: Princeton University Press, 1983), 305.

12. Favela, *Diego Rivera: Los años cubistas,* 32–49.

13. A very interesting explanation of this method, which dwelled on the division of the white light as a tool for presentation, can be found in Robyn S. Roslak, "The Politics of Aesthetic Harmony," *Art Bulletin* 73 (1991): 381–90. Also *Archivi del Divisionismo,* ed. Teresa Fiori (Rome: Officina Edizioni, 1968), 1:18.

14. Quoted in de Zayas, *How, When and Why Modern Art Came to New York,* 104.

15. Ibid.

16. Favela, *Diego Rivera: Los años cubistas,* 13–15.

17. Quoted in Henderson, *Fourth Dimension,* 305.

18. Ibid.

19. Quoted in de Zayas, *How, When and Why Modern Art Came to New York,* 103–4.

20. Ramón Favela, *El joven e inquieto Diego María Rivera (1907–1910)* (Mexico, D.F.: INBA/Secuencia, 1991).

21. On the drawing courses at the academy, see Clara y Elizabeth Fuentes Bargellini, *Guía que permite captar lo bello: Yesos y dibujos de la Academia de San Carlos, 1778–1916* (Mexico, D.F.: UNAM/Instituto de Investigaciones Estéticas, 1989).

22. Renato González Mello, "La UNAM y la Escuela Central de Artes Plásticas durante la dirección de Diego Rivera," *Anales del Instituto de Investigaciones Estéticas* 67 (1995): 21–68.

23. See n. 10.

24. Favela, *Diego Rivera: Los años cubistas,* 36. On Mondrian's neoplatonism, see Mark Arthur Cheetham, *The Rhetoric of Purity: Essentialist Theory and the Advent of Abstract Painting* (Cambridge, Eng.: Cambridge University Press, 1991).

25. De la Torriente, *Memoria y razón de Diego Rivera,* 2:180. "Una mujer alta, bien plantada, que mantenía las dos manos hacia delante como las mantiene los canguros o como las mantendría una mula parada de patas, manos magníficas y fuertes, más parecidas, tal vez, a las garras de una ave de presa que a las de un felino carnicero. Brazos nervudos terminando en un torso pequeño en relación a los muslos largos, como los de un animal salteador, terminando en piernas tremendas, magníficas, como de yegua de la más fina sangre y tras de un tobillo de pura raza pies como pezuñas de una belleza extraña y extrahumana cuya sensación colindaba con el horror. . . . Y, sobre todo esto, bajo un mechero suelto de crines negras, maravillosas, dos ojos verdes cuya pupila de tan zarca, se fundía con la córnea y daba la impresión de ceguera. Ojos de jhade azulverde, tan claro

que parecía más bien cuarzo en las cavidades de la más extraordinaria bella máscara olemazapoteca que se haya producido en la plástica, nacida, natural o creada de hombre, en toda Anáhuac."

26. Ibid., 181: "Hecha para desgarrar carne viva o triturar huesos."

27. Cheetham, *Rhetoric of Purity;* Bram Dijkstra, *Ídolos de perversidad: La imagen de la mujer en la cultura de fin del siglo* (Madrid: Debate, 1994), 289–90; María Tatar, *Lustmord: Sexual Murder in Weimar Germany* (Princeton, N.J.: Princeton University Press, 1995), 57–63.

28. Moyssén, *Diego Rivera, textos de arte,* 104.

29. Guadalupe Marín, *La única* (Mexico, D.F.: Editorial Jalisco, 1938), 249. "¡Camaradas! Esta que les habla ahora, no aspira a ser líder, porque sabe que en una lechuga de a centavo se encuentra la vitamina e, y que en un jitomate de a dos, la vitamina C; y que aún sin síntomas de esterilidad o escorbuto, le aprovechan."

30. De la Torriente, *Memoria y razón de Diego Rivera,* 2:180.

31. Jorge Cuesta, *Obras,* ed. Miguel Capistrán et al. (Mexico, D.F.: El Equilibrista, 1994), 1:47.

32. Raquel Tibol, ed., *Diego Rivera: Arte y política* (Mexico, D.F.: Grijalbo, 1979), 353–54.

33. Rita Eder, "The Portraits of Diego Rivera," in *Diego Rivera: A Retrospective,* 199.

34. Quoted in Henderson, *Fourth Dimension,* 305.

35. The head on the left is supposed to be either that of Cuesta's sister, Natalia, or the one of a former girlfriend; see Raquel Tibol, *Diego Rivera ilustrador* (Mexico, D.F.: SEP, 1986), 251.

36. It is noticeable that these three works are closely related to Frida Kahlo's famous double self-portrait of 1939, *Las dos fridas.*

37. Iliá Ehrenburg, *Las extraordinarias aventuras de Julio Jurenito y de sus discípulos,* trans. Lidia K. de Velasco, 1st ed. (Barcelona: Seix Barral, 1971).

38. One of Jurenito-Rivera's followers, enthusiastic about political extermination, is oddly named "Carl Schmidt," perhaps a reference to the famed German political theorist Carl Schmitt.

39. Ehrenburg, *Las extraordinarias aventuras de Julio Jurenito,* 97. The late Stanton L. Catlin

thought, indeed, that Rivera's invention resembled Baron Munchausen's adventures.

Antiquity and Modernity of the Portrait
by Luis Pérez-Oramas

1. Pascal Quignard, *Le Sexe et l'Effroi* (Paris: Gallimard, 1993), 48–49.

2. Gotthold Ephraim Lessing, *Laocoön ou des frontières de la peinture et de la poésie* (1766; Paris: Édition Hermann, 1990), 2:51.

3. Louis Marin, "La question du portrait. Figurabilité du visuel: La Véronique ou la question du portrait à Port Royal," in *Pascal et Port Royal,* Collège International de Philosophie (Paris: Presses Universitaires de France, 1997), 297.

4. Jean-Pierre Vernant, "De la présentation de l'invisible à l'imitation de l'apparence," in *Image et Signification: Rencontres de l'École du Louvre* (Paris: La Documentation Française, Paris, 1983).

5. Hans Belting, *Image et Culte: Une histoire de l'image avant l'époque de l'art* (Paris: Éditions du Cerf, 1998), 76–84, 277–300.

6. José Gorostiza, *Muerte sin Fin* (1939; reprint, Colección Itálica Mínima, 1990).

7. Leon Battista Alberti, *De Pictura* (1435; reprint, Paris: Macula, 1992),135.

8. Louis Marin, *La Critique du Discours: Sur la "Logique de Port Royal" et les "Pensées" de Pascal* (Paris: Minuit, 1975), 76.

9. See Michael Fried, *Absorption and Theatricality: Painting and Beholder in the Age of Diderot* (Chicago: University of Chicago Press, 1988).

10. Luis Pérez-Oramas, "Arturo Michelena: Vueltas a la patria y representación en la historia," in *Genio y gloria de Arturo Michelena* (Caracas: Galería de Arte Nacional, 1998).

11. Pliny, *Natural History,* 35, 43 (12) 151 (Paris: Société d'Édition les Belles Lettres, 1985), 101.

12. Charles S. Pierce, *Écrits sur le signe* (Paris: Seuil, 1978), 158, 160.

13. Antonio Ascisclo Palomino, *Vidas* (1724; reprint, Madrid: Alianza, 1986), 183.

14. Georges Didi-Huberman, "La ressemblance par contact: Archéologie, anachronisme et modernité de l'empreinte," in *L'Empreinte* (Paris: Centre Georges Pompidou, 1997).

15. Aristotle, *Nicomachean Ethics,* 6.5, 1140a.

16. Aby Warburg, "L'Art du portrait et la bourgeoisie Florentine: Domenico Ghirlandaio à Santa Trinita, les portraits de Laurent de Médicis et de son entourage," in *Essais Florentins,* trans. Sybilla Mueller (Paris: Klincksieck, 1990), 121.

17. Pliny, *Natural History,* 35, 43 (12) 151, 102.

18. See Georges Didi-Huberman, *La peinture incarnée* (Paris: Les Editions e Minuit, 1985), 38.

19. John Elderfield, "The Self-Portrait Drawings of Armando Reverón," *Master Drawings* 40, no. 1 (2002).

20. Ovid, *Metamorphoses,* 3.425 (Paris: Édition Garnier-Flammarion, 1966), 100–101.

Notes for Plate Captions
Section II, Precolumbian

Plates 1–5: Moche portrait vessels
Christopher Donnan, "Moche Ceramic Portraits," in *Moche Art and Archaeology in Ancient Peru,* ed. Joanne Pillsbury (Washington, D.C.: National Gallery of Art, 2001), 127–28.

Section III, Viceregal

Plate 10: Fray García Guerra
Guillermo Tovar de Teresa, *Repertorio de artistas en México: Artes plásticas y decorativas* (Mexico, D.F.: Grupo Financiero Bancomer, 1996), 2:282.

Plate 11: Juan Escalante Colombres de Mendoza
El Abogado Mexicano: *Historia e imagen* (Mexico, D.F.: UNAM, 1991).

Plate 12: R.P.D. Martín de Andrés Pérez
Enciclopedia del Arte en América: Biografías 3 (Buenos Aires: Bibliográfica OMEBA, 1968–69).

Plate 13: Portrait of an Indian Lady, Daughter of a Cacique
The Grandeur of Viceregal Mexico: Treasures from the Museo Franz Mayer (Mexico and Houston: Museo Franz Mayer and the Museum of Fine Arts, Houston, 2002), 94.

Plate 14: Don Joseph de Escandón y Helguera, Conde de Sierra Gorda
Susan Theran, *Leonard's Price Index of Latin American Art at Auction* (Newton, Mass.: Auction Index, 1999), 68.

Plate 16: Miguel de Berrio y Saldívar
Doris M. Ladd, *The Mexican Nobility at Independence, 1780–1826* (Austin: Institute of Latin American Studies/University of Texas, 1976).

Plate 21: Sor Juana Inés de la Cruz
Mexico: Splendors of Thirty Centuries (New York: Metropolitan Museum of Art and Little, Brown, 1990), 351–55.

Plate 23: Dom Luíz de Vasconcellos e Sousa
Pedro Doria to Carolyn K. Carr, Jan. 3, 2004. I wish to thank Mr. Doria and his father, Professor Francisco Antonio Doria, for sharing their research on Luíz Vasconcellos with me.

Nancy Priscilla S. Naro, "Imperial Palms over Colonial Gardens," *Revista/Review Interamericana* 29, http://www.sg.inter.edu/revista-ciscla/volume29/naro.html.

Enciclopédia artes visuais, "Leandro Joaquim," http://www.itaucultural.org.br/AplicExternas/Enciclopedia/artesvisuais2003/index.cfm.

Plate 24: Teodoro de Croix
Robert S. Weddle, *The Handbook of Texas Online,* Texas State Historical Association, 2003, http://www.tsha.utexas.edu/handbook/online/articles/view/CC/fcr26.html.

Plate 25: Bernardo de Gálvez
Robert H. Thonhoff, *The Handbook of Texas Online,* Texas State Historical Association, 2002, http://www.tsha.utexas.edu/handbook.

Plate 26: Doña María Mercedes de Salas y Corvalán
Isabel Cruz de Amenábar, *El traje: transformaciones de una segunda piel* (Santiago: Universidad Católica de Chile, 2002).

Plate 28: Un Alférez del Regimiento de Infantería Fijo de Puerto Rico
Susan Theran, *Leonard's Price Index of Latin American Art at Auction* (Newton, Mass.: Auction Index, 1999), 43.

Teodoro Vidal, *Cuatro puertorriqueñas por Campeche* (San Juan de Puerto Rico: Ediciones Alba, 2000), 62.

Plate 33: El Niño José Manuel de Cervantes y Velasco
Gutierre Aceves Piña, "El Arte Ritual de la Muerte Niña," *Artes de México* 15 (spring 1992): 18–19.

Section IV, Nineteenth Century
Plate 38: Los Hermanos Servantes y Michaus
Norman Neuerberg, "The Changing Face of Mission San Diego," *Journal of San Diego History* 32, no. 1 (winter 1986): 4.

Plate 41: Lucía Petrona Riera de López
Enciclopedia del arte en América: Biografías 2 (Buenos Aires: Bibliográfica OMEBA, 1968–69).

Plate 42: Agustín de Iturbide y Eposa Ana María de Huarte
Christopher Buyers, "México: The Iturbide Dynasty," 2002, http://www.4dw.net/royalark/Mexico/mexico3.htm.

Plate 43: José Raymundo Juan Nepomuceno de Figueroa y Araoz
Ricardo Mariátegui Oliva, *José Gil de Castro (El "Mulato Gil")* (Lima: Imprenta "La Confianza," 1981), 124–25.

Plate 46: Retrato de Caballero Muerto
Guillermo Tovar de Teresa, *Repertorio de artistas en México: Artes plásticas y decorativas* (Mexico, D.F.: Grupo Financiero Bancomer, 1996), 3:178.

Plate 49: Francisco Margallo y Duquesne
Historia contemporánea de Colombia (desde la disolución de la antigua república de ese nombre hasta la época presente), 6 vols. (Bogota and Cali: Arboleda & Valencia, 1918), vol. 1.

Plate 50: Francisco de Paula Santander
Pilar Moreno de Angel and Horacio Rodriguez Plata, *Santander: Su iconografía* (Bogota: Arco, 1984).

Miguel A. Bretos, "From Banishment to Sainthood: A Study of the Image of Bolívar in Colombia, 1830–1886" (Ph.D. diss., Vanderbilt University, 1976).

Plate 52: Manuela Gutiérrez (La Niña de la Muñeca)
Dawn Ades, *Art in Latin America: The Modern Era, 1820–1980* (New Haven, Conn.: Yale University Press, 1989), 344.

Plate 60: Intrépido Marinheiro Simão
Dicionário brasileiro de artistas plásticos, 4 vols. (Brasília: Ministerio de Educacao e Cultura, 1974), 2:478.

Plate 63: Esposa de Francisco Cevallos
Friedrich Hassaurek, *Four Years Among the Ecuadorians,* ed. C. Harvey Gardiner (Carbondale: Southern Illinois University Press, 1967).

Plate 65: Don José Gutiérrez del Arroyo y Delgado
Teodoro Vidal et al., *Essence and Presence: Our Traditional Arts* (San Juan: Banco Popular, 1993), n.p.

Plate 81: La Escuela del Maestro Rafael Cordero
Susan Theran, *Leonard's Price Index of Latin American Art at Auction* (Newton, Mass.: Auction Index, 1999), 85.

Luis R. Negrón Hernández, "Rafael Cordero Molina: Teacher of Great Men, Servant of God," 2003, http://www.preb.com/biog/cordero.htm.

Plate 82: Niña en Blanco
Arteperúgallery website, "Carlos Baca-Flor Soberón," http://www.arteperustore.com/.

Plate 83: Autorretrato
George W. Neubert, *Xavier Martínez (1869–1943)* (Oakland: Oakland Museum of California, 1974), 9–10.

Plate 84: Don Guillermo Puelma Tupper
Antonio R. Romera, *Historia de la pintura Chilena* (Santiago: Editorial Andrés Bello, 1976), 67–76.

Mario Céspedes, ed., *Gran diccionario de Chile,* 2d ed., 2 vols. (Santiago: Importadora Alfa, 1988).

Section V, Modern
Plate 85: El Pintor Zinoviev
Laurance P. Hurlburt, "Diego Rivera (1886–1957): Chronology of His Art, Life, and Times," in *Diego Rivera: A Retrospective* (New York: W. W. Norton, 1986), 34.

Plate 86: Abraham Valdelomar
Universidad Nacional Mayor de San Marcos, http://www.unmsm.edu.pe.

"Raúl María Pereira," in *Pinturas y pintores del Peru,* ed. Guillermo Tello Garust (Lima: C&C Servicios Especializados, 1997). Thanks to Carlos J. Olave, senior reference librarian, Hispanic Division, Library of Congress, for this information.

Plate 87: *Amado de la Cueva*
Philip Stein, *Siqueiros: His Life and Work* (New York: International Publishers, 1994), 22–56.

Plate 92: *Rostro Blanco*
Susan Theran, *Leonard's Price Index of Latin American Art at Auction* (Newton, Mass.: Auction Index, 1999), 94–95.

Plate 94: *Rockwell Kent*
David Traxel, *An American Saga: The Life and Times of Rockwell Kent* (New York: Harper and Row, 1980), 182–84; Archives of American Art, Smithsonian Institution, Rockwell Kent Papers, reel 5164, frames 77–307; reel 5223, frames 1343–1444.

Plate 97: *Mis Sobrinas*
María Izquierdo, 1902–1955 (Chicago: Mexican Fine Arts Center Museum, 1996).

Plate 100: *Autorretrato*
Susan Theran, *Leonard's Price Index of Latin American Art at Auction* (Newton, Mass.: Auction Index, 1999), 63.

Plate 102: *Joachim Jean Aberbach y su Familia*
Susan Theran, *Leonard's Price Index of Latin American Art at Auction* (Newton, Mass.: Auction Index, 1999), 40.

Section VI, Contemporary

Plate 105: *Autorretrato*
Susan Theran, *Leonard's Price Index of Latin American Art at Auction* (Newton, Mass.: Auction Index, 1999), 107.

Plate 106: *Tentaciones*
Enrique García Gutiérrez, in *Latin American Art in the Twentieth Century,* ed. Edward J. Sullivan (London: Phaidon, 1996), 133.

Plate 108: *Espectadores*
Hollister Sturges, *New Art from Puerto Rico* (Springfield, Mass.: Museum of Fine Arts, 1990), 26.

José Antonio Perez Puiz, "Myrna Baez," *Art Nexus* 23 (January/March 1997): 135.

Plate 110: *Duplo Reflexo do Outro*
Stella Teixeira de Barros, "Adriana Varejão: The Presence of Painting," *Art Nexus* 34 (November 1999/January 2000): 48–53, provides a recent overview of the artist's work.

Plate 111: *Niñas de Azúcar*
Jonathan Yorba, *Arte Latino: Treasures from the Smithsonian American Art Museum* (New York: Watson-Guptill, 2001), 74.

Plate 112: *Abridor de Caminos*
Julia P. Herzberg, "History of a People Who Were Not Heroes," part 1, Lehman College Art Gallery, New York, 1998, http://ca80.lehman.cuny.edu/gallery/.

Plate 113: *Carter, Anna, y Darryl*
From a handout produced by the Max Protetch Gallery, New York, 2001.

Abel-Vidor, Suzanne, et al. *Between Continents, Between Seas: Precolumbian Art of Costa Rica.* New York: Harry N. Abrams, in association with the Detroit Institute of Arts, 1981.

Aceves Piña, Gutierre. *Tránsito de angelitos.* Mexico, D.F.: Museo de San Carlos, 1988.

Ades, Dawn, et al. *Art in Latin America: The Modern Era, 1820–1980.* New Haven, Conn.: Yale University Press and London: South Bank Centre, 1989.

Angulo V., Jorge. "Teotihuacán: Aspectos de la cultura a través de su expresión pictórica." In *La pintura mural prehispánica en México: Teotihuacán,* edited by Beatriz de la Fuente, 2:65–186. Mexico, D.F.: UNAM/Instituto de Investigaciones Estéticas, 1996.

Arellano Hernández, Alfonso, et al. *The Mayas of the Classical Period.* Milan: Editoriale Jaca, 1999.

Arte precolombino de Ecuador. Quito: Salvat Editores Ecuatoriana, 1985.

Bantel, Linda, and Marcus B. Burke. *Spain and New Spain: Mexican Colonial Arts in Their European Context.* Corpus Christi: Art Museum of South Texas, 1979.

Bayón, Damián. *History of South American Colonial Art and Architecture: Spanish South America and Brazil.* New York: Rizzoli, 1992.

Benson, Elizabeth P. "An Olmec Figure at Dumbarton Oaks." *Studies in Pre-Columbian Art and Archaeology* 8 (1971).

———. "Some Olmec Objects in the Robert Woods Bliss Collection at Dumbarton Oaks." In *The Olmec and Their Neighbors: Essays in Memory of Matthew W. Stirling,* edited by Michael D. Coe, David Grove, and Elizabeth P. Benson, 95–108. Washington, D.C.: Dumbarton Oaks Research Library and Collections, 1981.

Benson, Elizabeth P., and Beatriz de la Fuente, eds. *Olmec Art of Ancient Mexico.* Washington, D.C.: National Gallery of Art, 1996.

Berrin, Kathleen, and Esther Pasztory, eds. *Teotihuacan: Art from the City of the Gods.* San Francisco: Fine Arts Museums; New York: Thames and Hudson, 1993.

Borrell M., Hector Rivero, et al. *La grandeza del México virreinal: Tesoros del Museo Franz Mayer.* Houston: Museum of Fine Arts; Mexico, D.F.: Museo Franz Mayer, 2002.

Burger, Richard L. *Chavín and the Origins of Andean Civilization.* London: Thames and Hudson, 1992.

Castillo, Mario. *Retratos de escritores hondureños.* Tegucigalpa: Fondo Editorial UPNFM, 2002.

Catlin, Stanton Loomis, and Terence Grieder. *Art of Latin America Since Independence.* New Haven, Conn.: Yale University Art Gallery, 1966.

Cavanagh, Cecilia. *Autorretratos y retratos.* Buenos Aires: Pontificia Universidad Católica Argentina/ Pabellón de las Bellas Artes, 2004.

Ciancas, María Ester, and Bárbara Meyer. *Catálogo de la colección de miniaturas del Museo Nacional de Historia.* Mexico, D.F.: Museo Nacional de Historia/INAH, 1988.

———. "El retrato civil novohispano en el Museo Nacional de Historia." In *El retrato civil en la Nueva España,* 51–65. Mexico, D.F.: Museo de San Carlos, 1991.

———. *La pintura de retrato colonial, siglos XVI–XVIII.* Mexico, D.F.: INAH/Museo Nacional de Historia, 1994.

Clark, John E., ed. *Los olmecas en Mesoamérica.* Mexico, D.F.: Citibank, 1994.

Coe, Michael D., et al. *The Olmec World: Ritual and Rulership.* Princeton, N.J.: Princeton University Press, 1995.

Coe, Michael D., and Richard A. Diehl. *In the Land of the Olmec.* 2 vols. Austin: University of Texas Press, 1980.

Coe, Michael D., David Grove, and Elizabeth P. Benson, eds. *The Olmec and Their Neighbors: Essays in Memory of Matthew W. Stirling.* Washington, D.C.: Dumbarton Oaks Research Library and Collections, 1981.

Coe, Michael D., and Justin Kerr. *The Art of the Maya Scribe.* New York: Harry N. Abrams, 1997.

Congdon, Kristin G., and Kara Kelley Hallmark. *Artists from Latin American Cultures: A Biographical Dictionary.* Westport, Conn.: Greenwood Press, 2002.

Cyphers Guillén, Ann. "San Lorenzo Tenochtitlan." In *Los olmecas en Mesoamérica,* edited by John E. Clark. Mexico, D.F.: Citibank, 1994.

Diego Rivera: Arte & revolución. Mexico, D.F.: Consejo Nacional para la Cultura y las Artes, 1999.

Donnan, Christopher B. "Moche Ceramic Portraits." In *Moche Art and Archaeology in Ancient Peru,* edited by Joan Pillsbury, 126–39. Washington, D.C.: National Gallery of Art, 2001.

Donnan, Christopher B., and Donna McClelland. *Moche Fineline Painting: Its Evolution and Its Artists.* Los Angeles: Fowler Museum of Cultural History, UCLA, 1999.

Durán, Fray Diego. *The History of the Indies of New Spain.* Translated and annotated by Doris Heyden. Norman: University of Oklahoma Press, 1994.

Easby, Elizabeth Kennedy, and John F. Scott. *Before Cortés: Sculpture of Middle America.* New York: Metropolitan Museum of Art, 1970.

El niño mexicano en la pintura. Mexico, D.F.: Fondo Cultural Banamex, n.d. [1979?].

El retrato en Buenos Aires. Buenos Aires: Museo de Arte Hispanoamericano Isaac Fernández Blanco, 1984.

El retrato novohispano en el siglo XVIII. Puebla: Museo Poblano de Arte Virreinal, 1999.

Enciclopedia del arte en América. 5 vols. Buenos Aires: Bibliográfica OMEBA, 1968–69.

Errázuriz, Jaime. *Tumaco—La Tolita: Una cultura precolombina desconocida.* Bogota: Carlos Valencia Editores, 1980.

Escamilla González, Iván. "Verdadero retrato: imágenes de la sociedad novohispana en el siglo XVIII." In *El retrato novohispano en el siglo XVIII,* 45–56. Puebla: Museo Poblano de Arte Virreinal, 1999.

Estabridis, Ricardo. "El retrato en Perú en el siglo XVIII: Las pinturas de Cristóbal Lozano." In *Tradición, estilo o escuela en la pintura iberoamericana, siglos XVI–XVIII,* ed. M. Concepción García Sáiz and Juana Gutiérrez Haces. Mexico, D.F.: UNAM, 2003.

Estrada de Guerlero, E. I. "El retrato en la Nueva España en el siglo XVI." In *El retrato civil en la Nueva España,* 15–20. Mexico, D.F.: Museo de San Carlos, 1991.

Exposición pintores y catedráticos. Catalogue introduction by F. Stastny. Lima: Museo de Arte y de Historia/Universidad Nacional Mayor de San Marcos, 1975.

Fane, Diana, et al. *Converging Cultures: Art and Identity in Spanish America.* New York: Harry N. Abrams, 1996.

Favela, Ramón. *Diego Rivera: The Cubist Years.* Phoenix, Ariz.: Phoenix Art Museum, 1984.

Frente al espejo: 300 años del retrato en Antioquia. Medellín: Museo de Antioquia, 1993.

Fuente, Beatriz de la. *Los hombres de piedra.* 2d ed. Mexico, D.F.: UNAM, 1984.

———. *Peldaños en la conciencia: Rostros en la plástica prehispánica.* 2d ed. Mexico, D.F.: UNAM, 1989.

———. *Cabezas colosales olmecas.* Mexico, D.F.: El Colegio Nacional, 1992.

Fuente, Beatriz de la, ed. *La pintura mural prehispánica en México: Teotihuacán.* 2 vols. Mexico, D.F.: UNAM/Instituto de Investigaciones Estéticas, 1996.

González Lauck, Rebecca B. "La antigua ciudad olmeca en La Venta, Tabasco." In *Los olmecas en Mesoamérica,* edited by John E. Clark, 93–111. Mexico, D.F.: Citibank, 1994.

Griffin, Gillett G. "Portraiture in Palenque." In *The Art, Iconography and Dynastic History of Palenque,* Proceedings of the Segunda Mesa Redonda de Palenque, part 3, edited by Merle Greene Robertson, 137–47. Pebble Beach, Calif.: Pre-Columbian Art Research, Robert Louis Stevenson School, 1976.

———. "Olmec Forms and Materials Found in Central Mexico." In *The Olmec and Their Neighbors: Essays in Memory of Matthew W. Stirling,* edited by Michael D. Coe, David Grove, and Elizabeth P. Benson, 209–22. Washington, D.C.: Dumbarton Oaks Research Library and Collections, 1981.

Grube, Nicolai, ed. *Maya: Divine Kings of the Rain Forest.* Cologne: Könemann, 2001.

Hermandad de Artistas Gráficos de Puerto Rico. *Puerto Rico arté identidad.* San Juan: Editorial de la universidad de Puerto Rico, 1998.

Hocquenghem, Anne Marie. "Un 'Vase Portrait' de femme Mochica." *Ñawpa Pacha* (Institute of Andean Studies, Berkeley) 15 (1977): 177–22.

Jalisco: Genio y maestría. Monterrey: Museo de Arte Contemporáneo de Monterrey, 1994.

Jaramillo de Zuleta, Pilar. *En olor de santidad: Aspectos del convento colonial, 1680–1830.* Bogota: Iglesia Museo Santa Clara, 1992.

Joralemon, Peter David. "The Old Woman and the Child: Themes in the Iconography of Preclassic Mesoamerica." In *The Olmec and Their Neighbors: Essays in Memory of Matthew W. Stirling,* edited by Michael D. Coe, David Grove, and Elizabeth P. Benson, 163–80. Washington, D.C.: Dumbarton Oaks Research Library and Collections, 1981.

———. "Human Mask." In *Olmec Art of Ancient Mexico,* edited by Elizabeth P. Benson and Beatriz de la Fuente, 237. Washington, D.C.: National Gallery of Art, 1996.

———. "Human Mask with Incised Design." In *Olmec Art of Ancient Mexico,* edited by Elizabeth P. Benson and Beatriz de la Fuente, 233–35. Washington, D.C.: National Gallery of Art, 1996.

Jordão, Vera Pacheco. *A imagem da criança na pintura brasileira.* Rio de Janeiro: Salamandra, 1979.

Klapisch-Zuber, Christiane. "Holy Dolls: Play and Piety in Florence in the Quattrocento." In *Women, Family, and Ritual in Renaissance Italy.* Translated by Lydia Cochrane. Chicago: University of Chicago Press, 1985.

Kolata, Alan, and Carlos Ponce Sangines. "Tiwanaku: The City at the Center." In *The Ancient Americas: Art from Sacred Landscapes,* edited by Richard Townsend, 317–33. Chicago: Art Institute of Chicago, 1992.

Larco Hoyle, Rafael. *Mochicas.* Vol. 2. Lima: Empresa Editorial "Rímac" S.A., 1939.

Lavalle, José Antonio de. *Arte y tesoros del Perú: Nazca.* Lima: Banco de Crédito del Perú, 1986.

Lazos de sangre: Retrato mexicano de familia, siglos XVIII y XIX. Mexico, D.F.: Museo de la Ciudad de México, 2000.

Lemos, Carlos Alberto Cerqueira, et al. *The Art of Brazil.* New York: Harper & Row, 1983.

Londoño Vélez, Santiago. *Arte colombiano: 3.500 años de historia.* Bogota: Villegas Editores, 2001.

Lozano, Luis-Martín. *Mexican Modern Art, 1900–1950.* Ottawa: National Gallery of Canada, 1999.

Marcus, Joyce, and Kent V. Flannery. *Zapotec Civilization.* London: Thames and Hudson, 1996.

María Izquierdo, 1902–1955. Chicago: Mexican Fine Arts Center Museum, 1996.

Martin, Simon, and Nicolai Grube. *Chronicle of the Maya Kings and Queens.* London: Thames and Hudson, 2000.

Martínez del Río de Redo, M. "Un retrato de doña Leona Vicario a los cinco años." *Anales del Instituto de Investigaciones Estéticas* 52 (1983): 117–21.

———. "El retrato novohispano en los siglos XVII y XVIII." In *El retrato civil en la Nueva España,* 23–41. Mexico, D.F.: Museo de San Carlos, 1992.

Matos Moctezuma, Eduardo. *The Great Temple of the Aztecs: Treasures of Tenochtitlan.* Translated by Doris Heyden. London: Thames and Hudson, 1988.

Merlo Juárez, Eduardo. "Un retrato novohispano." In *El retrato novohispano en el siglo XVIII,* 37–42. Puebla: Museo Poblano de Arte Virreinal, 1999.

Mesa, José de, and Teresa Gisbert. *Holguín y la pintura virreinal en Bolivia.* La Paz: Librería Editorial Juventud, 1977.

———. *Historia de la pintura cuzqueña.* 2d ed. Lima: Fundación A. N. Wiese/Banco Wiese, 1982.

Mexico: Splendors of Thirty Centuries. New York: Metropolitan Museum of Art; Boston: Little, Brown, 1990.

Miceli, Sergio. *Imagens negociadas: Retratos da elite brasileira, 1920–1940.* São Paulo: Companhia das Letras, 1996.

Miller, Mary Ellen. "The Image of People and Nature in Classic Maya Art and Architecture." In *The Ancient Americas: Art from Sacred Landscapes,* edited by Richard Townsend, 159–69. Chicago: Art Institute of Chicago, 1992.

Monjas coronadas. Mexico, D.F.: Museo Nacional del Virreinato, 1978.

Moreno Villarreal, Jaime. "Elogio del calor y del abanico." In *El retrato novohispano en el siglo XVIII,* 23–34. Puebla: Museo Poblano de Arte Virreinal, 1999.

Muriel, Josefina. *Retratos de monjas.* Mexico, D.F.: Editorial Jus, 1952.

Museo Dolores Olmedo Patiño. Xochimilco: El Museo, 1994.

Noriega, Robles, Eugenio. "Retratos de monjas muertas." In *Arte Funerario: Coloquio internacional de historia del arte,* edited by Beatriz de la Fuente, 155–63. Mexico, D.F.: UNAM, 1987.

Obregón, Gonzalo. "Algunas consideraciones sobre el retrato en el arte mexicano." *Artes de México,* XVII, 132 (1979): 23–26.

Pasztory, Esther. *Aztec Art.* New York: Harry N. Abrams, 1983.

———. "The Natural World as Civic Metaphor at Teotihuacan." In *The Ancient Americas: Art from Sacred Landscapes,* edited by Richard Townsend, 135–45. Chicago: Art Institute of Chicago, 1992.

———. "The Portrait and the Mask: Invention and Translation." In *Olmec Art and Archaeology in Mesoamerica,* edited by John E. Clark and Mary E. Pye, 265–75. Washington, D.C.: National Gallery of Art, 2000.

Pontual, Roberto. *Dicionário das artes plásticas no Brasil.* Rio de Janeiro: Civilização Brasileira, 1969.

Ribera, Adolfo Luis. *El retrato en Buenos Aires, 1580–1870.* Buenos Aires: Universidad de Buenos Aires, 1982.

Robertson, Merle Greene. "57 Varieties: The Palenque Beauty Salon." In *Fourth Palenque Round Table,* edited by Merle Greene Robertson and Elizabeth P. Benson, 29–44. San Francisco: Pre-Columbian Art Research Institute, 1985.

Robertson, Merle Greene, Marjorie S. Rosenbaum Scandizzo, and John H. Scandizzo. "Physical Deformities in the Ruling Lineage of Palenque, and the Dynastic Implications." In *The Art, Iconography and Dynastic History of Palenque,* Proceedings of the Segunda Mesa Redonda de Palenque, part 3, edited by Merle Greene Robertson, 59–86. Pebble Beach, Calif.: Pre-Columbian Art Research, Robert Louis Stevenson School, 1976.

Romero Flores, Jesús. *Iconografía colonial. . . .* Mexico, D.F.: Museo Nacional, 1940.

Ruiz Gomar, Rogelio. "La pintura de retrato en la Nueva España." In *El retrato novohispano en el siglo XVIII,* 9–20. Puebla: Museo Poblano de Arte Virreinal, 1999.

Sawyer, Alan. *Ancient Peruvian Ceramics: The Nathan Cummings Collection.* New York: Metropolitan Museum of Art, 1966.

Schele, Linda, and Peter Mathews. *The Code of Kings.* New York: Scribner, 1998.

Schele, Linda, and Mary Ellen Miller. *The Blood of Kings.* Fort Worth: Kimball Art Museum, 1986.

Schmidt, Peter, Mercedes de la Garza, and Enrique Nalda, eds. *Maya.* Milan: RCS Libri CNCA; Mexico, D.F.: INAH, 1998.

Shimada, Izumi. *Pampa Grande and the Mochica Culture.* Austin: University of Texas Press, 1994.

Shimada, Izumi, C. B. Schaaf, L. G. Thompson, and E. Moseley-Thompson. "Cultural Impacts of Severe Droughts in the Prehistoric Andes: Application of a 1500-Year Ice-Core Precipitation Record." *World Archaeology* 22 (1991): 247–70.

Sotos Serrano, Carmen. "La imagen de Felipe II en México." In *Felipe II y las Artes,* 553–67. Madrid: Actas del Congreso Internacional/Universidad Complutense de Madrid, 1998.

Toussaint, Manuel. *Colonial Art in Mexico.* Translated by Elizabeth Wilder Weismann. Austin: University of Texas Press, 1967.

Townsend, Richard, ed. *The Ancient Americas: Art from Sacred Landscapes.* Chicago: Art Institute of Chicago, 1992.

Trésors du Nouveau Monde. Brussels: Museaux Royaux d'Art et d'Histoire, 1992.

Uriarte, María Teresa. "Tepantitla, el juego de pelota." In *La pintura mural prehispánica en México: Teotihuacán,* edited by Beatriz de la Fuente, 2:227–90. Mexico, D.F.: UNAM/ Instituto de Investigaciones Estéticas, 1996.

Vargas Lugo, Elisa. "Una aproximación al estudio del retrato en la pintura novo-hispana." *Anuario de Estudios Americanos* 38 (1981): 671–92.

———. "El retrato de donantes y el autorretrato en la pintura novohispana." *Anales del Instituto de Investigaciones Estéticas* 51 (1983): 13–20.

———. "En torno a la pintura de retrato civil en la Nueva España." In *El retrato civil en la Nueva España,* 43–49. Mexico, D.F.: Museo de San Carlos, 1991.

Victoria, J. G. "Los autorretratos de Baltasar de Echave Orio." *Anales del Instituto de Investigaciones Estéticas* 53 (1983): 75–79.

Vidal, Teodoro. *Cuatro puertorriqueñas por Campeche.* San Juan de Puerto Rico: Ediciones Alba, 2000.

Wagner, Elisabeth. "Jade: The Green Gold of the Maya." In *Maya: Divine Kings of the Rain Forest,* edited by Nicolai Grube, 66–69. Cologne: Könemann, 2001.

Whittington, E. Michael. "Moche Ceramic Portraiture: Theme and Variation in Ancient Peruvian Art." Master's thesis, University of Florida, Gainesville, 1990.

ABOUT THE AUTHORS AND CURATORS

ELIZABETH P. BENSON (*essayist*) A graduate of Wellesley College and the Catholic University of America, Elizabeth Benson has taught at Columbia University, the University of Texas at Austin, and Catholic University. She was director of the Center for Precolumbian Studies at Dumbarton Oaks in Washington, D.C., between 1971 and 1978. During that period, she organized ten international conferences and edited more than eight volumes on Precolumbian subjects. She has lectured in numerous universities and museums throughout the United States, Europe, and Latin America and is the author of many books, including *Birds and Beasts of Ancient America* (1997) and *Atlas of Ancient America* (1986), with Michael Coe and Dean Snow.

FATIMA BERCHT (*co-curator*) Fatima Bercht is a native of Brazil and a graduate of the School of Fine Arts, Fundação Armando Alveres Penteado, in São Paulo and the Department of Art History and Archaeology at Columbia University. She is chief curator at El Museo del Barrio in New York City. Between 1988 and 1994, she served as director of visual arts for the Americas Society. The organizer of more than a dozen exhibitions of art from all over Latin America, Ms. Bercht has also lectured and published widely, especially on subjects dealing with modern and contemporary art. She is the coeditor of *MoMA at El Museo: Latin American and Caribbean Art from the Collection of the Museum of Modern Art* (2004), wrote the preface for the *St. James Guide to Hispanic Arts* (2002), and was the editor of *Latin American Artists of the Twentieth Century* (1993).

MIGUEL A. BRETOS (*co-curator, essayist*) Historian Miguel Bretos was born in Cuba and received his doctorate from Vanderbilt University. He is currently senior scholar at the Smithsonian Institution's National Portrait Gallery. Dr. Bretos has taught all over the world, including Oberlin College; Georgetown University; the Pontificia Universidad Javeriana in Bogota, Colombia; the University of New South Wales in Sydney, Australia; and the University of Yucatan in Mérida, Mexico. He has been the recipient of numerous awards, including two Senior Fulbright Fellowships. Dr. Bretos has co-curated more than ten museum exhibitions and is the author of three books and numerous scholarly and popular articles.

CAROLYN KINDER CARR (*co-curator, essayist*) Art historian Carolyn Carr is deputy director and chief curator of the Smithsonian Institution's National Portrait Gallery. She was educated at Smith College (B.A.), Oberlin College (M.A.), and received her Ph.D. from Case Western University. Between 1978 and 1983, she was chief curator at the Akron Art Museum in Ohio. She has taught art history at Kent State University and the University of Akron. Dr. Carr has curated many exhibitions on modern and contemporary art and is

the author of *Alice Neel's Women* (2002) and *Hans Namuth: Portraits* (1998), and the coauthor, with Dr. Ellen Miles, of *A Brush with History: Paintings from the National Portrait Gallery.*

CHRISTOPHER B. DONNAN (*essayist*) Archaeologist Chris Donnan is one of the world's leading authorities on Moche art and culture. Educated at the University of California at Berkeley (B.A.) and the University of California at Los Angeles (M.A., Ph.D.), Dr. Donnan is currently a professor in UCLA's Department of Anthropology. Between 1975 and 1996, he served as director of the Fowler Museum of Cultural History at UCLA. He has conducted extensive archaeological excavations in northern Peru and has been the recipient of major grants from the Guggenheim Foundation, the Getty Institute, the National Geographic Society, and the National Endowment for the Humanities. He has published and lectured widely throughout the United States and Latin America. His most recent books are *Moche Fineline Painting: Its Evolution and Its Artists* (1999) with Donna McClelland, *Royal Tombs of Sipán* (1993) with Walter Alva, and *Ceramics of Ancient Peru* (1992).

KIRSTEN HAMMER (*essayist*) Kirsten Hammer, director of Latin American Art at Sotheby's, received her undergraduate degree with high honors from Wesleyan University and is a graduate student in art and archaeology at Princeton University. She has received research grants from the MacArthur Foundation and UCLA and has lectured throughout the United States on Latin American art. Ms. Hammer has curated or co-curated more than ten exhibitions in Washington, D.C., New York, Mexico City, and elsewhere. She has published various articles on Spanish colonial art and has a longtime interest in convent life in colonial Mexico and the art associated with it.

MARÍA CONCEPCIÓN GARCÍA SÁIZ (*essayist*) María Concepción García Sáiz is chief curator of the Colonial Department of Madrid's Museo de América, which houses one of Europe's finest collections of Precolumbian and Spanish colonial art. She has lectured worldwide and has published several dozen important articles on Spanish colonial art. Among her most important books are *Los palacios de Nueva España* (1990), *Las castas mexicanas: Un género pictorico americano* (1989), and *El mestizaje americano* (1985).

RENATO GONZÁLEZ MELLO (*essayist*) Art historian Renato González Mello received his doctorate from the Universidad Nacional Autónoma de México in Mexico City in 1998 and is a full-time researcher with the university's Instituto de Investigaciones Estéticas. Between 1989 and 1992, Dr. González served as curator of the Museo de Arte Alvar y Carmen T. de Carrillo Gil. He has lectured widely on the muralist movement in Mexico, especially the murals of José Clemente Orozco and Diego Rivera, and served as guest curator for the exhibition *José Clemente Orozco in the United States,* organized by the Hood Museum of Art at Dartmouth College. His most recent books include and *José Clemente Orozco in the United States, 1927–1934* (2002), *José Clemente Orozco* (1995), and *Orozco, pintor revolucionario?* (1995).

LUIS-MARTÍN LOZANO (*essayist*) Art historian Luis-Martín Lozano is director of the Museum of Modern Art in Mexico City. He has taught at Mexico's Universidad Iberamericana and has been the guest curator of exhibitions in Spain, Mexico, Germany, Japan, Canada, and the United States, primarily in the area of modern art. He is the author of numerous books and catalogues, the most recent of which are *Frida: A Biography of Frida Kahlo* (2001), *Arte Moderno de México, 1900–1950* (2000), and *The Magic of Remedios Varo* (2000).

MARION OETTINGER JR. (*project director, co-curator, essayist*) Cultural anthropologist Marion Oettinger received his doctorate from the University of North Carolina at Chapel Hill in 1974 and has taught at Cornell University, Occidental College, UNC-Chapel Hill, and the Universidad Nacional Autónoma de México. He is currently senior curator and curator of Latin American Art at the San Antonio Museum of Art. Dr. Oettinger has lived and worked in various parts of Latin America and Spain for more than twenty-five years. He is the author of numerous books and articles of Latin American art and culture and has lectured widely in the United States, Latin America, and Europe. His most recent books include *The Folk Art of Spain and the Americas: El Alma del Pueblo* (1997), *The Folk Art of Latin America: Visiones del Pueblo* (1992), and *Folk Treasures of Mexico: The Nelson A. Rockefeller Collection* (1990).

LUIS PÉREZ-ORAMAS (*essayist*) Venezuelan Luis Pérez-Oramas is a writer, poet, and art historian, and holds a M.A. and Ph.D. from the École des Hautes Études en Sciences Sociales de Paris. Since 1995, Dr. Pérez has been professor of art history and Venezuelan art issues at the Instituto de Estudios Superiores de Artes Plásticas Armando Reverón in Caracas; he is currently adjunct curator at the Museum of Modern Art in New York. His books on art history and criticism include *La cocina de Jurassic Park y otros ensayos visuales* (1998), *Mirar Furtivo* (1997), and *Armando Reverón, de los prodigios de la luz a los trabajos del arte* (1990).

TEODORO VIDAL (*essayist*) Puerto Rican writer and art historian Teodoro Vidal has studied and collected art of Puerto Rico for more than thirty years and in 1996 donated a major collection of Puerto Rican art and artifacts to the Smithsonian Institution. He holds degrees from the University of Pennsylvania and the Wharton School. He has lectured widely on Puerto Rican folk art, as well as traditional festivals of that island, and is the author of a half-dozen books on Puerto Rican art and folk culture. His books include *Cuatro puertorriqueñas por Campeche* (2000), *Los Espada: Escultores Sangermeños* (1994), and *Los milagros en metal y en cera de Puerto Rico* (1974).

INDEX